greater than once they were.

As some of the petitioners in these cases demonstrate, marriage embodies a love that may endure even past death.

—Justice Anthony Kennedy, writing for the majority, *Obergefell v. Hodges*, 2015

LOVE

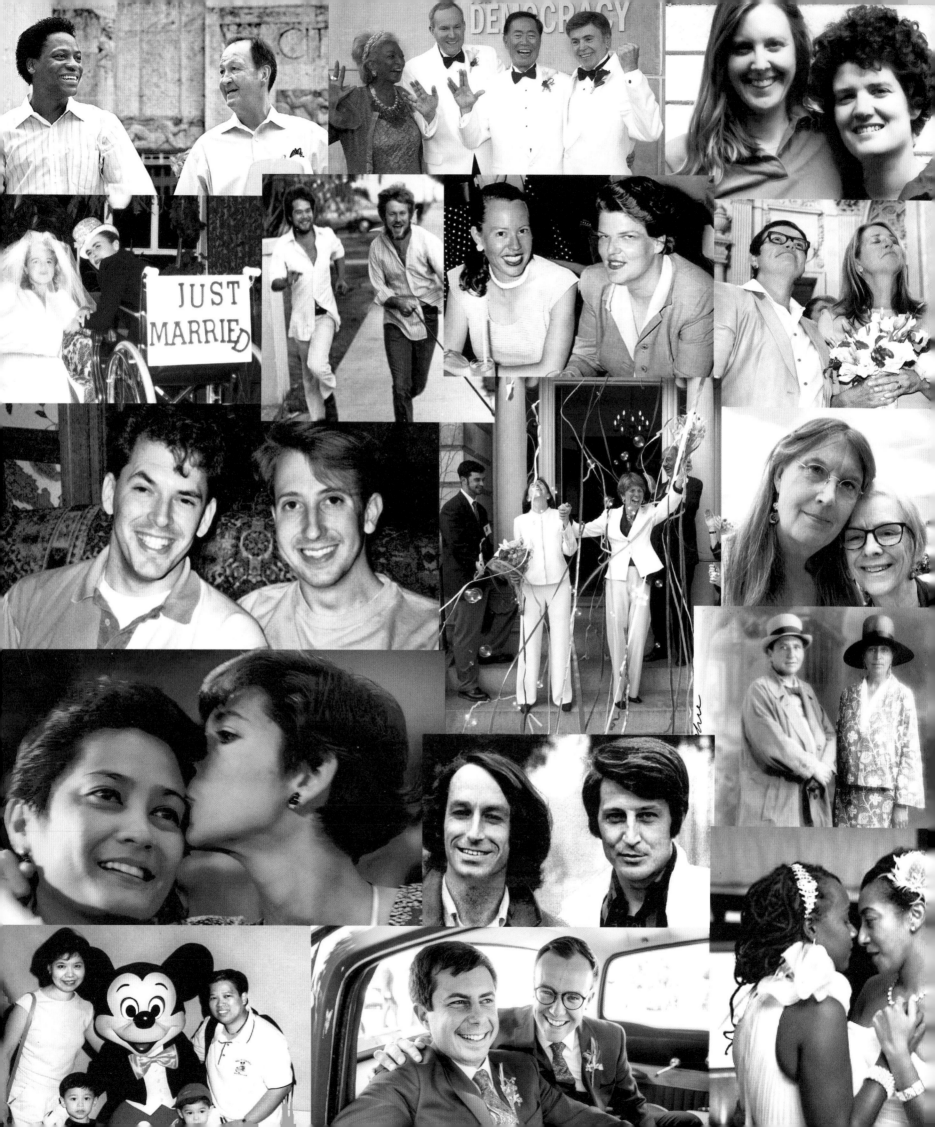

LOVE

THE HEROIC STORIES OF MARRIAGE EQUALITY

FRANKIE FRANKENY

WITH JOHN CASEY

FOREWORDS BY

EVAN WOLFSON AND

JIM OBERGEFELL

JustMarried

RIZZOLI
NEW YORK

New York · Paris · London · Milan

FOR THE LGBTQ+ COMMUNITY, HISTORY AND HEROES
HAVE OFTEN BEEN OUT OF REACH. *LOVE* CHRONICLES THE REMARKABLE JOURNEY
OF BRAVE COUPLES, ACTIVISTS, AND ALLIES ACROSS SEVEN DECADES WHO FOUGHT
TO SECURE LIFE-SAVING FREEDOMS. THEIR FIGHT CULMINATED IN ONE OF HISTORY'S
MOST SIGNIFICANT CIVIL RIGHTS VICTORIES OF THE TWENTY-FIRST CENTURY,
THE RIGHT TO MARRY.

THIS COLLECTION OF STORIES IS MOVING AND, AT TIMES, HEART-WRENCHING.
IT ILLUMINATES THE EXTRAORDINARY COURAGE OF THOSE WHO OPENED THEIR PRIVATE LIVES
TO PUBLIC SCRUTINY IN PURSUIT OF LIVING AND LOVING AS FREELY AS EVERYONE ELSE.
THEIR DETERMINATION AND PASSION CONVINCED POLITICIANS, PREACHERS,
AND THE PUBLIC THAT THEY HAVE A RIGHT TO THE DIGNITY THAT COMES WITH
THE INCLUSION IN HISTORY'S MOST CHERISHED INSTITUTION.

THE BEST TOOLS WE HAVE TO CREATE CHANGE ARE THE STORIES
WE TELL ABOUT OUR LIVES. THIS TRUTH IS AT THE HEART OF THE BRAVE SOULS
IN THIS BOOK AND BEYOND, WHO BOLDLY DECLARED, AFTER SPENDING THEIR
FORMATIVE YEARS IN ISOLATION, "YES, I AM"—GAY. EQUAL. LOVE IS LOVE.
THEY FOUGHT TIRELESSLY TO EXPAND LOVE AND PROTECTIONS FOR OUR COMMUNITY,
DOING WHATEVER THEY COULD TO CREATE A MORE JUST AND COMPASSIONATE WORLD.
THIS BOOK IS DEDICATED TO ALL OF THEM.

—FRANKIE FRANKENY

CONTENTS

ARGUING, MAKING, AND WINNING THE CASE
FOR MARRIAGE EQUALITY

The title of my 2004 book was *Why Marriage Matters*. Here, I reflect on why it matters that, on June 26, 2015, a decades-long movement, a clear strategy accompanied by powerful personal stories, and a tenacious, focused campaign all culminated in a long-sought, hard-won victory.

Why it matters that, by changing hearts, minds, and the law, we secured the freedom to marry for all loving and committed couples throughout the United States.

Why it matters that America lived up to its promise. Why it matters that love won.

Why Marriage Matters was published shortly after we had seen the first same-sex couples marry, but we still faced a long and uncertain road ahead to a full national win. I ended the book by asking:

> Thirty years from now—when gay people have won the freedom to marry and our society looks back and wonders what the big deal was—our children, grandchildren, nieces, and nephews will want to know where we stood and what we did at a pivotal moment. Did we make a difference? Did we stand up for what is right?

What happiness, what luck, what a triumph to be able to say now—after less than thirty years—that for so many Americans, the answer was "Yes."

We dug deep. We worked hard. And we helped transform non-gay people's understanding of gay, lesbian, bisexual, and transgender people and the values we all share.

As citizens, as a movement, and as a nation, we did make a difference. Millions stood up for what is right by engaging their loved ones and fellow citizens in often challenging conversations and by working to end injustice. The decision-makers—elected officials, judges, and justices—followed, and together we won the freedom to marry nationwide.

Throughout this Freedom to Marry legacy, we tell the story of how this victory happened. But why does it matter?

Jim Obergefell, the named plaintiff in the US Supreme Court case *Obergefell v. Hodges*, which granted marriage equality throughout the United States, celebrates the win at San Francisco Pride, June 26, 2015.

I believe the epic success of our campaign matters for several reasons.

First, winning the freedom to marry matters because, yes, marriage matters—and now millions more can share in it. Celebrating same-sex couples' love, strengthening their families, and affirming their equality under the law have brought joy, dignity, security, and connectedness to millions of people. Justice Anthony Kennedy's opinion in the marriage case extols what he calls the "enduring importance of marriage." It is the preeminent language of love, the vocabulary of full inclusion and respect—and alongside that comes a vast array of legal and economic protections and responsibilities, from birth to death (with taxes in between).

Marriage touches every vital area of life: creating kin, raising children, building a life together, celebrating and reinforcing love and commitment, caring for one another, retirement, and inheritance. Bringing the freedom to marry to so many has made a profound difference in people's lives, happiness, and well-being in the precious, short time we share on this planet.

Second, winning the freedom to marry signaled the dawn of equal citizenship for gay people. The victory meant that the US government, which for so many years was the number one discriminator against gay people, now puts its moral and legal weight on the side of fairness for all families. This marked a momentous milestone in gay people's decades-long journey from despised, oppressed minority to fully included citizens.

By claiming the resonant vocabulary of marriage, we seized an engine of transformation, helping non-gay people better understand who gay people are, furthering our inclusion and equality under the law. As Judge Robert Shelby wrote in his 2013 decision striking down Utah's denial of marriage to same-sex couples:

It is not the Constitution that has changed, but the knowledge of what it means to be gay or lesbian.

Now, it is no longer tolerable for the law to exclude gay people from the basic dignity and protections that are part of America's promise and that our Constitution guarantees.

Third, winning the freedom to marry enriched the lives not just of gay people but also of non-gay people who are our family members, friends, co-workers, and fellow citizens. Fathers could walk their lesbian daughters down the aisle. Grandmothers could dance with their gay grandsons at their weddings. Non-gay Americans could celebrate all of their friends' love and commitment equally.

Fourth, winning the freedom to marry fulfilled America's promise of liberty, dignity, equality, and freedom for all. Living up to our Constitution has not just improved the lives of same-sex couples and their loved ones—it has improved our society altogether.

Fifth, winning the freedom to marry was a victory for human rights and security around the world. On the morning we won in the Supreme Court, one of the first people to call me was then-Vice President Joe Biden. He thanked and congratulated me and Freedom to Marry, noting that this victory was a triumph not just for gay inclusion and human rights but for foreign policy.

A sign protesting the lack of equal rights for LGBTQ+ people, San Francisco City Hall, 2009.

Finally, our success in winning the freedom to marry matters because it provides valuable lessons for how to achieve change. We had many stumbles and missed opportunities, but we got some big things right—most notably our combination of a broad movement comprised of many organizations, activists, and stakeholders; a clear strategy we stuck with; and a tenacious central campaign that drove the strategy and leveraged the movement.

A central lesson, reflected in this book, is the power of stories—sharing the truths about our lives and connecting them to the shared values of the people we still need to reach.

As Freedom to Marry proclaimed on the day of victory:

Love won. America won. We all won.

For all these reasons, the triumph and transformation of winning the freedom to marry nationwide matters. It matters for LGBTQ+ people—tangibly and intangibly—and it matters for non-gay people. It matters for our country, for human rights around the world, and for history.

—EVAN WOLFSON

Evan Wolfson and Mary Bonauto, the lead strategists who shaped the gay marriage movement for decades, overjoyed at the US Supreme Court ruling, June 26, 2015.

17

NO UNION IS MORE PROFOUND
THAN MARRIAGE

I do.

What an extraordinary statement to make. Two words with so much power. Two simple words that declare intent. A personal statement and a testament captured in three letters. Does any other phrase carry that kind of punch? Do you promise to tell the truth? I do. Do you like Thai food? I do. Do you promise to love this person with your whole heart? I do.

When used in a wedding ceremony, that simple sentence becomes something profound. In that setting, saying "I do" represents a choice: a commitment to share life with another person, to put that person and their hopes, dreams, needs, and desires above everything and everyone else. No matter how long a couple's relationship might be, "I do" transforms it into something new, something wondrous. United States Supreme Court Justice Anthony Kennedy described marriage in this way:

> No union is more profound than marriage, for it embodies the highest ideals of love, fidelity, devotion, sacrifice, and family. In forming a marital union, two people become something greater than once they were. As some of the petitioners in these cases demonstrate, marriage embodies a love that endures even past death.

For the first 239 years of our nation's history, the right to make those promises and commitments was denied to same-sex couples. After years of advocacy by the LGBTQ+ community, our nation was brought to the precipice of marriage equality in 2013 when the Supreme Court of the United States struck down the federal Defense of Marriage Act, a law defining marriage as only between one man and one woman, with their decision in *United States v. Windsor*. Two years later, with the proverbial stroke of a pen on June 26, 2015, the right to marry was finally affirmed by the Supreme Court of the United States with their decision in *Obergefell v. Hodges*.

Throughout the fight for marriage—indeed the long fight for LGBTQ+ equality—courts of law and considerable public opinion have been firmly against the humanity, dignity, and human rights of LGBTQ+ people. State attorneys general argued that allowing same-sex couples to marry undermined the institution of marriage—that opposite-sex couples would stop marrying and, even more inexplicably, stop having children if marriage were opened to same-sex couples. Many advocates of same-sex marriage bans claimed the purpose of marriage is procreation, yet no laws existed to ban marriage between people who are unable to conceive. Opponents of marriage equality conflated holy matrimony, a blessing of a marital union by a faith leader in a house of worship, with marriage, a civil act requiring a license issued by a governmental agency but *no* religious ceremony, as demanded by the separation of church and state.

Opposite and pages 21–22: Captures from *Everything Must Change*, a short film created for GLBTQ Legal Advocates & Defenders (GLADD) to engage voters before the November 2008 election, featuring jazz singer Kellye Gray. *Everything Must Change* depicts a family at the apex of equality: finally free to marry, the gay couple, along with their adorable young daughter, celebrate the privilege and the right to live within the margins of mainstream society—a new reality they've dreamed of all their lives.

Religious leaders, elected officials, and others declared that advocates of marriage equality were attempting to devalue and redefine marriage, but this argument ignored history. Marriage has evolved from a pairing made by others to protect a family's wealth, power, and status into a relationship formed by two equals based on compatibility, love, and a desire to build a future together. Supreme Court Justice Ruth Bader Ginsburg undercut the redefining marriage argument when she reminded the courtroom that marriage had already been redefined because women are no longer the property of their husbands. Justice Kennedy also addressed this argument in his decision:

> It would misunderstand these men and women to say they disrespect the idea of marriage. Their plea is that they do respect it, respect it so deeply that they seek to find its fulfillment for themselves. Their hope is not to be condemned to live in loneliness, excluded from one of civilization's oldest institutions.

Marriage represents that human desire for connection and a sense of belonging. In 1967, sixteen states had laws banning interracial marriage, denying couples the companionship, rights, protections, benefits, and responsibilities that marriage confers. Richard and Mildred Loving lived in Virginia and married in Washington, DC. They were later sentenced to prison for violating Virginia's Racial Integrity Act of 1924, eventually leading to the Supreme Court of the United States' *Loving v. Virginia* decision on June 12, 1967. This decision, rooted in the Constitution's Equal Protection Clause, struck down interracial marriage bans and affirmed interracial couples' right to marry. This decision laid the groundwork that would be used decades later for marriage equality in Justice Kennedy's *Obergefell* decision:

> They ask for equal dignity in the eyes of the law. The Constitution grants them that right.

When the Sixth Circuit Court of Appeals ruled 2–1 against the plaintiffs in *Obergefell v. Hodges*, setting up their appeal to the Supreme Court decision, the two judges in the majority accused the plaintiffs of wasting the court's time. These judges told the plaintiffs from four states that they did not deserve to be in a courtroom, that they should instead be on the streets, working to gain approval for marriage equality in the court of public opinion. The public had already reached its judgment by passing state-level defense of marriage acts defining marriage as only between one man and one woman, denying rights to a minority through majority vote.

Mildred and Richard Loving found relief in the courts, bringing down interracial marriage bans. Thirteen parents in Topeka, Kansas, turned to the courts, ending school desegregation in *Brown v. Board of Education*. The framers of the Constitution created a system of courts the people could turn to when their rights were being denied or abridged by the majority; therefore, a courtroom *was* the appropriate place for these plaintiffs who were being denied the right to marry.

Court rulings have played a major part in civil rights progress throughout our nation's history. Laws passed by a majority of voters, or a legislature, are often the catalyst for transformational court rulings such as *Loving*, *Windsor*, and *Obergefell*. Those rulings force our nation and society forward at times when many people are unwilling to advance. As vital as the court system is for affirming rights that are being denied, lasting progress can occur only when people's hearts and minds change in concert with court decisions.

Plaintiffs in civil rights lawsuits help change public opinion, but the people who live openly in their communities every day create lasting change. Stereotypes are shattered when neighbors, co-workers, schoolmates, and acquaintances get to know someone who might at first seem different. Those differences that seem so great at first become insignificant when someone becomes part of daily life, when they become part of a community. Instead of seeing only the surface differences, people can instead focus on the similarities we share as human beings. Changing hearts and minds, although perhaps slower than a lawsuit, leads to lasting societal change.

But that progress can never be taken for granted. Permanent change requires every eligible voter to participate in every election. Federal judges and Supreme Court justices are nominated or appointed by the US president, and these jurists rule on civil rights cases like *Loving* and *Obergefell*. When voters choose not to exercise their right to vote, it can lead to extremist courts, putting civil rights at risk. In 2022, the Supreme Court of the United States did something it had *never* previously done—rather than affirm a right, it rescinded one. With their decision in *Dobbs v. Jackson Women's Health Organization*, the court overturned the constitutional right to abortion. In his concurring opinion on Dobbs, Justice Clarence Thomas stated that other decisions, including *Obergefell*, should be overturned, proving that when one right is taken away, all other rights are at risk.

Not voting allows others to determine the judges who rule on these cases, jeopardizing the rights and protections enjoyed by "We the People," particularly those in marginalized communities. Voting in every local, state, and federal election is the only way to create a government and judiciary that accurately reflect who we are as a nation, helping ensure that human and civil rights for all are affirmed. Without active voter participation, the United States will never achieve the Constitution's promise of a more perfect union.

Marriage equality became a reality in our nation because people wanted to formalize their union with the person they love, and they were willing to fight for that right in a courtroom, in the halls of government, in the media, and on the streets of their communities. A symbolic ceremony or a civil partnership is not the same as marriage, nor can it capture the love, promises, commitments, rights, and protections represented by marriage. These couples hoped to use the words "wife," "husband," or "spouse" with the full weight and meaning that comes with legal recognition. They wanted to be seen, respected, and recognized. They wanted to exist in the eyes of the law.

Activists and plaintiffs, people who tell their stories, create change. Those who live openly and authentically change hearts and minds. Their efforts enable all of us to utter those profound words:

I do.

—JIM OBERGEFELL

INTRODUCTION

Love = Love. The equation seemed simple, yet it took decades of defiant and courageous couples who stepped forward, opening their private lives, heartbreaks, struggles, and hopes to public scrutiny. Unimaginable love stories from people of all walks of life pushed forward in search of true community belonging. Combined with strategic political and legal campaigns, they won the constitutional right to be accepted as worthy and included in the most cherished cultural institution of all time: marriage. Collectively, they transformed a seemingly radical movement into one that truly affirmed that love is love.

Marriage has always been an exclusive club where membership comes with privileges: civil rights, protections, and benefits—1,138 to be exact. Most newlyweds are aware of only a tiny fraction of these marital advantages, but during the pursuit of equality, securing these freedoms became an essential part of the desire for matrimonial inclusivity.

Many couples waited thirty, forty, even fifty years just for the opportunity to say, "I do," to be included in a social construct that dates back to April 16, 1061, when Pedro Díaz and Muño Vandilaz were married by a priest in Spain. A celebration of love predating written history can be traced as far back as 2400 BCE in ancient Egypt, where Niankhnum and Khnumhotep lived and were buried as a couple, as depicted in the images and hieroglyphics within their tombs. Yet queer history has often been erased, leaving it largely invisible.

Unique to the LGBTQ+ community is the fact that, for our history to exist, our members first had to exist—openly. A person's history must be documented, something difficult to achieve when one lives in secret. Alone and unable to share our first crush with friends or celebrate our love with family, we turned to secret languages, like music lyrics, for soul-soothing knowledge that others like us were out there "somewhere over the rainbow."

Before the 1960s, couples like Alice B. Toklas and Gertrude Stein covertly showcased the possibility of love to a community so hidden that many didn't even know others like them existed. Many historians downplayed their decades-long relationship, referring to them as close friends, which left a shadow of uncertainty over our truth. As a result, we have rarely been allowed to have history, much less heroes.

24 An unknown couple, circa 1920, from the book *The Invisibles: Vintage Portraits of Love and Pride: Gay Couples in the Early Twentieth Century.*

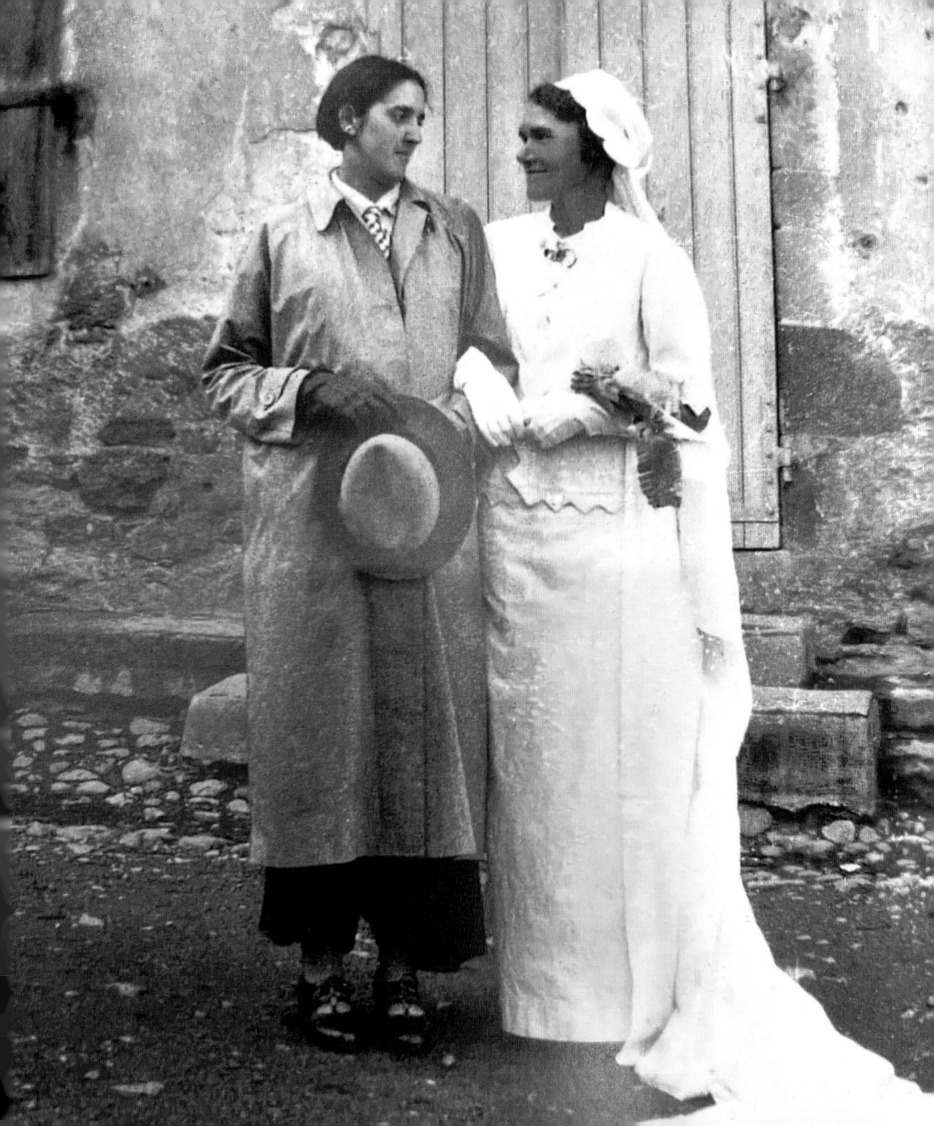

As the movements for Black and women's rights erupted in the mid-1960s, gay people began to see the potential for freedom as well. First on the list was the freedom simply to *be*. After shedding decades of facades, many came out, refusing to be harassed into silence. Several couples, believing they were as deserving as anyone else, boldly sought marriage licenses. Their efforts grabbed national headlines, sparking fierce debates about basic human rights, including the right of queer people to love, raise families, and live with dignity and respect.

In Minnesota, Jack Baker and Michael McConnell embarked on what can only be described as a caper—complete with a law degree, adoption, name change, and a failed Supreme Court case—to secure a legally recognized marriage license. Richard Adams and Tony Sullivan, a bi-national couple, obtained a legal marriage license from a sympathetic straight county clerk. When Justice Anthony Kennedy ruled against their right to stay together in the US, they fled the country, wandering for years to stay united. In a striking twist, Kennedy would later cast the tie-breaking vote that granted marriage rights across the country.

The next decade saw another step toward marriage equality, as the AIDS epidemic forced thousands to confront the urgent need for legal protections. Tom Joslin and Mark Massi's poignant documentary about their relationship and struggle with the disease sheds light on the reality of legally unrecognized same-sex relationships. Similarly, Karen Thompson fought a nine-year legal battle to bring her girlfriend, Sharon Kowalski, home after a car accident left her a quadriplegic. Thompson's fight became a powerful example of the need for legal rights.

In 1996, the fight for marriage equality intensified when a Hawaiian court granted same-sex couples the right to marry. This sparked a nationwide backlash, culminating in the passage of the Defense of Marriage Act (DOMA), which prohibited federal recognition of same-sex marriages for nearly two decades. It wasn't until Edie Windsor, an eighty-three-year-old widow, successfully challenged DOMA that federal recognition was achieved.

One couple's victory inspired another. After seeing Windsor's win, Ohio couple Jim Obergefell and his dying partner of twenty-two years, John Arthur, realized they, too, had to fight. The couple married on a tarmac in Maryland, but their battle wasn't over—they had to ensure John's death certificate recognized their marriage. Their ultimate victory overturned Baker and McConnell's case, cementing the first legal same-sex marriage license in the world.

It's a misconception that the right to marry was won quickly. This book shows the long, arduous journeys couples undertook to secure their rights. While the media often portrayed marriage equality as an elitist and white-privileged fight, this book highlights the diversity of the movement, which included couples of all ages, races, religions, gender identities, and socioeconomic backgrounds.

The second Twin Cities Pride March, Minneapolis, Minnesota, June 1973. The procession ended in Loring Park, a spot where LGBTQ+ people were often arrested or encountered danger.

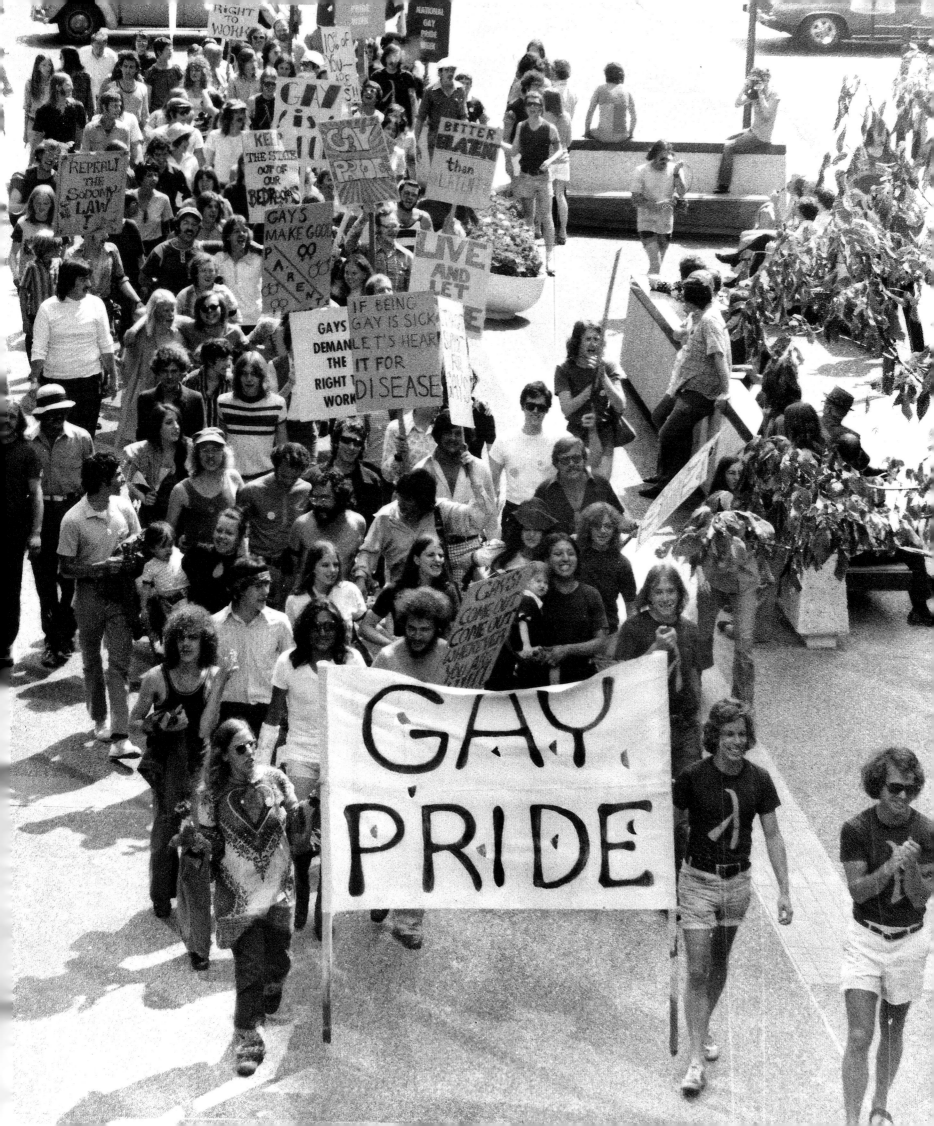

In 1996, at the time of the world's first freedom-to-marry victory in Hawaii, there were no states or countries where same-sex couples could marry. Today, thirty-five countries, representing more than 1.1 billion people, allow same-sex marriage, with Greece being the most recent addition. *Love* highlights these profound changes while telling some of the most important and heartwarming stories from around the globe. However, the fight is far from over, with rights still being challenged both in the US and around the world.

The simple right to have one's love recognized as equal tells the world: *We are equal*. More importantly, it shows the unknown millions living in isolation that we can dream of love just like everyone else—that our love was right all along. Future generations now have the opportunity to love openly, but they must vigilantly protect this right if they wish to preserve it.

Love is a collection of stories that are moving, joyful, and ultimately triumphant—a wedding dance of the heart. It is about hope, devotion, faith, integrity, dignity, and, most importantly, love.

—FRANKIE FRANKENY

A couple in Bangkok rejoices at the passage of Thailand's Marriage Equality Act, June 18, 2024.

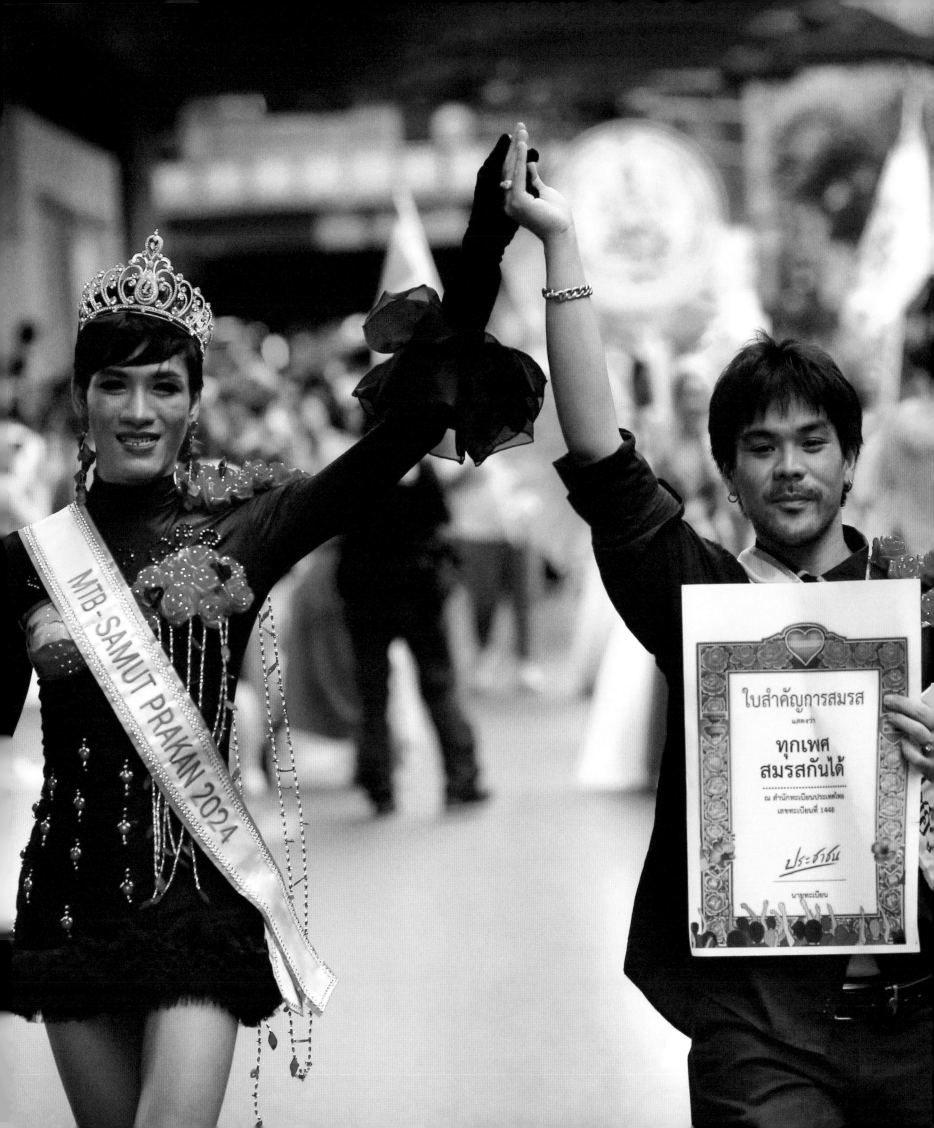

DEARLY BELOVED, WE GATHER HERE

1950–1970

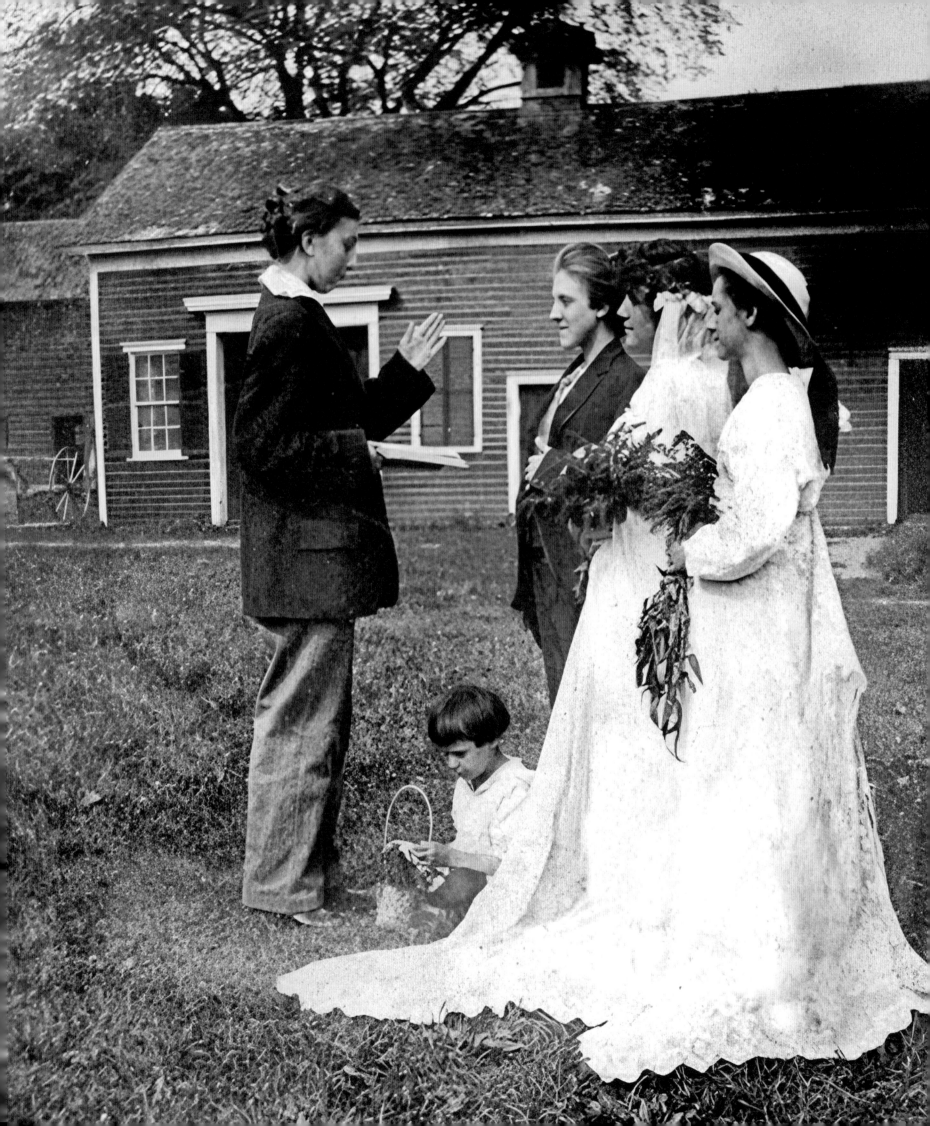

CHAPTER 1 — INTRODUCTION

Picture a time when people had to keep their love, identities, and lives hidden. This was the reality for LGBTQ+ individuals in mid-twentieth-century America—a time of stark oppression, profound secrecy, and, ultimately, a burgeoning fight for equality.

The invisibility of LGBTQ+ role models meant that stories of love and resilience were rare. Prominent couples like Alice B. Toklas and Gertrude Stein, who lived relatively open lives, were the exceptions. Their wealth and status afforded them freedoms and safety that were unimaginable for most in this era. As such, they used their privilege to pen somewhat covert musings on life together, offering a glimpse into possibility—a brave beacon of hope to those who knew no one else like themselves.

A few rebellious yet clandestine lovers risked it all to have a keepsake, some documentation of love's existence, as revealed in Hugh Nini and Neal Treadwell's globally lauded collection of imagery from the 1850s to the 1950s. These portraits are proof that our way of loving has always existed.

The 1950s were a paradoxical era—postwar prosperity mingled with Cold War paranoia and Jim Crow laws enforcing racial separation. LGBTQ+ individuals faced a ruthless witch hunt orchestrated by the era's most notorious figures. Senator Joseph McCarthy and his cronies, under the guise of rooting out communists, launched the Lavender Scare. This brutal campaign purged thousands from government jobs, branding them as "sexual perverts" and security risks susceptible to blackmail by Soviet spies because they lived in secret.

For LGBTQ+ people, being discovered could mean losing everything—jobs, homes, families, and reputations. Gay bars were one of the few places where the community could congregate and feel a semblance of safety, but even these were frequently targeted by police raids. Patrons faced arrest, public humiliation, and the very real threat of being outed—a fate that could destroy a person's career and personal life. Those caught in the Lavender Scare were often imprisoned or, worse, sent to mental institutions by family members, subjected to so-called cures like electroshock therapy and lobotomies.

Compounding this fear was a significant yet often overlooked change in religious doctrine: the addition of the word *homosexual* into the Bible shortly after World War II. This decision transformed religious interpretations of same-sex relationships and led to a more explicit condemnation of LGBTQ+ people within many communities, fostering increased stigma and discrimination.

Amid this climate of terror, two remarkable women—Del Martin and Phyllis Lyon—began a secret social club for lesbians. In 1955, in their San Francisco home, they established the Daughters of Bilitis (DOB), founded as a secure space for socialization, the DOB quickly evolved into a platform for advocacy, challenging the oppressive status quo and offering a glimmer of hope and solidarity.

Page 31: An unknown lesbian couple pictured with two witnesses at a symbolic wedding, from Sebastian Lifshitz's 2014 book, *The Invisibles: Vintage Portraits of Love and Pride*. Though the couple could not legally marry at the time this photograph was taken, it is still a powerful testament to the desire to record love's existence.

Opposite: George Harris and Jack Evans began dating in Texas in 1960 and kept their relationship secret for twenty years. They would eventually marry in Texas in 2015, in their eighties.

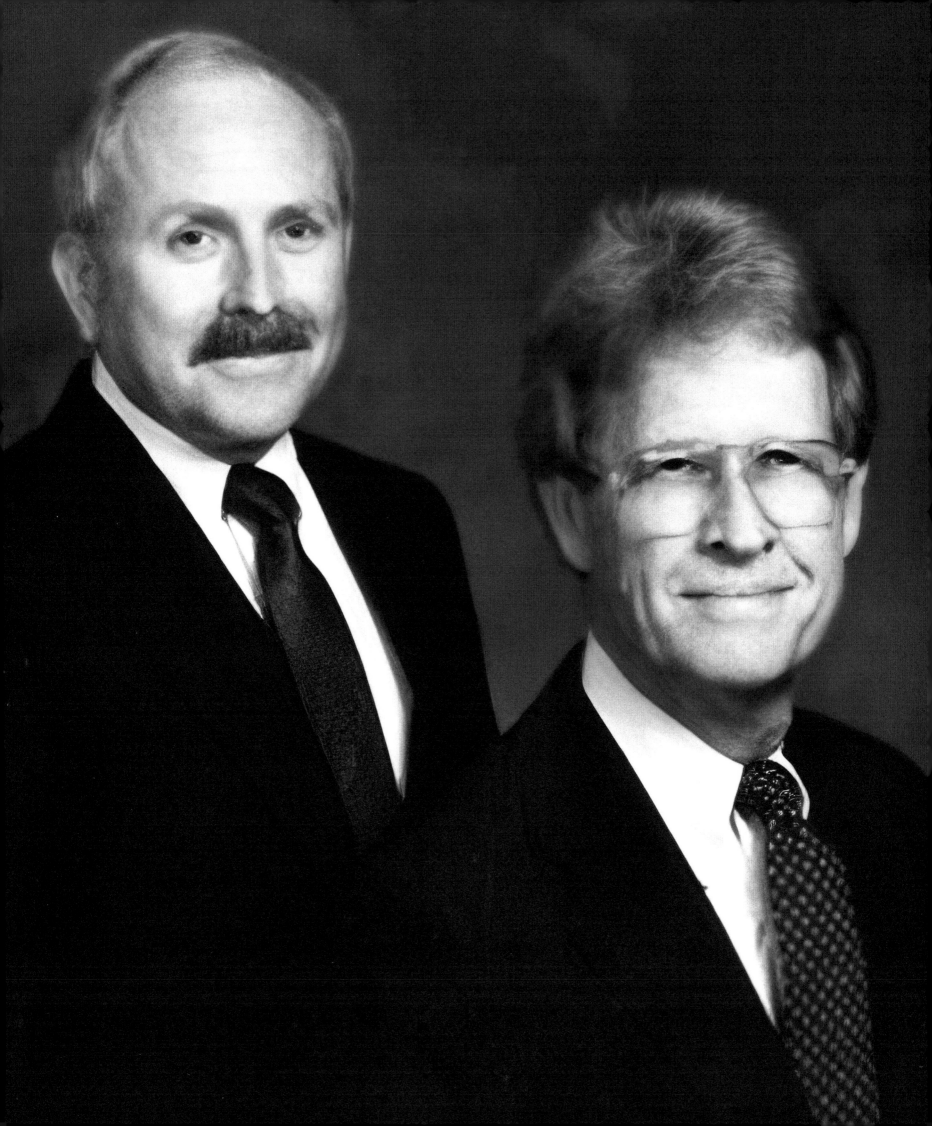

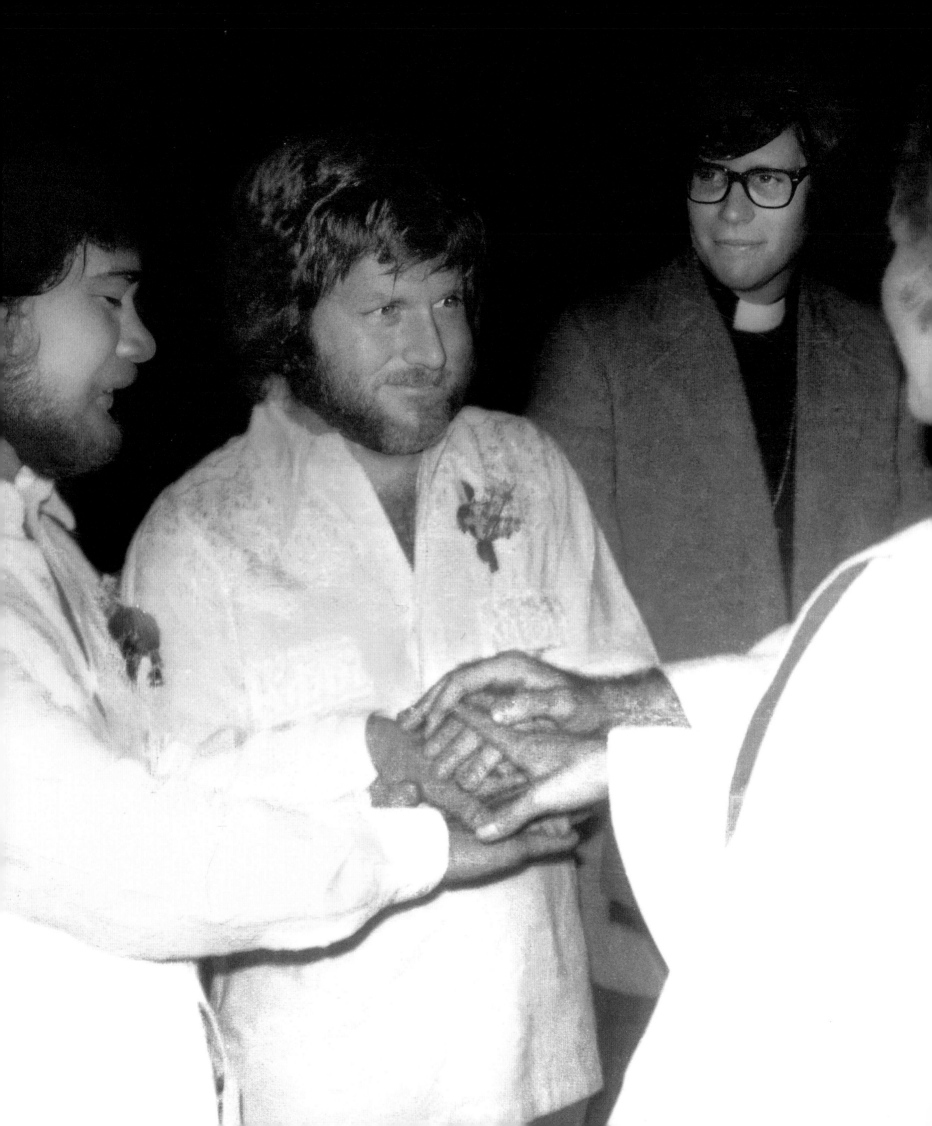

As the 1960s dawned, America was in flux, with civil rights movements challenging racial segregation, women's oppression, and the marginalization of LGBTQ+ individuals. Richard and Mildred Loving would challenge interracial marriage bans, up to the Supreme Court of the United States, and win. Their case, *Loving v. Virginia*, established many precedents for queer marriage equality later on. The decade witnessed a cultural shift—a tentative yet transformative push toward visibility and equality.

In January 1964, Randy Wicker, founder of the Mattachine Society, the male equivalent to DOB, appeared on national television on a late-night talk show, *The Les Crane Show*. He was one of the first, if not the first, "out" person to appear on a broadcast program without being pictured in shadow. He refused to hide, standing in stark contrast to the fear that had previously cloaked LGBTQ+ identities. Just two years later, in 1966, he orchestrated the famous "sip-in" at Julius' Bar in Greenwich Village—a play on the civil rights movement's sit-ins. The defiance was simple yet monumental. A year later, New York relaxed its alcohol laws, allowing LGBTQ+ people to gather in bars without fear of legal repercussions.

In 1968, Rev. Troy Perry founded the Metropolitan Community Church (MCC) and performed the first public same-gender wedding in US history.

Then came June 28, 1969. The world turned upside down on Christopher Street as patrons of the Stonewall Inn fought back against the police in an unprecedented display of resistance. The Stonewall Riots were a battle cry heard around the world. Transgender activists like Marsha P. Johnson, Sylvia Rivera, Miss Major Griffin-Gracy, and Stormé DeLarverie emerged as the faces of this defiance, as the Stonewall Uprising gave birth to the modern gay rights movement. A year later, on June 28, 1970, the first-ever gay pride parade marched through the streets of Los Angeles.

The following year, in 1970, Rev. Perry filed the first-ever lawsuit seeking legal recognition for same-gender marriages, challenging the legal system and advocating for equal rights. The Reverend then officiated the wedding of Canadian radio-TV personality Michel Girouard and his partner Réjean Tremblay in Los Angeles.

One of the main lifelines for the LGBTQ+ community during this era, in coping with the trauma of isolation, was music. Feelings of beauty and love, often realized at a young age, were condemned as wrong, perverse, and a barrier to salvation. Without a sister, mother, best friend, or aunt to confide in, many in the closet turned to music. It became the soul's only outlet for these overwhelming emotions—a soothing survival tool. Through cryptic lyrics, many discovered others like them, even famous and successful people. It was a quiet confirmation that others shared the same desires and, perhaps, that one day they too might experience true love.

The 1960s and 1970s were a wild time for music, with punk rock, hip-hop, and disco all making their debuts. Discotheques became a cool alternative to gay bars, bringing together people from all walks of life under the shiny disco ball—a spot where gay people could escape the discrimination and prejudice they often faced outside. They found a sense of belonging and celebrated together. Discos were a space for love and acceptance, where music became powerful community anthems of liberation. The LGBTQ+ community found strength and empowerment in tracks like Donna Summer's "I Feel Love" and Gloria Gaynor's "I Will Survive." Artists such as Janis Joplin, David Bowie, Elton John, Dusty Springfield, Freddie Mercury, and Janis Ian soared to the top of the charts, but their queer identities at the time were merely suspected, not substantiated.

The cultural revolution extended beyond music. Culturally, the 1970s were a time of both experimentation and nostalgia. The decade saw the continuation of the countercultural movements of the 1960s. However, there was also a growing sense of disillusionment, fueled by the Vietnam War, an oil crisis, and the Watergate scandal that led to the resignation of the president of the United States. Amid this backdrop of social upheaval and changing attitudes toward sexuality, the 1970s became a pivotal moment for the LGBTQ+ community, particularly in urban centers like New York City and San Francisco.

In 1970, a love story that would change history began in Minneapolis, Minnesota. Jack Baker, a law student, proposed to Michael McConnell, a librarian, and the two men applied for a marriage license. Their application was denied, but Jack and Michael persisted. They sued their county, arguing that no law explicitly barred two men from marrying. Although their case was dismissed, they found a legal loophole in another county, where they were able to obtain the first legal gay marriage license in US history although it wouldn't be deemed valid until almost fifty years later.

In 1972, however, the US Supreme Court dismissed their appeal in *Baker v. Nelson*, ruling that the case presented "no substantial federal question." The dismissal became a binding precedent, preventing federal courts from ruling in favor of same-sex marriage for decades. Despite the setback, Jack and Michael's marriage remained legally valid. Frank Kameny, who had advised the couple throughout their journey, believed that this was just the beginning of a longer battle for equal rights.

Meanwhile, across the country, LGBTQ+ activists were refusing to back down. On June 4, 1971, members of the Gay Activists Alliance marched into the New York City Marriage License Bureau, demanding marriage rights for same-sex couples. It was a brazen protest, a direct confrontation with the laws that oppressed them.

In Colorado, Clela Rorex, a county clerk who saw no reason to deny same-sex couples the dignity of marriage, became a hero. Between March and April of 1975, she issued six marriage licenses to same-sex couples in Boulder. Despite opposition from the state, including the attorney general, her bravery resonated with a community that had long been denied recognition.

Richard Adams and Tony Sullivan, a bi-national couple and the first to receive a license from Rorex, fought their own battle against the Immigration and Naturalization Service. When Adams, an American, applied for a green card for his Australian partner, their application was denied with a shocking and homophobic rebuke.

In 1973, the backlash against progress reached new heights. Maryland became the first state to explicitly ban same-sex marriage, followed by Virginia, Florida, California, and Wyoming. These laws reinforced a definition of marriage that excluded same-sex couples—a battle that would rage for decades. That same year, the Kentucky Court of Appeals ruled in *Jones v. Hallahan* that two women, Marge Jones and Tracy Knight, were properly denied a marriage license based on dictionary definitions of marriage.

Clela Rorex, the first US county clerk to issue gay marriage licenses, Boulder, Colorado, March 27, 1975.

In May 1974, PBS aired a one-hour debate titled "Should Marriage Between Homosexuals Be Permitted?" featuring participants like Frank Kameny and openly lesbian public official Elaine Noble. The debate was a sign that the conversation was starting to reach the public, but it also highlighted the deep divisions on the issue. In November 1976, in northwest Washington, Wayne Schwandt and John Fortunato walked down the aisle side by side, wearing matching embroidered tunics. Reporters wrote about what Fortunato and Schwandt called a holy union, which was controversial not because there was talk of legalizing gay marriage, but because the two men publicly asked for—and were denied—the blessing of the Episcopal Church.

By 1977, fierce opposition to LGBTQ+ rights was unmistakably palpable. Governor Reubin Askew signed legislation banning same-sex marriage in Florida, followed by similar legislation signed by Governor Jerry Brown in California. Wyoming also banned same-sex marriage by statute.

Born-again singer Anita Bryant's "Save Our Children" campaign successfully overturned local anti-discrimination laws in Dade County, Florida, in 1977, inspiring further anti-LGBTQ+ activism. Her campaign framed LGBTQ+ people as a threat to children and fueled a national backlash against gay rights.

At the same time, James Dobson founded Focus on the Family, an organization that would become one of the most influential anti-LGBTQ+ groups in the country. By the end of the 1970s, Dobson's organization, along with others, spearheaded campaigns against gay rights, particularly targeting marriage equality. In the final years of the 1970s, the conservative backlash grew even stronger. The rise of figures like Jerry Falwell, whose Moral Majority openly declared a "war on homosexuality," made it clear that marriage equality and LGBTQ+ rights were not just about social acceptance—they were about survival.

Tragically, this newfound visibility came at a high cost. Amid this opposition, Harvey Milk, an openly gay man and tireless advocate for gay rights, was elected to the San Francisco Board of Supervisors in 1978. Milk's election was a landmark victory for the LGBTQ+ community, but his triumph was tragically short-lived. On November 27, 1978, Milk was assassinated by former city supervisor Dan White. Harvey Milk's death was a sobering reminder of how far the movement had to go, and tragic for the man who spoke of the dangers of homosexuals remaining invisible. Yet it also cemented his legacy as a trailblazer who had dared to dream of a world where LGBTQ+ people could live freely and openly.

The journey of these trailblazers is not just a chapter in queer history, but the beginning of the marriage equality movement.

Twenty-eight-year-old Reverend Troy Perry performs what is described as the first public same-sex wedding ceremony in the US, marrying two Latino men in 1968.

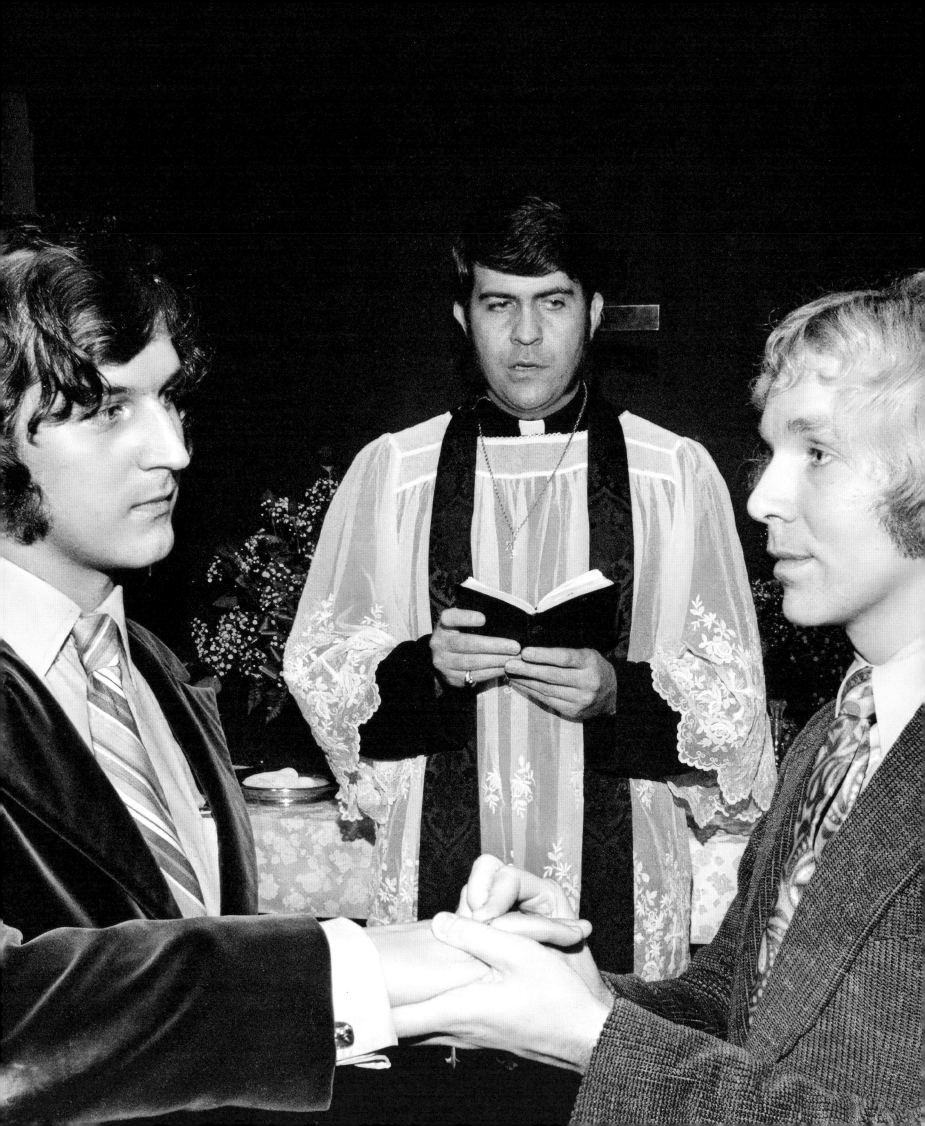

GERTRUDE STEIN AND ALICE B. TOKLAS

Their writings provided a rare and valuable model of queer domesticity.

Gertrude Stein and Alice B. Toklas, both Americans, were instantly attracted to each other when they met in Paris in 1907. Alice wrote of their first meeting in her memoirs: "I was impressed with her presence and her wonderful eyes and beautiful voice—an incredibly beautiful voice. . . . Her voice had the beauty of a singer's voice when she spoke." Both writers, they lived in France through two world wars and remained together for almost four decades. For many people who met them or read their modernist works, Gertrude and Alice's relationship was arguably the only queer one they would know—especially one that resembled marriage.

Gertrude and Alice shared an extraordinary life, both personally and in the literary world. Their relationship began when Alice moved to Paris and met Gertrude, a well-established avant-garde writer. They quickly became inseparable, with Alice taking on the role of Gertrude's confidante, lover, and muse. Together, they created a vibrant salon in Paris that attracted leading artists and writers of the time, including Pablo Picasso, Ernest Hemingway, and F. Scott Fitzgerald.

Known for her experimental prose and poetry, Gertrude was significantly influenced by their relationship. *The Autobiography of Alice B. Toklas* (1933) not only reflects her innovative approach to language and narrative structure but also, despite its title, is actually Gertrude's autobiography written from Alice's perspective, offering insights into their life and the artistic milieu of Paris.

Alice contributed significantly to their shared literary legacy. She managed their household, supported Gertrude's writing, and eventually became a writer herself. Her 1954 memoir, *The Alice B. Toklas Cookbook*, is famous for not only its recipes but also its anecdotes about their life and friends, providing a unique lens into their world.

Their wealth allowed them to live and write about their lives in ways other queer people could not, which fascinated their contemporaries and still fascinates and inspires people today. Gertrude often referred to Alice as "wifey" or her "wife," which was unquestionably revolutionary at the time.

Their openness about their partnership provided a rare and valuable model of queer domesticity and artistic collaboration during a period when such visibility was scarce. This visibility and their contributions to literature and culture have cemented their status as icons in LGBTQ+ history.

Gertrude's writing often challenged conventional narratives and identities, resonating with many who sought to understand and articulate their own experiences. Her bold defiance of traditional gender roles and her creation of a unique literary voice are seen as acts of resistance and self-definition that continue to inspire queer writers and artists.

In addition, Gertrude and Alice curated their Paris salon to create a space where art and life intertwined, fostering a community that transcended traditional boundaries. This space advanced modernist art and literature as well as provided a refuge for diverse identities and expressions, reflecting the inclusive spirit that characterizes much of LGBTQ+ activism.

Their voices were significant not only for their literary and cultural contributions but also for their roles as early exemplars of an openly queer relationship that continues to resonate within and beyond the queer community.

Gertrude Stein and Alice Toklas, Aix-les-Bains, France, circa 1927.

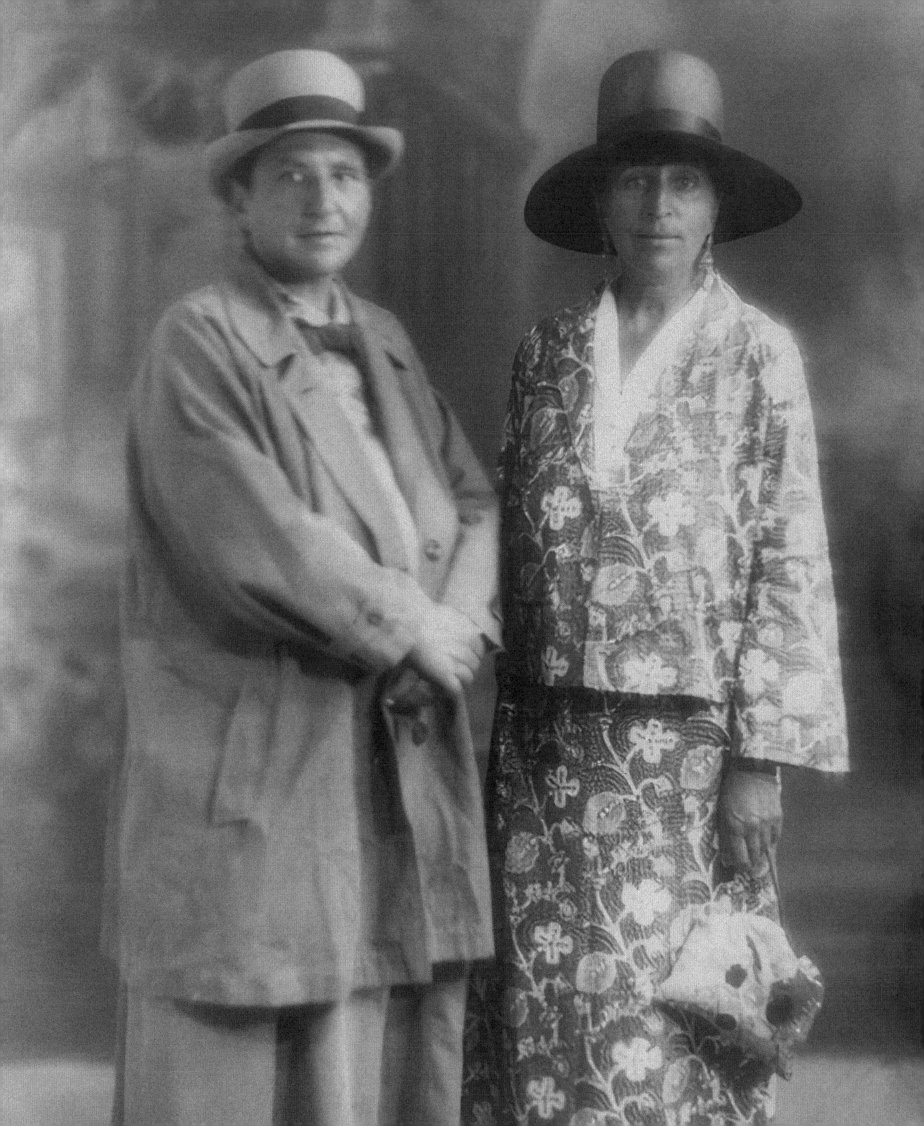

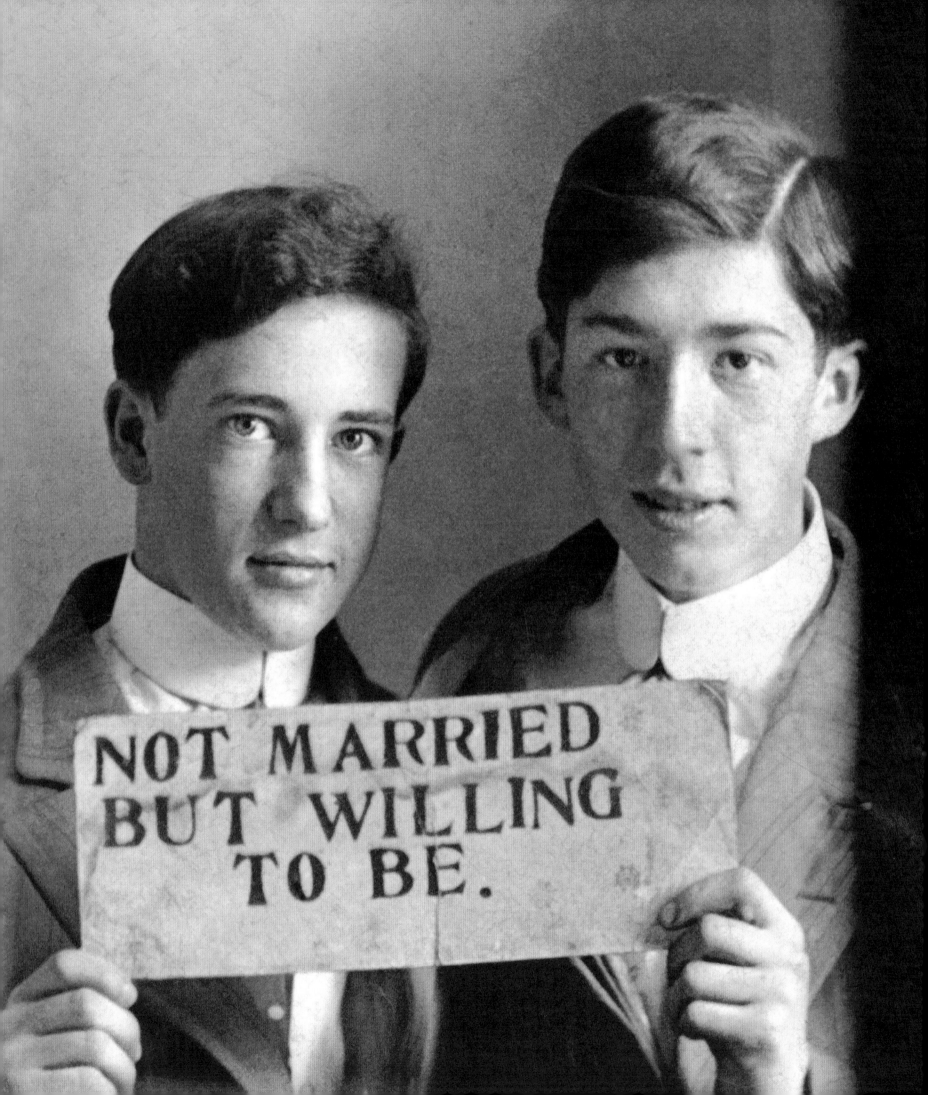

HUGH NINI AND NEAL TREADWELL

Photographing the long history of men in love.

Hugh and Neal's magical collection began twenty-three years ago when they came across an old photo that they thought was one of a kind. The subjects in this vintage photo were two young men in an embrace, gazing at one another, clearly in love. "We looked at the photo, and it seemed to look back at us. We seemed to recognize one another across an enormous span of time. And thus began a twenty-three-year journey that neither of us saw coming—much less planned." They call this their "accidental collection."

Back then, they didn't imagine that there would be a second photo. Much less, more than four thousand. Their annual travels to Europe, Canada, and across the US gave them opportunities to comb through boxes and piles of old photos at flea markets and antiques shops.

Their book *Loving: A Photographic History of Men in Love, 1850s–1950s* is a selection of their now world-renowned collection that reveals to the world that feelings of love, attachment, or longing between two people are universal—regardless of the gender makeup of the couple. "The power of their images come in that unmistakable look that two people have when they are in love. It can't be manufactured. And if you're experiencing it, it can't be hidden. They evoke as powerful a sense of love and humanity as has ever been filmed, or written about, or acted out on a stage. Their message of love is timeless."

An enduring philosophical question Neal and Hugh ask is: "If a tree falls in a forest, and no one is there to hear it, does it make a sound?" The correct answer, they believe, is "yes—or no. If these couples loved each other and memorialized their love with a photo, but no one else saw it, did their love exist, or matter? It did. Our book is filled with fallen trees whose sound, though delayed, is now being heard for the first time. They are the sounds of an embrace, a lingering glance, the touch of a hand, the softness of a brow, two figures lounging in the grass, a cheek pressed against another's cheek. Our collection contains the images of loving male couples that were, until now, largely kept secret from their families, their friends, and the world."

These men from times gone by memorialized their feelings for one another in the photos at great risk. "What we as collectors, personally, have come to understand from these photos is that couples like us have always existed. They were the trees falling in the forest that no one heard. Until now."

Hugh and Neal continue: "The human heart has never conformed to the strictures of society that is stumbling through its phase of understanding. The heart will always find its way to the light, and in this case, into daylight. Until this collection, we thought that the notion of us as a loving couple was 'new.' What we have learned from our collection is that we are, as a couple, not new.

We, and other couples like us, both male and female, are a continuation of a long line of loving couples who have probably existed since the beginning of time."

Holding one of these photos in the palm of your hand as Hugh and Neal once did, feeling its age, and seeing how the men look at one another, or back to us, their emotions are palpable even today, so many years later. Beyond their message of love, they seem to be calling out, saying, "We mattered to one another, and we were compelled to memorialize our feelings through a photograph—even if only for ourselves." Surely, these couples couldn't have imagined a day

when their secret photographic testament would become a museum exhibition and a book that celebrates them and the profound feelings that they had for one another. Though their message is as old as time, they are messengers from an unexpected, and heretofore hidden, part of our world. And now, they will narrate their own lives for the first time in history. Far from being ostracized or condemned, they will be celebrated, and the love that they shared will inspire others, as it has us. Love does not have a sexual orientation. *Love is universal.* "These subjects, these men, from a long and distant past, sent a message to the future for everyone. The question, now, is what message will we send."

Above: Hugh Nini and Neal Treadwell holding their book, *Loving: A Photographic History of Men in Love, 1850s–1990s.*
Opposite: Photo strip, undated. Provenance: Bulgaria, from the Nini-Treadwell Collection.
Following spread: Postcard, undated. Provenance: US, from the Nini-Treadwell Collection.

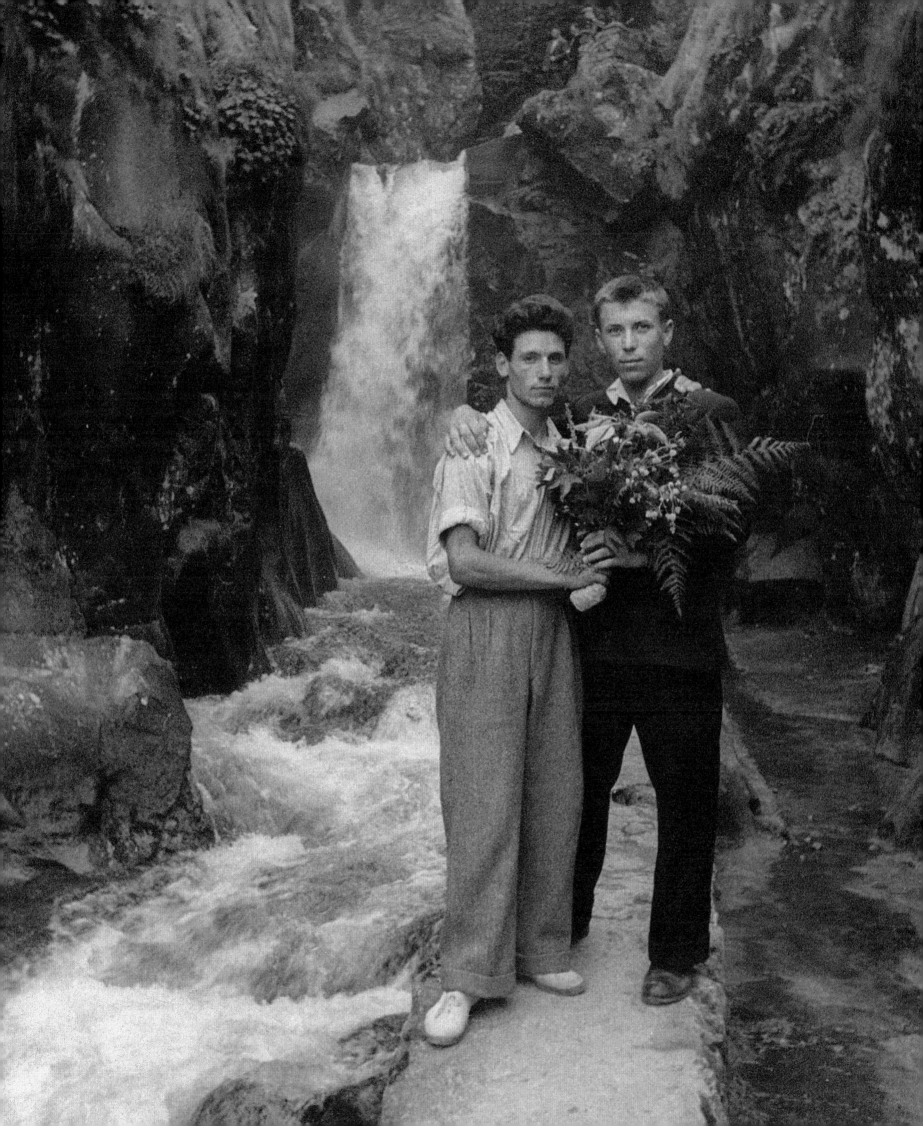

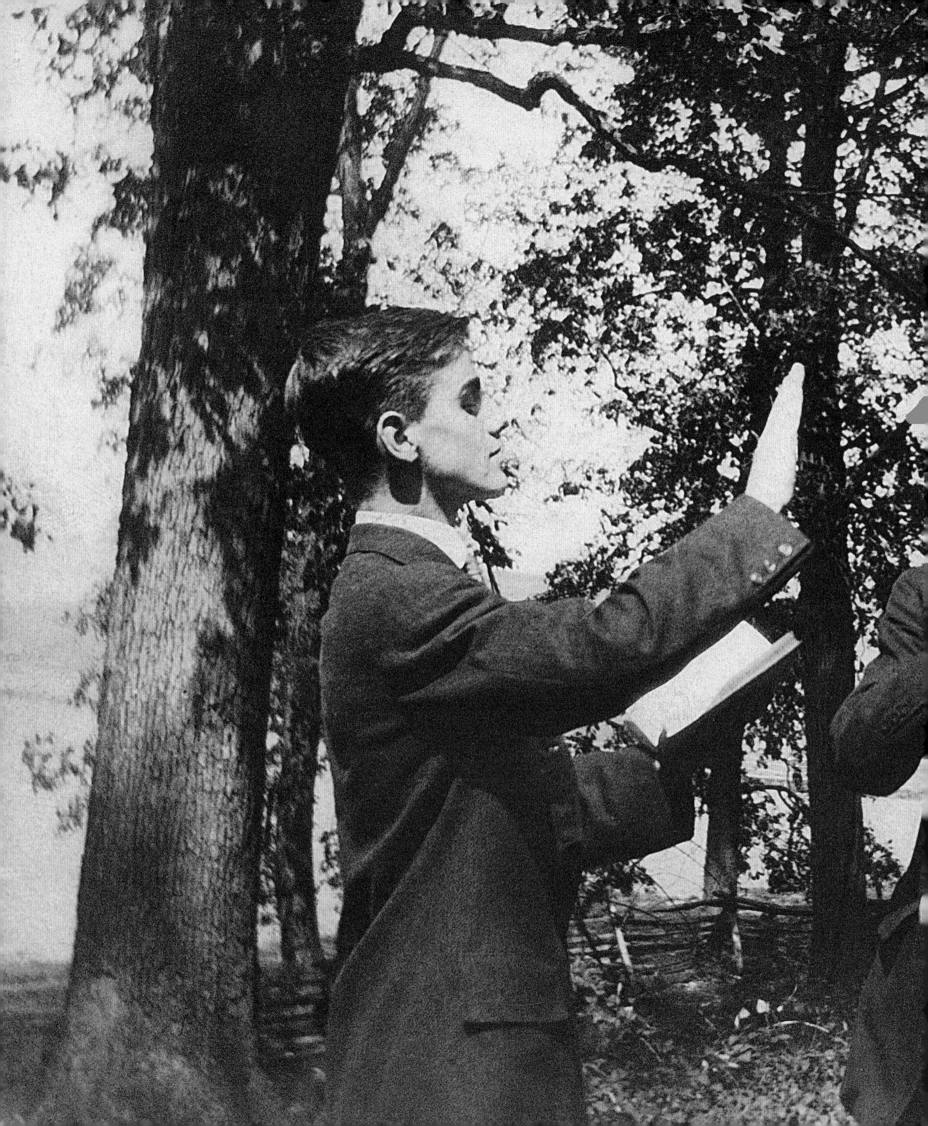

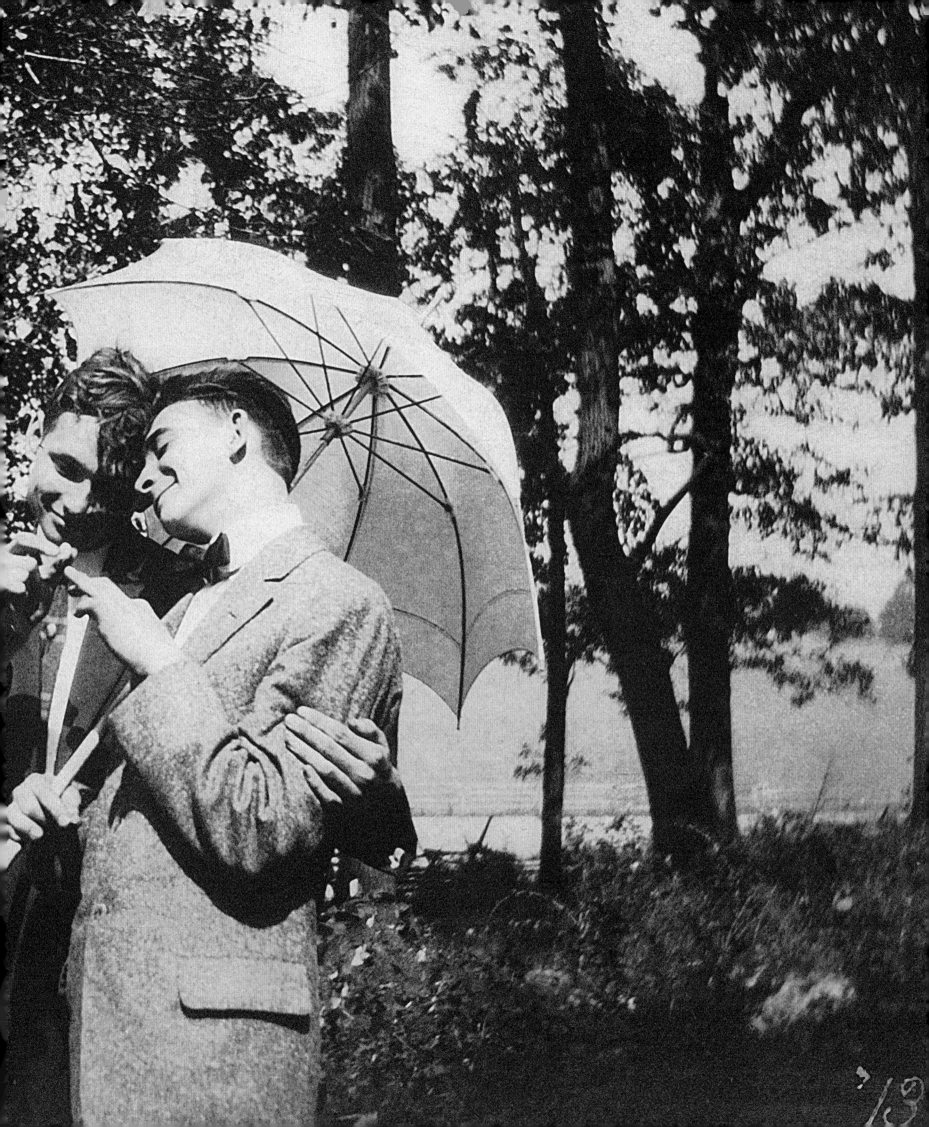

THE MYSTERY OF A 1957 GAY WEDDING

A love lost and found: the untold story of two men defying the era that rejected them.

In the fall of 1957, under the soft glow of a local drugstore's neon lights, a roll of film was quietly dropped off for developing. The photographs it contained revealed a love story—two men, dapper in suits, celebrating what could only be described as a commitment ceremony. There were smiles, intertwined hands, and a kiss. A tender moment frozen in time.

But when the drugstore manager developed the photos, he deemed them "inappropriate." Two men, embracing and exchanging vows, was an image the world wasn't ready for. The photos never made it back to their rightful owners. Instead, a young employee, moved by the tenderness captured in black and white, tucked the photos away. She waited, hoping one of the men would return to claim them. They never did.

Decades later, after the employee passed away, her daughter unknowingly sold the photos on eBay. They eventually found their way to the John J. Wilcox Jr. Archives of Philadelphia. Yet the mystery remains—who were these men, bold enough to celebrate their love in an era that could not comprehend it?

Archivists continue to search for answers, piecing together fragments of a love story that transcends time, hoping to give the couple the recognition they deserve. Though nameless, their story endures. Once hidden, it now stands as a testament to love that refused to fade, even when the world turned its back.

Gay wedding photo with unknown grooms and guests, Philadelphia, circa 1957.

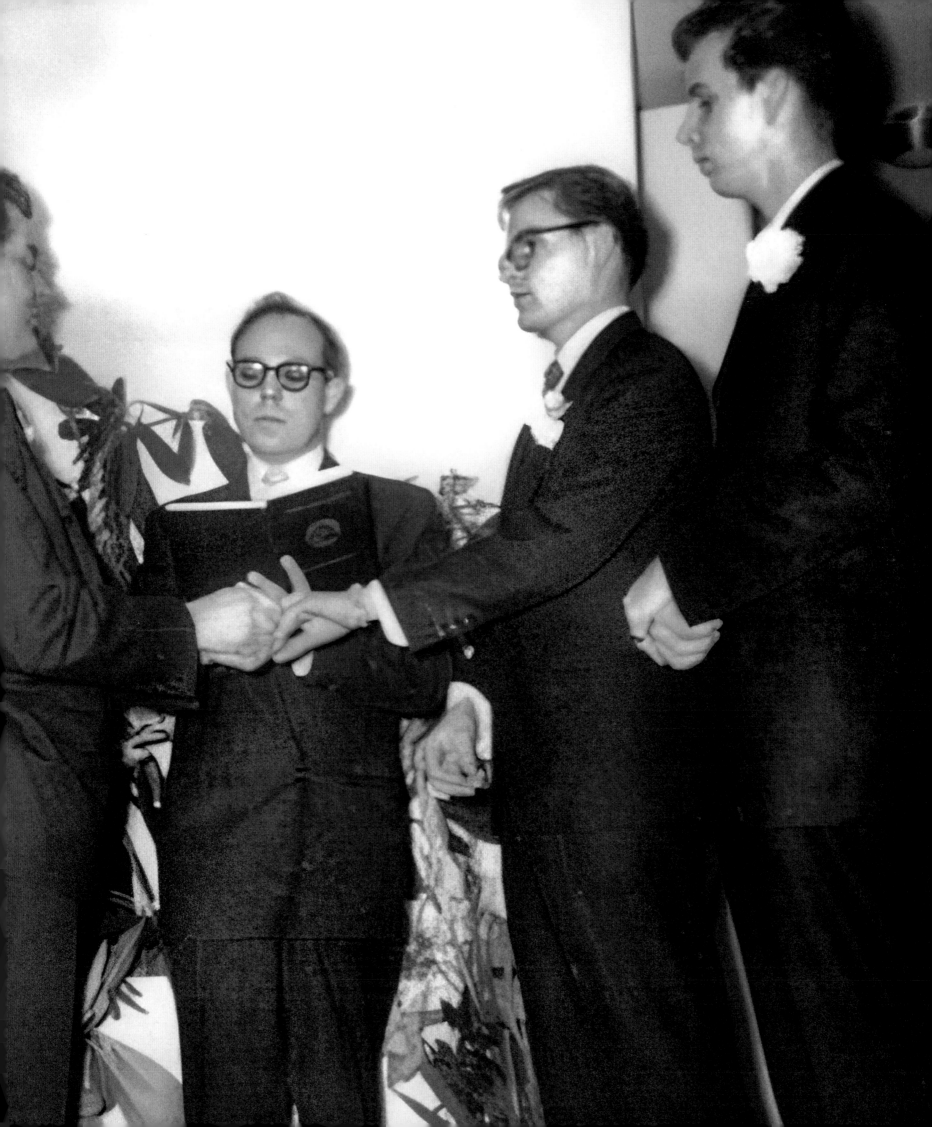

MILDRED AND RICHARD LOVING

Their court victory in *Loving v. Virginia*, established the right to interracial marriage, and set a legal precedent that later supported the right for all to marry.

Mildred Jeter and Richard Loving met and fell in love in a tiny town in rural Caroline County, Virginia, in the 1950s. As Richard would describe years later, their hometown was a place where people of different racial backgrounds "mixed together to start with and just kept goin' that way." When Mildred turned eighteen in 1958, the couple decided to get married.

But Mildred and Richard had a problem: they'd be thrown in jail if they got married in Virginia. What was their crime? Mildred's ancestry was Native American, African American, and Portuguese, while Richard came from English and Irish stock. At the time, Virginia was one of twenty-four states with racist "anti-miscegenation" laws that prohibited nonwhites from marrying whites. In Virginia, doing so was a felony.

So, the couple took a trip to nearby Washington, DC, to get married because the nation's capital had no such law denying them this basic right. However, soon after returning home to Virginia, police arrested them for violating the state's Racial Integrity Act of 1924, charging them with the crime of "cohabiting as man and wife, against the peace and dignity of the Commonwealth."

Mildred and Richard were sentenced to one year in prison, suspended for twenty-five years on the condition that they leave the state. They moved to Washington, DC, but they found it difficult to be separated from their friends and family back home. After their youngest child was hit by a car in the streets of DC in 1964, they went to court in the hope they would be allowed to return home to Caroline County.

Initially, things did not go well; the lower court judge ruled against them, opining: "Almighty God created the races white, black, yellow, malay, and red, and he placed them on separate continents. And, but for the interference with his arrangement, there would be no cause for such marriage. The fact that he separated the races shows that he did not intend for the races to mix."

But Mildred and Richard's lawsuit, *Loving v. Virginia*, went all the way to the US Supreme Court and changed their lives—as well as the lives of countless other interracial couples, like my own mom and dad. Nearly a half-century later, it would change my life as well because it would help pave the way for couples such as my husband John and me to be able to marry all across our nation.

In 1967, the US Supreme Court ruled unanimously in favor of the Lovings, holding that racist anti-miscegenation laws violated the Constitution's fundamental guarantees of liberty and equality. Declaring marriage to be one of the "basic civil rights," the Court held: "Under our Constitution, the freedom to marry, or not marry, a person of another race resides with the individual, and cannot be infringed by the State."

When I was born in 1962, the marriage of my mom, who was Chinese American, and my dad, whose heritage was English and Irish, was illegal in multiple states. Before *Loving*, the legality of my parent's marriage and thus our family would have depended upon which state we lived in. Only after the 1967 *Loving* decision was our family legal in all fifty states.

In 2015, the US Supreme Court in *Obergefell v. Hodges* declared that LGBTQ+ couples had the same right and freedom to marry that couples of all races were entitled to, citing the *Loving* decision multiple times as a key precedent. Together, these cases uphold the simple but profound principle that a person's fundamental right both to marry the person they love and to have the highest state recognition and protection for their relationship depends upon their humanity—and their humanity alone, not on any external factor, such as a class or category.

As the date of oral argument in *Loving v. Virginia* neared, Richard instructed his lawyer, "Tell the Court I love my wife." Hands down, there's never been a better name for a Supreme Court case than

Loving. Shortly before her death, Mildred spoke out broadly in favor of marriage equality in 2007 to commemorate the fortieth anniversary of the landmark decision:

> I am proud that Richard's and my name is on a court case that can help reinforce the love, the commitment, the fairness, and the family that so many people, black or white, young or old, gay or straight, seek in life. I support the freedom to marry for all. That's what *Loving*, and loving, are all about.

—STUART GAFFNEY

JACK BAKER AND MICHAEL McCONNELL

In the 1970s, Jack Baker and Michael McConnell became the first same-sex couple to get a legal marriage license. It took fifty years for the license to become valid.

The Midwest was enduring a heat wave in the early days of September 1971, but the temperature wasn't the only thing heating up. When America's first legally gay, married couple met, Michael McConnell and Jack Baker were hot for each other. "Jack was fit and handsome. His dazzling movie-star smile and subtle charm had my heart aflutter," recalled Michael. "I figured it had been a terrific one-night stand, and I'd never see Jack Baker again."

But that's not what happened. A romance began to simmer and, a year after they met, it bubbled over the top when Jack did the unthinkable. He proposed, as a man, to Michael, another man—unheard of in the spring of 1967. But a legal marriage? That was out of the question.

It wasn't until 1969, after Jack left the US Air Force with an honorable discharge, that he could focus on how to legally marry Michael. He enrolled in law school at the University of Minnesota. At the time, he believed that "this would enable me to work on my promise to Michael—to figure out a way for us to legally marry."

"There was nothing in the Minnesota statute that mentioned gender. We were old enough to get married. I was a resident in the state, and nothing said that we could *not* get married," Jack pointed out. "Whatever isn't prohibited by law is permitted. That's the first principle that we learned in law school."

Between Jack's proposal and their marriage in September of 1971, controversy was heating up around the laws of marriage in Colorado, where couples were also fighting for the legality of

issued licenses. However, there was no law on the Minnesota books that specifically forbade a man from marrying a man. And so, on May 18, 1970, the couple applied for a marriage license in their county of Hennepin.

Unfortunately, the blood of narrow-minded lawmakers who were against marriage equality was already beginning to boil, and Gerald Nelson, clerk of the district court in Hennepin County, rejected their application.

That's when the couple initiated legal action in the court, seeking to compel Nelson to issue the license. That case would go all the way to the Supreme Court, supported by the Minnesota Civil Liberties Union. In the interim, with the law in limbo, it was a race against time for Jack and Michael to marry. Clearly, they anticipated denial by SCOTUS, and the attention they drew to their unconventional marriage started to be paid by other legislatures to cement that a marriage was between a man and a woman—not two men.

While the case over the legitimacy of their marriage license was making its way through the courts, they got creative to protect their relationship. Michael adopted Jack, which involved Jack legally changing his name to the gender-neutral Pat Lyn McConnell. They then went to a different county, Blue Earth, that only required one person from the couple to get a license.

They were able to secure a license but could not ignore the growing pressure of government officials and courts seeking to cement marriage as exclusively heterosexual.

Jack Baker and Michael McConnell getting ready for their wedding.

Jack and Michael found themselves in a frantic race against time to exchange vows. Yet they had faith in love and in the belief that, as Michael's mom always told him, they were "as good as anyone else." Their wedding date was scheduled, but then, with twenty-four hours to go, their minister got cold feet and suddenly backed out. Pastor Roger Lynn, with whom Michael and Jack worked at a center offering support to gay people in the area, agreed to step in. Merely wanting the right to love openly and without prejudice, Michael and Jack said their vows on a sweltering day, on September 3, 1971.

"The most important thing I remember about the day we were married was that we had to get those marriage certificates into the registrar's office right away," Michael said. They wanted them filed before the media caught on. "I also remember that it was extremely hot. We were enduring a brutal heat wave at the time. But as for the day itself, I also remember that it felt good. It seemed like a really great day. And I don't know that we felt differently about each other. We still felt the same. But what I felt was that we were going to accomplish this mission. And we did."

They also remember that the day was filled with so much love—and an intrusively broken air-cooling system. "The air conditioner was off during the ceremony, so you can imagine how hot it was, but what we felt more than the intense heat was all the love in the room that day, and all the support we were receiving," Jack said fondly.

Their friends had rallied around them, not only planning the wedding but also making the unique white wedding outfits with matching macramé headbands, photographing the event, and baking a wedding cake with two grooms atop. "They took care of every detail," Michael emphasized.

"The suits were polyester, which was the norm then, and while we were hot in them of course, they were also just wonderful and perfectly tailored," Michael said. "And our friends had to improvise by breaking

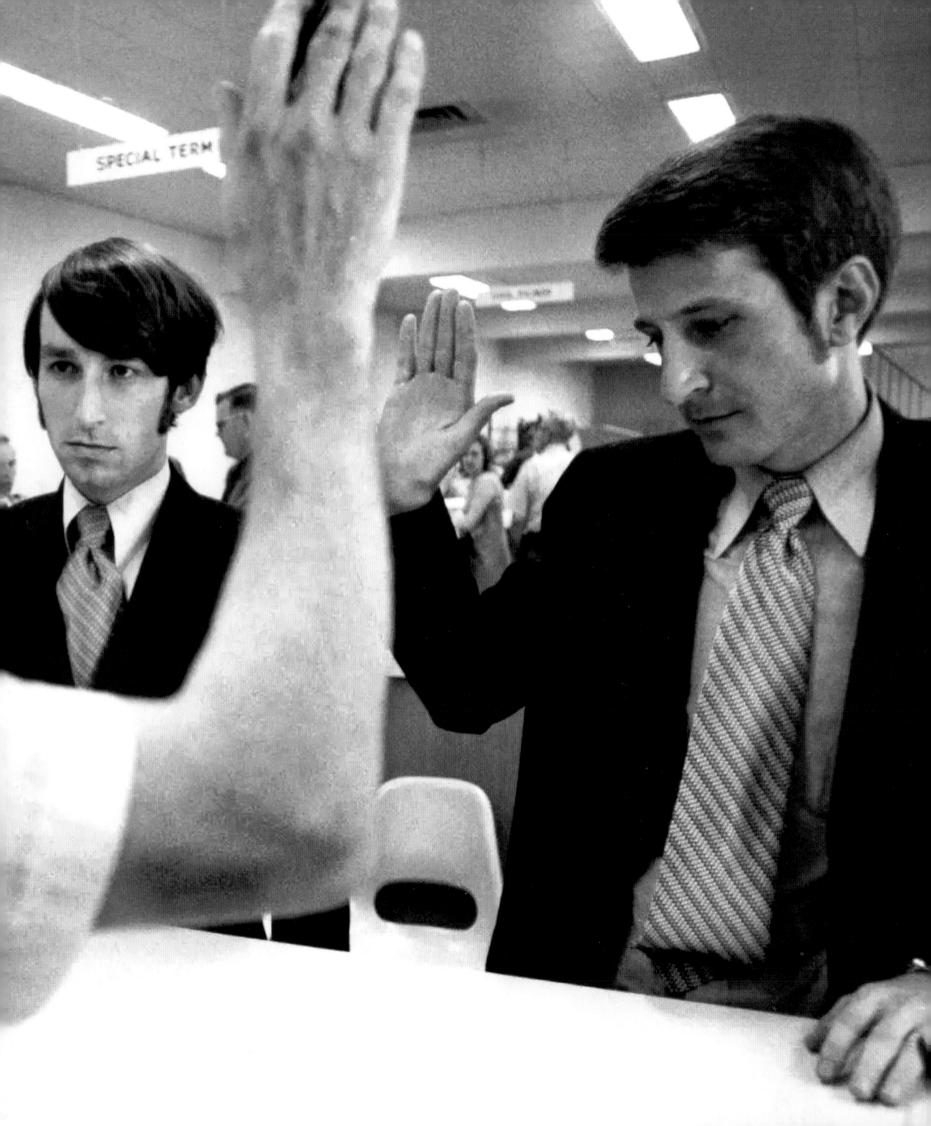

apart two male and female bride-and-groom figures and creating two male groom figures for the cake."

Jack and Michael's rings were particularly special, fashioned by a jeweler friend. "Our rings are so meaningful to us," Jack described. "When we put our rings together, they say, 'Jack loves Mike.' When you reverse the sides, they say, 'Mike loves Jack.'"

"I honestly didn't think we would pull the wedding off, but we did, and it was just one, big celebration," Jack reflected. "The whole thing really seemed like a dream to us." That was until the media reported that they'd gotten their license on their second attempt, causing Blue Earth County to deny the legitimacy of the license. Newspaper articles were packed with hateful quotes and unkind letters to the editor. Reverend Lynn was the target of intense venom and his contract with his church was going to be canceled until Michael launched a campaign to raise awareness of this injustice and many people protested. The courageous minister was able to keep his job, though only temporarily. When his contract later came up, it was not renewed for unspecified reasons.

Then, on October 10, 1972, their last hope for their dream took a hit when SCOTUS swiftly dismissed the appeal of their first marriage license, issuing a concise one-sentence order stating, "The appeal is dismissed for want of a substantial federal question." Unable to get their completed licenses actually filed and considered legal, the couple decided to retire from public life—but they still felt absolutely married.

Some thirty years later, in 2013, Jack and Michael would once again have a chance to marry legally after Edie Windsor's Supreme Court case—in which she successfully fought to have her forty-year same-sex relationship recognized—opened up marriages in Minnesota. But for Jack and Michael, getting yet another license would amount to admitting that what they did in the '70s was wrong. They knew it was not and stood strong in their belief in the law and that their original license was legal.

Finally, when Jim Obergefell won the right for all to marry in 2015, also fighting for his marriage to be recognized, Jack and Michael's SCOTUS ruling from 1971 was overturned, and their marriage license was deemed valid. As such, they officially became the very first legally licensed same-sex marriage in the world.

"It took forty-four years for the country to catch up to what we were saying way back in 1971," Michael observed. "And the reason that we believe it took that long, especially for the gay community, is that the community started to be defined as 'sexual beings, sexual orientation' rather than who you love and commit to. What we talked about back then was love, friends, family, community, building your life together, loving one another, and those around you."

Jack said that for them, the goal was always to have that love recognized. "When attitudes started to shift from sex to relationships after more and more people came out to their friends and families, that's when the fight for gay marriage really took off." And to that end, Jack offered some no-holds-barred advice, about why their marriage has lasted so long. "If you rely on a sexual relationship to sustain you, that will fail over time because sex gets old," he quipped—much to Michael's chagrin.

But Jack continued. "That's the big mistake most people make. It's got to be based upon a commitment, and a working relationship. The bottom line is that young gay people today have to love themselves first and understand that they are just as important as everyone else, and they have a right to marriage under the constitution in our country just like everyone else. And they shouldn't take that for granted." Reverend Lynn had no regrets either. Fifty-two years later, while celebrating Jack and Michael's fifty-second wedding anniversary, he said proudly, "I'd do it again."

Previous spread: Jack Baker and Michael McConnell apply for a marriage license in Minneapolis, May 18, 1970.
Opposite: Jack Baker and Michael McConnell posing with their marriage license shortly after their wedding, September 3, 1971.

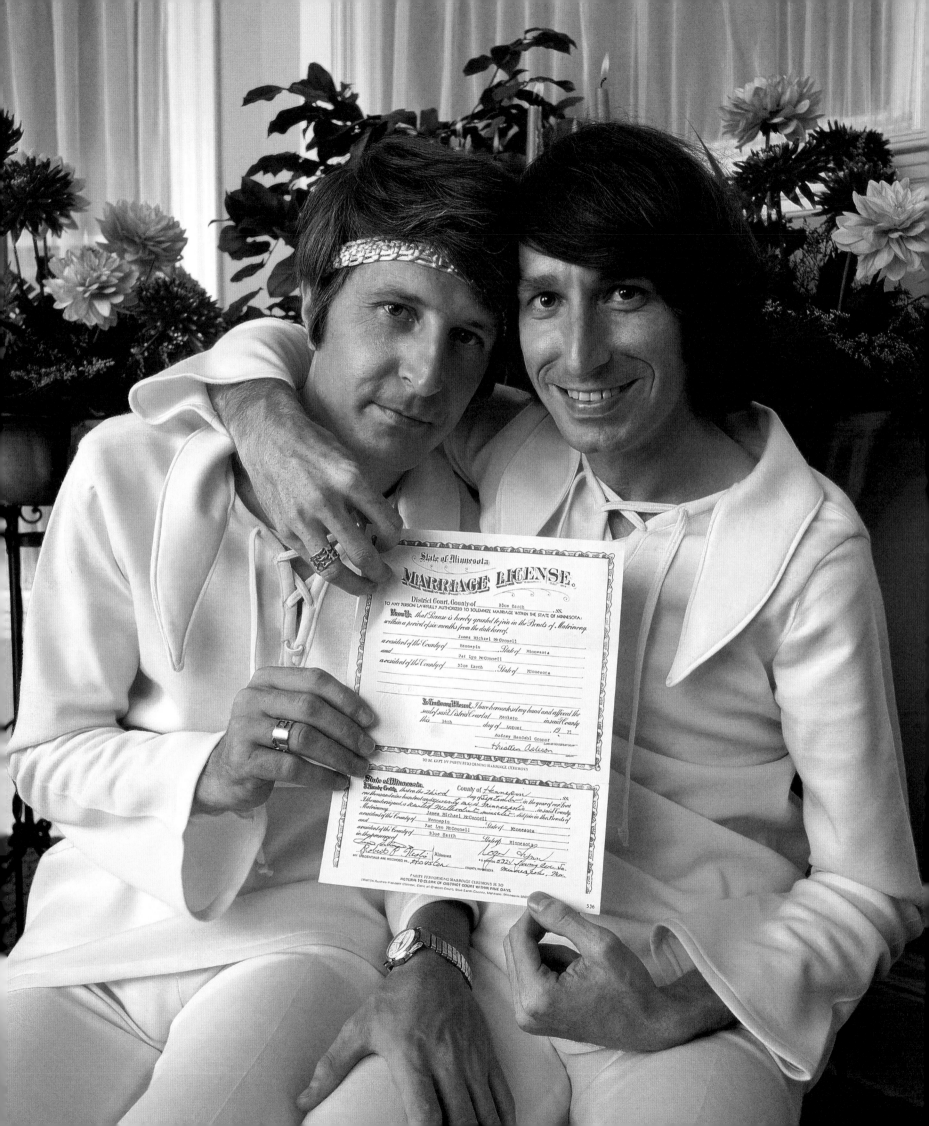

DEL MARTIN AND PHYLLIS LYON

Their willingness to speak openly about marriage equality for a half-century impacted America's view of LGBTQ+ unions.

In 1953, Del Martin and Phyllis Lyon, a young couple in love, moved into a San Francisco apartment on Valentine's Day. At the time, the Castro District— now synonymous with LGBTQ+ culture—was far from being the queer haven it is today. In fact, Martin and Lyon didn't even know any other lesbians. This was a period when finding community required careful navigation of societal dangers. Bars, the usual gathering spots for LGBTQ+ individuals, were frequent targets of police raids, resulting in arrests, public humiliation, and personal ruin. Yet, despite these risks, Phyllis and Del were determined to create a safe space for women like themselves.

Their journey toward becoming pioneers in the LGBTQ+ movement began when they were introduced to Rose Bamberger, a fellow lesbian who suggested forming a secret group for women who shared their identity. With Rose they started the Daughters of Bilitis (DOB), the first lesbian civil rights organization in the United States. The group's name, derived from a collection of nineteenth-century poems about love between women, was purposefully cryptic to shield its members from the pervasive homophobia of the time. The mere existence of the DOB in the 1950s was an act of defiance and courage.

The founding of the Daughters of Bilitis was a radical act because it not only created a physical space for lesbians to gather but set the stage for a new era of activism as well. During the McCarthy era, when the government actively purged LGBTQ+ individuals from federal jobs during the infamous Lavender Scare, Martin and Lyon were building a quiet resistance. The federal witch hunt, fueled

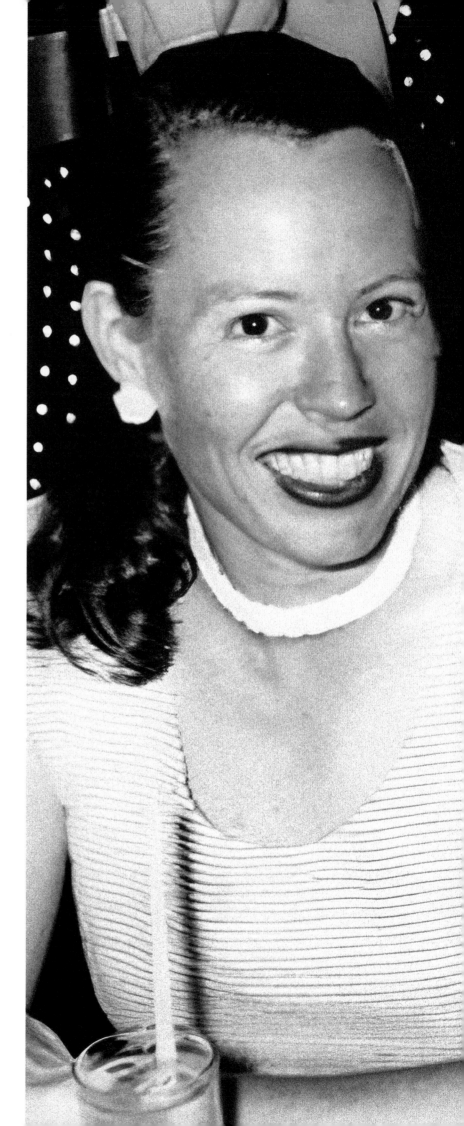

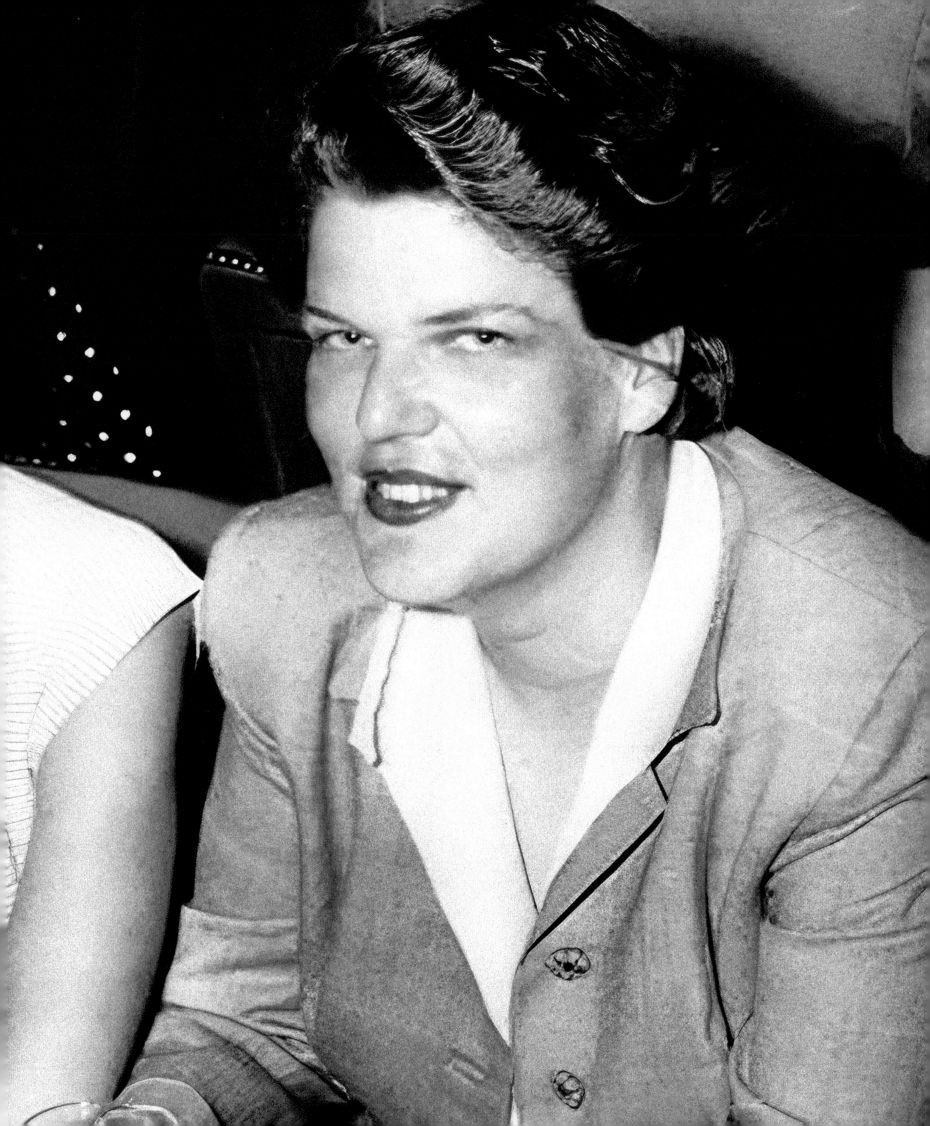

by Executive Order 10450, cost thousands of LGBTQ+ Americans their livelihoods and threatened their safety. While LGBTQ+ bars offered some refuge, public spaces remained fraught with danger. In response, DOB emerged as both a social group and a political lifeline.

Del and Phyllis were not just co-founders but visionaries. They envisioned a world where lesbians could come together safely, connect, and grow a collective consciousness. This vision materialized in 1956 with the creation of *The Ladder*, a publication that soon became the voice of the burgeoning lesbian movement. Edited by Lyon, *The Ladder* provided a platform for lesbians across the country to share stories, explore sexuality, and build a community in a time when being open about one's identity could be life-threatening.

The Ladder was more than a magazine—it was a way to support isolated lesbians seeking community. The publication allowed readers to see themselves reflected in stories and letters for perhaps the first time. The readership grew, albeit carefully, as women discreetly shared copies with trusted friends. The small, clandestine circulation may have been a symptom of the fear that gripped the LGBTQ+ community, but it also demonstrated the power of community in the face of oppression.

Through *The Ladder*, Martin and Lyon nurtured a new kind of activism. Their work went beyond creating a secret space—it transformed into a more public-facing movement that paved the way for future generations of LGBTQ+ activists. They sought to educate the public, provide social opportunities for lesbians, and advocate for changes to the discriminatory laws that targeted LGBTQ+ individuals.

Their courage was not without its risks. At a time when simply being suspected of homosexuality could result in job loss or worse, Martin and Lyon standing on the front lines as activists became a symbol of what is possible when individuals band together to demand dignity.

The work of Martin and Lyon didn't stop with the DOB. In the 1960s, as the feminist movement gained traction, the couple recognized the natural alignment between the fight for women's rights and the LGBTQ+ cause. In 1967, they became the first lesbian couple to join the National Organization for Women (NOW), taking advantage of a couples discount that was originally intended for heterosexual women and their husbands. Martin's eventual role on NOW's national board marked a historic moment for both movements, as she became the first out lesbian to hold a leadership position within the organization.

Their feminist activism complemented their work for LGBTQ+ rights. Martin's 1976 book, *Battered Wives*, was among the first to expose the issue of domestic violence, calling for both legal reform and broader societal recognition of women's struggles. Martin and Lyon tackled numerous challenges head-on, embracing the intersectional issues they faced as women and lesbians.

Their enduring advocacy led to their most symbolic battle—marriage equality. In 2004, long after their early activism had helped shift LGBTQ+ rights into the national consciousness, Martin and Lyon were chosen by then-Mayor Gavin Newsom as the first couple to be married in a highly publicized challenge to California's same-sex marriage ban. Their wedding was part of a legal strategy to advance marriage equality, which would eventually succeed in overturning bans across the country. The ceremony, though later annulled by the courts, solidified Martin and Lyon's status as icons in the movement.

In 2008, four years after their first marriage was invalidated, Martin and Lyon finally achieved legal recognition when California legalized same-sex marriage. Once again they stood at the altar, this time assured that their union was valid under the law. For Martin and Lyon, the moment was both personal and political. After more than fifty years together, their love was not only recognized but celebrated as a symbol of the broader fight for LGBTQ+ rights.

Del Martin passed away just two months after their 2008 wedding, marking the end of their shared journey but not their legacy. Phyllis told the media she took solace "in knowing we were able to enjoy the ultimate rite of love and commitment before she passed."

Previous spread: Phyllis Lyon and Del Martin in an undated photograph from the 2003 documentary *No Secret Anymore: The Times of Del Martin & Phyllis Lyon*. **Opposite**: Del Martin and Phyllis Lyon are married by San Francisco Mayor Gavin Newsom in a private ceremony at San Francisco City Hall, June 16, 2008.

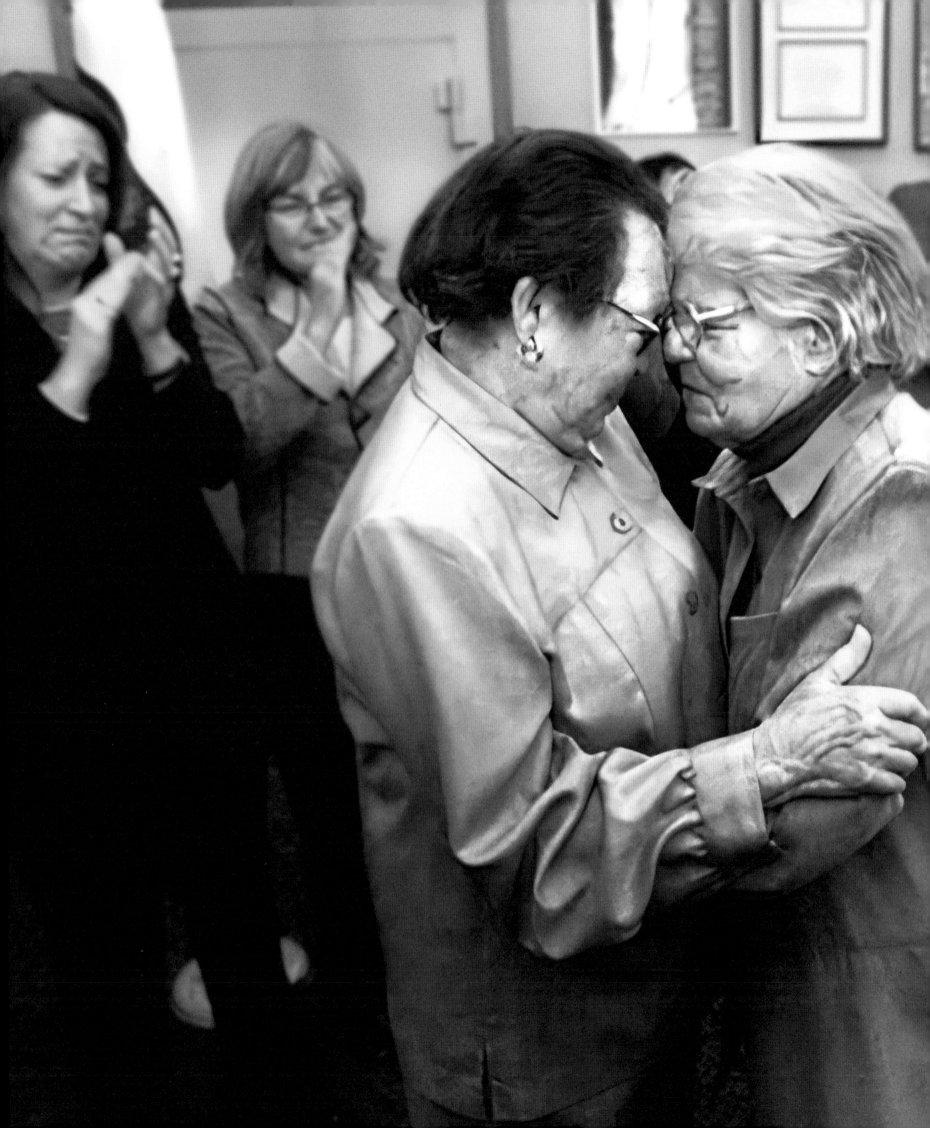

RICHARD ADAMS AND TONY SULLIVAN

In 1969, Richard Adams and Tony Sullivan's love story was one that defied time, borders, and limitations.

Their journey together began on May 5, 1971, the beginning of a life-altering romance, in a Los Angeles bar aptly named The Closet. It was a classic moment of chance—two souls united in a room full of strangers. Cinco de Mayo celebrations swirled around them, while their eyes met.

From the very beginning, there was a magnetic pull between them, a connection that was impossible to ignore. Tony, an Australian tourist who had been traveling through the US, and Richard, a naturalized American citizen of Filipino heritage, found something in each other that neither had ever experienced. The chemistry was undeniable, and it didn't take long for them to realize that they were meant to spend their lives together.

Yet, as their love deepened, so did the complexity of their situation. Tony's tourist visa only allowed him to stay in the US for short periods of time, forcing him to periodically leave the country and return. The pair found themselves living under the shadow of immigration regulations, always anxious about when they might be torn apart. They longed for a permanent solution, but in 1971, the legal landscape for same-sex couples was unforgiving.

In their search for a way to keep Tony in the US, the idea of a marriage of convenience surfaced. Tony considered marrying a female friend who was willing to help, but when he confessed the true nature of the arrangement to an immigration officer, the plan fell apart. It seemed as though every avenue was closed to them—until they heard about something remarkable happening in Boulder, Colorado.

The story of Clela Rorex, a county clerk who was issuing marriage licenses to gay and lesbian couples, sent hope their way. Inspired by her courage and moved by the possibility of legitimizing their love in the eyes of the law, Richard and Tony made the pilgrimage to Boulder. After obtaining their marriage license from Rorex, they were married in Boulder, at one of the Metropolitan Community Churches (MCC), on April 21, 1975. The MCC, a group of faith communities of Christian denomination with a special outreach to LGBTQ+ people, was significant for many same-sex couples who sought recognition of their love and commitment, even if legal recognition was uncertain or denied. This solemn celebration of their love was a deeply meaningful day for Richard and Tony.

But their victory was short-lived. Upon returning to Los Angeles, Richard filed a spousal visa application for Tony, hoping that their legal marriage would allow them to finally live in peace without fear of deportation. What they received in response was a crushing blow. The US Immigration and Naturalization Service (INS) denied their request in the most callous terms imaginable: "You have failed to establish that a bona fide marital relationship can exist between two faggots."

Richard Adams and Tony Sullivan run with their dog, 1975.

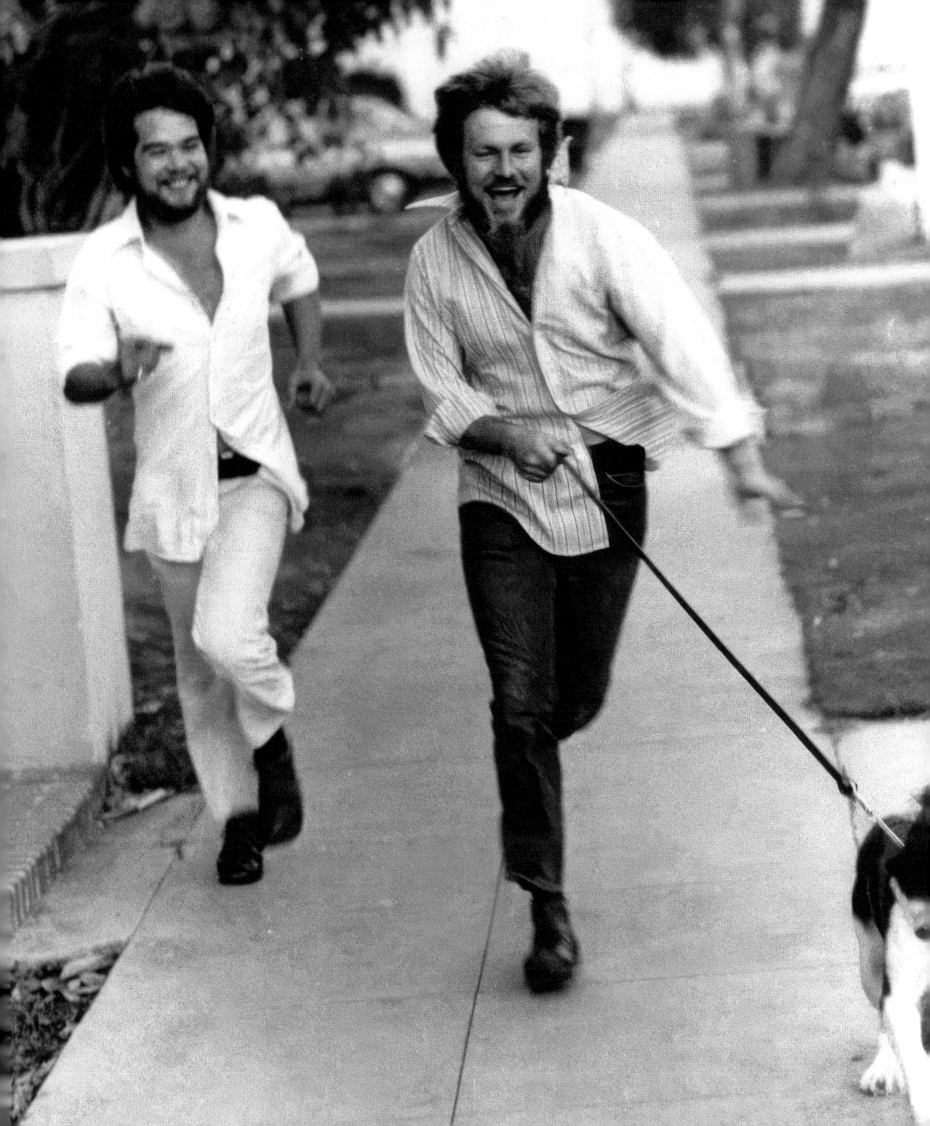

That single sentence set the tone for the next forty years of their lives. The rejection was not just a legal defeat—it was a cruel reminder of the pervasive discrimination they faced. But Richard and Tony were not the type to back down. Rather than accepting their fate, they decided to fight. The outrageous language of the INS letter helped propel their story into the public eye, garnering media attention and sparking debates about the rights of same-sex couples. Reluctant activists, they understood that their visibility could protect them, even if the legal system could not.

Despite the support they received from parts of the media and the gay rights movement, many within the LGBTQ+ community urged caution, fearing that a legal fight over marriage equality might set the movement back. But Richard and Tony pressed on, determined to make their case heard. Their lawsuit, *Adams v. Howerton*, would become the first federal case in US history that sought recognition for a same-sex marriage.

Their legal battles were arduous and filled with heartbreak. A federal district court dismissed their case, and appeal after appeal were met with rejection. The couple's argument that Tony's deportation would cause "extreme hardship" found little empathy, with the US Ninth Circuit Court of Appeals ruling against them in 1985. Ironically, one of the judges involved in that decision was Anthony Kennedy, a man whose future rulings would play a pivotal role in the LGBTQ+ rights movement.

With a final legal defeat, Richard and Tony were left with a devastating choice: face separation or go into exile. Unwilling to be torn apart, they left the United States and began a nomadic life, eventually settling in Northern Ireland. But no matter where they went, their hearts remained tethered to their home in the US. The longing to return, to reclaim the life they had built

together, was overwhelming. In 1986, they made the dangerous decision to return to Los Angeles, where Tony entered the country secretly by crossing the border from Mexico.

The years that followed were filled with a constant undercurrent of anxiety. They lived quietly, mindful of the ever-present threat of deportation. Tony referred to this time as living in the "immigration closet." They were in the country they loved, but they were always mindful that one wrong move could separate them for good.

Then, after decades of uncertainty, a glimmer of hope emerged. In 2011, the Obama administration introduced a policy that provided protection for same-sex couples facing deportation. Tony and Richard could now live without the imminent threat of separation. Yet, even with this policy, the legal recognition of their union that they so desperately sought remained elusive.

In December 2012, after more than forty years together, Richard passed away from cancer. Tony was by his side, holding his hand as Richard took his final breaths. Losing Richard was a shattering blow, but even in his grief, Tony knew their fight wasn't over. He requested that the US government issue a formal apology for the dehumanizing language used in their 1975 rejection letter. He also petitioned for the reopening of Richard's original spousal visa application. This request finally led to justice.

In 2016, forty-one years after they were married in Boulder, Tony Sullivan received a green card as the widower of Richard Adams. It was a bittersweet victory—too late for Richard to witness but a powerful testament to the endurance of their love. The US Citizenship and Immigration Services officially recognized their marriage, a symbolic act that vindicated their decades-long struggle. On the forty-first anniversary of their

The offensive letter denying them a green card that Richard Adams and Tony Sullivan received from the Immigration and Naturalization Service in 1975.

UNITED STATES DEPARTMENT OF JUSTICE
Immigration and Naturalization Service
300 N. Los Angeles Street
Los Angeles, California

REFER TO THIS FILE NO.

A 20 537 540

Richard Frank Adams
10265 Tujunga Canyon Boulevard, Apt. 1
Tujunga, CA. 91042

Date: November 24, 1975

DECISION

Upon consideration, it is ordered that your <u>visa petition filed on April 28, 1975 for classification of Anthony Corbett SULLIVAN as the spouse of a United States citizen</u> be denied for the following reasons:

You have failed to establish that a bona fide marital relationship can exist between two faggots.

If you desire to appeal this decision, you may do so. Your notice of appeal must be filed within **15 days** from the date of this notice. If no appeal is filed within the time allowed, this decision is final. Appeal in your case may be made to:

☒ Board of Immigration Appeals in Washington, D. C., on the enclosed Forms I-290 A.

☐ Regional Commissioner on the enclosed Form I-290 B.

If an appeal is desired, the Notice of Appeal shall be executed and filed with <u>this</u> office, together with a fee of <u>$25.</u> A brief or other written statement in support of your appeal may be submitted with the Notice of Appeal.

Any question which you may have will be answered by the local immigration office nearest your residence, or at the address shown in the heading to this letter.

Sincerely yours,

District Director

Enclosure(s)

Form I-292
(Rev. 2-1-72)Y

wedding, Tony held his green card in hand, a piece of paper that carried with it the weight of a lifetime of love, perseverance, and sacrifice.

The remarkable love story and legal battle of Richard Adams and Tony Sullivan was chronicled in the 2014 documentary *Limited Partnership* by filmmaker Tom Robbins. The documentary highlighted the resilience of their forty-year journey and the courage it took for them to continue fighting against the rejection of legal and political systems. *Limited Partnership* shared their story with a wider audience, reminding the world of the importance of visibility and family protections— and the dignity that comes from both.

The story of Richard Adams and Tony Sullivan is not just about marriage equality; it is a story of the power of love in the face of seemingly insurmountable obstacles. It is a story about resilience, about the way two gay men stood together against the tides of discrimination and societal rejection, their bond unbroken.

And perhaps the greatest irony of all is that Judge Anthony Kennedy, who had once rejected Tony's appeal for relief, which sent them fleeing the United States, would later author the majority opinion in *Obergefell v. Hodges*, the Supreme Court case that finally affirmed the freedom to marry for all.

Tony and Richard at a press conference in 1975 discussing their disturbing letter from the US government.

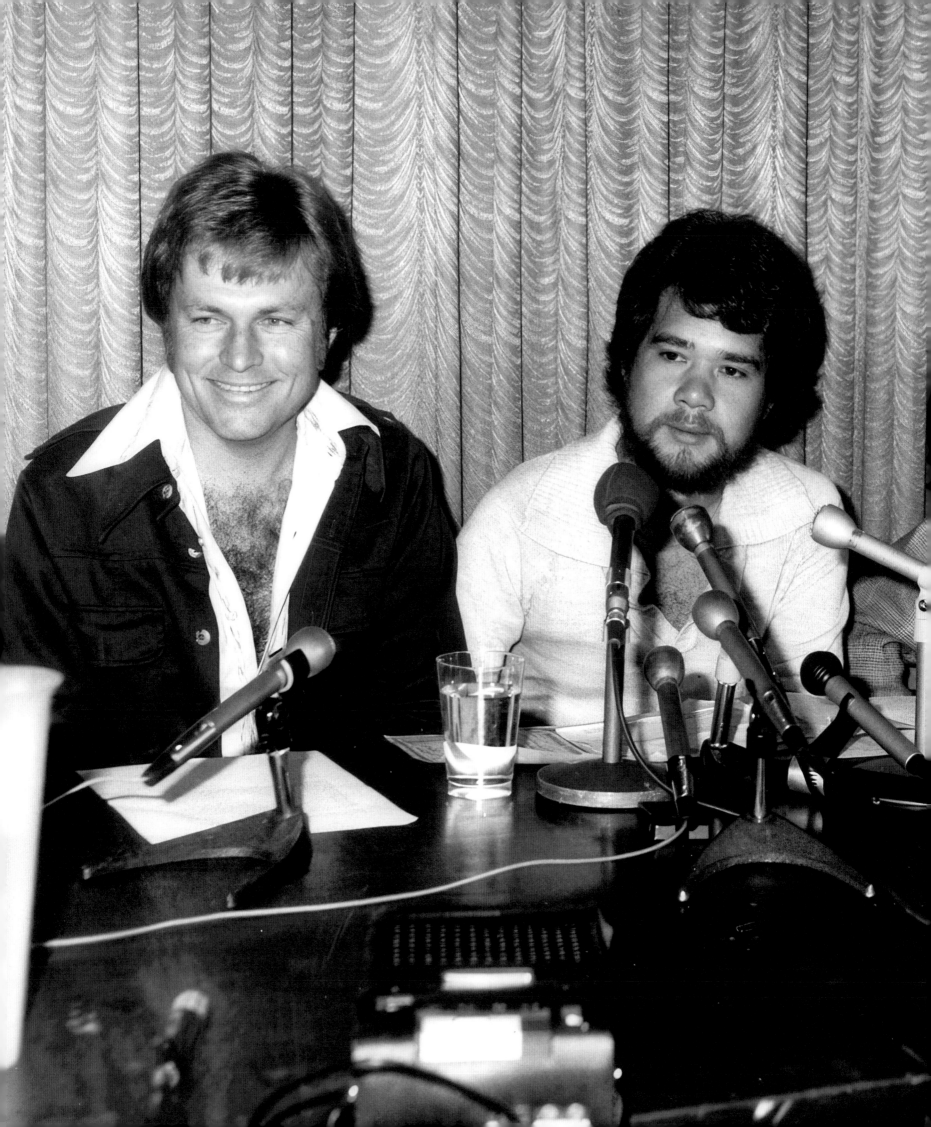

IN SICKNESS AND IN HEALTH

1980s

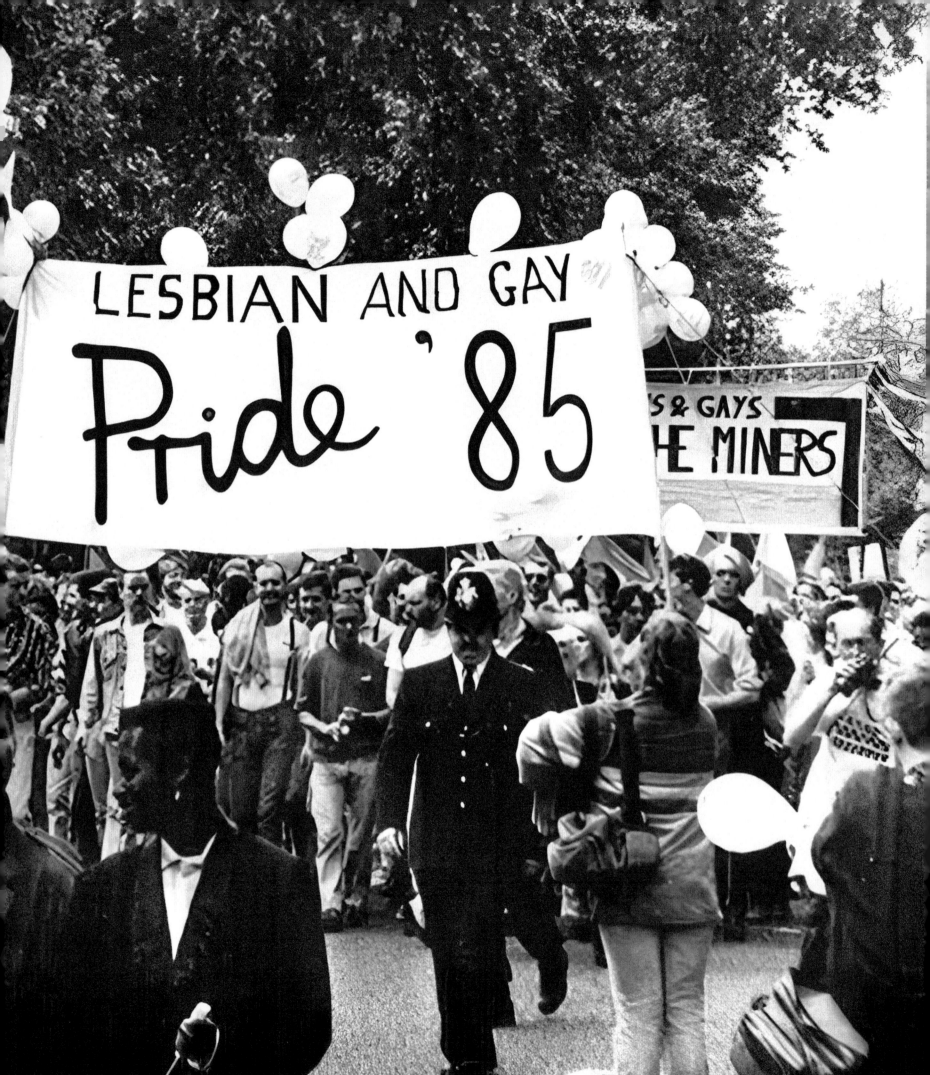

CHAPTER 2 — INTRODUCTION

After the Stonewall Riots captured the media's attention and energized a community fed up with flagrant societal abuse, the 1980s marked a turning point for the gay community and the quest for relationship recognition and rights. Much of this change was driven by adversity. The onset of HIV/AIDS triggered a profound cultural shift. This decade's shift was partly driven by the growing emergence of stories about gay people, with more Americans likely to know a queer person—whether a celebrity or someone they knew personally.

The disease acquired immune deficiency syndrome (AIDS) was first reported in 1981, and initially struck the gay population and spread rapidly thanks to a microculture created by forced silence and years of government neglect towards the gay community and life-saving medical treatment It ravaged a hidden populace, claiming the lives of longtime committed partners, best friends, brothers and sisters, parents, grandparents, children, clergy, and even celebrities. (Yes, as true then as it is now, we are everywhere. The difference then was that society refused to acknowledge our presence.) Even today, some people still refuse to accept that Rock Hudson, Anthony Perkins, or Robert Reed, who played the dad on *The Brady Bunch* were gay—even though they died from complications related to the disease. Even Roy Cohn could not escape its reach. Millions of people, isolated by fear and shame for who they loved, were forced into the open as they and others they loved were dying.

As death tolls surged, so did the realization that many people knew—and likely loved—a gay person. From the inevitable outings caused by deaths, stories began to emerge of love and loss—the loss of a longtime partner, a rejection by family, or even the loss of a beloved pet, taken away by estranged relatives wielding next-of-kin rights. Over the years, these shared stories wove together into the first mass cultural empathy toward our lives and our struggles. Celebrities began coming out—or were outed—including icons like Elton John, Ian McKellen, Boy George, Rupert Everett, Gerry Studds, Barney Frank, Billie Jean King, and Martina Navratilova. Elton, Barney, Billie Jean, and Martina would go on to become outspoken advocates for gay rights, all eventually marrying.

Sage Sohier's series *At Home With Themselves: Same-Sex Couples in 1980s America* offered a groundbreaking portrayal of LGBTQ+ domestic life during a time when same-sex relationships were often hidden. Beginning in 1986, Sohier sought to challenge stereotypes and highlight the love and intimacy of gay couples in their home environments, countering the dominant narratives of AIDS and sexual promiscuity. To protect them from the risks faced in being publicly out, her subjects were identified only by first names. Captured in black and white, the photographs reveal not only the psychological depth of these relationships but also the courage of her subjects, many of whom simply wanted their love to be seen and valued.

AIDS also ignited a spirit of unity and resistance, bringing the gay and lesbian communities closer and drawing allies to the cause. As a result, marriage equality took a back seat to a more immediate need: securing spousal rights for same-sex couples. The many coming-out stories set the stage for the fight for marriage rights in the following decades, as people began to understand the value and dignity intrinsic in the protections provided by equal rights.

Page 69: Bill and Ric, with Ric's daughter Kate, San Francisco in 1987, from Sage Sohier's *At Home With Themselves: Same-Sex Couples in 1980s America*, a groundbreaking book capturing the private lives of same-sex couples. Those included were identified only by their first names to protect their anonymity, a reflection of the era's challenging climate of intolerance. **Opposite**: Lesbian and Gay Pride, London, 1985.

The impact of AIDS was particularly devastating in Los Angeles, New York City, and the San Francisco Bay Area, where the call for protections was especially urgent. Barry Warren and Tom Brougham were at the forefront of this advocacy in Berkeley. Brougham, who worked for the City of Berkeley processing parking tickets, was deeply embedded in both the LGBTQ+ community and the municipal workforce. His experience proved invaluable in advocating for domestic partnership workplace benefits for Berkeley employees.

In December 1984, Berkeley became the first city in California to adopt a domestic partnership policy, allowing same-sex couples to register legally as domestic partners. This policy treated domestic partnerships as equivalent to marriages for employee benefits, such as healthcare, pensions, and survivor benefits, and it became a model for similar legislation across the country.

Advocating for domestic partnership required persuading politicians, unions, and benefits administrators that adding unmarried domestic partners to employee benefit plans would not have a negative financial impact to a company's bottom line, and that LGBTQ+ households were as stable as heterosexual marriages. The City of West Hollywood followed Berkeley in 1985, becoming the first city in the US to enact a domestic partnership registry open to all its citizens.

In 1986, another major legal battle took place when Miguel Braschi received an eviction notice after the death of his partner, Leslie Blanchard. The landlord of their shared apartment claimed that Braschi, whose name was not on the lease, could not be recognized as family. Braschi fought the eviction in court and won in 1989, when the New York State Court of Appeals ruled that a gay couple living together for at least ten years could be considered a family for purposes of rent control protections. This was the first time a state's highest court had ruled that a gay couple could be legally defined as a family, setting a precedent for the legal recognition of non-traditional families nationwide.

Amid the AIDS crisis, there were other storms to weather. The Catholic Church, led by Pope John Paul II, continued its attacks on gays, labeling them "evil" and ordering the withdrawal of all Church support for gay Catholic organizations.

In 1987, Michael Hardwick was arrested for sodomy after a policeman entered his home and found him in bed with another man. Hardwick fought the charge in a case that reached the Supreme Court—*Bowers v. Hardwick*—but the Court, in a now-repudiated decision, ruled that there was no "fundamental right" to be gay. This era of sodomy laws was often exploited to hinder HIV prevention efforts, as legislation allowed HIV education but prohibited any information that could be interpreted as promoting "illegal" activity. Since homosexuality was criminalized under these laws, meaningful discussion of same-sex relationships and their role in HIV prevention was effectively silenced. Overturning sodomy laws became a central issue for activists fighting for both LGBTQ+ rights and public health education.

In 1987, a mass wedding of two thousand same-sex couples was staged in front of the IRS building, protesting the lack of partnership rights and recognition, as well as marriage inequality. Couples sang Madonna's "Open Your Heart," dressed for the occasion, marched on Washington, DC, pledged their vows, exchanged rings, and were pronounced newlyweds. Thousands witnessed this historic event on the National Mall, throwing rice and confetti as family, friends, and community members took part in what became known as "The Wedding."

Opposite: Tennis star Billie Jean King was one of the very few big names in the 1980s known to be gay.

72 **Following spread**: The Second National March on Washington for Lesbian and Gay Rights, displaying the massive AIDS quilt on the National Mall, 1987.

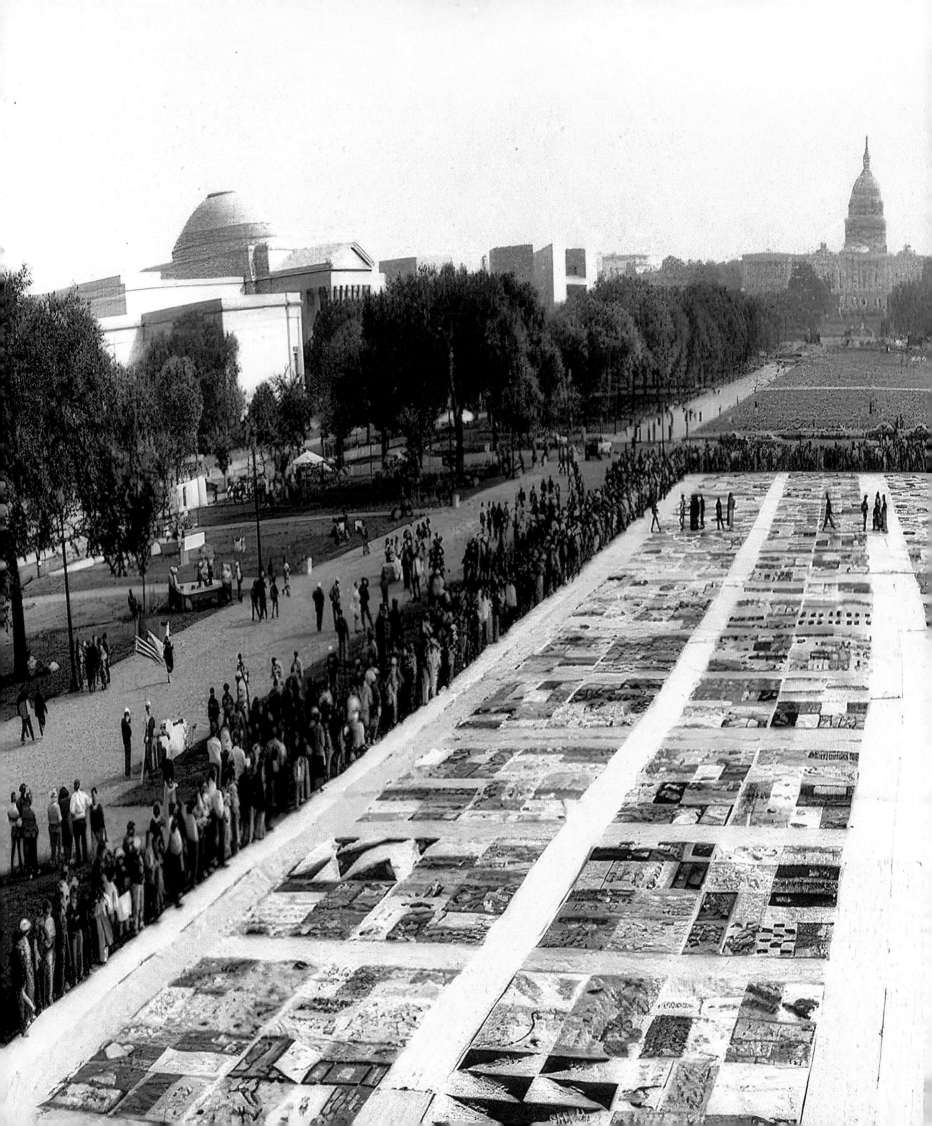

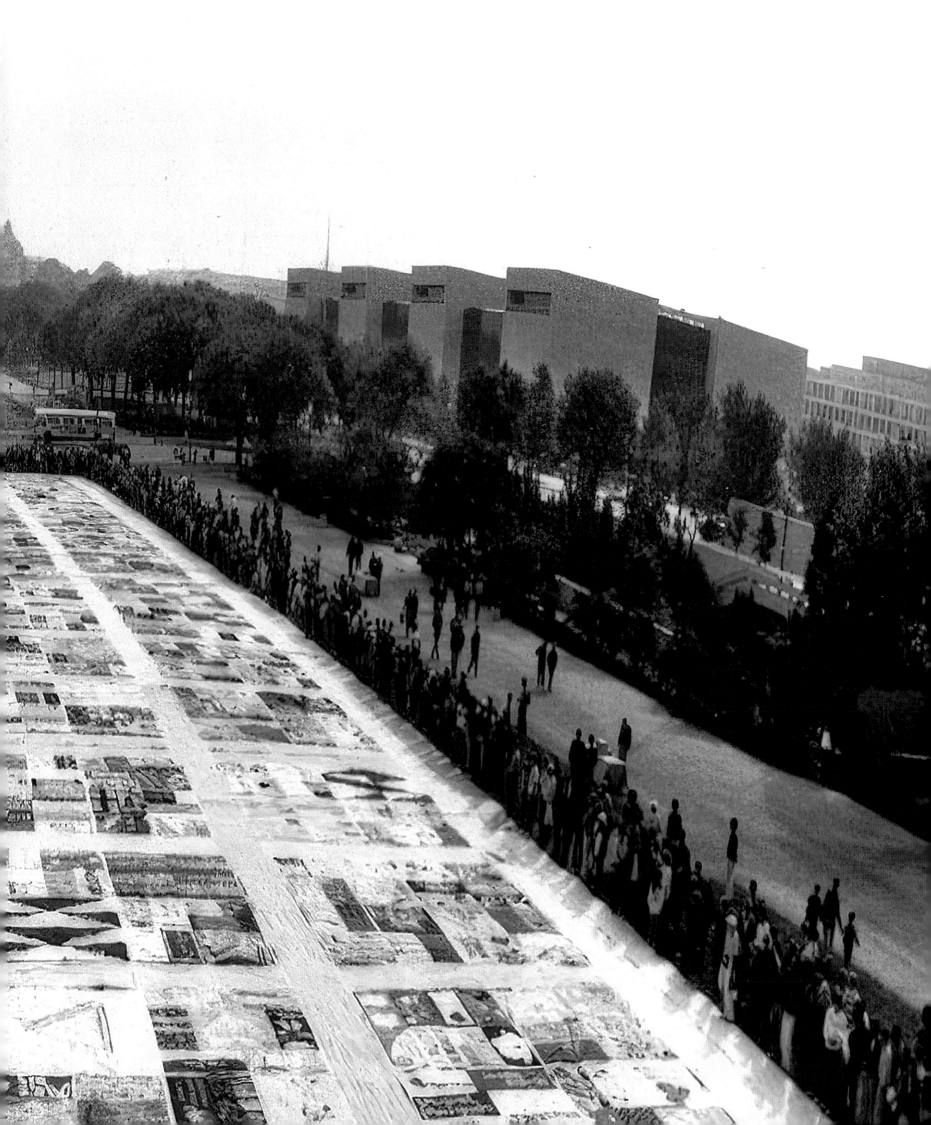

EVAN WOLFSON

The architect of marriage equality.

Evan Wolfson, often called the architect of marriage equality, was the driving force behind one of the most profound civil rights achievements in American history. From his groundbreaking law school thesis in 1983 to the Supreme Court's landmark decision in 2015, which affirmed the right to marry for LGBTQ+ couples nationwide, Wolfson's vision and determination shaped the path to victory. His brilliance in strategy, unwavering commitment, and ability to inspire hearts and minds ensured that the fight for love and equality reached its historic triumph.

Wolfson's commitment to marriage equality can be traced back to his childhood. At just ten years old, feeling excluded by societal images of marriage, he confided to his mother his doubts about ever getting married. This early realization, coupled with a growing understanding of the legal and social importance of marriage, ignited his passion for challenging the laws that denied same-sex couples this fundamental right.

In 1983, while attending Harvard Law School, Wolfson authored a pioneering thesis calling for the inclusion of same-sex couples in marriage. At the time, most in the gay rights movement viewed marriage as a far-fetched, even impossible, aspiration. Yet his steadfast belief in the legality and morality of marriage rights for all, combined with its potential to advance LGBTQ+ rights on multiple fronts, drove him to confront skepticism and opposition.

After graduating from Harvard, Wolfson became a senior staff lawyer at Lambda Legal Defense and Education Fund, where he worked from 1989 to 2001. During this time, he championed critical cases involving partnership and custody rights, military discrimination, HIV/AIDS advocacy, and employment discrimination. He also led Lambda's Marriage Project and coordinated the National Freedom to Marry Coalition, laying the foundation for the Freedom to Marry organization he would later establish. Notably, Wolfson collaborated with Hawaii attorney Dan Foley as co-counsel in *Baehr v. Lewin* (later renamed *Baehr v. Miike*), the first case in the world to hold that denying marriage licenses to same-sex couples was presumptively unconstitutional.

The *Baehr* case sparked significant political and public responses, positive and negative. In 1998, Hawaii voters approved a constitutional amendment restricting marriage in the state, effectively nullifying the court's decision. This "marriage panic" led Congress to pass the Defense of Marriage Act (DOMA) in 1996, which restricted marriage federally to different-sex couples and allowed states to refuse respect to the marriages that same-sex couples might secure someday.

Undeterred, Wolfson contributed to *Baker v. Vermont*, which led to the establishment of civil union in the state. While he viewed civil union as a "wonderful step forward," he emphasized that it fell short of true equality. In 2001, Wolfson left Lambda after receiving a substantial grant from the Evelyn and Walter Haas Jr. Fund. Articulating a vision that went beyond legal change, he said, "I'm not in this just to change the law. It's about changing society. I want gay kids to grow up believing that they can get married, that they can join the Scouts, that they can choose the life they want to live."

Evan Wolfson working on his 140-page thesis titled "Same-sex Marriage and Morality: The Human Rights Vision of the Constitution," published during his third year at Harvard Law in 1983.

Freedom to Marry, the national campaign Wolfson founded, became the leading force behind the marriage equality movement. Under his leadership, the organization united stakeholders through grassroots mobilization and strategic legal efforts. In 2004, as Massachusetts celebrated its first marriages of same-sex couples, opponents passed constitutional amendments further cementing marriage discrimination in thirteen states. In response, Wolfson encouraged LGBTQ+ leaders to renew their commitment, resulting in the "2020 Vision" strategy. This ambitious plan aimed for nationwide marriage equality by 2020 and gained the endorsement of major LGBTQ+ organizations and funders.

Wolfson expanded Freedom to Marry's operations after California voters approved Proposition 8 in 2008, which temporarily blocked same-sex couples' freedom to marry in the state. He recruited key personnel, including National Campaign Director Marc Solomon and messaging expert Thalia Zepatos, and grew the organization's budget and staff significantly. Between 2010 and 2014, Freedom to Marry led campaigns across the country, coordinating efforts in legislation, ballot measures, and litigation.

Wolfson was instrumental in persuading President Barack Obama to endorse the freedom to marry, a pivotal moment that helped the Democratic Party add marriage equality to its 2012 platform. That same year, he also spurred successful efforts in four states to finally deliver marriage wins at the ballot, marking the first electoral victories for the marriage movement.

The campaign reached a major milestone in 2013 when the US Supreme Court struck down DOMA, paving the way for federal judges to overturn state bans on same-sex marriage. It culminated in the landmark *Obergefell v. Hodges* decision on June 26, 2015, guaranteeing same-sex couples nationwide the right to marry. Reflecting on this achievement, Frank Bruni wrote in the *New York Times*, "Nothing about [the marriage fight] feels quick if you consider that Evan Wolfson, a chief architect of the political quest for same-sex marriage, wrote a thesis on the topic at Harvard Law School in 1983."

Wolfson faced criticism from some quarters for prioritizing marriage, with opponents arguing it risked sidelining other LGBTQ+ issues. Yet he remained steadfast, defining marriage in his book *Why Marriage Matters* as "a relationship of emotional and financial interdependence between two people who make a public commitment," and underscoring its significance in achieving broader equality. Wolfson's decades-long argument that marriage is both an important goal and strategy carried the day.

After securing nationwide marriage equality, Wolfson continues to advise and assist other causes, campaigns, and countries, ensuring that the Freedom to Marry campaign's lessons on how to win continue to inspire and advance change worldwide.

Just as we all hold rights which trump the mere tastes and prejudices of those who would suppress them, so, too, do gay individuals among us have human rights to express their identities, their "innermost traits of being"[701] and their love together, regardless of what others believe or fear.[702]

Refusing people samesex marriage denies them the opportunity to develop their loving selves, and contributes to negative perceptions and feelings about gay people.[703] Gay individuals, like society as a whole, lose faith in their ability to develop personal relationships and in their capacity to love.[704] The resultant alienation often takes on a political cast as well, as gay citizens on some levels reject the society which rejects them.[705] Deprived of a stable shelter perhaps even more essential to them than to those conforming to majority standards,[706] gay people often stand exposed and alone.[707] Thus, the refusal to recognize gay marriage is not merely the withholding of one final blessing, but a global and sometimes devastating blow to people striving to build lives for themselves in society.

It need not, and should not, be this way. The Constitution morally respects the freedom of individuals to create, live, and love in the happiness they can make for themselves in the world, consonant with the rights of others. Marriage, the social recognition and approbation of one such choice, is an institution of

p.77

much value to many.[708] People are born different, into different circumstances, but are inherently equal in moral terms and in the eyes of the law, as our Constitution confirms. According this equality is perhaps most vital when it comes to love, the great leveler, which comes to each of us not wholly by choice[709] or design. The choice we do and should have is what to make of what we are. For gay women and men, who also love, samesex marriage is a human aspiration, and a human right. The Constitution and real morality demand its recognition.. By freeing gay individuals as our constitutional morality requires, we will more fully free our ideas of love, and thus more fully free ourselves.[710]

MASS WEDDING, 1987

A half-decade into the AIDS epidemic, a historic and powerful event took place in Washington, DC, on October 10, 1987, as two thousand same-sex couples gathered to pledge their vows in a mass wedding ceremony. This unprecedented event was strategically held behind the National Museum of Natural History and in front of the Internal Revenue Service building, a poignant protest against the lack of recognition for same-sex domestic partners in the US tax code.

This mass wedding, affectionately dubbed "The Wedding," was a significant highlight of a larger movement—a six-day demonstration known as the Second National March on Washington for Lesbian and Gay Rights. The broader event aimed to draw attention to former President Ronald Reagan's lack of response to the AIDS crisis. It took place on the heels of *Bowers v. Hardwick*, the 1986 Supreme Court ruling against Michael Hardwick, who had sought to overturn sodomy laws nationwide that were enforced mainly to harass and shame the gay community.

Nearly five thousand people filled the streets, either to participate in or witness the mass wedding, adding to the sense of solidarity and shared purpose. The ceremony was presided over by Minister Dina Bachelor, who officiated the vows in front of a diverse and emotional crowd, whose very presence was testament to their passion for change.

Unknown couples on Constitution Avenue and 10th Street in front of the IRS building, 1987.

KAREN THOMPSON AND SHARON KOWALSKI

Their gripping story led to landmark rights for couples and people with disabilities.

In the 1980s, amid a landscape of societal prejudice and legal restrictions, Karen Thompson and Sharon Kowalski found themselves entwined in a love story that would test their resilience and redefine the fight for LGBTQ+ family protections and disability rights. Their journey unveils a tale of love, loss, and the relentless pursuit of justice.

It all began at the University of Minnesota, where Karen and Sharon, both deeply religious college professors and coaches, forged a close friendship. They did not know a single gay person and knew nothing about the first Pride parades only towns away. They were Ronald Reagan–voting conservative Christians, who took long rides on Sharon's motorcycle, making stops along the way to picnic and read the Bible. Little did they know their bond would blossom into a love that defied societal norms and familial expectations.

Karen found herself taken aback one afternoon as Sharon reclined on her bed, professing her affection through the whimsy of a sock puppet, a polyester alter ego that served as a buffer from possible rejection for Sharon. Initially stunned into silence, Karen eventually excused herself, but not without agreeing to reconvene the next day. In their subsequent meeting, Karen confessed her own deepening emotions, and thus began a clandestine romance, despite the threat of social condemnation within their conservative community. Their bond only grew stronger over

time, culminating in a bold display of commitment one evening after months apart for work, when each surprised the other with a ring. They laughed and promised to stay together for life.

The two women decided to purchase a house under Karen's name to avoid suspicion, yet they maintained equal financial contributions. However, tragedy struck one evening when Sharon was involved in a devastating car accident, leaving her in a coma with severe brain injuries and rendering her quadriplegic. As Sharon lay unconscious in the ICU, Karen, unable to receive updates due to her non-family status, desperately sought information about her beloved's condition. Turning to a sympathetic local priest at the hospital, Karen endured this agonizing ordeal by fervently praying for Sharon's recovery.

Sharon began to awaken from her coma, miraculously, though her debilitating injuries rendered her unable to speak or tend to her own needs. In the face of adversity, Karen stepped forward as Sharon's steadfast advocate, devoting countless hours to her bedside, administering care, facilitating quality physical therapy, and offering unwavering love and support each day. Despite Sharon's family maintaining a stance of denial and visiting Sharon only sporadically, Karen remained resolute. She procured a keyboard through which Sharon, with a pen clutched in her mouth, communicated answers to queries, at times infused with her trademark humor.

Snapshots from the lives of Karen Thompson and Sharon Kowalski, spanning their early years together in the late 1970s and early 1980s before Sharon passed away; their advocacy for partnership rights in the 1990s; and their life with Patti Bresser, who shared their home and hearts as a beloved part of their family.

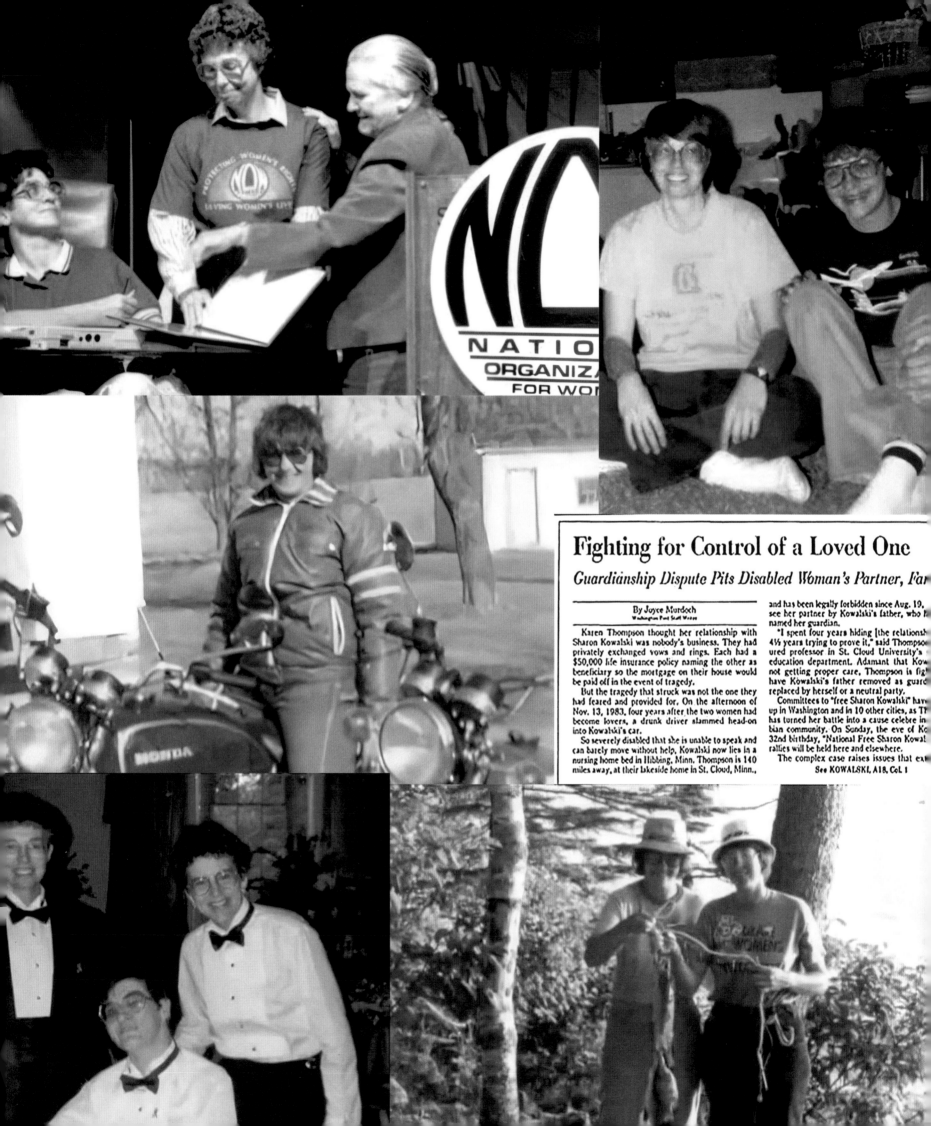

Fighting for Control of a Loved One

Guardianship Dispute Pits Disabled Woman's Partner, Far...

By Joyce Murdoch
Washington Post Staff Writer

Karen Thompson thought her relationship with Sharon Kowalski was nobody's business. They had privately exchanged vows and rings. Each had a $50,000 life insurance policy naming the other as beneficiary so the mortgage on their house would be paid off in the event of tragedy.

But the tragedy that struck was not the one they had feared and provided for. On the afternoon of Nov. 13, 1983, four years after the two women had become lovers, a drunk driver slammed head-on into Kowalski's car.

So severely disabled that she is unable to speak and can barely move without help, Kowalski now lies in a nursing home bed in Hibbing, Minn. Thompson is 140 miles away, at their lakeside home in St. Cloud, Minn.,

and has been legally forbidden since Aug. 19, ... see her partner by Kowalski's father, who h... named her guardian.

"I spent four years hiding [the relationsh... 4½ years trying to prove it," said Thompso... ured professor in St. Cloud University's ... education department. Adamant that Kow... not getting proper care, Thompson is fig... have Kowalski's father removed as guard... replaced by herself or a neutral party.

Committees to "free Sharon Kowalski" hav... up in Washington and in 10 other cities, as Th... has turned her battle into a cause celebre in... bian community. On Sunday, the eve of Ko... 32nd birthday, "National Free Sharon Kowal... rallies will be held here and elsewhere.

The complex case raises issues that ext...

See KOWALSKI, A18, Col. 1

Nurses on site noticed that Sharon only seemed to respond to Karen. The doctors, rarely present, reported little progress, and Karen's efforts were met with resistance from Sharon's parents, who viewed her as an intruder in their daughter's life, especially after learning they were more than just friends. Despite Karen's dedication, the Kowalskis, among other slights, sought to erase her presence from Sharon's life, stripping her of visitation rights, which left Sharon without the person she loved the most, hopelessly alone in a vegetative state. Cruelly, her family proceeded to dump her into a nursing home. The last time Karen was allowed to see Sharon, Sharon typed, "Help me. Get me out of here. Take me home." Karen then embarked on a nine-year legal battle to bring Sharon home.

The ensuing battle would become a landmark case, intertwining the struggles of the LGBTQ+ and disability rights movements. For those nine years, Karen fought tirelessly for Sharon's right to choose her visitors and make decisions about her own life, challenging the archaic notion that only blood relatives held authority over disabled individuals. All along, despite her efforts, Karen still could not visit Sharon, and every day had to wonder how Sharon was doing, who was taking care of her, and even if Sharon still knew who she was. As her fight garnered national attention, it sparked a groundswell of support from activists and allies alike. After Karen spoke at a rally, a disability activist approached to let her know they would be in the same town as Sharon and would try to find her—and they did. They let Sharon know Karen was fighting to bring her home and loved her dearly. In response, Sharon typed, "I thought she left me."

At this time in the 1980s, the AIDS crisis had reached a critical point within the gay community, amplifying the significance of Karen's advocacy of couples having the right to secure legal paperwork. United by their shared cause, the gay community stood behind Karen, acknowledging that her struggle resonated with their larger battle for rights and equality. Coverage of Karen's determination to get Sharon home appeared in local media like the *Minneapolis Star Tribune* (home state reporting supported the couple) and big outlets like the *Washington Post*, *New York Times*, *Los Angeles Times*, and *Time* magazine. Karen was changing hearts and minds, yet she was still unable to bring Sharon home. Then she changed lawyers. With the help of donations from people across the country, she hired M. Sue Wilson, who proved to be effective, getting Sharon a new competency hearing.

The doctors conducted private assessments with Sharon and, when she was finally allowed in court, asked her more serious questions: Did she know where she wanted to live? She typed, "With Karen." Did she know what the word "gay" meant? She typed, "Yes. It means I love Karen, I want to be with her." Independent evaluations, conducted by doctors who were not connected to Don and Della Kowalski, showed unmistakably that Sharon was a thoughtful, mentally competent (and quite humorous) adult. The new doctors confirmed that Sharon was indeed capable of making decisions about where and with whom she wanted to live. Mirroring the slowly changing, more compassionate attitudes across the country toward gay people and their relationships, the new judge and jury agreed. After nearly a decade of legal battles and personal sacrifices, Sharon was granted the freedom to return home—a victory not only for Karen and Sharon but for marginalized communities everywhere.

Kelly Weisberg, an authority on Karen and Sharon's story, summed up their legal battle:

> It was marked as a triumph for two social movements: LGBTQ+ and Disability rights and protections but also a case that transcends these boundaries for it touches the human

Karen Thompson on her quest across the US to bring Sharon home, 1989.

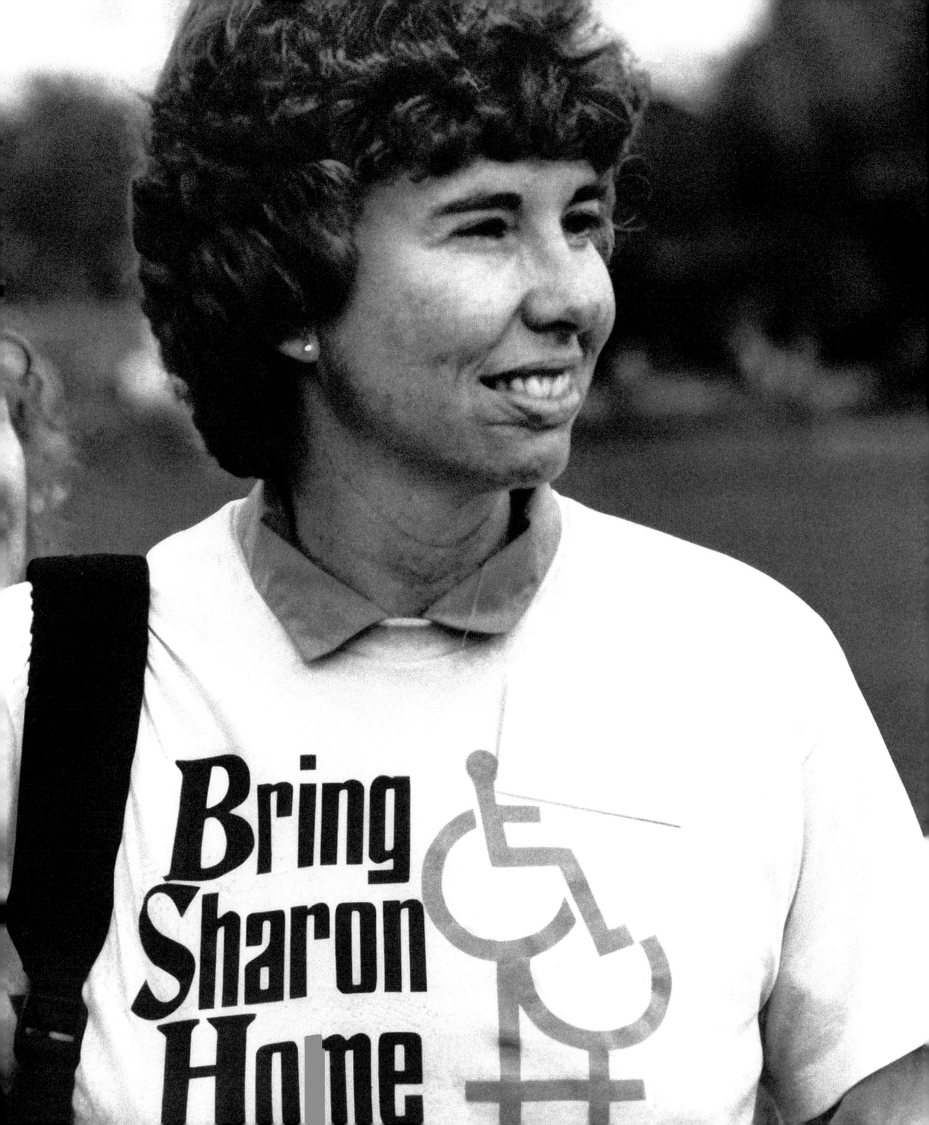

spirit. Karen's battle against discrimination riveted public attention on the harm inflicted by society for the elemental act of loving someone. Her struggle reflects universal themes:

— The fear of being separated from a loved one
— The dread of not being able to care for a loved one in a time of crisis
— The pain of persons kept apart by the medical system
— The anguish of persons wronged by the legal system

Her battle is a showcase of love, commitment, caring, courage, and persistence in the face of adversity. Her story became our story because any one of us could suffer the same fate of a sudden catastrophic illness that separates us from our loved ones.

Their story is a testament to their unbreakable bond, the power of love, resilience, and the enduring fight for justice in the face of adversity. In the aftermath of their ordeal, Karen and Sharon continued to advocate for LGBTQ+ and disability rights, sharing their story on national platforms and TV shows like *Donahue* and *The Larry King Show* to stress the importance of legal protections for all marginalized individuals. Especially critical when the AIDS crisis was at its height, their legacy lives on as a beacon of hope and inspiration for those fighting for equality and recognition in a world that often seeks to erase their existence.

Sharon and Karen legally married in 2003 and published two books together.

Karen Thompson and Sharon Kowalski, at a Lambda Legal event discussing the importance of legal paperwork for LGBTQ+ couples barred from the protections of lawful marriage, 1994.

DEBORAH PRICE AND JOYCE MURDOCH

**Their relatable life became part of everyday conversation in America—
and shaped public perception of gay relationships.**

In 1992, Deborah Price boldly took to the pages of the *Detroit News* with her first column, "Trying to Find a Name for a Gay Partner." In an era when LGBTQ+ voices were largely muted in mainstream media, this column marked a significant moment in public discourse and bravely confronted a topic often overlooked. Deborah, a thirty-four-year-old editor who helmed the newspaper's Washington bureau, posed a question that many in the LGBTQ+ community grappled with: How to define her relationship with Joyce Murdoch, her partner of six years.

With wit and introspection, Deborah toyed with labels like "girlfriend," "longtime companion," "life partner," and "lover," ultimately prompting readers to reconsider the terminology surrounding same-sex relationships. Her closing line—"So how do I introduce Joyce?"—sparked a national conversation about LGBTQ+ identity and relationships, inviting readers into a world that had long been kept in the shadows.

As the nation's first nationally syndicated LGBTQ+ columnist, Deborah aimed to demystify gay life for Middle America. By sharing relatable stories about her life with Joyce, she hoped to humanize LGBTQ+ experiences and challenge societal norms that denied equal rights. Over eighteen years, she penned nearly nine hundred columns, each a testament to her belief that understanding could foster acceptance. Joyce later reflected that Deborah "wasn't singing to the choir" but rather reaching out to those unfamiliar with a queer voice. Through her relatable scenarios, Deborah slowly altered perceptions and contributed to the cultural shift that culminated in the legalization of marriage equality in 2015.

Deborah's dedication to fearless journalism extended to controversial subjects like the military's treatment of gay personnel and the importance of being open about one's identity. They tackled these topics with a nuanced approach, balancing insight with optimism and engaging readers who might have otherwise remained indifferent.

Deborah and Joyce's love story began in 1985 at the *Washington Post*, where they both served as national desk editors. Together, they authored two influential books: *And Say Hi to Joyce: America's First Gay Column Comes Out* (1995), a compilation of Deborah's columns complemented by Joyce's commentary, and *Courting Justice: Gay Men and Lesbians v. the Supreme Court* (2001), an acclaimed examination of the legal struggles faced by the LGBTQ+ community.

Navigating a legal landscape that offered few protections for same-sex couples, Deborah and Joyce became the first to register as domestic partners in Takoma Park, Maryland, in 1993, and eagerly joined in a Vermont civil union in 2000. In 2003, they made history with the first LGBTQ+ wedding announcement in the *Washington Post*, which captured their love for travel, tennis, and scuba diving, with Hawaii as their dream honeymoon destination.

The legacy of Deborah Price and Joyce Murdoch is profound. Their work resonated deeply with many, including Michigan Attorney General Dana Nessel, who, as a regular reader, found solace and hope in their words as well as a rare visibility. Together, they not only opened doors for LGBTQ+ visibility in media but also fostered a climate of understanding that has paved the way for future generations to embrace their identities without fear.

Opposite: Deborah Price with Joyce Murdoch in 1985, the year they became a couple while working at the *Washington Post*.
Following spread: Deborah Price's article, published in the *Detroit News* on May 8, 1992, explores the challenge of finding the right words to describe a same-sex partner—and brings LGBTQ+ relationships into the mainstream conversation for the first time in a nationally syndicated newspaper column.

Trying to find a nan

There is no confusion when a woman says: "This is my husband."

But how do I introduce the woman I've lived with for six years to my boss? Is she my "girlfriend" or my "significant other"? My "longtime companion" or my "lover"?

Who says the gay-rights movement hasn't made a lot of progress? In just 100 years we've gone from the love that dare not speak its name to the love that doesn't know its name.

It sometimes seems as if we speak most clearly about our relationships once they are over: "My ex."

The term is blunt with a lingering air of possessiveness.

No one thinks you mean ex-roommate or ex-business partner. They know exactly what your relationship used to be.

Documentary-maker Debra Chasnoff brought this little dilemma of mine to world attention at the Academy Awards this year when she thanked her "life partner."

No sooner had she uttered thes words than gay couples turned to eacl other on couches all across the natior and said, "Honey, did you hear that' That means she's a lesbian, right?"

Those of us who live in the land o the gay euphemism were pretty sure and won the bet. But to me, "life part ner" sounds like what you become when you buy a health-club member ship.

"Significant other" sounds a though it should only be used by straight liberals who don't care who' doing what with whom — they jus want to know how many people are coming to the barbecue.

"Longtime companion" sounds like the obituary-page creation that it is.

"Girlfriend" can be fun in the right crowd, but I feel pretty silly using it in mixed company to describe a 38-year old professional.

"Domestic partner" always has a certain sarcastic ring to it for those of us whose dust bunnies breed like rabbits.

e for gay partner

And then there's "spouse," "the woman I live with," and the psychobabble that is guaranteed to land me on the couch for the night, "my relationship."

This vocabulary vacuum is a perennial problem for gay couples.

In "Borrowed Time: An AIDS Memoir," Paul Monette said he and Roger Horwitz settled on "friend." They decided the most likely alternative, "lover," had a "beaded '60s topspin."

But "lover" is the term Craig Dean uses to describe the man whose name he wants joined with his on a marriage license. Dean says "lover" underscores a vexing reality that "we're not legally married."

If he wins his lawsuit against the District of Columbia to marry, he says he'll call Patrick Gill his "husband."

The tabloids have come up with "datemates" and "gal pals" to describe lesbian couples. And, for the first time ever in 1990, the Census Bureau counted us as "unmarried partners."

Yet most of the time, straight people and straight forms have no category to describe us. "Check one. Are you married, single, widowed or divorced?"

Help me out on this one. Maybe I should cross out "single" and print in "double." Or, when things are really going great at home, "a party of two."

None of the terminology fits me — or us. Whatever phrase I use, I end up sounding like a foreigner who hasn't quite gotten the hang of U.S. colloquialisms.

Do we need a unique word to describe gay coupledom? Maybe we should seize a word, as we did with "gay," and make it ours. Or is it simply part of gay culture to have a love that answers to many names?

Surely a little ingenuity will solve this problem. So tell me, America, how do I introduce Joyce?

DEB PRICE *is the news editor at the Washington bureau of The Detroit News.*

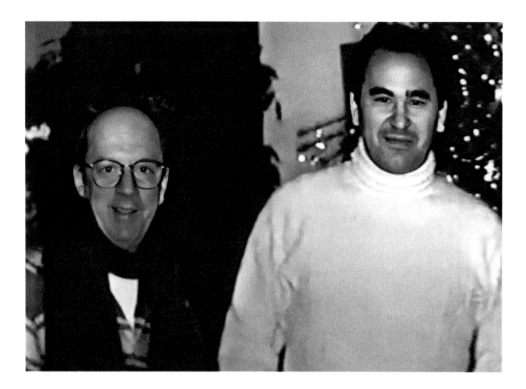

LESLIE BLANCHARD AND MIGUEL BRASCHI

Love breaks down barriers, turning a fight against eviction into a landmark victory for queer housing rights.

Miguel Braschi and Leslie Blanchard's love story began in December 1975 when they met at a gay bar in San Juan, Puerto Rico. They quickly became inseparable, and by 1976, Miguel, who was from an upper-class Puerto Rican family, had moved into Leslie's one-bedroom, rent-controlled apartment at 405 East 54th Street in Manhattan. Leslie, a renowned hair stylist with a celebrity clientele, owned the Private World of Leslie Blanchard, a salon that catered to New York's elite. His face was also well known from magazine ads for Clairol, for which he served as a spokesperson.

For a decade, Miguel and Leslie lived together as partners, sharing a home and a deep bond. Though they couldn't legally marry, they considered themselves a family. But in 1986, their life together was shattered when Leslie passed away from AIDS. Shortly after, Miguel began receiving eviction notices from the building's landlord, who argued that Miguel wasn't a legal family member and had no right to stay in the apartment.

Determined to honor their life together, Miguel fought the eviction, beginning a legal battle that would forever change housing rights for LGBTQ+ couples. Though he initially won in the New York Supreme Court, the decision was reversed on appeal. It wasn't until Bill Rubinstein from the ACLU's Lesbian and Gay Rights Project took over the case—joined by advocacy groups such as Lambda Legal and Gay Men's Health Crisis— that the New York State Court of Appeals ruled in Miguel's favor in 1989. The court's decision redefined family, stating that it should be based on "the reality of family life," not legal distinctions.

Miguel's victory was a landmark moment, paving the way for the recognition of non-traditional families in housing law. Tragically, he passed away from AIDS shortly after winning his case, but his legacy lives on, continuing to influence LGBTQ+ rights to this day.

BARRY WARREN AND TOM BROUGHAM

**The nation's first domestic partnership law stemmed from two men's commitment
to each other and became a critical stepping-stone to marriage equality.**

Barry Warren and Tom Brougham were deeply committed to each other but unable to legally marry. Yet they wanted the marriage-linked benefits that married heterosexual couples had, such as health coverage through a spouse's employment. It was the late 1970s, when marriage equality seemed unimaginable, and so they sought the best alternative they *could* imagine. Even before the 1980s, they highlighted the discrimination same-sex couples faced in obtaining employment-related rights by confronting the City of Berkeley's policies that tied essential employment benefits to marriage.

Their plan was not to fight what they saw as an uphill battle for marriage but instead take an incremental but impactful step: change the rules employers use to determine family coverage. Barry and Tom proposed the innovative solution of domestic partnerships, for which same-sex couples would be able access the same benefits traditionally reserved for married heterosexual couples through contracts with employers, unions, and health maintenance organizations. It was a groundbreaking idea that broadened the national conversation about the rights of LGBTQ+ families.

Their efforts took years, but Berkeley became the first city to adopt a domestic partnership policy, thanks largely to the perseverance of Barry and Tom, who were first in line to sign up. Their success sparked a movement, laying the foundation for cities, schools, and employers to offer protections to LGBTQ+ families— long before state legislatures were ready to take action.

As the AIDS crisis and family custody battles underscored the critical nature of marriage-linked benefits, domestic partnerships proved to be a lifeline. Civil unions and marriage equality eventually overshadowed policies built on the establishment of domestic partnerships; however, these policies should be seen as playing a crucial role in establishing the fact that same-sex couples deserved the same rights and protections as their heterosexual counterparts. For decades, domestic partnerships formed the only protection that a same-sex couple had. Limited as they were, they became a critical stepping-stone in the journey toward marriage equality. Barry and Tom fought to protect the health and well-being of their family and notched a victory for the generations of queer families who have followed.

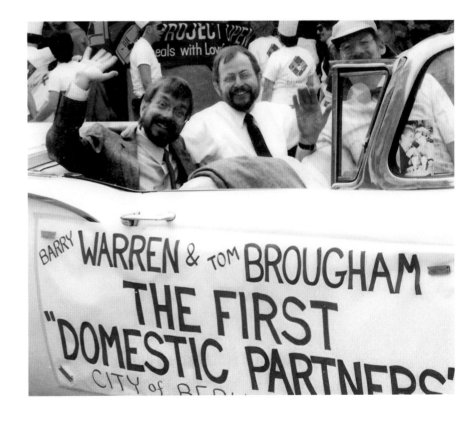

Barry Warren and Tom Brougham ride in the San Francisco Pride parade, late 1980s.

93

FOR BETTER, FOR WORSE

1990s

CHAPTER 3 — INTRODUCTION

The 1990s were a defining moment in LGBTQ+ history, marked by monumental battles for recognition, equality, and love. Amid profound progress, the gay community faced extensive challenges—socially, legally, and culturally. This decade witnessed a rise in visibility, from celebrities coming out to legal challenges to marriage equality—all while the AIDS crisis continued to cast a long shadow over the community. It was a time of vast courage and heartbreak, with stories that shaped the movement for generations to come.

By the 1990s, the AIDS epidemic had been ravaging the LGBTQ+ community for nearly a decade. What had begun as a mysterious and terrifying illness in the 1980s continued to claim countless lives, primarily among gay men. Despite the community rallying to care for its own, the stigma surrounding HIV/AIDS was inescapable. Politicians and religious figures often portrayed the disease as divine retribution for a so-called immoral lifestyle, further isolating those who were already marginalized. However, activism surged during this time. Groups like ACT UP (AIDS Coalition to Unleash Power) fought tirelessly for funding, research, and compassion. Their battle cry—"Silence = Death"—became a symbol of the community's resilience and demand for action. The LGBTQ+ community's response to the crisis forged bonds of friendship, activism, and, most notably, love in the face of death. People came out in greater numbers, not just to claim their identities but to fight for survival.

One of the most significant cases highlighting the struggle for recognition in the 1990s was that of Karen Thompson and Sharon Kowalski. After Sharon was left severely disabled following a car accident in 1983, her family barred Karen from visiting or making medical decisions. Despite having been together for four years before the accident, their relationship lacked legal recognition, leaving Sharon's parents in control of her care. For nearly a decade, Karen fought a legal battle for guardianship over Sharon. In 1991, the Minnesota Court of Appeals ruled in Karen's favor, affirming that Sharon had the right to live with her and making a crucial statement about the rights of non-married partners to care for one another. In a time when AIDS ravaged the community, their story illuminated the urgent need for legal recognition of same-sex relationships and inspired many to advocate for broader protections for LGBTQ+ couples.

While full marriage equality seemed like a distant dream in the early 1990s, the concept of domestic partnerships had gained traction. Cities like San Francisco and New York started to recognize domestic partnerships, offering limited legal rights to same-sex couples such as hospital visitation and shared health benefits. Though these arrangements fell far short of marriage, they represented

Page 94: The 1970s and 1980s saw increased demonstrations against repressive laws in the fight for recognition in the eyes of the government. Members of the Gay Activists Alliance protested in front of New York's City Hall, holding signs that read, "Gay is Good" and "America, Grow Up." **Opposite**: Ninia Baehr, left, and Genora Dancel at the Hawaii Supreme Court, 1993.

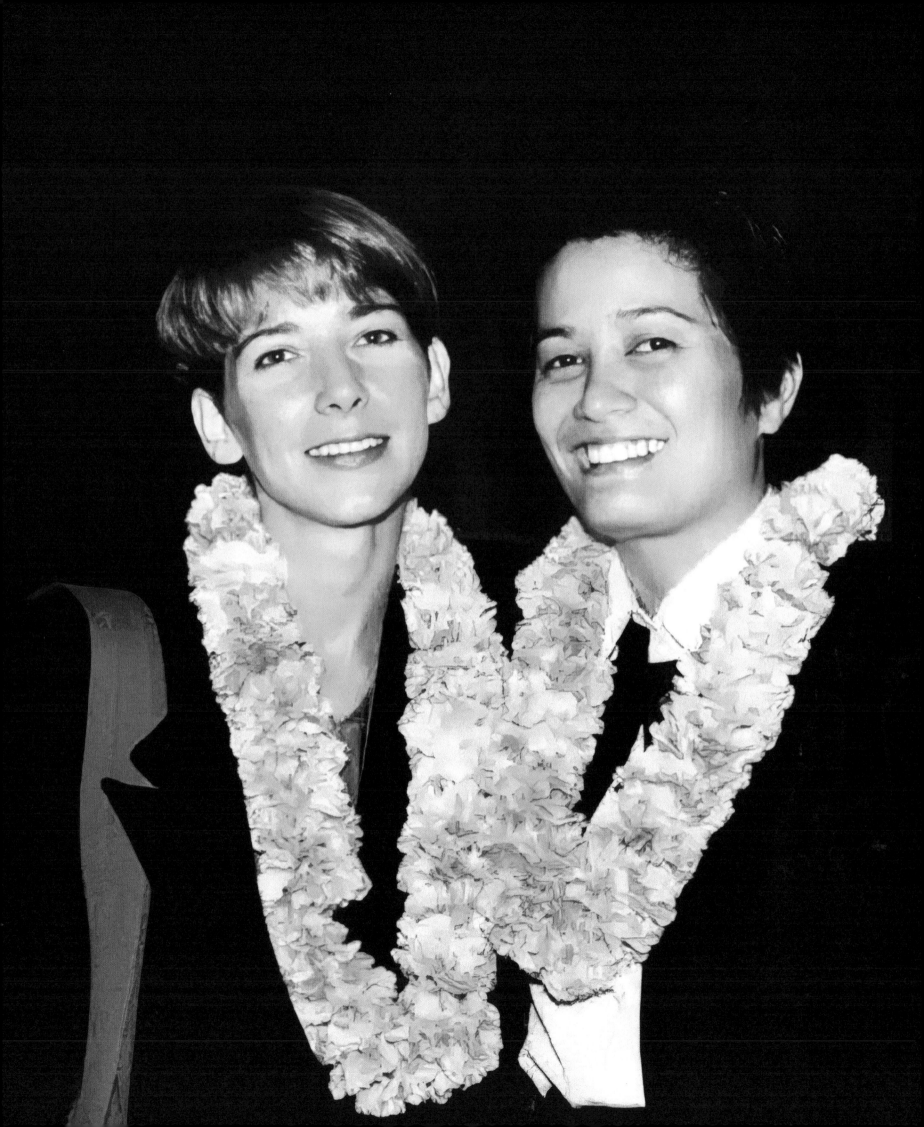

an acknowledgment that queer couples deserved some legal protections. This small but significant progress laid the groundwork for future battles for marriage equality, signaling that the conversation about gay rights was moving into the mainstream. Domestic partnerships offered a legal foothold that LGBTQ+ activists would expand upon in the coming years, laying the foundation for challenges to state and federal marriage laws.

One notable case was that of Christie Lee, a happily married trans woman in Texas. After her husband, John, tragically died due to medical malpractice, Christie faced insurmountable challenges in her quest to sue for justice. Despite Christie having undergone full gender reassignment surgery, Texas law claimed that her chromosomes invalidated her marriage. In addition, the Defense of Marriage Act made it illegal for same-sex couples to marry. With her marriage invalidated, Christie found herself ineligible to sue as John's next of kin, a heartbreaking consequence of the discriminatory laws in place at the time. However, her case would later provide a pathway for two lesbians in Texas to wed, as one of them, a transgender woman, possessed the required chromosomes for marriage under the law. Christie's story highlights the complexities and injustices that many faced during this era, within a legal realm shaped by outdated views on gender and marriage.

One of the most transformative moments in the marriage equality movement occurred in Hawaii in the early 1990s. Ninia Baehr and Genora Dancel, a couple living in the state, sought to name each other as beneficiaries on their insurance policies but were denied because they were not legally married. In 1991, they, along with two other same-sex couples, filed a lawsuit against the State of Hawaii for the right to marry. Their case, *Baehr v. Lewin*, argued that the denial of marriage rights to same-sex couples violated the state's constitution. Crucial to this fight was the work of Evan Wolfson, who recognized that Hawaii could be a test case for the nation. Although the case did not directly achieve marriage equality, it forced the issue into the national consciousness.

In 1993, the Hawaii Supreme Court ruled that the state's refusal to allow same-sex marriage amounted to sex discrimination unless the state could show a compelling reason for the ban. This ruling, while not granting immediate marriage rights, was groundbreaking. It was the first time a court recognized that denying marriage to same-sex couples could be unconstitutional. The case sent shockwaves through the country, prompting conservative backlash and fear that same-sex marriage could soon become a reality. In response, Congress passed the Defense of Marriage Act (DOMA) in 1996, defining marriage as a union between one man and one woman and allowing states to refuse to recognize same-sex marriages performed in other states. DOMA was a blow to the LGBTQ+ community.

While the 1990s saw increased visibility and legal victories for the LGBTQ community, it also experienced fierce conservative backlash. Figures like Pat Robertson, founder of the Christian Coalition, and Newt Gingrich, the Speaker of the House, spearheaded efforts to roll back LGBTQ+ rights and stoke fear about the so-called gay agenda. Robertson's Christian Coalition worked tirelessly to mobilize conservative Christians against LGBTQ+ rights, portraying LGBTQ+ people as a threat to traditional family values. The organization was instrumental in promoting anti-LGBTQ+ legislation and pushing for laws that restricted LGBTQ+ rights, particularly for adoption, military service, and education. Newt Gingrich's Contract with America, a conservative legislative agenda aimed at reducing the size of government and promoting family values, also had an anti-LGBTQ+ undercurrent.

Captains Daniel Hall and Vincent Franchino, pictured in 2009, served in the military as Apache helicopter pilots during the repressive "Don't Ask, Don't Tell" era. After enduring those challenges, they began dating and married in 2018.

Gingrich and his allies saw the fight against LGBTQ+ rights as part of their broader culture war and used DOMA as a key tool in their efforts to define marriage as a union between a man and a woman. The political climate of the 1990s made it clear that while the LGBTQ+ community was making progress, the fight for equality would continue to be met with strong resistance.

One of the earliest and most significant straight allies of the LGBTQ+ community was Phil Donahue, who used his influential daytime talk show in the 1980s to promote LGBTQ+ visibility and tackle issues like marriage equality, AIDS, and equal rights. At a time when homophobia and misinformation were rampant in the media, Donahue prioritized fairness and accuracy, giving LGBTQ+ people a platform to share their stories. He was a vital supporter of GLAAD and consistently elevated personal, human stories at the heart of the LGBTQ+ struggle, including topics such as HIV, coming out, and trans and women's equality. In 1990, Donahue made history by hosting the first-ever same-sex wedding to be broadcast on US television, featuring the Black, gay couple Michael Marlowe and Wayne Watson, who shared their experiences with the studio audience. Reflecting on his early advocacy, Donahue recounted his initial fear of hosting a gay guest in 1968 but explained how his activism deepened his empathy for those living in the closet. As he told Oprah in 2002, "If you don't understand those feelings, then you don't understand homophobia. There's a reason for the closet. As the years went by after that show, I got involved in gay politics. And through my activism, I began to realize what it must be like to be born, to live, and to die in the closet. I can't even imagine it. Gayness is not a moral issue, yet no institution on earth has promoted homophobia more than the Church. That's what's so ironic about the scandal in the Catholic Church. Here you have the most homophobic institution in the world with the largest closet of homosexuals." Karen and Sharon's appearance on *Donahue* brought much-needed attention to the challenges faced by gay couples, highlighting the urgent need for legal protections—especially during the AIDS epidemic.

One of the most influential figures fighting against DOMA was Barney Frank, the first member of Congress to voluntarily come out as gay in 1987. Frank was already a well-known advocate for LGBTQ+ rights by the time DOMA was introduced, and he fiercely opposed the bill. He argued that the law was discriminatory and unnecessary, pointing out that marriage was traditionally a state issue, and DOMA represented an overreach of federal authority. Throughout the 1990s, Frank remained one of the most visible and vocal queer voices in Congress. His courage in coming out while serving as a US representative, particularly during a time of rampant discrimination, helped destigmatize LGBTQ+ identities in American politics. His leadership and willingness to speak openly about his life helped pave the way for future LGBTQ+ politicians and underscored the importance of representation in government.

In 1998, Tammy Baldwin made history by becoming the first openly LGBTQ+ woman elected to Congress when she won a seat in the US House of Representatives, representing Wisconsin's Second Congressional District. Baldwin's election was a significant milestone that marked the arrival of openly gay politicians in national office. Her presence in Congress signaled that people like her could not only serve but thrive in political leadership roles, influencing policies and debates on a national scale. Baldwin's election, along with Barney Frank's ongoing presence, represented a shift in the political landscape. Gay people were no longer just subjects of debate; they were active participants in shaping the laws and policies that affected their lives.

Melissa Etheridge and Julie Cypher proudly display their relationship in Los Angeles, 1996.

Visibility mattered in the 1990s, and few celebrities made a bigger impact than singer Melissa Etheridge and her partner, filmmaker Julie Cypher. Etheridge came out publicly in 1993, becoming one of the most high-profile openly gay musicians of the time. The couple's decision to have children together—Cypher gave birth to two children conceived via artificial insemination—made headlines and challenged traditional ideas of family. Their openness about their relationship and family life helped normalize same-gendered relationships for many Americans who had never before seen LGBTQ+ families represented in mainstream media. Etheridge and Cypher's visibility, along with Etheridge's music, gave many in the LGBTQ+ community the courage to come out, live authentically, and demand equality.

If Melissa Etheridge's coming out was significant, Ellen DeGeneres took it to a whole new level. In 1997, DeGeneres came out as a lesbian both in real life and through her character on her hit sitcom, *Ellen*. The episode, fittingly titled "The Puppy Episode," drew enormous attention and became a cultural touchstone. DeGeneres's coming out was a watershed moment in LGBTQ+ visibility, marking the first time a major television character had acknowledged their sexuality on prime-time television. However, the backlash was swift. Ellen faced a fierce conservative response, and the show was eventually canceled after its ratings dropped. Despite the fallout, her courage when LGBTQ+ representation was still rare made her an icon in the movement. As the comedian became one of the most successful TV personalities of the next two decades, her legacy would continue to evolve; nevertheless, Ellen's boldness in the 1990s helped pave the way for greater LGBTQ+ representation in media.

In October 1998, the LGBTQ community was shaken to its core by the brutal murder of Matthew Shepard, a twenty-year-old college student from Wyoming. Shepard was beaten, tied to a fence, and left for dead by two men who targeted him because he was gay. He died six days later, and his murder became a national symbol of anti-LGBTQ+ hate and violence. Shepard's death galvanized the LGBTQ+ community, prompting widespread calls for hate crime legislation that would protect LGBTQ+ individuals. His story highlighted the persistent dangers of being openly LGBTQ+ in America, even as visibility and acceptance were increasing. The tragedy of his death mobilized activists and led to the passage, one decade later, of the Matthew Shepard and James Byrd, Jr. Hate Crimes Prevention Act, which expanded federal hate crime law to include crimes motivated by a victim's sexual orientation or gender identity.

Matthew Shepard, in Laramie at the University of Wyoming, 1998.

BILL WILSON AND FERNANDO ORLANDI

Their paper trail to marriage began one of the first state-sanctioned domestic partnerships in 1991.

Bill Wilson and Fernando Orlandi say their paper trail to marriage began when they heard about a heartbreaking court case in the 1980s, about a man whose partner died of AIDS. Despite the long-term relationship, the apartment was in the partner's name, and the partner's family could legally force him out with nothing. The judge ruled that if the deceased partner had wanted their relationship to be treated like a marriage, they could have registered as domestic partners. This ruling made Bill Wilson and Fernando Orlandi realize that they never wanted to face a similar situation, so they vowed to take every opportunity to register as domestic partners. At that time, the possibility of marriage was unthinkable.

They lived in Washington, DC, from 1972 until 1997, except when they were in San Francisco in 1991 and 1992, where Fernando was transferred to design a satellite for Intelsat. They returned in 1997 when he was transferred there again.

While crossing the country several times, Bill and Fernando tried to protect themselves. Bill said:

> We . . . registered as domestic partners in San Francisco in 1991, in Washington, DC, in 1993, and in the State of California in 1999—though at the time, it didn't afford us many rights. We registered again in 2004, which offered more legal protections. Later that year, we got married, but the California Supreme Court ruled our marriage "null and void." Finally, in 2008, we had a legal California marriage, though it wasn't recognized nationally until the US Supreme Court's decision in 2014. We received one of the first domestic partnership licenses for a gay couple in the State of California. We were number ten, as our license says on the back.

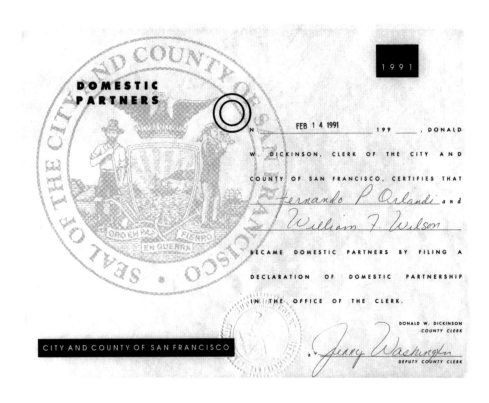

Eighteen years after their many attempts to legalize their relationship, Bill Wilson and Fernando Orlandi legally married at San Francisco City Hall, June 2008.

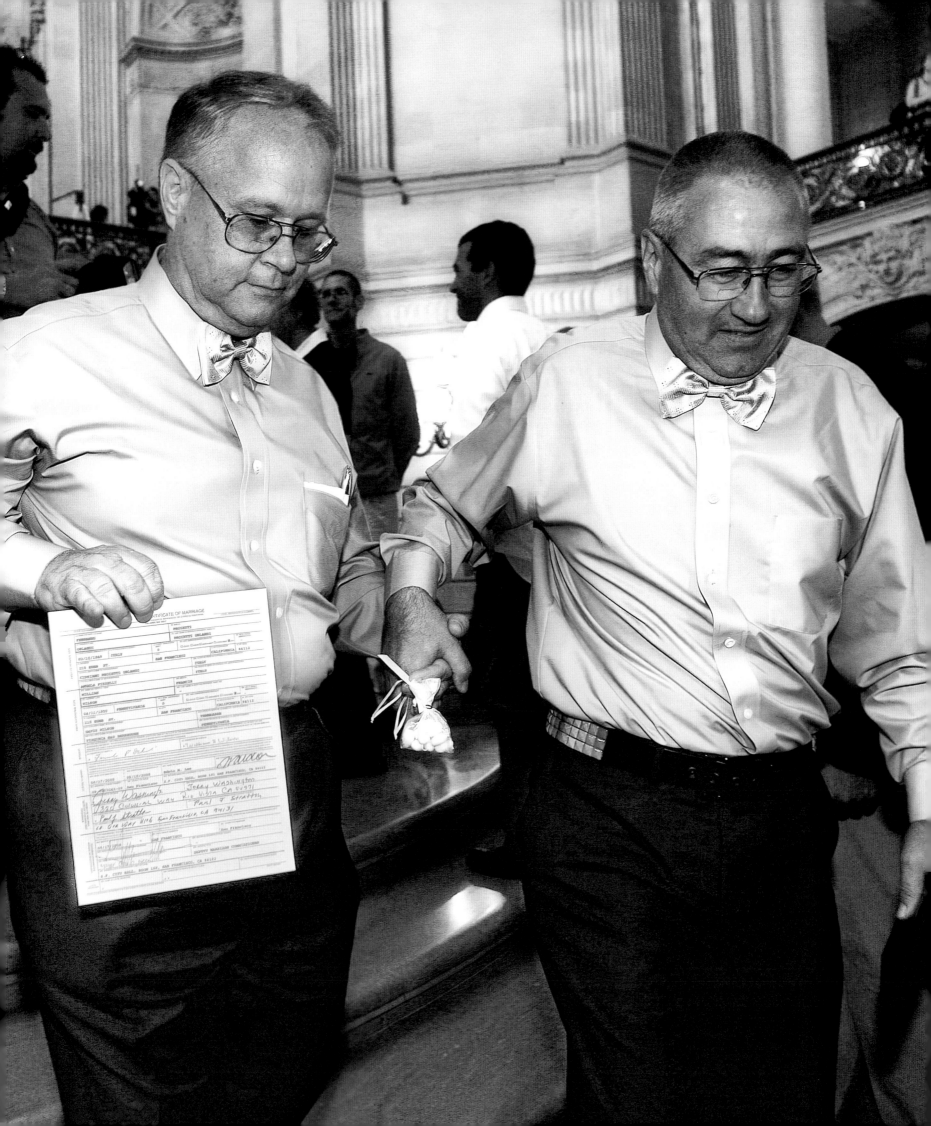

TOM JOSLIN AND MARK MASSI

With guts and humor, they filmed their love and dedication for the world to see as they died from AIDS.

Silverlake Life: The View From Here is a deeply moving 1993 documentary that began after filmmaker Tom Joslin and his partner, Mark Massi, were both diagnosed with HIV. As Tom's health deteriorated, Mark took over filming, and eventually one of Tom's former students, Peter Friedman, completed the project. The film offers an intimate portrait of love, resilience, and mortality, capturing the couple's everyday life as it oscillates between life memories, doctor visits, and the ever-present bond that held the two men together, even in the face of overwhelming sorrow.

For many, watching the groundbreaking film *Silverlake Life* was a rite of passage for gay men. Tom and Mark met in the 1970s, a time when the LGBTQ+ community was gaining visibility yet still faced significant societal and legal challenges. Their love story began in Silver Lake, Los Angeles, a neighborhood known for its vibrant gay community. Both men were deeply committed to each other, and their relationship flourished despite the external pressures and prejudices of the time.

Tom was passionate about documenting the human experience, including his own as a gay man, while Mark worked in the health services field. Their love story took on a public dimension with the creation of their powerful documentary.

Tom began filming their life in 1988, when contracting AIDS was, for the most part, a death sentence. The documentary captures the profound challenges faced by Tom and Mark, including the physical and emotional toll of the illness, the fear of societal rejection, and the inevitability of death.

In one of the final scenes, Mark struggles to transfer Tom's ashes into an urn, spilling some in the process: "Tom, you're all over the place!" he says, adding a bittersweet touch of humor and joy. It is a heartbreaking moment that highlights how, despite their being unable to marry, Tom and Mark's relationship exemplified the vow "in sickness and in health" in a profoundly tragic yet beautiful way.

Silverlake Life was groundbreaking for its raw and honest depiction of a couple denied the dignity and protections of marriage while facing the ravages of AIDS. The film won several awards, including the Grand Jury Prize at the Sundance Film Festival in 1993, and it became an important cultural artifact in the fight for LGBTQ+ rights and AIDS awareness.

Tom and Mark's courage in documenting their journey provided a powerful counter-narrative to the often-dehumanizing coverage of the AIDS crisis in mainstream media. In fact, for many viewers, the film brought them inside a gay couple's home for the first time. By sharing their personal lives, their love, and their struggles, the couple helped pave the way for greater acceptance, legal recognition of gay couples, and the need for societal change. They were two ordinary men who became extraordinary storytellers of an era that devastated the gay community.

Pages 107–9: Tom Joslin and Mark Massi in scenes from their award-winning 1993 film *Silverlake Life: The View From Here*.

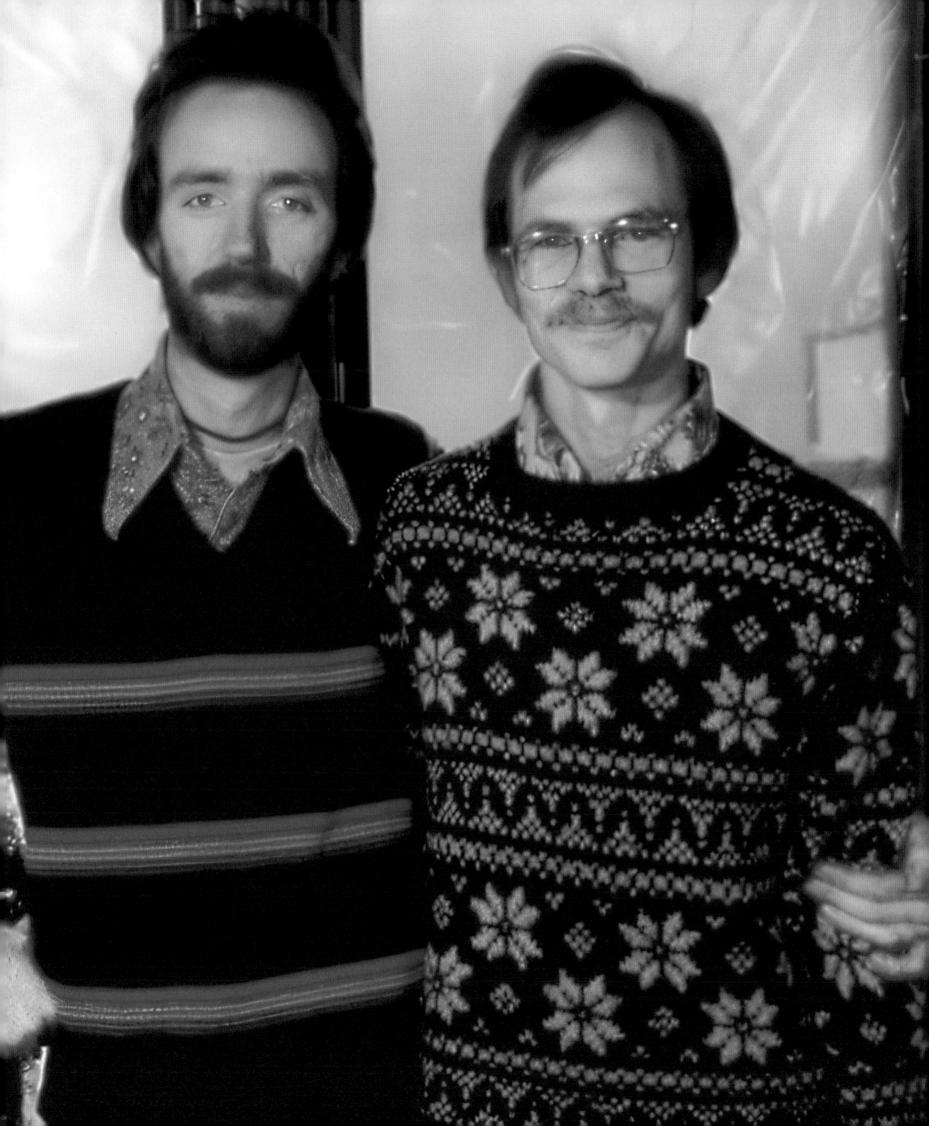

SUSAN PARKER AND WENDY SCOTT

When this couple wanted a ceremony for a non-legal union, residents in their small North Carolina town congregated around them.

In 1997, a devoted couple deeply committed to their faith and each other decided they wanted to solidify their union through a ceremony at Wake Forest University's Wait Chapel. Active members of the Wake Forest Baptist Church in Winston-Salem, North Carolina, Susan Parker and Wendy Scott envisioned their union blessed within the sacred space that had significant meaning to them. However, their dream was shattered when the university denied their request, citing policies that did not permit same-sex ceremonies.

The decision from Wake Forest University ignited a firestorm of controversy, dividing the community of Winston-Salem and drawing national attention. For Susan and Wendy, the rejection felt like a personal and profound denial of their love and commitment. It also sparked a broader debate about religious freedom, equality, and the role of institutions in sanctioning such unions.

Refusing to accept the university's decision, Susan, Wendy, and their church, the Wake Forest Baptist Church, mobilized to challenge the policy. The church had a long history of advocating for social justice and inclusivity, and its members were determined to support the couple. Reverend Richard Groves, the pastor of the church, spoke out passionately, arguing that the church should have the right to marry whomever it chose, regardless of the couple's gender.

As the controversy gained momentum, the community became deeply polarized. Supporters of Susan and Wendy rallied, organizing protests, writing letters to the university administration, and engaging in public debates. They argued that love and commitment should be honored, and that the university's stance was a form of discrimination that had no place in a progressive society. Opponents maintained that the university had the right to uphold its policies and traditions, even if they were rooted in more conservative interpretations of marriage.

The media quickly picked up the story, and soon Susan and Wendy found themselves at the center of a national debate. The couple's fight resonated with many across the country, drawing support from LGBTQ+ advocacy groups and individuals who saw their struggle as emblematic of the broader fight for marriage equality.

Despite the growing pressure, Wake Forest University stood firm in its decision. The administration released statements defending their policies and emphasizing their commitment to following university guidelines. The refusal to budge, however, only fueled further activism and advocacy.

Throughout this tumultuous period, Susan and Wendy remained resolute. Their relationship, already strong, grew even more resilient as they faced the public scrutiny and the emotional toll of the battle. They continued to attend their church, supported by their faith community, which provided a haven amid the storm of controversy.

The fight for their union ceremony at Wait Chapel became a symbol of the larger struggle for LGBTQ+ rights and became the subject of a 2001 documentary, *A Union In Wait*. While the university ultimately did not change its policy at the time, the efforts of Susan, Wendy, and their supporters further laid the groundwork for future societal changes and increased awareness of same-sex couples being denied the right to use their chosen venues.

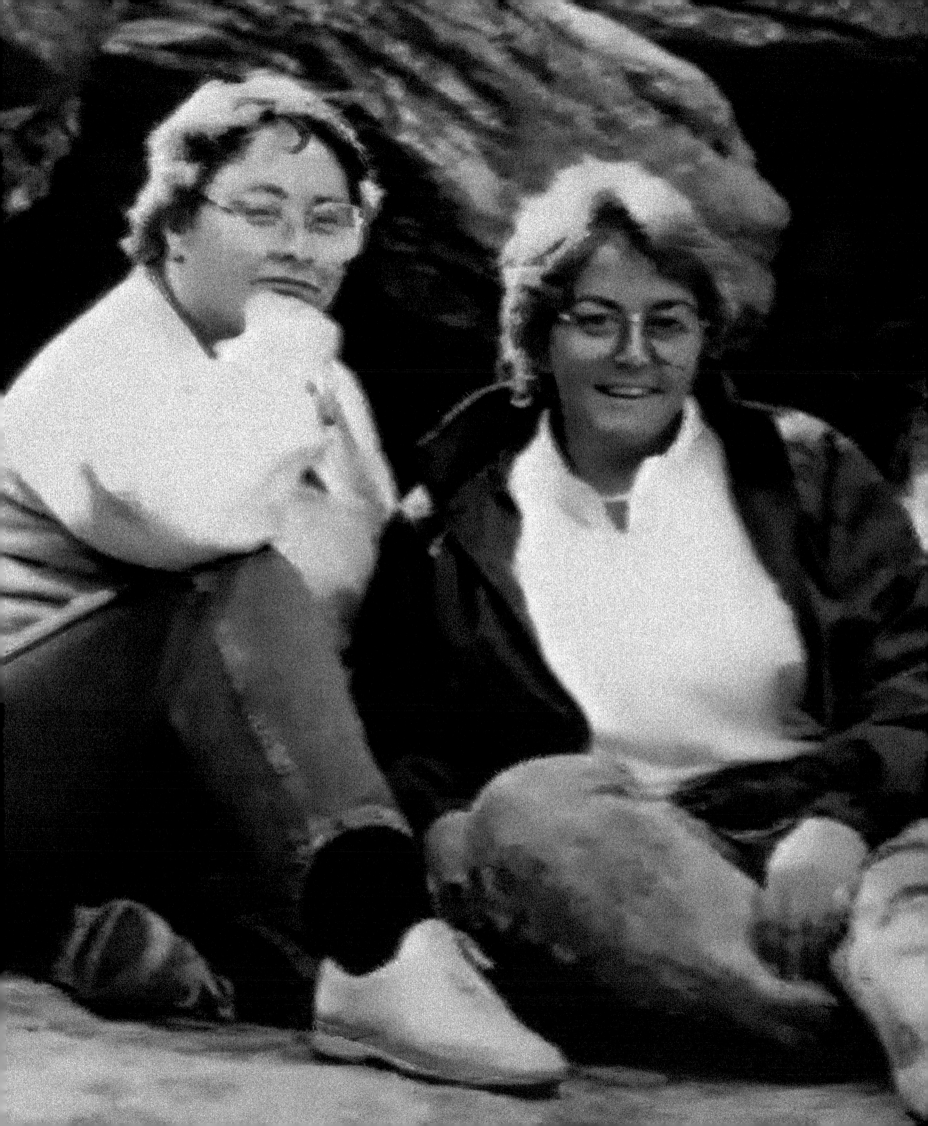

JON HOLDEN AND MICHAEL GALLUCCIO

Their fight wasn't just about expanding legal protections; it was about expanding love.

In the mid-1990s, Jon Holden and Michael Galluccio stood at the forefront of a battle that was more than about adoption; it was about redefining what it meant to be a family. Their story began in 1995 when they became foster parents to Adam, a fragile, HIV-positive infant born to a drug-addicted mother. Despite the challenges, Jon and Michael nurtured him with love and care, creating a bond that transformed them from caregivers to parents in every sense of the word. But legally, their journey was only just beginning.

In 1997, the couple made headlines when a New Jersey state court allowed them to jointly adopt Adam, marking a historic moment for gay rights. At the time, joint adoptions were reserved for married couples, and unmarried partners—gay or straight—faced a complicated, costly process that entailed filing separate petitions. For Jon and Michael, this hadn't just been a legal hurdle to clear but a threat to the integrity of their family to overcome as well. "We're a family now," Jon said outside the courthouse, his voice filled with emotion as he stood beside Michael and their son, Adam. Their win was personal, but it also carried broader significance. Though narrow in its legal scope, the ruling was a way to begin chipping away at the exclusionary policies that defined the state's—and the nation's—adoption laws.

It was not an easy victory. The New Jersey Department of Youth and Family Services had opposed the adoption, a stance that reflected the broader societal resistance to granting equal rights to same-sex couples. However, as the court ruled in their favor, Jon and Michael's success moved hearts and minds, highlighting the necessity for legal protections for LGBTQ+ families. Their battle did not end with Adam.

With a foster daughter, Madison, also in their care, Jon and Michael became plaintiffs in a class-action lawsuit challenging the state's ban on joint adoptions by unmarried couples. They understood firsthand the emotional and financial toll such a barrier placed on families like theirs.

Jon and Michael's determination to adopt children whom others had abandoned—children who needed the love and care they could offer—reflected a powerful truth. LGBTQ+ families have often been willing to adopt children that others have not, and their commitment to providing safe, loving homes to these children emphasized the importance of family protections. Their case also highlighted the changing landscape of family rights in the 1990s. Laws were slow to adapt to evolving societal norms, but stories like theirs used the power of love to challenge outdated policies.

In 2002, Jon and Michael shared their story in *An American Family*, a poignant memoir that detailed their journey through the legal system that was fueled by their love for Adam, and their ongoing fight for equality. Today, Jon and Michael are still together, raising their children and celebrating their grandchildren, a testament to the enduring strength of their love and commitment.

Michael Galluccio and Jon Holden hold their newly adopted two-year-old former foster son Adam, December 1997.

NINIA BAEHR AND GENORA DANCEL

After meeting in a parking lot, their wedding became an act of Congress.

Ninia and Genora's love story began in an unlikely place—a Honolulu parking lot. Ninia's mother introduced her to Genora, and it wasn't long before Ninia mustered the courage to visit Genora at the PBS station where she worked. Their first date was spent chatting next to a Big Bird statue, lasted nine hours, and led to them falling deeply in love.

In the early 1990s, the political debate around gay rights largely focused on whether anyone other than straight people was fit to serve in the military. But Genora had a different dream—one of marriage. She proposed to Ninia, who eagerly accepted, even though they both knew a legal wedding wasn't possible. Their attitude about being discriminated against changed when Ninia needed medical care and was uninsured. If they had been married, Genora's health insurance could have covered Ninia, providing essential protection. Initially, the couple sought domestic partnership status, but as they confronted the limitations of that arrangement, they decided to join the fight for full marriage equality by becoming plaintiffs in a lawsuit.

Their quest for marriage equality began when they joined two other couples in December 1990 to apply for a marriage license at the Hawaii Department of Health. Though denied, they were ready for the challenge. Dan Foley, a civil rights lawyer, saw the potential for a landmark case and helped them and the other couples file a lawsuit in 1991 (*Baehr v. Lewin*), challenging Hawaii's refusal to grant them marriage licenses.

This was one of the first cases in the US to argue that same-sex couples had the right to marry under the state's constitution, despite the fear of becoming public figures and facing backlash even within the gay community. Their case caught the attention of Evan Wolfson, then working for Lambda Legal, who saw the potential to turn the tide of marriage equality. In May 1993, the Hawaii Supreme Court ruled in their case that the state's refusal to allow same-sex couples to marry was indeed discriminatory. The Court sent the case back to the lower court to determine if there was a "compelling state interest" in preventing marriage equality. This was a major legal victory for the plaintiffs and the gay rights movement as a whole.

However, the victory was short-lived. A full-on marriage equality culture war had commenced, and Congress responded by passing the Defense of Marriage Act (DOMA), which allowed states to refuse recognition of same-sex marriages. Anti-gay groups poured money into Hawaii and successfully passed a state constitutional amendment in 1998 that nullified Ninia and Genora's court victory. A wave of similar constitutional amendments spread across the country, stifling progress.

Despite this setback, Ninia and Genora's fight was not in vain. Their courage helped ignite a passionate national conversation and laid the legal and political groundwork for future battles.

Reflecting on their journey, Genora always believed they would see marriage equality in their lifetime, a belief that kept her hopeful even during the toughest times. Today, Ninia and Genora have moved on with their lives, each marrying other women—something their past efforts made possible. Ninia wed in Montana, while Genora returned to Hawaii, where she received her marriage license from the same clerk who had denied her years before. The moment was bittersweet, symbolizing how far the fight had come.

STANNARD BAKER AND PETER HARRIGAN

Not content with domestic partnerships, Vermont couples advocate for civil unions and win.

Marriage equality strategists, smarting from the setback in Hawaii, turned to Vermont to try to establish the legality of civil unions there. Domestic partnerships offered paltry protections compared to marriage, while civil unions, which were accepted in countries worldwide, seemed a reachable goal.

Three couples joined a lawsuit against the state to sue for the right to enter into a civil union: Holly Puterbaugh and Lois Farnham, Nina Beck and Stacy Jolles, and Peter Harrigan and Stannard Baker, the named plaintiff in *Baker v. Vermont*, which would ultimately grant the right to all residents, gay and straight.

When the press asked Stan and Peter why they chose to join the lawsuit, their answer was simple: "Because we fell in love. After four years together, we wanted to have a legal bond joining us, and we wanted to be able to proclaim our love in front of our family and friends. Marriage is a core institution of our society, and being barred from it is akin to losing the right to vote. If anyone is excluded from a right that others have, then no one's rights are safe."

In 1996, a friend from Vermont asked Stan to narrate *Freedom to Marry: A Green Mountain View*, a seventeen-minute video. This experience nudged him to go home to Peter and discuss marriage. They quickly went from thinking about the impossibility of marriage to believing that it could happen for LGBTQ+ couples in Vermont—and that the time had come. Peter and Stan joined the lawsuit as a gay male couple alongside two brave lesbian couples.

Because out of all the names, Baker came first alphabetically, Stan became the named plaintiff. Stan said:

Our case will forever be *Baker v. Vermont*—the *Baker* case, or simply *Baker*. The three years between 1997 and 2000, when the case was decided, were difficult and exhilarating. We were buoyed by the support of the Freedom to Marry Task Force, the LGBTQ+ community, and our crack legal team: Susan Murray, Mary Bonauto, and Beth Robinson. Mary remains a force in many subsequent lawsuits, and Beth is now a Vermont Supreme Court justice.

During those three years, Vermonters had a conversation that was often difficult and vitriolic. Regular folks found themselves using words they'd never used before: homosexual, gay, lesbian, bisexual, transgender, same-sex, etc. Some who had previously maintained a veneer of tolerance suddenly had to confront their own biases. It was difficult and trying, and I had to put up my imaginary "Leviticus shield" whenever I sat in the statehouse at the judiciary hearings, as person after person testified about how evil or sinful I was. Yet Vermonters were educated, no violence occurred, and Vermont moved forward. Our state was the first to legislate equal rights for same-sex couples, which included civil unions. Peter and I exercised that right in August 2000.

Love is love was just beginning to take off.

Ten years after the momentous *Baker v. Vermont* decision, Peter Harrigan and Stannard Baker, just married, in their backyard, August 13, 2010.

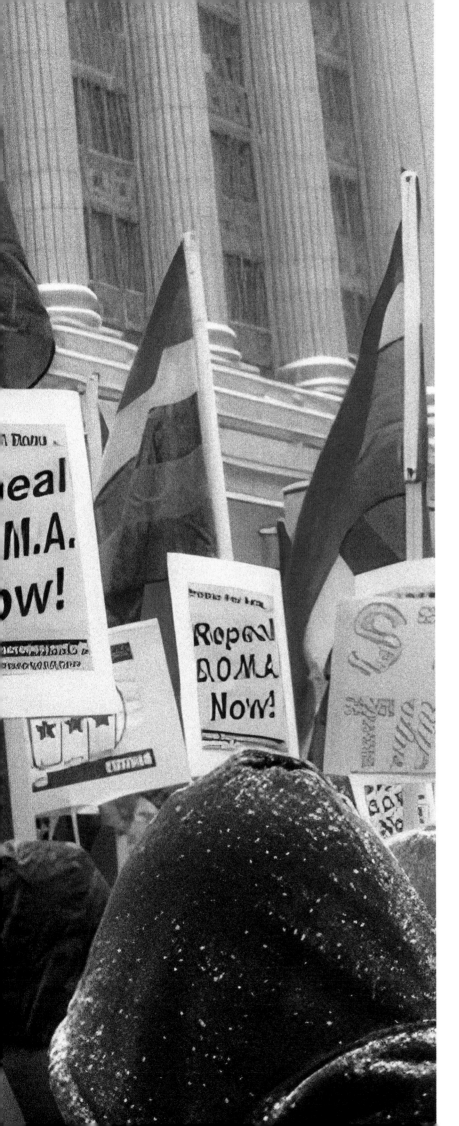

DOMA

The Defense of Marriage Act (DOMA), sparked by the "Hawaii marriage panic," hindered progress on marriage equality for nearly two decades.

In the early 1990s, the landscape of American politics began to shift dramatically as the religious right emerged as a powerful force, influencing public policy and political discourse. This new political movement was galvanized by fears surrounding the prospect of same-sex marriage, particularly following the Hawaii Supreme Court's 1993 decision in *Baehr v. Lewin*, which opened the door to marriage equality. In response to what became known as the "Hawaii marriage panic," Congress enacted the Defense of Marriage Act (DOMA) in 1996, a legislative move that reflected both bipartisan support and deep-seated anxieties about changing societal norms.

DOMA, signed into law by President Bill Clinton, defined marriage for federal purposes as the union between one man and one woman. It also allowed states to refuse to recognize same-sex marriages performed in other states, effectively nullifying any progress toward marriage equality that had begun to emerge. The act garnered support from politicians on both sides of the aisle, as many sought to distance themselves from the growing influence of LGBTQ+ rights movements and appease the newly powerful Christian conservatives.

The passage of DOMA was a significant setback for LGBTQ+ advocates, entrenching discriminatory practices into federal law and establishing a precedent that would hinder progress for nearly two decades. It was perceived as another betrayal by President Clinton, especially after "Don't Ask, Don't Tell" led to the discharge of thousands of LGBTQ+ individuals from the military. Yet, Clinton argued that the alternative—a constitutional amendment—would be much harder to revoke than an act of Congress, a concern he passionately asserted during the debate.

People protesting the Defense of Marriage Act (DOMA) outside the US Supreme Court, Washington, DC, 2013.

ELLEN DEGENERES

**The comedian's decision to love herself and utter three words, "Yep, I'm gay,"
changed the trajectory of the marriage equality movement.**

Three words from this comedian changed the trajectory of the marriage equality movement. In 1997, Ellen made a decision that transformed not just her life but the broader cultural landscape in accelerating society's acceptance of LGBTQ+ individuals.

On January 26, 1958, Ellen was born in the small southern town of Metairie, Louisiana. Growing up with her now-famous love for animals, she dreamed of becoming a veterinarian. The only problem, at least to her, was that she didn't think she had the smarts to be a doctor. (Her later life would prove that to be a big misconception.)

She attended the University of New Orleans for only one semester, dropped out, and went on to work a series of jobs such as waitressing and selling vacuum cleaners. In 1980, Ellen experienced a tragic loss when her girlfriend at the time was killed in a car accident. Deeply affected by the event, Ellen drove by the crash site, a moment that left a lasting, indelible imprint with her. This heartbreaking experience contributed to her decision to pursue a career in comedy to cope with the pain and find meaning within such tragedy. She honed her skills as a burgeoning standup comic, and, after years of performing, finally got her big break: an appearance in 1986 on *The Tonight Show* with Johnny Carson, during which Johnny famously invited her to come back "anytime."

Ellen quickly began to carve out a successful career as a standup comic and actress, eventually getting her own television show. Her eponymous sitcom, *Ellen*, was a huge hit in the 1990s, and her star rose until she became one of the most beloved figures in America. Her approachable, "girl next door" persona endeared her to millions. Plus, she was downright funny.

However, beneath the surface, Ellen was grappling with a profound truth about her identity. Like so many during that time, she lived in fear of coming out as queer. If revealed, it could threaten everything she had worked so hard to achieve. Her worries proved to be justified—at least at first.

On April 14, 1997, Ellen took what was then an unprecedented and meteoric step: she came out as gay on the front of *Time* magazine with the bold headline, "Yep, I'm Gay." Anyone of a certain age has that *Time* cover image of Ellen forever in their memories of the era. Similarly unforgettable is the scene from her television show when her character, Ellen Morgan, accidentally (and hilariously) leans over a live airport microphone, repeating the words, "I'm gay." She not only outed herself via the airport loudspeaker but to her viewers and the world as well.

This was when LGBTQ+ representation in mainstream media was scarce and often fraught with stereotypes and negativity. Ellen's decision to come out was nothing short of revolutionary. She risked her career—one that had been built on being relatable and noncontroversial—for the sake of living authentically. At first, the risk she took seemed to result in the very outcome she had feared.

Ellen DeGeneres, Hollywood, California, 1996.

Ellen began depicting the life of a lesbian, and the world wasn't ready for that yet. Advertisers pulled their support from her show, and the once-popular sitcom struggled in the ratings before ultimately being canceled in 1998. In an interview with Diane Sawyer that year, Ellen questioned why she was accused of being "political" by pushing her sexuality. "How is that political? How is it political to teach love and acceptance?" She went on to say that there is nothing wrong with being gay and that someday "people are going to get it."

For a time, Ellen was a pariah in Hollywood, blacklisted for daring to live openly. But Ellen, like the LGBTQ+ community around her, had always fought back and won. Ellen's coming out became more than a headline: it was a catalyst. From one story—her story—came many. Closeted high-profile individuals began to find the strength to live openly, inspired by Ellen's bravery. Artists like Brandi Carlile and public figures like Chasten Buttigieg have credited Ellen as a major influence in their own journeys. It's not an exaggeration to say that for most queer people over thirty, Ellen's coming out was a turning point in their lives, and in their families' attitudes toward being queer.

Ellen became an advocate for LGBTQ+ rights, using her platform to shine a light on injustices and to support those who were vulnerable. In the tragic case of Matthew Shepard, a young gay man who was brutally murdered in 1998, Ellen was one of the public figures who spoke out most passionately, ensuring that his story and the cruelty of homophobia was brought into the national conversation. Shepard's death put a spotlight on the violence and prejudice that LGBTQ+ individuals faced, and Ellen's voice added weight to the push for change.

Ellen spoke emotionally at Matthew's vigil. "I am so pissed off, I can't stop crying," she began. "This is what I was trying to stop. This is why I did what I did." Through the years, Ellen has not stopped talking about Matthew, because she has always vowed that his story cannot be forgotten.

A few years after that fateful year of 1997, Ellen's career not only recovered but thrived. She went on to host one of the most successful talk shows in television history, *Ellen*, with her trademark humor, kindness, and generosity. Her journey from pariah to powerhouse is a testament to the power of authenticity and the importance of representation. For many—queer and straight alike—Ellen's willingness to live her truth paved the way for others to do the same and to be more accepting.

Over time, mothers and grandmothers, who were the primary audience for Ellen's afternoon talk show, once again began adoring the funny and approachable Ellen. By being her true self, Ellen made being gay less abstract, less frightening, and more human, allowing so many more people—celebrities and everyday folk—the freedom and security to come out themselves. Ellen is more than an icon, and her story is legendary. Now, just imagine what life would have been like for the queer community—and for society as a whole—if Ellen had succeeded in selling vacuums.

Ellen DeGeneres and then-girlfriend Anne Heche, one of Hollywood's first openly gay couples, Hollywood, California, 1997.

CHRISTIE LEE AND JONATHAN LITTLETON

A small-town Texas couple lived as husband and wife for seven years until tragedy struck—and opened the national debate on transgender marriage.

Christie Lee Littleton Van De Putte entered this world in San Antonio, Texas, as Lee Cavazos Jr. In childhood, Lee was prescribed hormones in an attempt to alleviate the anguish of gender dysphoria.

From the tender age of seventeen, Lee embarked on a quest to find a compassionate physician who could guide her through her journey to embrace her true self. Between November 1979 and February 1980, she underwent significant surgeries, marking pivotal milestones in her transformation. With unwavering determination, she successfully amended her Texas birth certificate to reflect her true gender.

A decade later, fate wove an unexpected thread into Christie's narrative when she encountered Jonathan Littleton in the unassuming setting of a motel lobby in Kentucky. In a moment of vulnerability and honesty, she bared her soul to him, and he was smitten. They exchanged vows in the quaint town of Pikeville, Kentucky, before returning to San Antonio, where Christie nurtured her passion for beauty by running a hair salon. Tragically, after seven years of shared dreams and sorrows, Christie found herself grappling with the unbearable loss of her beloved husband, who succumbed to health complications after a doctor's misdiagnosis.

In 1999, Christie, still grieving the loss of her husband, took legal action, alleging that it was malpractice—a doctor's negligence—that contributed to her husband's untimely death. However, what began as a pursuit of justice swiftly transformed into a legal quagmire, highlighting the systemic hurdles faced by transgender individuals seeking recourse within a legal framework that often fails to recognize their identities.

The crux of Christie's legal dilemma lay in the refusal of the legal system to acknowledge her marriage to Jonathan. Despite having undergone full gender reassignment surgery and having legally amended her birth certificate to reflect her true gender, Christie encountered resistance from the courts, which cited archaic laws and discriminatory policies to deny her marital status. Texas claimed Christie's chromosomes invalidated her marriage; just two years before, the congressional Defense of Marriage Act (DOMA) had made it illegal for two men to get married. As her marriage was invalidated, so was her eligibility to sue as Jonathan's next of kin.

Christie's efforts were thwarted at every turn. Her appeal to higher courts, including the US Supreme Court, proved futile, and she was denied a court settlement. But her case would positively influence the outcome of subsequent legal battles involving transgender individuals, such as that of Nikki Araguz in Texas, in 2011, a transgender widow who fought for and won recognition of her marriage following her husband's death.

Christie Lee and Jonathan Littleton at their wedding in Kentucky in 1989, and at their home in San Antonio, Texas, in 1996.

TO LOVE AND TO CHERISH

2000–2004

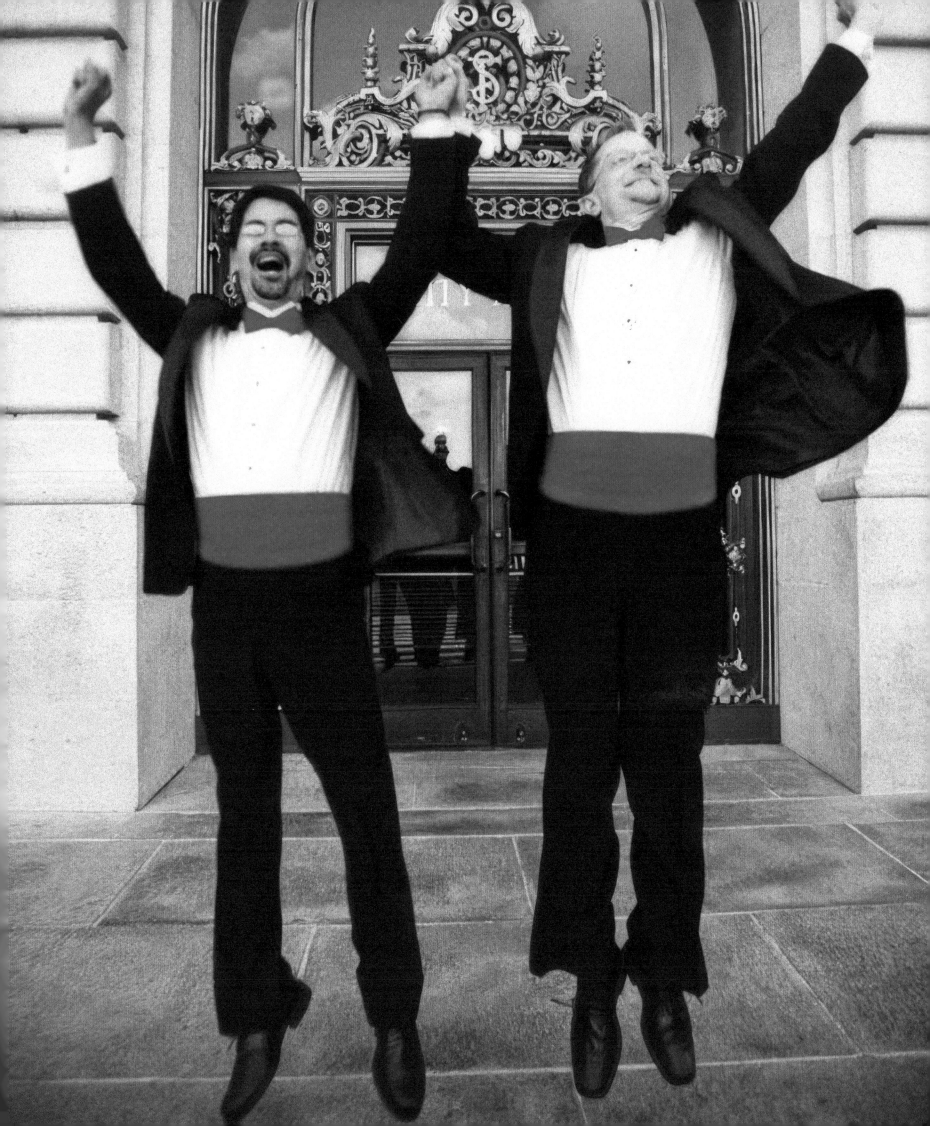

CHAPTER 4 — INTRODUCTION

At the start of the twenty-first century, the United States found itself at a crossroads, grappling with an earnest cultural and legal reckoning over the rights of LGBTQ+ individuals. The years between 2000 and 2004 became a crucible of change, marked by a passionate struggle for legal recognition of same-sex relationships and the freedom to marry. Amid both historic triumphs and fervent opposition, a collective determination surged, reflecting the deep-seated desire for acceptance and dignity.

In April 2000, Vermont made history with the passage of the Civil Union Bill, a significant milestone achieved through the tireless efforts of Stannard Baker and Peter Harrigan. Their victory in the fight for civil unions sparked hope for same-sex couples across the nation seeking legal recognition for their committed relationships. However, the triumph was quickly overshadowed when, in November 2000, Nebraska voters approved a constitutional ban on same-sex marriage, marking a resistance to marriage equality that still loomed large.

Internationally, a wave of change was unfolding. On April 1, 2001, the Netherlands became the world's first country to legalize same-sex marriage, inspiring advocates across the globe. Yet, in stark contrast, in November 2002, Nevada voters followed Nebraska's lead, approving a constitutional amendment that reinforced barriers against marriage equality.

Amid this turbulent climate, a monumental legal breakthrough occurred on June 26, 2003, when the US Supreme Court struck down sodomy laws in *Lawrence v. Texas*. This landmark ruling not only decriminalized intimate relationships between consenting adults but also dismantled the stigma that had long criminalized LGBTQ+ identities. The case arose from the harrowing experience of John Lawrence, an ex-Army veteran, and Tyron Garner, who were arrested for engaging in consensual sexual activity in the privacy of their home. When Lawrence discovered the police's egregiously inaccurate arrest report, he felt compelled to take those law enforcement lies to task all the way to the highest court in the land and in so doing catalyze a civil rights movement to reshape the legal landscape for LGBTQ+ individuals. Lawrence and Garner's courageous fight not only affirmed the right to privacy in one's own home but also significantly reduced legal persecution against the community, empowering many to live openly and authentically.

The narratives of those advocating for marriage rights flourished, including the courageous efforts of Hillary and Julie Goodridge, who became the faces of the marriage equality movement when they, along with six other couples, were the named plaintiffs in *Goodridge v. Department of Public Health*. Bolstered by attorney Mary Bonauto—who, over several decades, would dismantle barriers to many LGBTQ+ rights—the Goodridge plaintiffs helped drive a historic legal victory.

Page 127: Stuart Gaffney and John Lewis celebrate getting married at San Francisco City Hall, 2004.

Opposite: One of the first same-sex marriages in Canada, the wedding of Mathieu Chantelois and Marcelo Gomez in Toronto, July 3, 2003. Toronto City Hall is in the background.

After the birth of their daughter, Annie, Julie was denied access to Hillary in the hospital because she was not recognized as a legal spouse. This painful moment revealed the critical lack of legal protections for same-sex couples during times of need, underscoring the urgent necessity for change—not only for their own family but for countless others facing similar struggles. This experience left a lasting impact, solidifying their belief in the importance of legal recognition for their family's security and dignity. Their resolve deepened when their four-year-old daughter asked the simple yet profound question, "Why aren't you married?" Their story struck a chord with many that reverberated across the nation and provoked a backlash of fear and resistance, prompting President George W. Bush to call for a constitutional amendment restricting marriage to heterosexual couples.

As momentum for marriage equality grew, so too did the opposition. The Vatican launched a campaign against same-sex marriage on July 31, 2003, and by August 1, proposed constitutional bans on same-sex unions began to gather sponsors across several states. Public opinion remained divided. A poll conducted on August 18 revealed that 60 percent of Americans opposed same-sex marriage. The atmosphere of resistance intensified on October 28, when President Bush reiterated his support for the constitutional amendment to restrict marriage.

Despite these obstacles, hope shined in Massachusetts, where, on November 18, 2003, the state supreme court's decision in *Goodridge et al. v. Dept. of Public Health* made Massachusetts the first state in the US to legalize same-sex marriage. This landmark ruling brought joy to the LGBTQ+ community, even as nationwide efforts to counter progress grew stronger.

The fervor continued into 2004. On February 12, San Francisco Mayor Gavin Newsom took a courageous stand against public opinion, allowing the city to begin marrying same-sex couples. For many, this was a moment of indescribable joy—a dream realized for those who had long sought the legal recognition of their love and inclusion within their communities. However, this moment was short-lived, as the city was forced to revoke the marriages amid mounting political pressure, crushing the hopes of thousands who had gathered to celebrate a union they never thought possible in their lifetimes.

Then the landscape shifted again. A March 16 poll by the *New York Times* and CBS showed that 59 percent of Americans supported a constitutional amendment restricting marriage to a man and a woman. Nevertheless, on May 17, 2004, the first legal same-sex marriage in the United States was celebrated, marking an indelible moment in history.

Between 2000 and November 2, 2004, opposition to same-sex marriage swept across the United States, as eleven states passed constitutional amendments banning such unions. Sparked by the growing visibility of the marriage equality movement, particularly after Massachusetts legalized same-sex marriage in 2003, these bans were a reactionary effort to prevent similar legal victories. Arkansas, Georgia, Kentucky, Michigan, Mississippi, Montana, North Dakota, Ohio, Oklahoma, Oregon, and Utah all defined marriage exclusively as a union between one man and one woman.

An anonymous woman expresses her support for marriage equality over civil unions, outside the Mormon Temple at New York City's Lincoln Center on October 13, 2008.

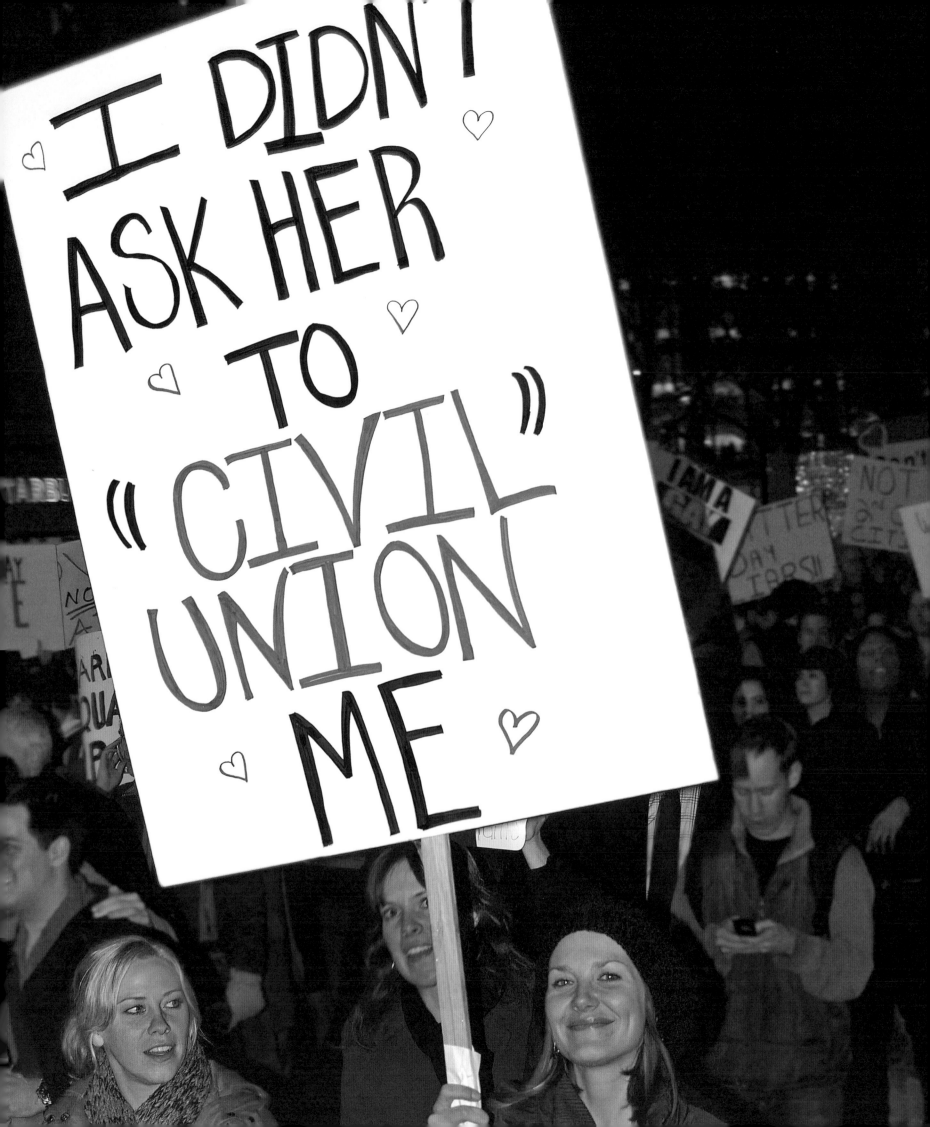

On November 2, 2004, amid President George W. Bush's re-election campaign and bolstered by his advocacy for a national ban on same-sex marriage, all eleven of these states passed ballot initiatives, fueled by fear that marriage equality would erode traditional values. These bans represented a significant setback for LGBTQ+ rights, stalling progress. Even so, on November 29, the Supreme Court declined to review Massachusetts' same-sex marriage law, providing a glimmer of hope amid the mounting resistance.

Love. Commitment. Fairness. Freedom. Those four words perfectly describe this era and begin Evan Wolfson's 2004 book, *Why Marriage Matters*, which would become the definitive guide for the decades-long movement as it looked ahead with a tenacious, focused plan to change hearts, minds, and the law through the stories of those fighting for the right to marry. Evan founded Freedom To Marry, which would become the lead organization coordinating a national political and public strategy to win marriage rights. Along with Mary Bonauto, Wolfson helped build a strategic foundation for the community and its allies.

These years represented more than just a series of events; they marked a transformative journey in the aftermath of the devastation wrought by the AIDS crisis. Increased visibility fostered growing compassion for the gay community, and frustration with weak domestic partnership laws galvanized advocates to rally for the rights and dignity that only marriage could provide. The combination of *Lawrence v. Texas*, which decriminalized being gay, and *Goodridge v. Department of Public Health*, which secured the right to marry in the first US state, ignited an explosion of new rights. This progress offered society a new perspective on their fellow Americans, ushering in a more rapid path in the marriage equality movement—referred to by marriage equality scholars simply as "After Goodridge."

Opposite: San Francisco Mayor Gavin Newsom orders marriage licenses issued to same-sex couples who apply, February 2004. **Following spread**: From left, Peter Wittebrood-Lemke, Frank Wittebrood, Ton Jansen, Louis Rogmans, Helene Faasen, and Anne-Marie Thus cut their wedding cake after exchanging vows at Amsterdam's city hall, April 1, 2001. They were among four couples to marry under the world's first law allowing LGBTQ+ marriages, which took effect on April 1, 2001.

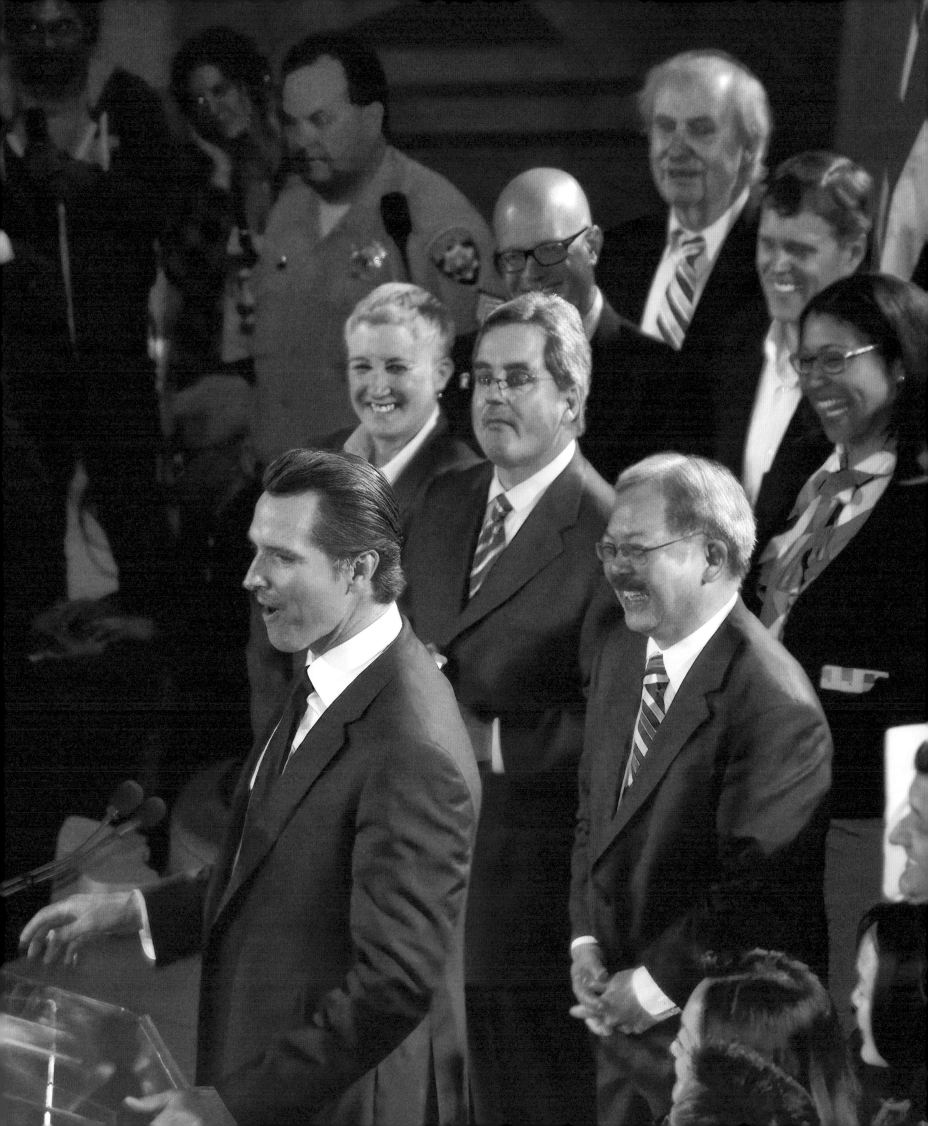

MICHAEL STARK AND MICHAEL LESHNER

Righteous activism powered by love led "The Michaels" to become the first married, gay couple in Canada.

Their love story began unassumingly, with dinner dates and movie nights. However, this was a time of extreme prejudice against the gay community. In February 1981, Toronto police raided gay bathhouses, arresting nearly three hundred men. This event galvanized "The Michaels," as they would come to be known, to fight for equal rights. Leshner, a Crown attorney, played a pivotal role in advancing gay rights through legal avenues. His landmark human rights case in 1992 extended benefits and pensions to same-sex partners of Ontario's civil servants.

The ultimate goal was marriage. In May 2001, Stark and Leshner joined other couples in a court challenge arguing that denying same-sex couples the right to marry violated equality rights under the Canadian Charter of Rights and Freedoms. Their passion and persistence paid off on June 10, 2003, when the Court of Appeal for Ontario recognized equal marriage rights for all. Prepared for a positive outcome, they giddily but quickly tied the knot at Toronto City Hall, becoming Canada's first legally married LGBTQ+ couple. Their wedding was a modest affair, but the significance was monumental, garnering global media attention.

In September 2001, Paula Barrero and Blanca Mejias managed to get married using an ancient Christian tradition, the banns, which didn't require specifying the spouse's gender. Other couples, including Kevin Bourassa and Joe Varnell, also married using the banns method, although their marriages weren't initially registered.

The 2003 ruling retroactively validated these marriages, demonstrating the evolution of the legal landscape.

The struggle for LGBTQ+ rights didn't end with their wedding. While most provinces followed Ontario's lead, some, like Alberta, were fiercely opposed, and others waited for federal legislation. Canada finally legalized equal marriage nationwide in July 2005, becoming the fourth country to do so.

Stark and Leshner remain deeply concerned about the current political climate, particularly in the United States, where numerous states are attacking gay rights.

The couple remains vigilant, knowing that rights can be easily stripped away. While they may not return to street protests, they are committed to supporting the fight for safety and equality. According to the Council on Foreign Relations, as of 2024, same-sex marriage is legally recognized in nearly forty countries. At the same time, around seventy countries still criminalize homosexuality, and in approximately eleven to twelve countries, consensual same-sex acts can result in the death penalty. "We obviously care a lot about these issues, and we're part of the fight," Stark said, emphasizing the need for continuous vigilance in protecting hard-won civil protections.

Michael Leshner and his husband, Michael Stark, flash their wedding rings after legally marrying, Toronto, June 10, 2003.

JOHN GEDDES LAWRENCE AND TYRON GARNER

A police lie went all the way to the US Supreme Court. Their successful case decriminalized being gay and opened up the right to marry in the courts as well as in the court of public opinion.

On the night of September 17, 1998, a false report of a man with a gun led sheriff's deputies to storm an apartment just outside Houston. Instead of finding a gun, they arrested John Lawrence and Tyron Garner for having sex. This arrest set off a chain of events that would ultimately lead to a landmark Supreme Court decision.

John Lawrence, born in 1943, was a retired Navy veteran and medical technologist living a quiet life in Houston. Tyron Garner, who was Black and born in 1967, was struggling with unemployment and had a criminal record. Despite being accused of engaging in sexual activity—as their story is often portrayed in the media—the men were not lovers, just acquaintances, caught up in a fabricated tale. Jealous of their flirting, Tyron's white boyfriend called the police and falsely claimed a "Black man was wielding a gun," knowing officers would bust in. It was a classic "Karen" case gone awry.

The 1998 arrest seemed insignificant, but it caught the attention of several closeted officers who alerted gay-rights activists, including Annise Parker, who would later become the first out mayor of Houston. She and others saw an opportunity to challenge the Texas sodomy law that criminalized intimate relations between people of the same gender. John and Tyron became the faces of the fight for privacy and personal dignity.

At the time, sodomy laws were still in effect in many states, used primarily to harass, shame, and stigmatize gay individuals. The 1986 Supreme Court case *Bowers v. Hardwick* had upheld such laws, ruling that the Constitution did not protect the right to engage in homosexual acts. However, the cultural climate was changing, with public support for gay rights and visibility both increasing.

Lambda Legal, a national gay-rights organization, took on their case, focusing on privacy and the right to intimate relationships rather than the specifics of the case. Paul Smith, a respected appellate litigator, argued that the Texas sodomy law violated the constitutional rights to privacy and equal protection and emphasized that same-sex relationships were fundamentally similar to heterosexual ones, deserving of the same dignity and respect.

On June 26, 2003, the Supreme Court ruled in a 6–3 decision that the Texas sodomy law was unconstitutional, thus overturning *Bowers v. Hardwick*.

The *Lawrence v. Texas* decision marked a turning point in the legal and cultural landscape for gay rights in the United States. It affirmed the right of individuals to engage in consensual intimate conduct without government intrusion. By decriminalizing gay relationships, it laid the legal and social groundwork for future advancements, leading to the legalization of marriage for all in 2015.

John Lawrence passed away in 2011, followed by Tyron Garner in 2015. Their lives were far from perfect, but their case changed the course of history.

Tyron Garner (left) and John Geddes Lawrence (right) on their way to address the press after their Supreme Court victory in the landmark *Lawrence v. Texas* case, Houston, 2003.

JULIE GOODRIDGE AND HILLARY GOODRIDGE

Hillary and Julie Goodridge, alongside six other couples, led Massachusetts to become the first US state to legalize marriage equality in the landmark case *Goodridge v. Department of Public Health* (2003). In doing so, they managed to tick off the Pope and the president.

In 2004, Hillary and Julie Goodridge married amid great fanfare and protests. In pastel suits, with broad smiles and colorful streamers, they exchanged vows and rings just hours after Massachusetts became the first state in America to allow same-sex marriage.

The Goodridges were the face of the movement. The lawsuit that made gay and lesbian marriages a reality bears their name: *Goodridge v. Department of Public Health*. Historians often divide the equal-marriage movement into "before Goodridge" and "after Goodridge." But less than five years later, they divorced. In winning the right to marry, they lost their own marriage.

Hillary, Julie, and their daughter, Annie Goodridge, speak candidly about their experience. "If you look at any interview that we've done, we've never talked about the trauma," says Julie Goodridge. "But I think that it's important to tell the full story."

Julie and Hillary Goodridge, accompanied by their daughter, Annie, register to marry at Boston City Hall as the named plaintiffs in the landmark case *Goodridge v. Department of Public Health*. The couple received the first same-sex marriage license in Boston on May 17, 2004.

Many years into their relationship but long before Hillary and Julie were involved in any court case, they were dreaming about having a child. Because they were a lesbian couple, marriage was forbidden. But they wanted to do something to mark that they were a family. So, they say, they dug through their family trees and picked a common last name: Goodridge. Julie remembers thinking, "Oh, that sounds positive; let's pick that!"

A few years later, their daughter made a dramatic appearance. She was rushed to the newborn intensive care unit, and Julie, her biological mother, was also in critical condition and receiving intensive care. But Hillary was stuck in the hospital's waiting room. With no legal relationship to either of them, she was unable to visit or help make medical decisions.

"It's not like that happened and we thought, 'We have to sue for marriage equality,'" remembers Hillary. But later, that was one of the memories that motivated them to find a way to formalize their relationship, she says. As the story goes, the immediate impetus was a simple question from three-year-old Annie: "If you love each other, then why aren't you married?" By the time Annie was five, they were the named plaintiffs in the lawsuit that would spur a decade of intense national debate.

As the lawsuit gained momentum and the question of same-sex marriage consumed the country, pressure mounted and resistance grew. Now, with the passage of time, Hillary and Julie Goodridge say the trauma they experienced during that time took a few different forms. Initially, Hillary says, they felt the pressure to be perfect. It was "the stress of feeling like I have the entire community resting on our being likeable,"

she says. Every TV outlet wanted shots of Hillary flipping pancakes, Julie ironing, and Annie eating breakfast. "We had to look like the girls who could be next door," says Hillary. "Not too threatening." No leather. No piercings. Just two moms and their curly-haired daughter. "It was a lot of stress for all of us, all the time," says Annie, now twenty-three. "When you have to be on all the time, it's hard to turn yourself off."

The Goodridge lawsuit became a call to arms for opponents of same-sex marriage, including then-President George W. Bush. In his 2004 State of the Union address, just a few months after the decision came down, he declared to thunderous applause: "Our nation must defend the sanctity of marriage."

"I remember watching that and thinking, 'Oh my gosh. He's talking about us,'" Hillary says. "It really got crazy very quickly." Across the country there were efforts to ban same-sex marriage. Forty-one states ultimately limited marriage to heterosexual couples.

In the middle of it all, Hillary got a voicemail from her mother that went something like this: "Hi, darling. Well, I see today you've managed to piss off the pope and the president. But when you get done with that, please give your mother a call." The pope and the president were pissed off, and soon Annie's playmates were, too. Elementary school classmates refused to come to her house; she was called homophobic slurs; and opponents sent around a flyer. "It went into our sex life and how we were harming our daughter," recalls Julie. "It was a mass mailing." And, Annie remembers, "It was sent to the house of every family that was at my school." Julie says about walking into Annie's school: "we felt a little bit like animals being looked at that were in cages in a zoo."

Hillary and Julie Goodridge celebrate their victory and wedding, cheered by crowds, Boston, Massachusetts, May 17, 2004.

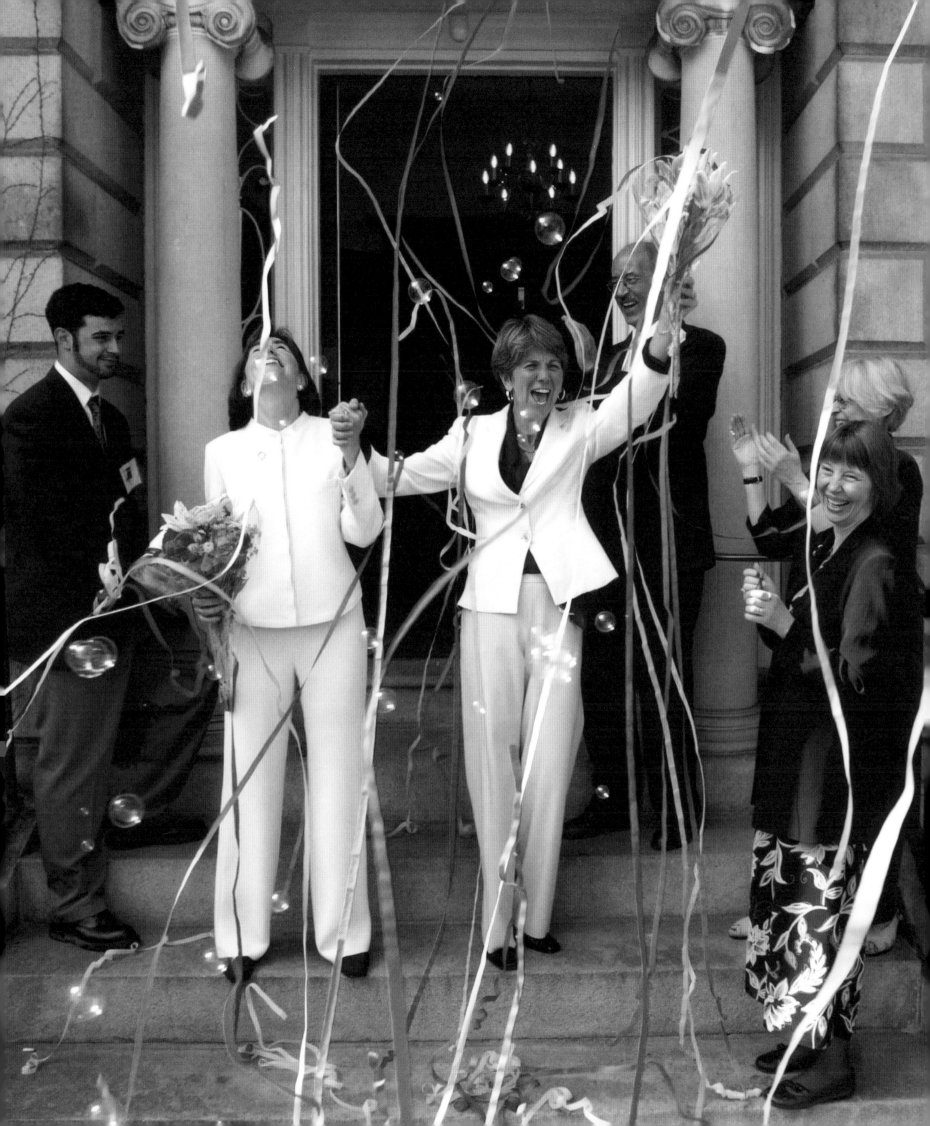

After spending all day in the public eye, often discussing their relationship, the last thing they wanted to do when they got home was discuss their relationship. "We kind of went our separate ways in the house," says Julie. Annie echoes that sentiment: "When you have to be so public about every tiny detail of your lives, it really exacerbates any minute divide between how you deal with stress and what you need to do at the end of the day."

Hillary and Julie say seeking couples counseling wasn't an option. "We couldn't do that. It felt like too much of a risk. It felt like the word would get out," remembers Julie.

Less than two years after getting married, Hillary and Julie had separated. A few years later, they were divorced. When news of their split was leaked to the media, it sent shock waves through the gay community.

Julie remembers receiving "an incredibly nasty email about how we were going to be destroying the gay community. It went on for several pages. And I just felt like saying, 'This is not what I chose. I'm doing the best I can.'" "I felt like our family let everyone down," says Annie, who was ten when her parents separated.

The Supreme Court has now guaranteed same-sex couples the right to marry nationwide. Public opinion has shifted dramatically in support of gay and lesbian marriages. And the Goodridges have been able to step out of the limelight.

The three of them still spend Christmas together. They exchange Mother's Day gifts. When their dog was alive—affectionately named Mary Bonauto after their lawyer in the case—they all helped care for her. And, in some fundamental ways, they still think of themselves as a family. "Would I ever consider changing my name? The answer is no," says Julie.

In Julie's office, there's a picture from a gay pride march. Somebody is holding a sign that reads, "Brown Roe and Goodridge." Their state lawsuit was printed alongside monumental Supreme Court decisions. "I just kind of love that," Julie says.

When asked if it was worth it, they are quick to say it was heart-wrenching personally but, they think, good for the country and the world. It was worth it, they decide, but they're not sure they would do it all again. Then, they tell a story: A few weeks ago, a waitress at a nearby restaurant showed them pictures of her wedding. Looking at the shots, they saw two smiling brides staring back. "I remember thinking, 'She has absolutely no idea who we are.' And that's what was kind of great," says Julie. "She was just showing us because she could and she felt comfortable enough to bring her pictures to her place of work."

"Every single time that I scrolled through them, I would cry a little bit because you would see they're so happy and you feel like you had a part in that," says Annie. After all, the Goodridges say, "It is nice to have their family name stamped on something that made so many gay couples happy."

144 Hillary and Julie Goodridge with Annie, Boston, 2019.

OTHER COUPLES WHO TOOK THE LEAP
AND TRANSFORMED MARRIAGE FOREVER

In the landmark case *Goodridge v. Department of Public Health*, seven courageous same-sex couples stood together, challenging the State of Massachusetts to recognize their right to marry. Their fight wasn't just for legal recognition—it was for the state and society to acknowledge their love, commitment, and families through marriage, an institution that symbolizes security, equality, and belonging. And they won.

Joining Hillary and Julie Goodridge along with David Wilson and Rob Compton were Gloria Bailey and Linda Davies, who had been together for over thirty years. As life partners and business partners, their lives were deeply intertwined, and they knew marriage was crucial for protecting their shared assets and ensuring their bond was respected by the law. For Gloria and Linda, marriage was about peace of mind—knowing that, in life's most critical moments, their commitment to one another would be honored. They had built a life together through hard work and dedication, and they wanted that life to be protected, especially as they neared retirement.

For Michael Horgan and Edward Balmelli, partners for over thirteen years, it was about joining the broader community of married couples and finally receiving the same social validation that came so naturally to others. Like all these couples, they yearned for the protection that marriage affords and for the acknowledgment that their love deserved a place among society's most cherished bonds.

Gary Chalmers and Richard Linnell, teachers from Worcester with an eight-year-old daughter, Maureen Brodoff and Ellen Wade, who had been together for over twenty years and were raising a daughter, and Heidi Norton and Gina Smith joined *Goodrich v. Dept. of Health.* They tired of navigating the complexities of family life without the full legal protections that marriage offered. For them, marriage meant protecting their children and knowing that, in the eyes of the law—and more importantly, as with the Goodridges, in the eyes of their children—their family would be treated as equal to any other. They were as good as anyone else.

When the Massachusetts Supreme Judicial Court ruled in their favor, civil marriage was redefined as a union that upholds a litany of meaningful truths. The court declared, "Civil marriage is at once a deeply personal commitment to another human being and a highly public celebration of the ideals of mutuality, companionship, intimacy, fidelity, and family. Because it fulfills yearnings for security, safe haven, and connection that express our common humanity, civil marriage is an esteemed institution, and the decision whether and whom to marry is among life's momentous acts of self-definition."

Since that momentous victory, countless couples have spoken these words with deep reverence at their weddings, honoring the moment these rights were granted, the brave couples who fought for them, and the fundamental right they secured for all.

Michael Horgan and Edward Balmelli embrace at the Massachusetts Supreme Judicial Court after the state became the first in the nation with equal marriage rights, November 18, 2003.

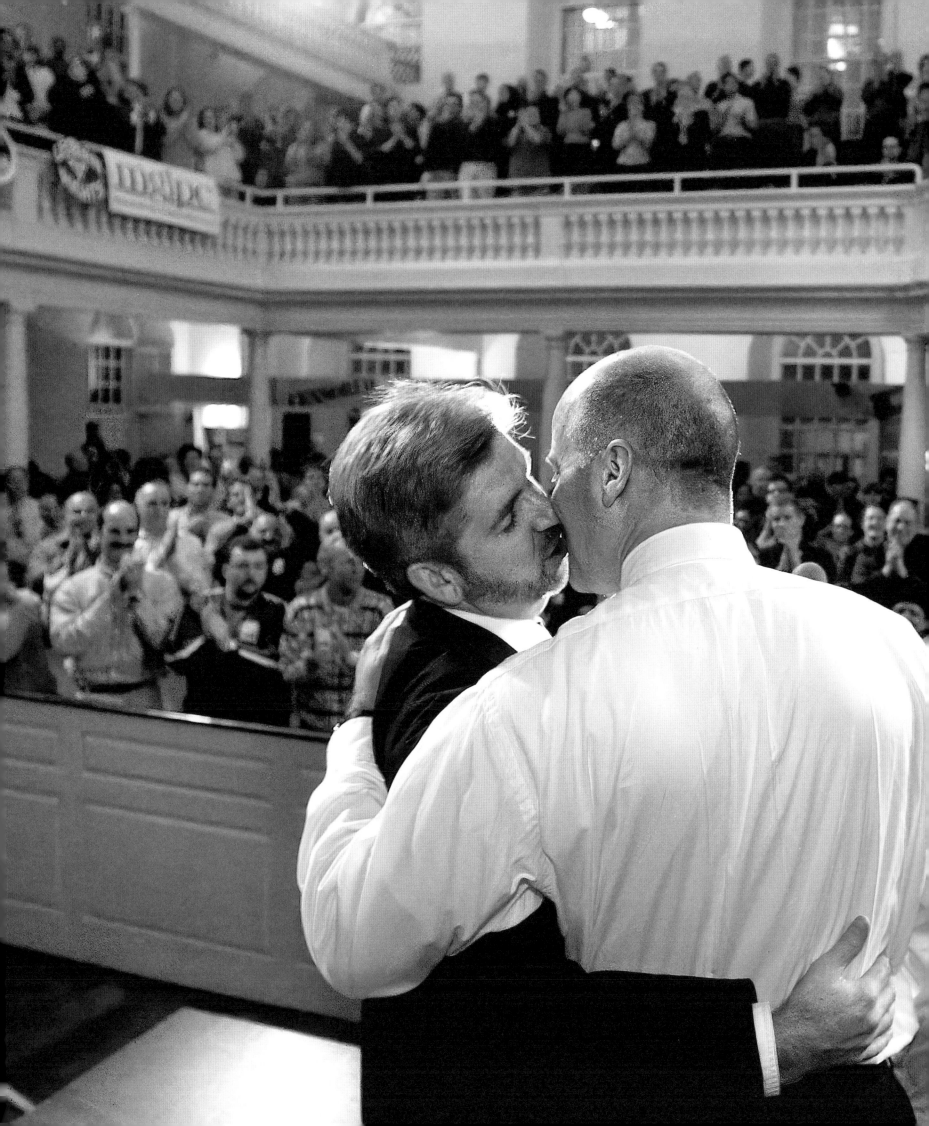

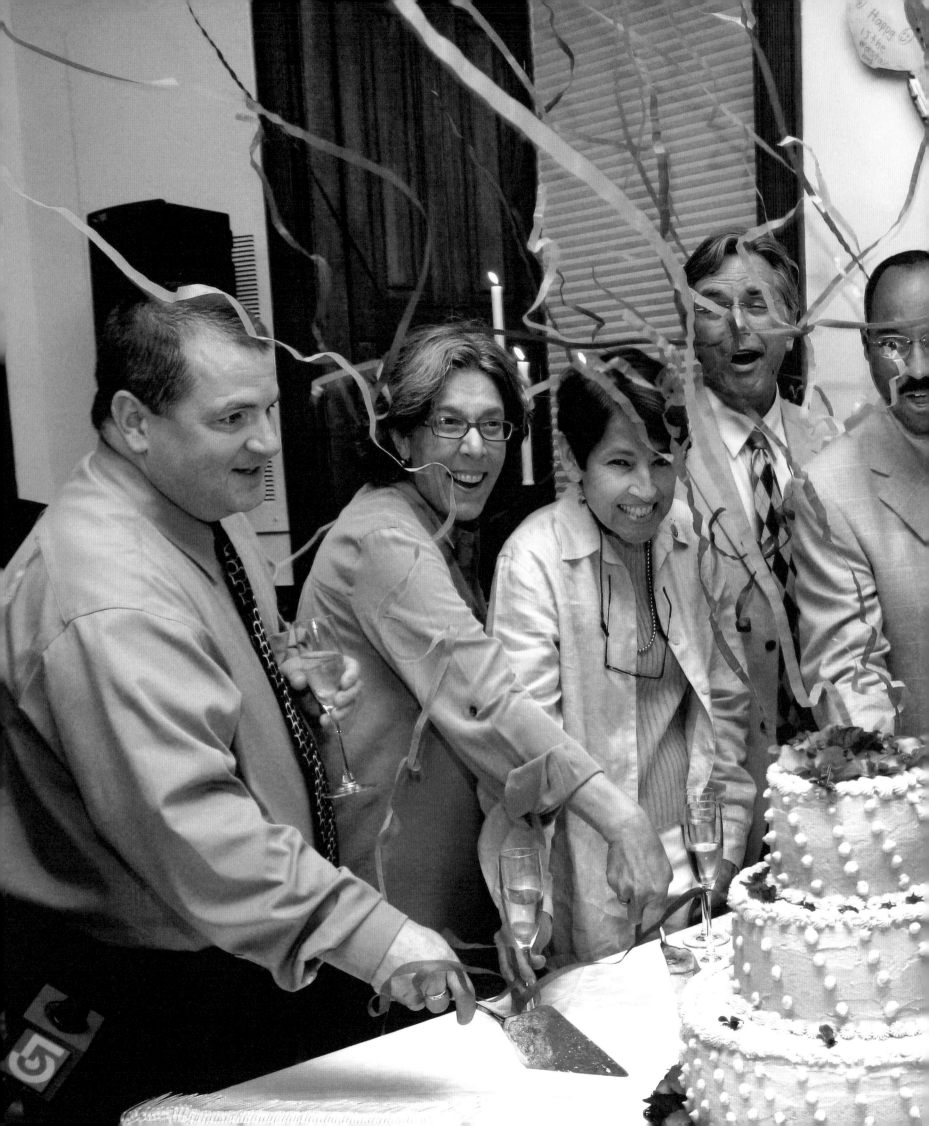

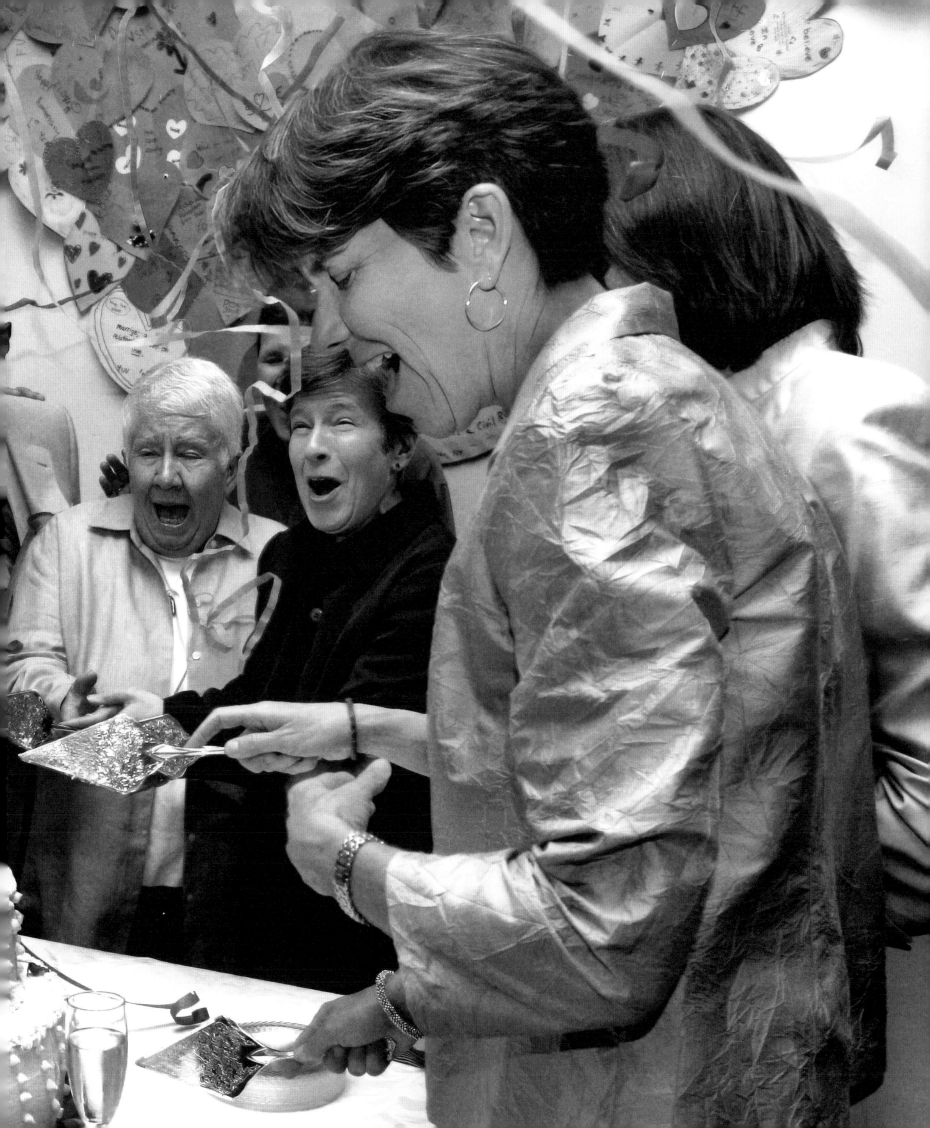

MARY BONAUTO

Attorney Evan Wolfson, founder and president of Freedom to Marry, describes her as a "giant" in the marriage rights movement, someone who, "more than any other person, shaped the legal assault on DOMA."

In November 2003, the Massachusetts Supreme Judicial Court made history by ruling that same-sex couples had the right to marry. *Goodridge v. Department of Public Health* was a landmark victory for marriage equality, led by Mary Bonauto, the civil rights project director for the Boston-based GLBTQ Legal Advocates & Defenders (GLAD). This ruling made Massachusetts the first state to see same-sex couples get married in the US.

Mary Bonauto's work in this case was just one of her many contributions to the fight for marriage equality. A year later, in June 2013, another significant victory was achieved when the US Supreme Court struck down Section 3 of the Defense of Marriage Act (DOMA), which had denied federal marriage benefits and privileges to married same-sex couples. Bonauto's efforts were instrumental in paving the way for this victory. In 2009 and 2010, she had challenged the constitutionality of Section 3 in two cases, securing the first district court and appellate court rulings against DOMA.

Bonauto's successes did not start or end with *Goodridge* and DOMA. In 1999, she and two co-counsels won a case in Vermont that resulted in the country's first civil union law, a significant step toward full marriage rights.

Same-sex couples now have the freedom to marry in all fifty US states, the District of Columbia, and the US territories, a monumental achievement solidified by the Supreme Court's landmark 2015 ruling in *Obergefell v. Hodges*. This victory was built on the tireless work of trailblazing advocates like Mary Bonauto, whose legal brilliance and unyielding dedication to equality paved the way. Bonauto was instrumental in shaping the arguments that helped dismantle discriminatory laws and ensured that love knows no boundaries. Her work, along with that of countless others, changed marriage equality from a dream to a reality for millions.

In 2013, Bonauto was one of three recipients of the first Stonewall Awards given by the American Bar Association Commission on Sexual Orientation and Gender Identity. The ABA honored her for her work on nearly every facet of the legal movement for equality for gay men, lesbians, bisexuals, and transgender individuals.

At a 2014 Hamilton College event in Washington, DC, organized by Spectrum, the college's LGBTQ+ alumni organization, Bonauto provided a comprehensive overview of marriage rights. Equipped with maps, numbers, and insights, she walked through the history, placing little

Previous spread: November 18, 2003: The Massachusetts Supreme Judicial Court ruled 4–3 in *Goodridge v. Department of Public Health* that denying marriage licenses to same-sex couples violated the state constitution. The seven plaintiff couples celebrated their victory at the GLAD office before addressing the press.

emphasis on her own role. Bonauto, a petite woman with a quiet voice and intense presence, focused on facts and praised the courage of her clients. She also acknowledged that opponents of marriage for same-sex couples have the right to their views, even though she believes they are wrong. "It's a free country," she said.

Bonauto's journey began in Newburgh, New York. She now lives in Maine with her spouse and twin daughters. She is married to Jennifer Wriggins, a professor at the University of Maine School of Law. Despite her formidable reputation as a lawyer and leader, Bonauto is known as a warm friend, a wonderful mother, and a beloved person.

At Hamilton, Bonauto majored in comparative literature and history, inspired by mentors like Nancy Rabinowitz, professor of comparative literature. Bonauto credits Rabinowitz and Hamilton for encouraging her intellectual exploration. Rabinowitz remembers Bonauto as an extraordinary student, dazzling in her ability to put things together and ask hard questions. Bonauto was also an activist, coordinating the Women's Center and graduating Phi Beta Kappa before earning a law degree from Northeastern University School of Law.

Bonauto began her career at GLAD in 1990. Early in her tenure, she received a call from a lesbian couple in western Massachusetts about marriage. Although she supported their cause, she felt the timing wasn't right yet to take on the marriage issue while people were still being fired just for being gay. Her approach was to build structures of equality brick by brick.

In 1997, she took on her first marriage case on behalf of a couple in Vermont, which led to the nation's first civil union law. By then, major developments had already taken place, including the Hawaii Supreme Court's 1993 decision that a state ban on same-sex marriage was unconstitutional, and then the 1996 passage of DOMA by Congress.

Bonauto and GLAD took on DOMA, winning historic lower-court victories in 2009 and 2010. Although her cases weren't chosen for the Supreme Court, the *Windsor* decision in 2013 struck down Section 3 of DOMA. *Windsor* counsel Roberta Kaplan acknowledged Bonauto's contributions, stating that "no gay person in this country would be married without Mary Bonauto." Former US Congressman Barney Frank called her "our Thurgood Marshall."

Bonauto's cumulative achievements have had a profound impact. While many highlight her marriage and DOMA work, she emphasizes the early efforts to address violence and job discrimination against gay people as equally important. These efforts helped solidify respect for gay people and same-sex families.

Bonauto looks forward to tackling other pressing issues such as job discrimination, bullying of LGBTQ+ youth, and homelessness among LGBTQ+ youth. Her passion for civil rights work remains unwavering.

DAVID WILSON AND ROBERT COMPTON

The denial of access to a hospital room led this pair to join Hillary and Julie Goodridge's fight to win marriage equality rights in Massachusetts.

In 1994, David Wilson came home from work to find his partner, Ron Loso, unconscious in their driveway. The EMTs who arrived called the police, suspicious of David because he was a Black man in a predominantly white neighborhood. At the hospital, David was denied information about Ron's condition because their relationship was not legally recognized. Instead, the hospital contacted Ron's elderly mother in Vermont, who authorized the release of information. Tragically, Ron had suffered a massive heart attack and died.

The devastating experience of being denied hospital visitation and the right to medical decision-making helped David realize the gravity of the legal inequalities between heterosexual couples and same-sex couples in the United States. At the time, no state recognized gay relationships. The issue had gained national attention in 1993 when three couples sued Hawaii for the right to marry. This legal battle lasted five years and ultimately led to Hawaii amending its constitution to define marriage as a union between a man and a woman.

After Ron's death, David joined the Gay Fathers of Greater Boston, where he met Rob Compton, a dentist who had lost his job after coming out as gay. They fell in love and held a commitment ceremony, which many mistook for a wedding. However, the lack of legal recognition meant that when Rob eventually fell seriously ill, David was denied access to him at the hospital. This recurring injustice led them to seek a more supportive environment in Shrewsbury, Massachusetts.

In 1999, Vermont became the first state to grant same-sex couples the benefits and protections of marriage through civil unions. In Massachusetts, David and Rob joined a legal challenge for marriage equality. Their case, *Goodridge v. Department of Public Health*, was filed in 2001. In 2003, the Massachusetts Supreme Judicial Court ruled in favor of same-sex marriage, making it the first state to do so. David and Rob were among the first same-sex couples to marry, on May 17, 2004.

The fight for marriage equality remained contentious, as exemplified by California's long battle. In 2004, San Francisco Mayor Gavin Newsom issued same-sex marriage certificates, which were later nullified. The California Supreme Court legalized same-sex marriage in 2008, but Proposition 8, a ballot initiative, subsequently amended the state constitution to ban it.

Reflecting on their role in the historic Massachusetts case, David recalled the support of his father, who initially had reservations. However, after a heartfelt discussion, his father encouraged him, seeing the fight for marriage equality as a broader struggle against discrimination. On their wedding day, David's father, who had faced lifelong discrimination, proudly celebrated their union, viewing it as a victory for all marginalized people.

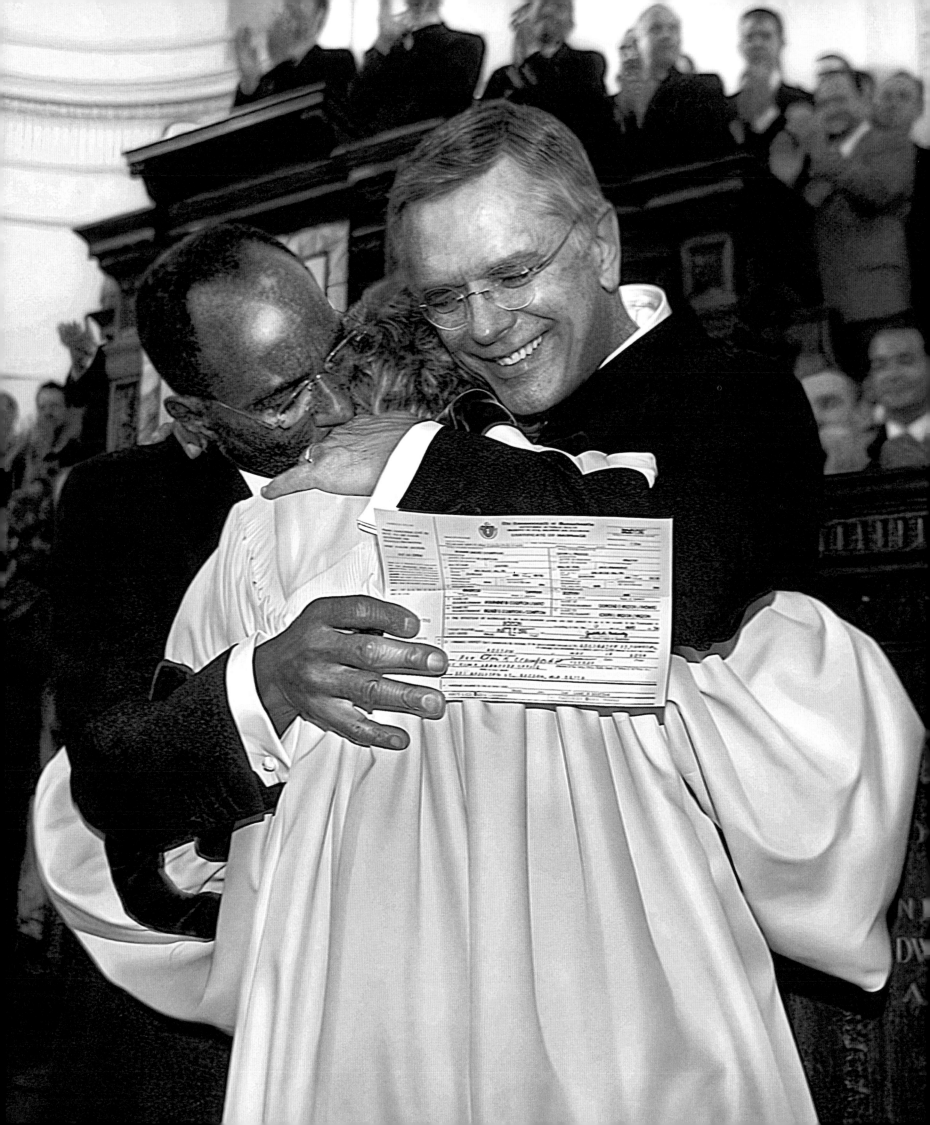

BREAKING BARRIERS

Mass marriages spread to states from Massachusetts to California thanks to brilliant strategists and brave couples.

Over eight thousand LGBTQ+ people from forty-six states and eight countries came to San Francisco to marry when the opportunity arose. Although the California Supreme Court eventually halted and invalidated the 2004 marriages, the experience ignited a new wave of activism. Couples were inspired to launch the Marriage Equality Express, a bus tour across the US affectionately known as "the caravan." The caravan aimed to connect people in communities across the country with LGBTQ+ couples, who shared real-life stories of how marriage discrimination impacted lives, and revealed their humanity.

The forty-four caravan riders included bi-national couples, veterans still serving under "Don't Ask, Don't Tell," parents of LGBTQ+ people, and ministers. Their first stop in Reno, Nevada, highlighted the absurdity of exclusionary marriage laws when a wedding chapel denied access for same-sex couples to marry—but agreed to marry them if the couples switched partners.

In Laramie, Wyoming, they commemorated Matthew Shepard and shared personal stories of surviving anti-LGBTQ+ violence. In Rawlins, Wyoming, a waitress quietly confided in one of the riders about her gay son, offering a reminder that LGBTQ+ presence exists even in the most unexpected places.

While some rallies had smaller turnouts, media coverage was extensive. The *San Francisco Chronicle* ran daily stories about the caravan, and the national rally in Washington, DC, broadcast on C-SPAN 2, brought the message of the human side of the fight for marriage equality to a wider audience.

Former US Army Sergeant Jacqueline Frank of Akron, Ohio; John Lewis and Stuart Gaffney of San Francisco; and Jeanne Fong and Jennifer Lin of Emeryville, California, are sworn in as "Love Warriors" during a rally at the US Capitol, October 11, 2004.

154

MORE STARS SHOW
SUPPORT FOR MARRIAGE

Weddings in California and Massachusetts set off
a political panic, prompting President George
W. Bush to call for a constitutional amendment
restricting marriage to one man and one woman.
Rosie O'Donnell responded with, "Hold my
champagne."

Soon after Mayor Gavin Newsom ordered marriage
licenses to be issued to LGBTQ+ couples, Rosie
O'Donnell flew in from Los Angeles and married
her longtime partner, Kelli Carpenter, in a
powerful display of support for civil rights. The
ceremony took place in San Francisco, where over
four thousand same-sex couples had exchanged
vows since February 12, 2004.

After the intimate ceremony in the mayor's office,
O'Donnell, holding a vibrant bouquet of purple
and yellow flowers in the city hall rotunda,
expressed her gratitude for the city's unwavering
commitment to equality. "I want to thank the city
of San Francisco for this amazing stance the mayor
has taken for all the people here, not just us but all
the thousands and thousands of loving, law-abiding
couples," she told the media.

O'Donnell's wedding came just days after President
Bush proposed a constitutional amendment to ban
same-sex marriage. Announcing her plans earlier
that morning on ABC's *Good Morning America*,
the former talk show host made it clear that her
union was not only a personal milestone but also
a public statement in the ongoing battle for
marriage equality.

Rosie O'Donnell and her then-partner, Kelli Carpenter,
walk down the steps of San Francisco City Hall after their
marriage, February 26, 2004.

TOM FORD AND RICHARD BUCKLEY

A glance that sealed a lifetime.

When Tom Ford and Richard Buckley met in 1986 at a fashion show, little did they know this meeting would change their lives. Ford, then a young, aspiring designer of twenty-five, was immediately captivated by Buckley, the confident and experienced fashion editor of *Women's Wear Daily*. Although Buckley was thirty-eight, the age difference meant little to Ford, who already knew in his heart that Buckley was "the one."

Their first encounter was charged with intensity, and Ford was unnerved by Buckley's deep, piercing stare. Overwhelmed by the connection, he fled after the show. But fate wasn't finished with them. Ten days later, Ford found himself at Buckley's office to retrieve clothes. Buckley, full of life and dancing around, flashed his eyes, and in that moment, Ford made a decision that would shape the rest of his life: he was going to marry Richard Buckley.

Within a month, they had moved in together, a testament to their instant and powerful connection. They remained by each other's side for thirty-five years, until Buckley's passing in 2021. Their relationship was marked by great joy but also deep sorrow as they navigated life's challenges together. Buckley was diagnosed with cancer in 1989, a battle he survived. They also endured the loss of many close friends to AIDS during the late 1980s and early 1990s, a devastating era for the LGBTQ+ community. Through these hardships, their love only deepened, becoming a source of strength for one another.

Publicly, they celebrated their love in ways both big and small. In 2008, just as marriage equality was being realized in Connecticut, Ford dedicated his book, *Tom Ford*, to Buckley and their beloved dog, John. Their love, however, existed in a time when the rights and legal protections afforded to heterosexual couples were denied to them. This was particularly painful during moments of crisis. When Buckley was hospitalized, Ford carried a folder of legal documents to ensure he would be granted the right to visit Buckley and make medical decisions on his behalf. Without these papers, Ford, like many same-sex partners, would have been treated as a stranger and locked out during the most critical moments.

Ford's 2009 film, *A Single Man*, poignantly explored the isolation and grief gay couples often endured when losing a long-time partner. Inspired in part by Ford's experiences, the film tells the story of a gay man grappling with the death of his partner in a world that refuses to acknowledge their love. It illuminated the unique struggles same-sex couples faced during periods of loss.

This lack of recognition was a painful reality that Ford spoke out against, calling the state of marriage inequality in the United States "disgusting." He pointed to the financial and emotional burdens same-sex couples faced due to unjust laws, including the inability to share healthcare benefits or file joint tax returns, and the constant need to fight for the right to care for their loved ones.

In the final years of their relationship, Tom and Richard were able to enjoy nearly a decade together as legally married husbands, thanks in part to the powerful voice they jointly added to the movement for equality.

American fashion designer Tom Ford embraces his longtime partner, Richard Buckley, after their marriage in the US at an undisclosed location in 2014.

FEDERAL MARRIAGE GRANTS 1,138 RIGHTS, PRIVILEGES, AND PROTECTIONS

FREEDOMS THEY WOULD NO LONGER BE DENIED

Joint & Family-Related Rights: Joint Filing of Bankruptcy Permitted; Joint Parenting Rights, Such as Access to Children's School Records; Family Visitation Rights for the Spouse and Non-Biological Children, Such as to Visit a Spouse in a Hospital or Prison; Next-of-Kin Status for Emergency Medical Decisions or Filing Wrongful Death Claims; Custodial Rights to Children, Shared Property, Child Support, and Alimony After Divorce; Domestic Violence Intervention; Right to Enter into Prenuptial Agreement; Right to Inheritance of Property; Preferential Hiring For Spouses of Veterans in Government Jobs; Tax-Free Transfer of Property Between Spouses (Including on Death); Special Consideration to Spouses of Citizens and Resident Aliens; Funeral and Bereavement Leave; Threats Against Spouses of Various Federal Employees is a Federal Crime; Right to Continue Living on Land Purchased from Spouse by National Park Service When Easement Granted to Spouse; Court Notice of Probate Proceedings; Domestic Violence Protection Orders; Existing Homestead Lease Continuation of Rights; Regulation of Condominium Sales to Owner-Occupants Exemption; Joint Adoption and Foster Care; Joint Tax Filing; Insurance Licenses, Coverage, Eligibility, and Benefits Organization of Mutual Benefits Society; Legal Status With Stepchildren; Making Spousal Medical Decisions; Spousal Non-Resident Tuition Deferential Waiver; Permission to Make Funeral Arrangements for a Deceased Spouse, Including Burial or Cremation; Right of Survivorship of Custodial Trust; Right to Change Surname Upon Marriage; Spousal Privilege in Court Cases (the Marital Confidences Privilege and The Spousal Testimonial Privilege); Continuation of Employer-Sponsored Health Benefits; $100,000 to Spouse of Any Public Safety Officer Killed in the Line of Duty; Renewal and Termination Rights to Spouse's Copyrights on Death of Spouse; Veteran's Medical and Home Care Benefits Housing Assistance; Housing Loans for Veterans; Eligibility for Federal Matching Campaign Funds; Changing Beneficiaries in a Retirement Plan or Waiving the Joint and Survivor Annuity Form of Retirement Benefit Requires Written Spousal Consent; Late Spouse's Benefits, Including: Social Security Pension; Veteran's Pensions, Indemnity Compensation for Service-Connected Deaths, Medical Care, and Nursing Home Care, Right to Burial in Veterans' Cemeteries, Educational Assistance, and Housing; Survivor Benefits for Federal Employees; Making, Revoking, and Objecting to Post-Mortem Anatomical Gifts; Additional Benefits to Spouses of Coal Miners Who Die of Black Lung; Inclusion in Social Security and Related Programs, Housing, and Food Stamps such as Medicare and State Health Care Programs; Recovery of SSI overpayments; Medicare + Choice Program Nutrition Services for Older Americans; Public Safety Officers' Death Benefits; Grants to Combat Violent Crimes Against Women; Energy Employees Occupational Illness Compensation Program; Family Violence Prevention and Services; National and Community Service; National Affordable Housing; Violent Crime Control and Law Enforcement; Intercountry Adoptions; Veterans' Benefits including Extended Care Services; Medical Care for Survivors and Dependents; Benefits for Children of Vietnam Veterans; Servicemembers' Group Life Insurance; Burial Benefits; Educational Assistance for Armed Forces, Employment and Reemployment Rights; Waiver of Recovery of Claims; Veterans Outreach Services; Taxation Benefits: Child Tax Credit; Hope and Lifetime Learning Credits; Medicare + Choice MSA; Interest on Education Loans; Roth IRAs; Qualified Tuition Programs; First-time Home-buyer Credit for DC; Estate Tax, Gift Tax and GST Exemptions; Relief from Joint Liability on Joint Return; Federal Civilian and Military Service Benefits: Relocation Expenses; Overseas Allowances; Long-term Care Insurance; Charitable Trusts for Armed Services; Health Care Coverage Demonstration; Survivor Benefit Plan; Military Child Care; Basic Allowance for Housing; Travel and Transportation Allowances; Family Separation Allowance; Access to Employment Benefits and Related Provisions: Workforce Investment Definitions; National Emergency Grants; Surface Owner Protection; Educational Assistance to Dependents of Law Enforcement Officers; Energy Employees Compensation Program; Immigration, Naturalization, and Aliens Support: Sponsor's Affidavit of Support; Removal Proceedings; Cancellation of

Thousands of couples lined up around San Francisco City Hall in the rain for a chance to marry. Newlyweds David Michael Barrett and Mark Peters were among the lucky ones on February 16, 2004.

DANIEL ANDREW GROSS AND STEVEN GOLDSTEIN

Love, self-worth, and persistence landed their wedding on the pages of the *New York Times*.

As the marriage equality movement moved into a new century, the desire to gain marital rights grew stronger. In 2001, Stefan Erik Oppers and Gary Penn asked the *New York Times* a pivotal question: "Would it print an announcement of their civil union on the society pages?" The *Times* declined. A year later, Daniel Andrew Gross and Steven Goldstein asked the same question. This time, the *Times* initially hesitated but eventually agreed.

Steven recalled the moment he found out, shortly before their commitment ceremony. "I started screaming: 'Daniel! Daniel! The *New York Times* has changed its policy! And we're going to be the first couple!'" This apparent sudden shift in policy was the culmination of decades of debate both within and outside the gay community.

Throughout the 1980s, the gay community was focused more on battling discrimination, antigay violence, and the AIDS epidemic than on the legal recognition of same-sex marriage. However, the AIDS crisis highlighted the deep commitment of queer couples, who cared for each other through sickness and death, and it exposed the harsh realities they faced—being denied hospital visits, insurance benefits, and inheritance rights.

During this time, as commitment ceremonies became more common, *The New York Observer* speculated, based on leaked memos, that the *Times*'s reluctance to acknowledge these unions in its society pages was a way to hide behind the argument that their announcements only recorded legal weddings.

The turning point came in 2001 when Oppers and Penn requested an announcement for their wedding in the Netherlands. Allan M. Siegal, the *Times* assistant managing editor, explained that the newspaper limited announcements to marriages legally recognized in the United States. However, a year later, Howell Raines, the executive editor, asked Siegal to lead a committee to devise a new policy. Siegal noted, "We wanted to treat same-sex unions, in print, the same way we treated lawful marriages, but without implying that the unions were marriages."

The new policy was implemented in September 2002, aligning with Gross and Goldstein's plans to celebrate their civil union in Vermont on September 1. Following this, on August 24, 2003, the *Times* published a wedding announcement for Peter Freiberg and Joe Tom Easley, married in Toronto, and on February 22, 2004, for Dr. Helen Sperry Cooksey and Dr. Susan Margaret Love, married in San Francisco.

Despite these milestones, not all the couples featured in the *Times*'s wedding pages lived happily ever after (like all marriages, some of these relationships ended in divorce). Gross and Goldstein's relationship ended in 2015 after twenty-three years together. And they were able to utilize the protections provided within now legal unions, making the process of separating less stressful. Nevertheless, Goldstein remains proud of their historic announcement, believing it played a significant role in advancing marriage equality. He proudly told the *Times* in 2017, "Nothing helped the cause of marriage equality more than the stories of same-sex couples falling in love and having the same joys and challenges as any other couple."

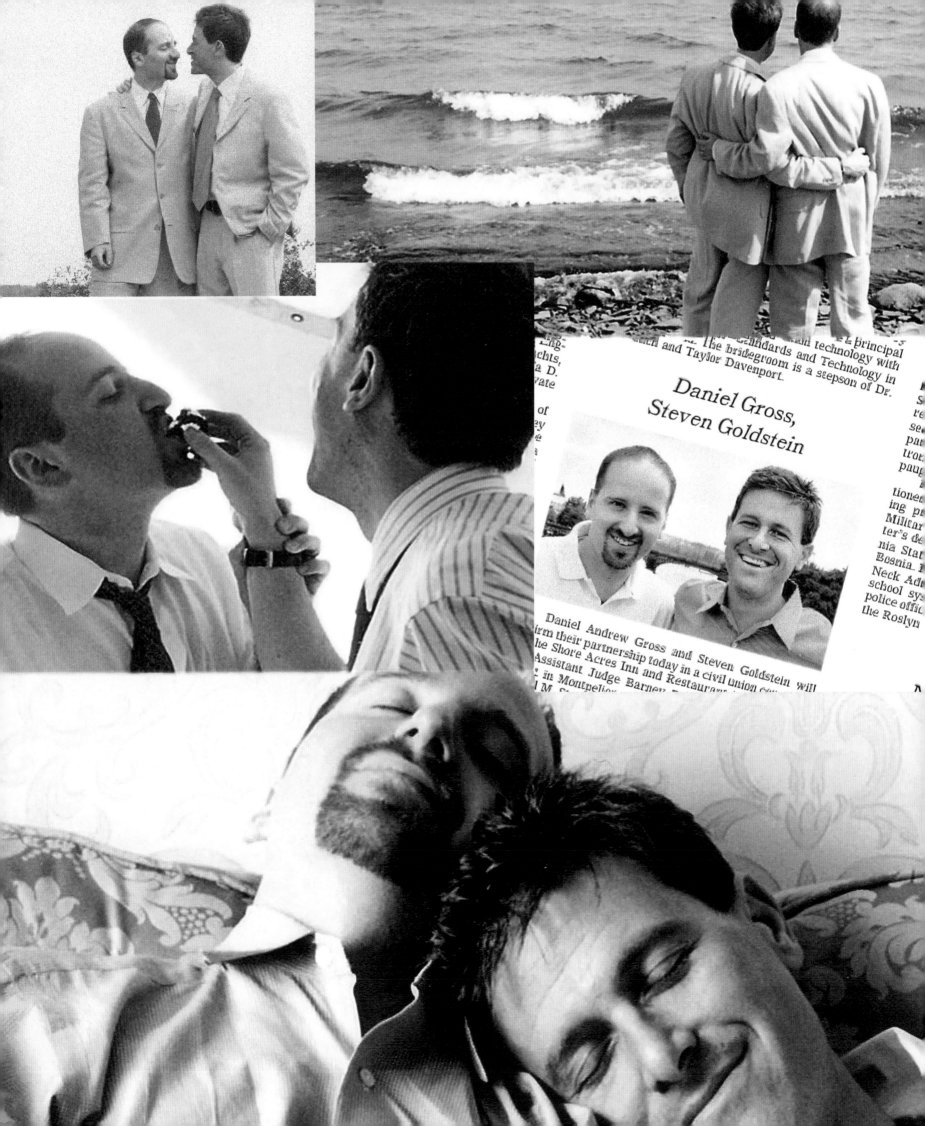

ACCORDING TO GOD'S HOLY ORDINANCE

2005–2008

CHAPTER 5 — INTRODUCTION

As the dust settled from the historic ruling in Massachusetts that legalized same-sex marriage, a palpable tension muted the celebratory feeling in the air. The ruling sparked a backlash across the nation, culminating in constitutional amendments in eleven states that banned same-sex marriage. Many advocates for LGBTQ+ rights, including those at GLBTQ Legal Advocates & Defenders (GLAD), experienced unsettling anxiety during their celebrations; they were torn between joy and fear, concerned they might have opened a Pandora's box and set back the movement's progress.

In the wake of the Massachusetts ruling, critics pointed to the state as the culprit behind John Kerry's unsuccessful bid for the presidency in 2004. The claim that "gay marriage" played a detrimental role in the campaign was widespread, despite little evidence to substantiate it. Kerry, a Democrat from Massachusetts, found himself in a precarious position. The specter of LGBTQ+ rights loomed large in the political arena, making marriage equality a divisive issue among voters. As an increasing number of states responded with bans on same-sex marriage, the landscape for LGBTQ+ rights became increasingly precarious.

Under Mary Bonauto's leadership, GLAD remained undeterred, filing a lawsuit in Connecticut in August 2004 to challenge the state's refusal to recognize same-sex marriages. Their efforts reflected a determination to continue the fight for equality amid a growing chorus of disapproval. However, as various states rejected marriage equality, a sense of foreboding crept into the hearts of many advocates.

In 2005, significant developments emerged that underscored the conflicting emotions surrounding the marriage equality movement. On February 4, a New York State judge ruled that the state's ban on same-sex marriage was illegal, a beacon of hope amid a disheartening landscape. However, this victory was quickly overshadowed by other events. On February 23, Pope Benedict XVI publicly condemned same-sex marriage, labeling it "evil." His remarks reflected the mounting religious opposition that sought to undermine the progress being made across various states.

Despite this opposition, flashes of optimism emerged on the horizon. In June 2005, Spain legalized the freedom to marry, becoming the third country to do so after the Netherlands and Belgium. This international development sparked renewed hope for LGBTQ+ advocates in the US that change was possible. However, the political climate was rapidly shifting against them. On April 5, Kansas voters approved a state constitutional amendment defining marriage as the union of one man and one woman, and on April 14, Oregon's highest court ruled that the three thousand same-sex marriages performed in the state in March and April 2004 had never been valid.

Page 165: Clergy of many faiths march to protest the lack of marriage rights for LGBTQ+ couples, San Francisco, California, 2009. **Opposite:** Reverend Roland Stringfellow gives the invocation at the Love and Marriage Rally in Sacramento, California, in February, 2009.

These events laid the groundwork for a series of legislative challenges. On April 20, Connecticut Governor Jodi Rell signed a civil unions bill into law after the state senate passed it 26 to 8. However, many LGBTQ+ advocates believed that civil unions were insufficient, arguing that "separate" was not "equal."

On July 4, during the 25th General Synod of the United Church of Christ, delegates voted to adopt the resolution "Equal Marriage Rights for All," affirming that homosexuality was compatible with Christian living. This marked a significant moment, as the United Church of Christ became the first major mainstream Christian denomination to endorse same-sex marriage, signaling a shift in religious attitudes toward LGBTQ+ rights.

Despite this positive development, the pressure against marriage equality continued to grow. California Governor Arnold Schwarzenegger vetoed legislation establishing same-sex marriage for the second time on September 29, 2005. Meanwhile, voters in Texas approved a state constitutional amendment defining marriage as the union of one man and one woman, further entrenching opposition across the country.

As 2006 unfolded, the atmosphere grew even more tense. The New York Court of Appeals decided in *Hernández v. Robles* that LGBTQ+ couples did not have the right to marry under the New York Constitution. This ruling exemplified the challenges that LGBTQ+ advocates faced as they navigated a patchwork of state laws that varied dramatically from one region to another.

In response, more celebrities, like Lance Bass, came out. A member of the iconic boy band NSYNC, Bass made headlines when he proclaimed, "Yes, I am," on the cover of *People* magazine in July 2006. Reflecting on his decision, Bass shared that he was initially afraid to come out, largely due to witnessing the backlash faced by figures like Ellen DeGeneres. However, the support he received from icons like Elton John, who welcomed him into the LGBTQ+ community with a heartfelt gift basket, inspired him to embrace his truth.

As the fight for marriage equality continued, the political landscape began to shift again. In October 2006, the New Jersey Supreme Court delivered a landmark unanimous decision in *Lewis v. Harris*, declaring that the exclusion of same-sex couples from marriage infringed upon the state constitution's guarantee of equal protection. The court instructed the state legislature to amend the marriage laws or establish civil unions within six months, marking a growing recognition of the need for equality amid increasing resistance.

The tension between progress and opposition became even more pronounced in 2007. Barack Obama, then a candidate for president, publicly supported civil unions while expressing his belief that marriage should be defined as a union between a man and a woman. His statements reflected a broader societal struggle to reconcile deeply held beliefs about marriage with the desire for equality.

In the summer of 2007, the political winds shifted again as various states began to consider measures to recognize same-sex relationships. In April 2007, Washington Governor Chris Gregoire signed a domestic partnerships bill into law, and on May 9, Oregon followed suit. These incremental victories represented small but significant steps forward, reinforcing the belief that change was possible, even in the face of overwhelming opposition.

As the clock ticked toward 2008, LGBTQ+ advocates remained vigilant and hopeful. The California Supreme Court's historic ruling on May 15, 2008, which overturned the state's ban on marriage equality, sparked widespread celebrations and infused the LGBTQ+ community with renewed hope. This groundbreaking decision permitted same-sex couples to marry, with county clerks starting to issue marriage licenses on June 17. For countless individuals, this moment served as a powerful affirmation after years of relentless struggle and sacrifice.

Yet, the joy was tempered by the harsh reality of political maneuvering. On August 1, 2008, President Obama publicly defined marriage as a union between a man and a woman during an interview with Rick Warren, a prominent evangelical leader. Although he maintained his support for civil unions, his remarks drew sharp criticism from LGBTQ+ advocates who felt betrayed by his stance. The irony was not lost on many, as Obama had also voiced support for the repeal of the Defense of Marriage Act (DOMA) earlier in his campaign.

As the summer progressed, the political landscape shifted dramatically. On November 4, 2008, voters in California, Florida, and Arizona approved state constitutional amendments defining marriage as a union between one man and one woman. Proposition 8 in California, which overturned the recently secured rights for same-sex couples, marked a gut-wrenching setback. Many advocates who had fought tirelessly for equality felt a profound sense of loss as they witnessed their hard-won rights stripped away overnight.

Spain's parliament, the Cortes Generales, legalizes marriage equality on June 30, 2005. The law passes by a vote of 187–147. In defiance of Roman Catholic conservatives and clergy, when the law is enacted on July 3, 2005, Spain becomes the third country to officially recognize same-gender unions.

CALIFORNIA COUPLES SAY "I DO" AGAIN

Together, they challenged the constitutionality of state laws that discriminated against same-sex couples in marriage.

In 2008, marriage equality in California took a go at the altar, echoing the triumphs and trials of the past. This renewed hope for marriage equality came after a tumultuous time that began in 2004 when San Francisco Mayor Gavin Newsom took a bold stand by issuing marriage licenses to same-sex couples. Thousands took the leap to say, "I do," but their joy was short-lived. The California Supreme Court intervened, ruling that the city had acted unlawfully, and the floodgates of marriage were abruptly closed once more.

The closure left a bitter taste for many, especially as the courts shut down the marriage licenses on the grounds of legality, forcing couples back into the shadows. This action ignited a fire within the LGBTQ+ community and prompted over a dozen couples to step forward, determined to reclaim their rights. The case that emerged from this activism was 2008's *In re Marriage Cases*, which consolidated the voices of those yearning for equality.

The plaintiffs, a diverse group of fifteen same-sex couples, argued that California's marriage laws violated the state constitution's guarantees of equal protection, privacy, and due process. They asserted that denying them the right to marry was not only discriminatory but also an affront to their dignity and humanity. As these couples fought valiantly for their rights, the California Supreme Court listened, ultimately ruling on May 15, 2008, that same-sex couples are entitled to the same fundamental right to marry as their heterosexual counterparts.

The decision sent waves of joy across the state. In a matter of weeks, couples were once again preparing for their weddings. Over eighteen thousand couples rushed to the altar, eager to finally celebrate their love legally. High-profile couples such as Ellen DeGeneres and Portia de Rossi, Wanda and Alex Sykes, George and Brad Takei, and activists Robin Tyler and Diane Olson made headlines as they celebrated their unions.

Yet, the victory was bittersweet. Just as the joy of marriage reignited, so too did the efforts of anti-LGBTQ+ forces. In response to the Supreme Court's ruling, opponents of same-sex marriage swiftly organized to place a voter initiative on the November ballot, Proposition 8, aiming to strip away the recently granted marriage rights.

In re Marriage Cases marked a historic moment in California's journey toward equality. The ruling was rooted in the understanding that marriage is a fundamental civil right, protected by the California Constitution. Chief Justice Ronald George's poignant reminder that "the right to marry is not simply a benefit or privilege" resonated deeply within the community and beyond, affirming that love should never be limited by the confines of gender. The Supreme Court's decision was not just a legal victory; it symbolized a shift in societal attitudes toward LGBTQ+ rights.

As couples stood together in lines stretching around city halls, there was a palpable sense of community and solidarity. The return to marriage brought hope and healing after years of struggle, proving that love could prevail, even in the face of adversity. California's journey for marriage equality was far from over, but the wave of weddings in 2008 brought much joy and activism to keep these marriages going into November.

Paul Hill and Brad Akin, Jon Carr and Sergio Suhet, and a third unidentified couple listen to pro-marriage equality speakers at a rally aimed at informing attendees about how to fight back against Proposition 8.

JOHN LEWIS AND STUART GAFFNEY

When Stuart was six, his mom and dad, from different backgrounds, were also not allowed to marry. So John and Stuart set out on a journey to make sure they could.

Most weddings require unending planning: choosing a venue, sending out invites, and hiring a DJ, among many tasks. Even elopement calls for a bit of logistical preparation. But seldom do you hear about a significant other telling their partner to cancel an impending business lunch so that they might get married within the next hour.

Interwoven in John Lewis and Stuart Gaffney's love story is their lifelong commitment to social justice and political activism. Their journey from childhood to becoming prominent figures in the marriage equality movement is a testament to their dedication to making the world more equal for all.

"From an early age, we both felt highly motivated to try to help make the world a better place through social and political advocacy and activism," John recalled. Both John and Stuart grew up in the 1960s and 1970s, influenced by their parents, who were university professors deeply interested in and affected by political and social issues.

John's father, despite growing up in small-town southern Illinois, wrote to his parents during World War II to express his disgust at the racism and anti-Semitism he witnessed, as well as the internment of Japanese Americans. "He thought the war was supposed to be about fighting racism, yet Americans were perpetuating racism themselves," John explained. This perspective, rooted in his family's values of kindness and inclusivity, shaped John's worldview.

Stuart's parents were also progressive educators. They had also had difficulty getting married, due to legal and social barriers against interracial marriage. His Chinese American mother could only marry his English and Irish American father because of the landmark 1948 California Supreme Court decision in *Perez v. Sharp*, making the state's ban on interracial marriage void and their marriage no longer a crime.

Even after their marriage, they encountered discriminatory laws in other states, such as Missouri, which prohibited marriages between whites and Asians. Richard and Mildred Loving changed all of that when they fought to be together and won in the 1967 US Supreme Court case *Loving v. Virginia*, which overturned all such laws nationwide in a landmark ruling, in which the court declared marriage as one of the "basic rights of man." Finally, Stuart's parents had the legal protections provided by the federal government.

Stuart's father, eulogized by the *New York Times* for his progressive advocacy, participated in the lunch-counter protests against racial segregation in Columbia, Missouri. Stuart's mother, a professor, was deeply committed to multiculturalism and diversity. "She attended the 1951 signing of the Treaty of San Francisco, which formally ended World War II in the Pacific," Stuart noted, highlighting her dedication to global peace and justice.

Thus, their backgrounds make John and Stuart's first meeting inevitable. It was at a house party for Harry Britt, Harvey Milk's successor on the San Francisco Board of Supervisors, in 1987. "After that, our first date was to the candidate's debate— you know it's true love when you both want to go to the candidate's debate!" Stuart joked. "And our first real date was to a Chinese herbalist restaurant that only served medicinal Chinese foods, so the beginning was a bit unorthodox.

"After I met John, a friend of mine from college visiting San Francisco asked me, 'Are you seeing anybody?' And I said, 'I think I've met my future husband,' and that was after only one week."

They eventually moved in together, and sixteen years after they met, John had an awakening moment: "I remember this distinctly. It was April 14, 2003, at seven-thirty p.m., and we were doing our taxes at the kitchen table. I got to the box where it asks if you are married or single. And I thought, I have to take my hand with a pen and mark that box single. I have to lie as an educated person, and lie about our love, our family together for sixteen years. That's when I fully realized how important the right to marry was."

Given their passion for politics, as soon as they came out, getting involved politically in the LGBTQ+ and AIDS movements was an obvious choice. Further, they lost many close friends to HIV/AIDS, which fueled their activism.

Their involvement in the marriage equality movement progressed over time. "We followed the Hawaii marriage equality litigation in the early 1990s and were inspired by its initial success," John explained. Then the Defense of Marriage Act, which limited the definition of marriage to one man and one woman, plus the support it garnered from supposed LGBTQ+ allies, and its signing in 1996 by President Bill Clinton galvanized their commitment to fighting marriage discrimination.

When the US Supreme Court overturned *Bowers v. Hardwick* in 2003, it felt like a significant victory. "We decided we wanted to get actively engaged in the burgeoning movement for marriage equality," Stuart says. They made a New Year's resolution in 2003 to bring a lawsuit against California for the right to marry.

Their activism led John to attend a rally on the steps of San Francisco City Hall on February 12, 2004, which was their first foray into the fight for marriage equality. "Stuart had a lunch meeting so he couldn't go to the rally. And I got there, and I went up to the Marriage Equality USA organizer Molly McKay and I said, 'What's the plan? When's the rally? She said, 'You can get married right now.' And I was like, what? *What?* I could not believe it."

Unbeknownst to John, that morning, San Francisco mayor Gavin Newsom had instructed city officials to begin issuing marriage licenses to same-sex couples. "I knew I had to call Stuart right away, but I didn't have a cellphone, so fortunately someone let me borrow theirs."

Stuart picked up the story. "I was at my desk and had a lunch meeting. And I don't know if it's possible for a phone's ring to be more urgent than usual, but somehow, as I was getting ready to go, I went back and answered the phone," Stuart marveled. "It was John, and in a panicked voice he essentially asked me to marry him. I always thought that it might be more special, perhaps flowers being involved."

By chance, a reporter from the *San Francisco Chronicle* was in the crowd, and she tapped John on the shoulder. "She said, 'Can I follow you through this?' I said, 'Sure,' and she wrote about us, and we were on the front page of the *Chronicle* the next day.

"John and I both understood that this right to marry could be temporary, and be shut down the

next day, or within the next hour. That's why we had to rush, and we got married less than an hour after John's call."

John and Stuart were right. In August, the California Supreme Court took away same-sex marriage licenses in *Lockyer v. City and County of San Francisco,* and as a result, they joined the ongoing litigation for the right to marry.

Their unexpected marriage at San Francisco City Hall was more than a personal milestone. "When we got married on that amazing day in February 2004, which went on to be called 'The Winter of Love,' we felt for the first time in our lives that our government was treating us as equal human beings," John says. It would take another ten years before their marriage would be ruled legal by the Supreme Court.

"Unlike many movements for social justice, Stuart and I experienced from the first moment of our getting involved what the end point was going to taste like," added John.

"From that moment on, we understood that marriage equality is about ending the practical harms of marriage discrimination and about our human dignity as LGBTQ+ people," Stuart emphasized. "At heart, it gives us great pleasure and a sense of fulfillment to be a small part of making the world a better place for all of us."

They eventually got remarried but they often reflect on that hurried day. "We, of course, had no guests, or reception, or anything else. In fact, Stuart went back to work once we tied the knot," John pointed out:

> We only have a picture of that day because a friend was there with another couple, and he said, "Oh, do you want me to snap a photo?"
>
> But there was this feeling of romance, that what we were doing was just right, and for a very brief time, in an otherwise chaotic day, the rest of the world melted away.

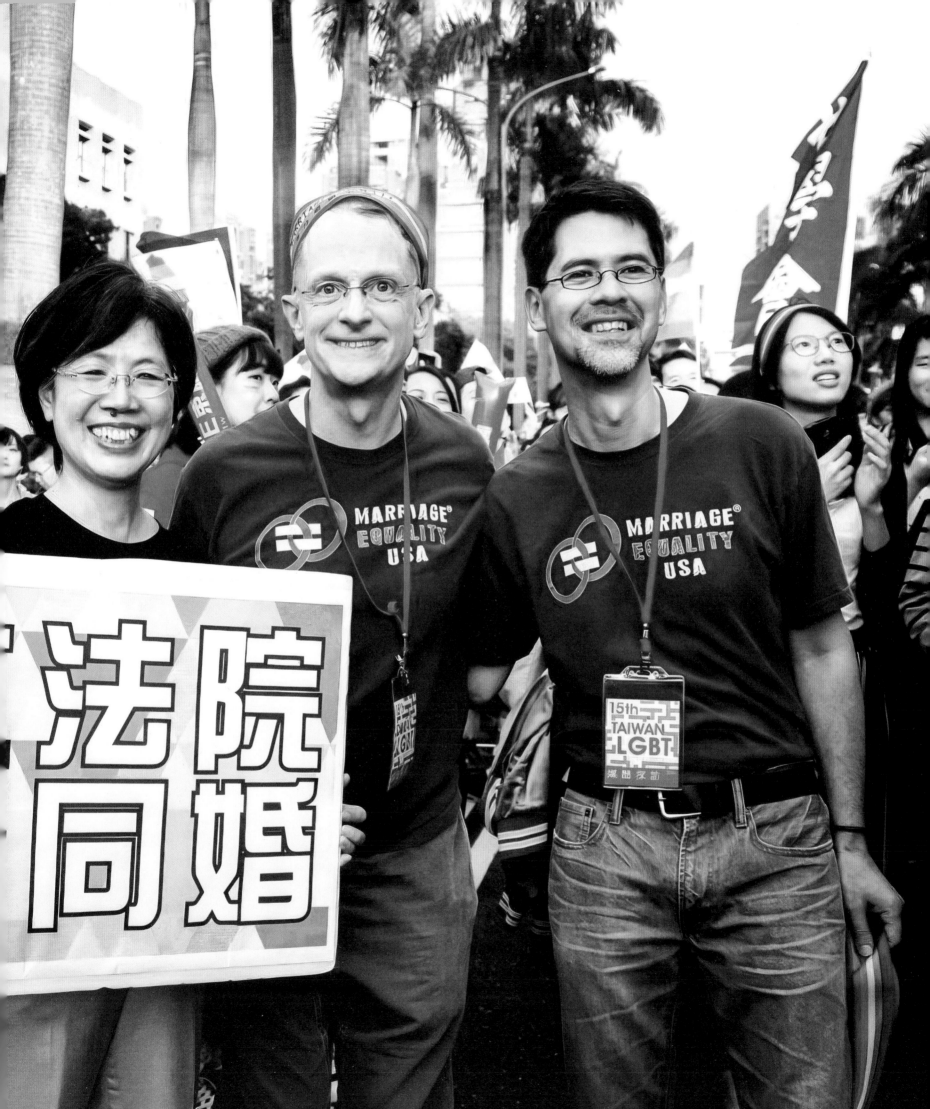

BETH KERRIGAN AND JODY MOCK

A rose by any other name does not smell as sweet.

And the Connecticut Supreme Court agreed. Beth Kerrigan and Jody Mock, a couple from West Hartford, Connecticut, had built a family over the past decade, raising their twin sons, Fernando and Carlos, whom they adopted from Guatemala. For Beth and Jody, the desire to marry was a profound yearning for recognition and protection for their family. But they made it clear: words matter.

Their understanding of the vulnerabilities that came from not being allowed to marry surfaced on a trip when traveling with their twins. Border officials took in the sight of the family and raised concerns about potential kidnapping simply because the twins' birth certificate did not list a mother. This experience led Beth and Jody to seek legal recognition through marriage, a fundamental right they believed should be accessible to all adults.

In 2004, after being denied marriage licenses, they joined seven other couples to challenge Connecticut's ban on equal marriage in a case, *Kerrigan v. Commissioner of Public Health.* Supported by GLBTQ Legal Advocates & Defenders (GLAD), their fight led them to the New Haven Superior Court in 2006. By that time, the civil unions statute had been implemented to grant same-sex couples all the legal benefits and responsibilities of marriage. However, in so doing, the statute also defined marriage as the union of a man and a woman, creating a distinct separation between a civil union and a marriage—the first time that Connecticut had done so.

The plaintiffs filed an amendment complaint focusing on this distinction, arguing that civil unions were not equivalent to marriage. But their initial attempt ended in disappointment, with Judge Patty Jenkins Pittman ruling against them. She described the establishment of civil unions as "courageous and historic," finding no meaningful difference between marriages and civil unions except for the provision of federal benefits, which she deemed irrelevant to the state's authority. Judge Pittman acknowledged that the plaintiffs might feel relegated to a second-class status but asserted that there was nothing in the law to support that claim.

The case moved to the Connecticut Supreme Court, where their hopes rested on the arguments of GLAD attorney Bennett Klein. The state's attorney, Jane R. Rosenberg, argued, "We're not talking about granting rights and benefits; we're talking about a word." Klein countered, asserting that civil unions were "a less prestigious, less advantageous institution."

On October 10, 2008, the Connecticut Supreme Court agreed: separate is not equal. In a 4–3 ruling, the court found that denying LGBTQ+ couples the right to marry while providing them with an equivalent status under a different designation, such as civil unions, infringed upon the equality and liberty provisions of the Connecticut Constitution. Justice Palmer, delivering the majority opinion, issued a compelling statement: "While both marriage and civil unions provide the same legal rights within our legal framework, they are fundamentally unequal. Marriage represents an institution of profound historical, cultural, and social importance, whereas civil unions do not hold the same significance." He further emphasized, "Ultimately, the civil unions law conveys that what same-sex couples possess is neither as valuable nor as meaningful as true marriage."

Beth and Jody celebrated their hard-won victory. They married and became a legally recognized family, with all the rights, privileges, protections, and dignity that came with the word "marriage."

Beth Kerrigan and Jody Mock toast their fifteenth wedding anniversary with friends and family, 2009.

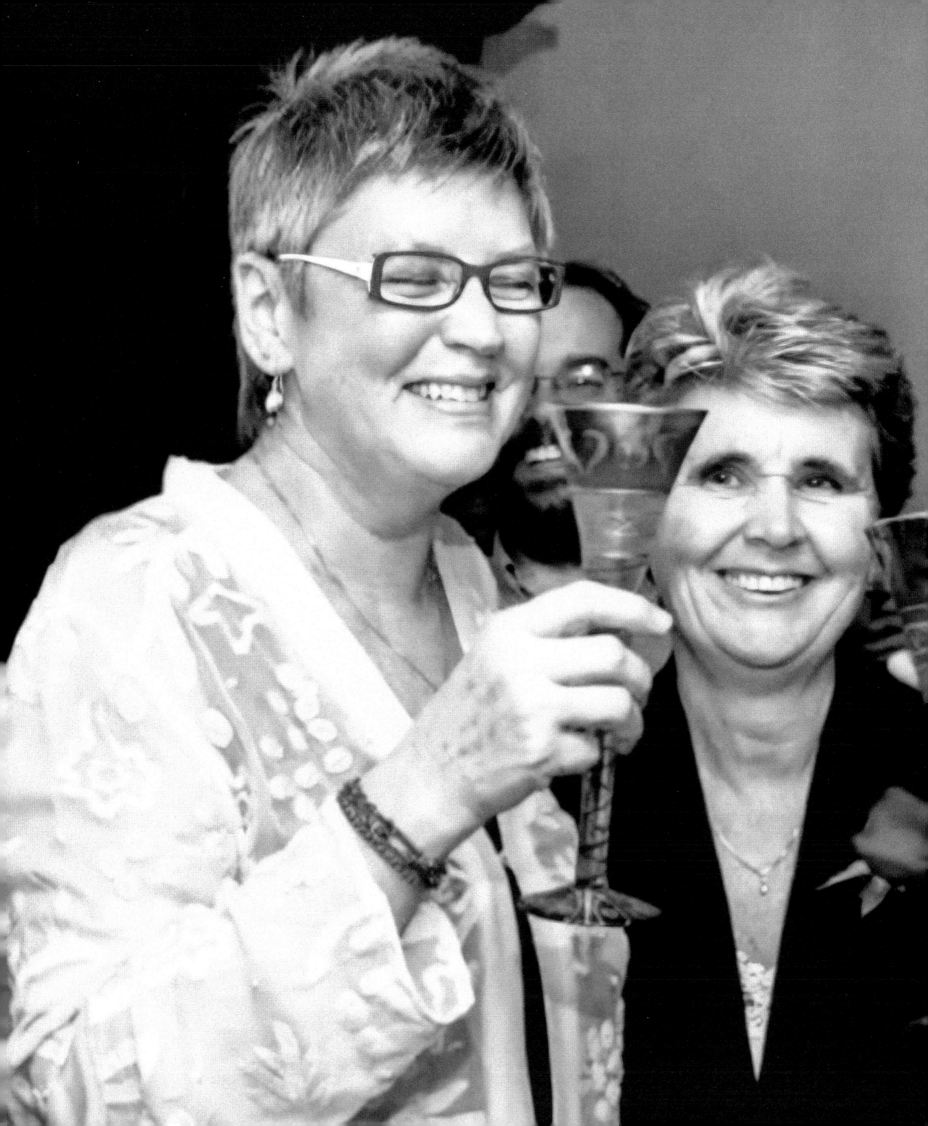

THE BISHOP GENE ROBINSON AND MARK ANDREW

When it came to marriage rights, Christendom learned to be more Christian thanks in large part to this couple.

Gene was born into poverty in Kentucky in 1947, the son of tobacco sharecroppers. He was a sickly infant right from birth, temporarily paralyzed and so seriously ill that doctors asked for a name to add to the baby's death certificate. But baby Gene endured. He survived to become a gay hero to many in the Episcopal Church.

This southerner had a deep connection to God and church from an early age, never missing a day of Sunday school in thirteen years. He also wholeheartedly felt he wanted to have a relationship like his parents. But not with someone like his mom—someone more like his dad. As with most children who grow up rooted in the church, he believed that fire and brimstone would shower down upon people with feelings like his. But he knew that his feelings stemmed from love. And Gene also knew God was all about love.

Throughout Gene's adolescence and into adulthood he continued to struggle between his love for God and his feelings for men. After receiving a master of divinity degree from the General Theological Seminary of New York in 1973, he moved to New Hampshire. It was there that he befriended a lovely woman, Isabella. They soon became close—within the strict social rules that

Gene Robinson hugs his partner, Mark Andrew, during his consecration ceremony as the Episcopal Church's first openly gay bishop, Durham, New Hampshire, November 2003.

society then allowed—and he felt he could talk with her and be himself. They eventually married and had two children together. Throughout their marriage, Gene was honest with his wife about his attraction to men and his struggles with his sexuality, something that would gradually take its toll on Gene and his marriage. Finally, in 1987, Robinson came out as gay, and he and his wife had an "unvowing ceremony" and then divorced.

Gene met Mark shortly thereafter and knew this was the love he had hoped for his entire life. Their relationship began during a time when being openly gay was fraught with personal and professional risks, particularly for someone devoted to the church. Despite these challenges, they co-parented as a family with Isabelle, and Mark was able to help Gene through his journey of self-discovery and the challenges that followed his coming out. In 2003, the New Hampshire diocese elected Gene as bishop and, as such, he would be consecrated, or blessed, as the first openly out bishop in Christendom.

An international furor erupted, and the Episcopal Church's General Convention saw conservatives and liberals pitted against one another over whether Gene Robinson should be allowed to become bishop. Robinson faced smear tactics including false allegations that he abandoned his wife and children and that he had inappropriately touched children. An investigation found no evidence, and the House of Bishops voted in favor of Robinson. However, Gene's fear of fire and brimstone raining down was not misplaced: thirty-two congregations and one full diocese would sever themselves from the American arm of the Anglican Church.

Yet Gene's faith sustained him, and his consecration seemed to go off without a hitch. But what some three thousand people, three hundred press

members, a two-hundred-strong choir, and forty-eight bishops didn't hear about were the death threats to Gene and his family. They did not notice that at one point Mark was disguised as one of the clergy. They did not see the bulletproof vests Gene and his family wore underneath their garments.

In June 2008, Gene and Mark were legally married in a civil ceremony in New Hampshire, shortly after the state legalized same-sex marriage. Their wedding was a joyous occasion, attended by family, friends, and many members of the Episcopal Church, which had come around considerably on gay marriage thanks to a better understanding of the LGBTQ+ community. A lot of this newfound acceptance was brought thanks to Gene and Mark putting their story of gay love and faith out into the world with Gene's book, *God Believes in Love: Straight Talk About Gay Marriage*, and opening their private lives to the media and in their documentary, *Love Free or Die*. It took immense strength for the couple to endure the public scrutiny of something they both considered pure: their love for each other. In 2012, Mark and Gene announced their separation, due in large part to the stress on their relationship from fighting for marriage equality.

After marriage equality was made legal in the United States in 2015, the Episcopal Church also approved same-sex marriage. Gene and Mark's relationship and marriage played a crucial role in the fight for marriage equality, namely by forcing other denominations and other religions to confront the question of whether to sanction LGBTQ+ marriages.

There are now over fifteen organized religious groups in the United States that bless these marriages, including the Alliance of Baptists, the Evangelical Lutheran Church, Reform Judaism, and the Presbyterian Church. God believes in love.

A CHAMPION OF MARRIAGE RIGHTS
NOBODY EXPECTED—BUT SHOULD HAVE

Many people were taken aback when the State of Iowa granted marriage rights ahead of more left-leaning states like New York or California. But in the heartland of America, the Hawkeye State has long set its sights on progressive thought and civil rights. This legacy set the stage for a historic moment on April 3, 2009, when the state supreme court unanimously ruled in *Varnum v. Brien*, and Iowa became the third state in the nation to legalize marriage for LGBTQ+ Americans. This decision was not merely a legal victory; it was a testament to the tireless efforts of countless individuals who fought for equality and recognition.

The story began in 2005 when six same-sex couples—Kate and Trish Varnum, Dawn and Jen BarbouRoske, Ingrid Olson and Michelle Gartner, Jason Morgan and Chuck Swaggerty, David Twombley and Lawrence Hoch, and Bill Musser and Otter Dreaming—sought marriage licenses from the Polk County Recorder's office in Des Moines. Their applications were denied, citing Iowa law that only recognized the marriage between one man and one woman. The couples felt their constitutional rights were being violated and decided to take action.

Led by Camilla Taylor, a senior staff attorney for Lambda Legal, the plaintiffs filed a lawsuit against Timothy Brien, the Polk County recorder. In August 2007, Judge Robert Hanson ruled in favor of the couples, declaring the state's marriage statute unconstitutional. He emphasized that denying marriage licenses to qualified couples based on sexual orientation was a violation of the Iowa constitution's equal protection clause.

Despite this victory, the battle was far from over. The Polk County recorder appealed Hanson's ruling, leading to a higher court review. The Iowa Supreme Court heard the case in December 2008, with the justices fully aware of the history of civil rights in Iowa. The supreme court in Iowa had rejected discriminatory practices with rulings upholding the notion that human beings could not be treated as property long before in the famous US Supreme Court's *Dred Scott* case in 1857, and had ruled practices like "separate but equal" unconstitutional before they were addressed nationally in *Brown v. Board of Education* in 1954.

On April 3, 2009, the court delivered its unanimous decision, affirming Judge Hanson's ruling and allowing same-sex couples to marry. This moment marked a significant leap forward in the national fight for marriage equality. The decision emphasized that the exclusion of gay and lesbian individuals from marriage did not serve any substantial governmental objective. It was a strong statement that echoed Iowa's tradition of progressive values, reinforcing the idea that all people should be treated equally under the law.

Following the ruling, the Iowa Supreme Court set a date for the issuance of marriage licenses, effective April 27, 2009. The excitement and anticipation

Iowans proudly announce their newfound freedom to marry, making Iowa the third US state to grant marriage equality following Massachusetts and Connecticut, April 2009.

surrounding this date were palpable, as same-sex couples across the state prepared to celebrate their love in a legally recognized way.

However, the ruling was not without repercussions. The judges responsible for the decision—Chief Justice Marsha Ternus, Justice David Baker, and Justice Michael Streit—faced backlash from conservative groups. In the 2010 retention election, all three judges were voted out of office, marking the first time since the retention system was established in 1962 that justices were not retained. This vote illustrated the divisive nature of the issue at the time, fueled by out-of-state conservative and religious organizations campaigning against the judges.

Despite their dismissal, these judges were later recognized for their courage. In 2012, they were awarded Profile in Courage Awards from the John F. Kennedy Library Foundation, which praised them for their commitment to justice and equality. Caroline Kennedy stated, "They don't consider that they are doing anything particularly courageous; they just feel they're doing what's right; they're doing their job."

As the dust settled from the judicial battles, Iowa's legalization of same-sex marriage set a powerful precedent in the nationwide movement for LGBTQ+ rights. The ruling was influenced by the landmark decision in *Lawrence v. Texas*, which invalidated laws criminalizing same-sex intimacy. This growing recognition of LGBTQ+ rights established a legal framework that would support further advancements in equality across the country.

By becoming the third state to recognize same-sex marriage, Iowa not only aligned itself with Massachusetts and Connecticut but also positioned itself as a leader in civil rights. The state's decision resonated beyond its borders, inspiring activists and advocates across the nation to continue fighting for marriage equality and broader LGBTQ+ rights.

In the years that followed, public opinion in Iowa shifted significantly. A 2012 poll indicated that a majority of Iowans supported same-sex marriage, reflecting a growing acceptance and understanding of LGBTQ+ issues. The progress made in Iowa became a model for other states grappling with similar legal and social challenges.

On April 3, 2009, the Iowa Supreme Court made a landmark decision that recognized same-sex marriage as legal in the state. This pivotal ruling stemmed from a lawsuit initiated in 2005 by six same-sex couples who had been denied marriage licenses in Polk County.

The Des Moines Register

SATURDAY, APRIL 4, 2009 | DESMOINESREGISTER.COM | THE NEWSPAPER IOWA DEPENDS UPON | 75¢ | METRO EDITION

IOWA GAYS HAVE A RIGHT TO MARRY, JUSTICES RULE

Unanimous decision cites fairness; law can't be reversed before 2012

JUSTIN HAYWORTH/THE REGISTER

Gay couples who sued for the right to marry in Iowa learn of their victory Friday. From left are Trish and Kate Varnum, and Jason Morgan and Chuck Swaggerty.

JOE WILSON AND DEAN HAMER

Their wedding announcement in the conservative rural community of Oil City, Pennsylvania, sparked a major controversy—and eventually a documentary.

In the quiet town of Oil City, Pennsylvania, Joe and Dean decided to celebrate their love in a way that would ultimately test a community's tolerance and start a monumental shift in attitudes. Placing their wedding announcement in the local newspaper was a simple gesture of love, yet it ignited a wildfire of controversy that ripped through the town.

Oil City, known for its conservative values and traditional mindset, was not prepared for such a public declaration of same-sex love. The announcement of Joe Wilson's marriage to another man challenged deeply held beliefs and stirred up a public outcry. Letters poured in to the newspaper, some filled with support but many with rejection laden with anger and fear.

Amid this turmoil, a quiet revolution began to take shape. The fiancés found themselves unexpectedly thrust into the role of activists simply by living openly and honestly. The unfolding events became a focal point for their 2009 documentary *Out in the Silence*, which captured not only the backlash but also the unexpected acts of compassion and bravery that emerged from the community.

As the town grappled with its prejudices, a turning point came when a distraught mother reached out to Joe for help. Her gay son was enduring relentless bullying at school, his torment exacerbated by the town's hostile atmosphere toward anything perceived as different. Joe and Dean had moved from Oil City after their marriage. After the distraught mother contacted Joe, the couple returned as compassionate advocates.

Within the universal struggle of those who dare to be themselves in environments that resist change, Joe's experience shows the power of breaking silence, confronting prejudice with empathy, and fostering understanding instead of division.

Their film documented a transformation. What began as a controversial wedding announcement evolved into a catalyst for dialogue and change. The film highlighted the courage of individuals who dared to challenge the status quo, the ripple effects of their actions, and the hope that even in the most resistant places, hearts and minds can open.

In the end, Oil City changed. The community learned to reckon with its biases and to see beyond them, thanks to the couple's courage, and the many voices that joined them in breaking the silence.

Dean Hamer and Joseph Wilson's wedding announcement, published in the *Oil City Derrick*, 2004.

Dean Hamer and Joseph Wilson
Wilson, Hamer

THEY DIDN'T GO INTO IT TO BE ACTIVISTS; THEY DID IT TO BE TOGETHER.

Across the nation, countless couples were not part of high-profile court cases or media spectacles; they were simply individuals deeply committed to marrying the love of their lives. These couples consistently showed up, speaking to the media and sharing their stories to represent the broader LGBTQ+ community. Over the years, they honed their messages, embodying the dreams and aspirations of regular couples longing for the legal recognition of their relationships. Like many others featured in this book, not all of these couples are still together; some married, while others have moved on. However, they formed a passionate coalition of individuals determined to make their voices heard.

Frank and Joe Capley-Alfano were one such couple. They attended activist events whenever they could, often dressed in their everyday clothes or straight from work, always holding a giant replica of their marriage license—the very license that was up for debate and vote. Like many couples turned activists, Frank and Joe were legally married in California in 2008, during the brief period when same-sex marriage was permitted, prior to the passage of Proposition 8, which prohibited same-sex marriages in the state.

Molly McKay, a civil rights attorney, and Davina Kotulski, a psychologist and author of *Why You Should Give a Damn About Gay Marriage*, consistently appeared in public in wedding attire, drawing media attention. Molly became the co-executive director of Marriage Equality California and served as the media director for Marriage Equality USA, and was always ready to provide compassionate, knowledgeable insights in front of the camera.

Many families were represented by advocates like Kate Kendall, the executive director of the National Center for Lesbian Rights, who bravely put their lives in the public eye. Therese Stewart, the first openly gay president of the Bar Association and chief deputy city attorney, took a stand during Mayor Gavin Newsom's landmark decision to issue four thousand marriage licenses to same-sex couples in 2004. When California Attorney General Bill Lockyer sought to halt these marriages, Stewart led the city's legal defense, firmly supporting Newsom's groundbreaking actions for marriage equality. Despite her demanding responsibilities, she made time to attend rallies and marriage equality events with her wife and daughter.

Across the country, couples faced the public, often confronting animosity and hatred. Yet they continued to show up, and as support for the freedom to marry grew, it became evident that their stories and representation mattered.

Joe Capley-Alfano with Frank Capley-Alfano at a rally in the plaza of the Phillip Burton Federal Building, supporting marriage equality in advance of closing arguments in the Proposition 8 case in federal court in San Francisco, California, June 16, 2010.

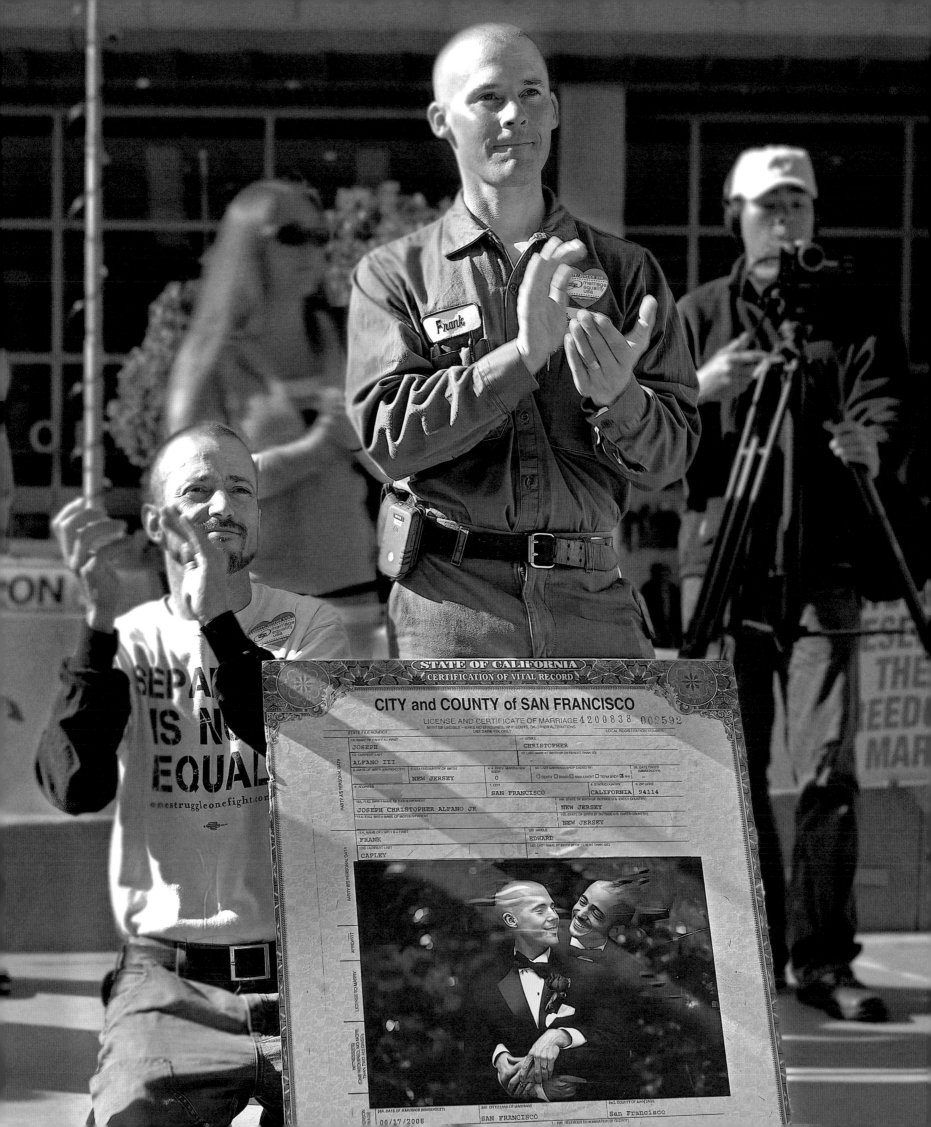

TO HAVE AND TO HOLD

2008–2009

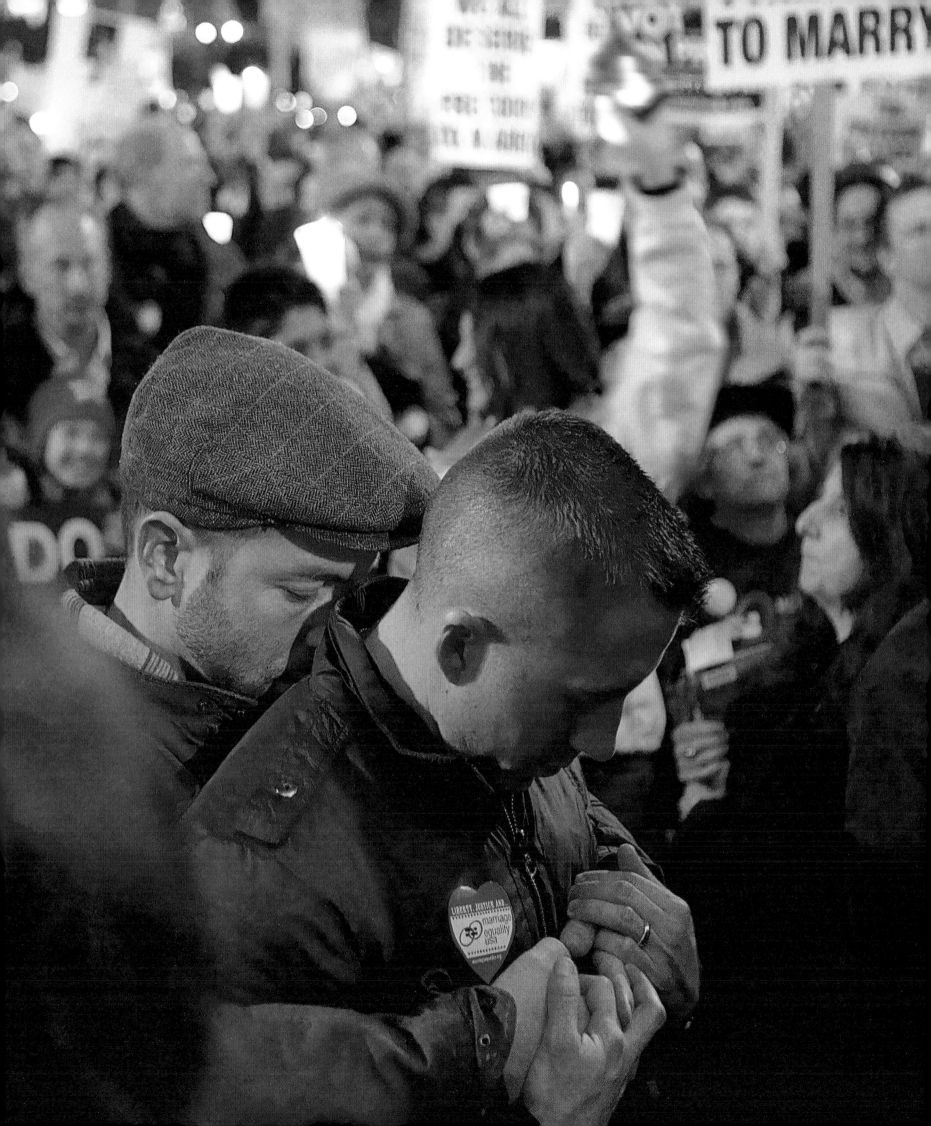

CHAPTER 6 — INTRODUCTION

The passage of Proposition 8 in California in November 2008 stunned the nation as one of the most liberal states in the union took away the right to marry for queer couples, denying them the dignity and inclusion in the straight community they craved. The LGBTQ+ community had celebrated recent significant victories, and so the unexpected repeal of their rights shook advocates to the core. Proposition 8, which amended the state constitution banning same-sex marriage, became a rallying cry for those determined to reclaim their rights in the face of overwhelming opposition.

In the immediate aftermath of Proposition 8, LGBTQ+ advocates flooded the streets in protest, their voices echoing in cities across California and beyond. Citizens looked at family members, co-workers, and strangers and wondered if they had voted against their own marriages. It was counterintuitive that the state electorate would simultaneously vote for the first Black president in the country's history with the motto "Yes, We Can" and deliver to the LGBTQ+ community a resounding "No, you can't." Hollywood took a strong stance against the removal of marriage rights once again, and LGBTQ+ individuals and their allies stepped up, attending mass rallies, creating videos, plays, and utilizing their creative strengths to influence the reversal of this injustice over the following years.

The national media paid attention and began exposing the deep financial involvement of the Mormon and Catholic churches in Proposition 8, exposing how their significant contributions leveraged deeply entrenched societal fears and highlighting how their tactics echoed past campaigns against civil rights. As anger and sorrow swept through the community, hope remained alive due to previous victories in states like Massachusetts, Iowa, and Connecticut. On 2008's election night, Kris Perry and Sandy Stier, whose story symbolized the emotional toll of this loss, experienced a bittersweet mix of joy at Barack Obama's election as president—and despair over their status as second-class citizens. The impact of the voter-approved amendment reverberated across the nation, emboldening anti-equality forces and igniting a fire under those who had just begun to visualize the freedom to marry.

In March 2009, the legal landscape shifted when Mary Bonauto with GLAD filed a significant challenge against Section 3 of the Defense of Marriage Act (DOMA), representing Nancy Gill and other married LGBTQ+ couples in federal court. This landmark case, *Gill v. Office of Personnel Management*, aimed to dismantle the federal government's discrimination against same-sex marriages. It was a strategic move within a broader campaign against DOMA, an act that had become increasingly untenable as public opinion began to shift in favor of marriage equality.

Previous page, opposite, and following spread: People protesting the passage of California's Proposition 8, which for a second time overturned the right to marry for all, San Francisco, 2009.

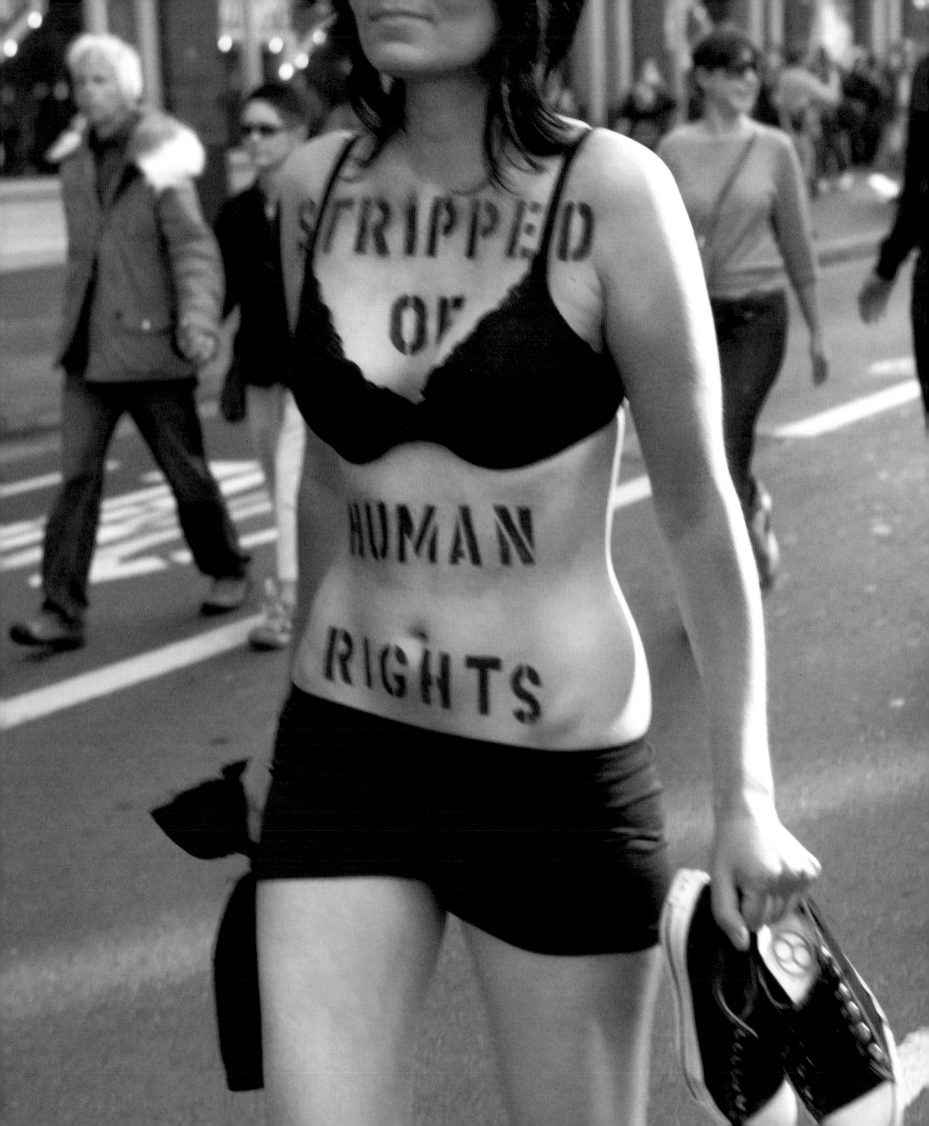

The political environment was fraught with challenges as the No on 8 campaign faced relentless attacks, particularly around a misleading narrative regarding a kindergarten teacher's wedding celebration. Opponents twisted the story of a teacher whose students joyfully celebrated her marriage, alleging that children were being indoctrinated against their parents' wishes. This potent misinformation campaign misrepresented the facts and fueled a firestorm of opposition. Despite millions of dollars poured into pro-marriage advocacy, the damage to the campaign's credibility was profound, illustrating how easily public sentiment could be swayed by fear-based rhetoric.

Despite setbacks, victories in other states offered glimmers of hope. In October 2009, the Connecticut Supreme Court ruled in favor of marriage equality, allowing same-sex couples to marry rather than abide by the previously established civil union law. This decision was a turning point, as couples like Joanne "Jody" Mock and Elizabeth Kerrigan celebrated their hard-fought right to marry. Their joy symbolized a rebirth of hope within the community; progress was still achievable despite recent losses.

The Connecticut ruling came on the heels of victories in Massachusetts and Iowa. Marriage equality was becoming not merely a dream but a tangible goal. Advocates across the nation celebrated these milestones, recognizing the potential for further change. Yet the victory in Connecticut was bittersweet for many, as the recent events in California underscored the tenuous nature of their rights. Approximately 18,000 same-sex couples who had married in California before the passage of Proposition 8 were still considered legally married, but anxiety lingered about their future status.

Throughout 2009, the political landscape continued to shift. Former Vice President Dick Cheney spoke out in favor of marriage equality, in light of his daughter Mary's same-sex relationship, stating that individuals should be free to enter into any kind of union they choose. This marked a significant departure from previous administrations and indicated a growing acknowledgment of the legitimacy of same-sex relationships within the political sphere. Furthermore, President Obama's administration began to express support for civil unions and federal rights for LGBTQ+ couples, although many advocates felt his administration was not doing enough to advance their cause.

The introduction of significant legislation further underscored the momentum building behind the marriage equality movement. The Respect for Marriage Act, introduced in the House of Representatives, aimed to repeal DOMA, signifying a legislative push toward equality. As states began to recognize same-sex marriages, advocates called for comprehensive federal protections, arguing that equality should not be contingent upon state lines.

The National Equality March in October 2009 served as another turning point, drawing hundreds of thousands to the nation's capital to demand full equality for LGBTQ+ individuals. This massive gathering of advocates from diverse backgrounds and experiences was a testament to the unity within the community committed to securing equal rights. The collective energy of the march reverberated throughout the nation, reminding everyone that the fight for equality was far from over.

Opposite and page 204: Signs protesting the potential revocation of legal marriages in California after a voter-passed referendum. With 51 percent in favor, it halted same-sex marriages once again, San Francisco, 2009.

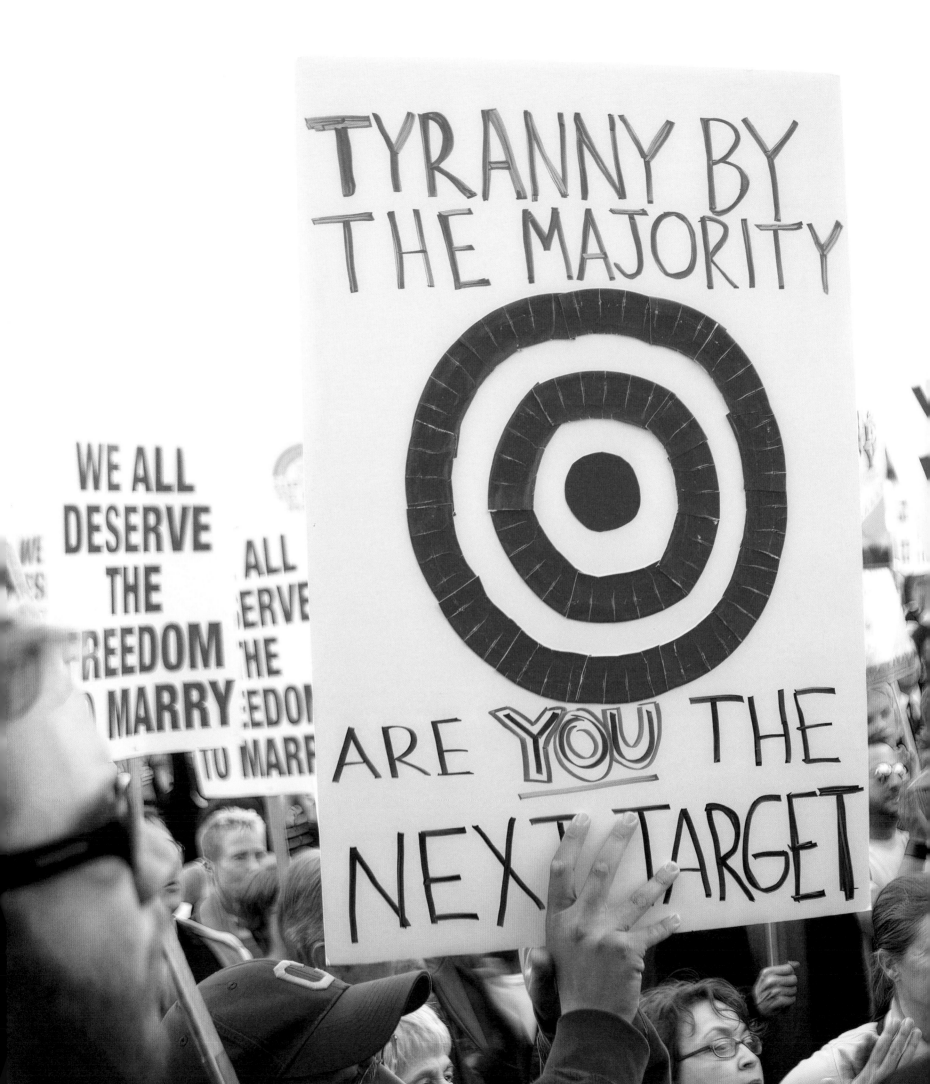

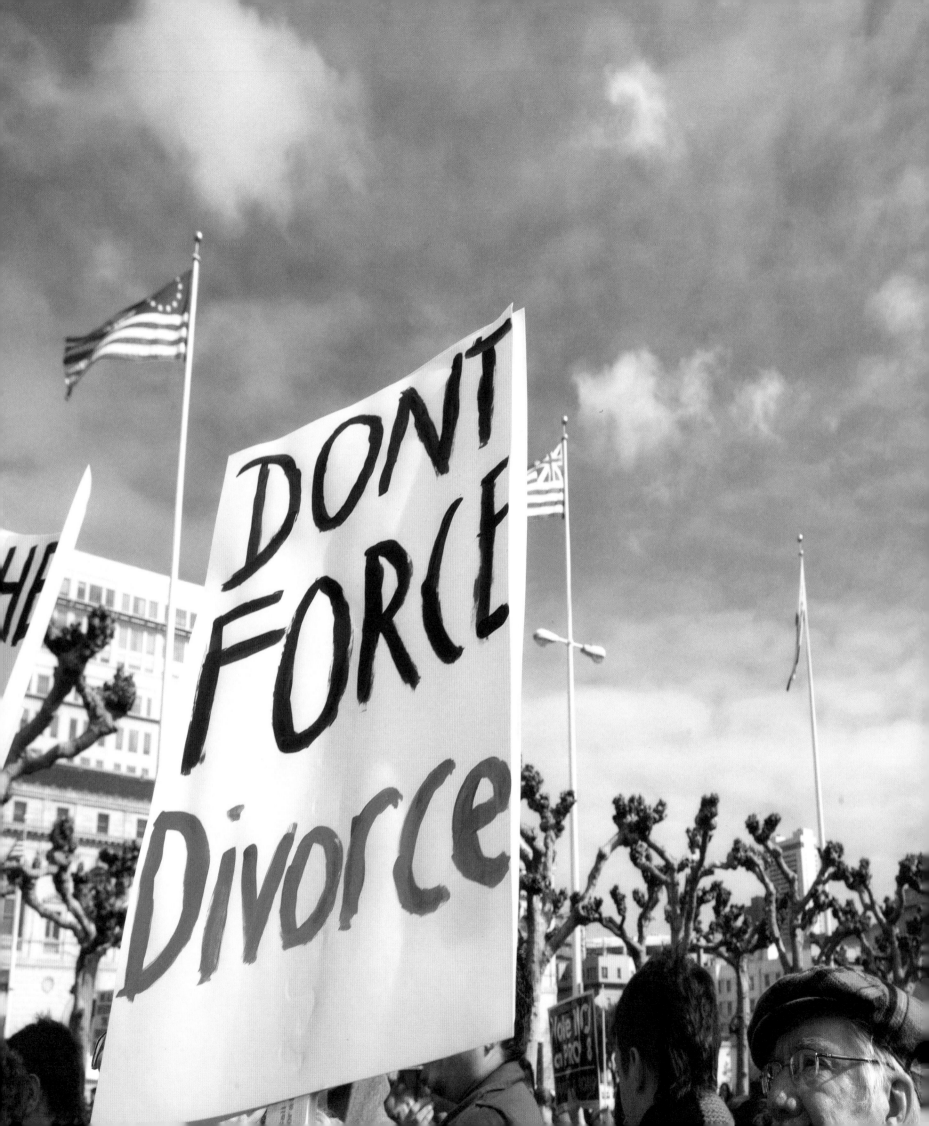

Amid these national events, the landscape in various states continued to change. The Iowa Supreme Court's ruling in *Varnum v. Brien* in April 2009 declared the state's restriction of marriage to different-sex couples unconstitutional, making Iowa the first Midwestern state to legalize same-sex marriage. The Vermont General Assembly followed suit, overriding Governor Jim Douglas's veto to become the first state to institute same-sex marriage by statute in April 2009. These victories signaled a broader acceptance of marriage equality that transcended regional boundaries.

As the year progressed, the complexity of the legal landscape made the ongoing struggle for rights seem precarious. The California Supreme Court upheld Proposition 8's ban on same-sex marriage in May 2009 while also confirming that marriages performed before its passage remained valid. In Maine, however, the tide shifted dramatically when a voter referendum repealed the state's same-sex marriage law, preventing it from going into effect. This loss echoed the pain felt in California, reminding advocates that the battle for marriage equality was far from won. While victories in other states brought hope, the setbacks in Maine and California underscored the ongoing need for activism and education.

As the year came to a close, the LGBTQ+ community recognized that the fight for marriage equality was not just a legal battle but a deeply personal one. Couples like Kris Perry and Sandy Stier, who had shared their story with the world, continued to inspire others to take up the cause. The collective efforts of activists began to transform the conversation around marriage equality nationally, fostering a community that would ultimately refuse to back down in the face of adversity.

Following spread: Crowds outside San Francisco City Hall watching Chief Justice Ronald M. George ruling Proposition 8 unconstitutional in 2010, a pivotal decision upheld by the Ninth Circuit that advanced LGBTQ+ rights and paved the way for marriage equality in California.

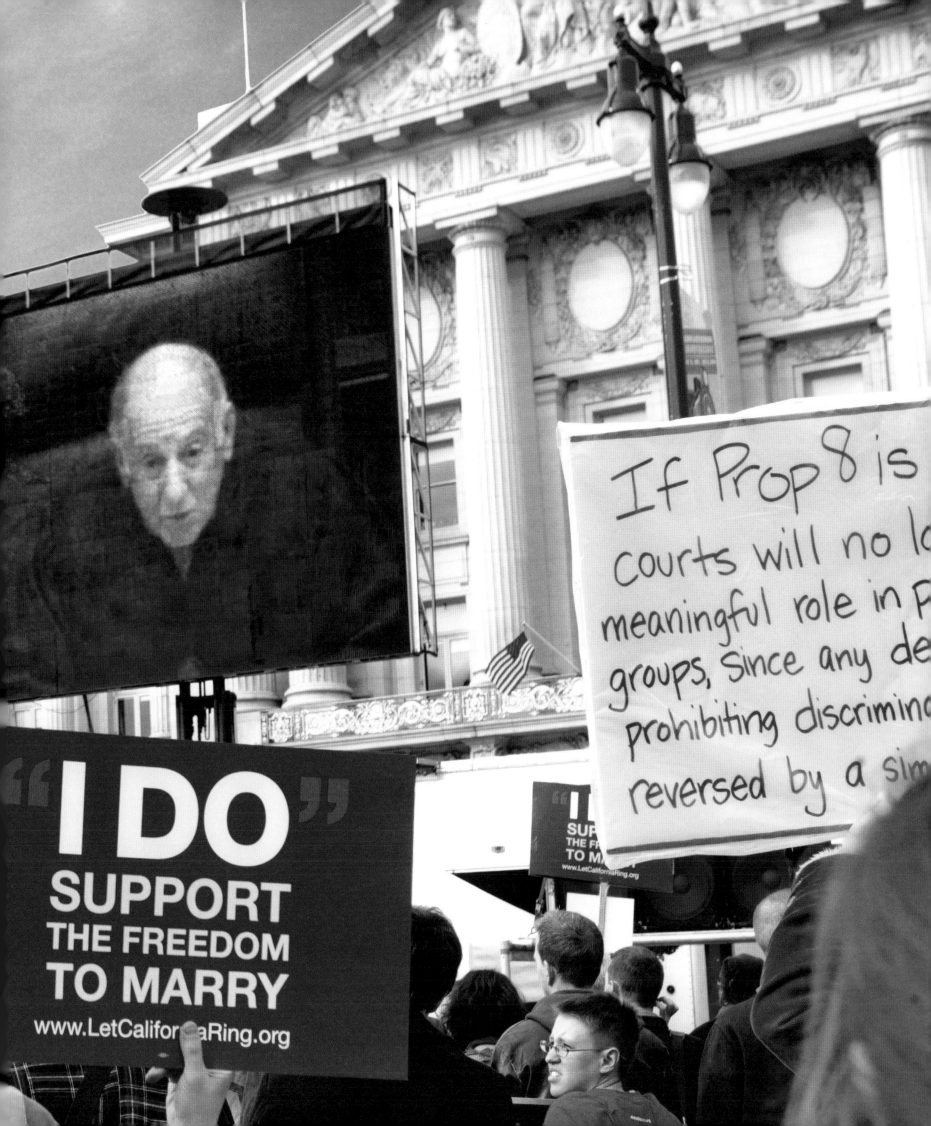

PAGE HODEL AND
MADALENE RODRIGUEZ

An art-filled love story moved masses.

Monday Hearts for Madalene became a visual anthem during the latter part of the marriage movement. San Francisco artist Page Hodel could hardly believe she had found the love of her life, and, true to her calling, she expressed her devotion so passionately that Madalene Rodriguez could not doubt her affection. Page woke very early every Monday morning, created a heart for Madalene, and left it for her to discover near her front door. These hearts were fashioned from a whimsical variety of materials: cardboard, clothespins, corks, flowers, acorns, asparagus berries, elastic bungee cords, buttons, herbs, and even candy corn. Less than a year after they met, however, Madalene died of ovarian cancer. Page continued to make hearts for over a decade, which carried her through the unbearable darkness of loss. "They were the physical embodiment of the billion 'I love yous' that I didn't get to say."

Her hearts still resonate with people around the world and are shared with lovers, friends, and family via her book *Monday Hearts for Madalene*.

Photographs of some of the hundreds of hearts Page Hodel made for Madalene Rodriguez, fashioned from a magical and surprising diversity of materials: acorns, asparagus, berries, buttons, bungee cords, cardboard, clothespins, corks, and candy corn.

ADAM BOUSKA AND JEFF PARSHLEY

No H8ters.

In the aftermath of Proposition 8's passage, photographer Adam Bouska and his partner Jeff Parshley were inspired to take action. After returning from a protest, they conceptualized a simple yet powerful image to symbolize the silencing of LGBTQ+ voices. Bouska photographed Parshley with duct tape over his mouth and "NOH8" painted on his cheek, representing the oppression brought by Prop 8 and similar legislation.

What began as a personal protest shared on social media quickly gained momentum. The overwhelming response led Bouska and Parshley to establish the NoH8 Campaign, a silent photo protest advocating for marriage equality and broader LGBTQ+ rights. Featuring everyday people and celebrities alike, the campaign has since captured over 56,000 portraits, including famous faces like Annie Lennox, Jane Lynch, and Deepak Chopra. Each portrait carries the campaign's signature message of resilience and love against hate.

While the NoH8 Campaign began in response to the fight for marriage equality, its mission has expanded to address discrimination in all its forms, spreading a universal message of acceptance. Today, the campaign continues its worldwide impact, uniting people from all walks of life under a shared vision of equality and respect for all.

Top: Jeff Parshley and Adam Bouska, 2009. **Opposite:** A sampling of the many celebrities who came out to fight for marriage equality after the passage of California's Proposition 8 in 2009. Left to right: Lisa Ling, Weird Al Yankovic and family, Gloria Allred, Jane Lynch, Joy Venturini Bianchi, Electrik Red, Kyndra "Binkie" Reevey, Lesley Lewis, Naomi Allen, Sarah Rosete, Liza Minnelli, LeVar Burton, Fran Drescher, Lance Black, Deepak Chopra, Lieutenant Dan Choi, Stephen tWitch Boss and Allison Holker and their daughter, Andy Cohen, Leslie Jordan, Annie Lennox, and longtime AIDS activist Larry Kramer.

ELLEN DEGENERES AND PORTIA DE ROSSI

Humor has it.

Before their marriage, Ellen openly shared her feelings about her girlfriend, Portia. Through the stories she recounted about their relationship, she prepared her audience—and much of America—for their forthcoming nuptials.

Ellen was able to be authentic because she paved the way for herself to do so—she was her own trailblazer. Once she started to convince America that being queer was okay, she then took the country on a journey to accepting same-sex marriage.

After Ellen spilled the beans about their engagement with her fans, the dynamic duo wed in the summer of 2008. Their marriage represented several notable "firsts" for the LGBTQ+ community, being one of the first high-profile celebrity weddings that occurred after California legalized same-sex marriage earlier that year. The couple's wedding was the first gay marriage to be featured on the cover of *People* magazine, bringing immense visibility to LGBTQ+ relationships and further normalizing same-sex unions in mainstream media.

Portia recounted to Oprah Winfrey her first face-to-face encounter with Ellen: "She took my breath away. I had never experienced anything like it before, where I saw someone and felt completely overwhelmed. We were just meant to be together." However, it took Portia three years to confess her true feelings to Ellen. Recognized for her roles in *Ally McBeal* and *Arrested Development,* the actress faced her own struggles while coming to terms with her sexuality. She spoke candidly about the difficulties she faced, especially as someone who did not fit the stereotypical image of a lesbian. "I had a hell of a time convincing people I was gay—which was so annoying!" she told *The Advocate.*

The lovebirds started planning a commitment ceremony in early 2008 and set a date of August 16. When equal marriages opened in California a second time, they kept the date and felt synchronistic with the universe.

Their legal wedding made headlines around the world. Ellen shared the joyful news about her wedding with her talk show audience shortly thereafter. With her signature humor and warmth, Ellen revealed details of their intimate nuptials. Her audience reacted with cheers and applause as they looked at images from their special day. Her audience fell in love with love.

"She's my wife; I get to say that she's my wife, and that's just the way it is," Portia boasted in an interview with Oprah. For Ellen, marriage brought a profound sense of security and belonging. "Anybody who's married knows there is a difference," she said in the same interview. "It feels like you're home. There's an anchor; there's safety. I'm going to be with her until the day I die, and I know that."

WANDA AND ALEX SYKES

Wanda went from doing stand-up, while quietly marrying, to standing up for equality proudly with her wife by her side.

Wanda Sykes has carved out a niche in comedy with her sharp humor, but her impact extends far beyond the stage as a passionate advocate for marriage equality. Her journey, marked by a pivotal coming-out moment and the embrace of her identity in her comedy, highlights the importance of representation and the power of humor in normalizing LGBTQ+ experiences, particularly for Black LGBTQ+ individuals.

Sykes quietly married her partner, Alex, in 2008, but it was the passing of Proposition 8, a California amendment that sought to ban same-sex marriage, that propelled her into the spotlight. At a rally in Las Vegas protesting the amendment, Sykes surprised herself and her fans by publicly acknowledging her sexuality and her recent marriage. This unplanned act of defiance, fueled by anger and a deep need to protect her own love, catapulted her into the role of an LGBTQ+ advocate. "I'm here, I'm queer, and I'm not going anywhere," she declared, making a powerful statement that resonated with many. She also quipped in a way only Wanda could, stating at a rally for marriage equality in Sacramento, California, that "homophobia is wack!"

After coming out, Sykes was not shy about standing up for gay rights and marriage equality. She took to the airwaves, appearing on shows like *Oprah*, and *Today* and networks like CNN and NBC, using her platform to speak out on behalf of the LGBTQ+ community. Sykes's decision to share her story was driven by the realization that the fight for marriage equality was deeply personal and impacted real lives. It was crucial for her to represent the diversity within the LGBTQ+ community, emphasizing that this movement wasn't solely about "white gay men" but also included "women," "mothers," and "kids." She fearlessly incorporates her marriage and children into her routines, using humor to dismantle stereotypes and portray a relatable image of a lesbian family. Mentioning her wife and kids on stage became a conscious effort to normalize their existence, hoping to eventually reach a point where it wouldn't elicit surprise or shock. Her comedic approach not only entertains but also educates, shifting perceptions one joke at a time.

Her stand-up act is sprinkled with anecdotes about raising twins with her wife, Alex, offering a glimpse into their everyday lives. By sharing the humorous and sometimes challenging aspects of parenthood, Sykes showcases that LGBTQ+ families experience the same joys and struggles as any other. "If you want to see how normal I am, just look at my kids," she quips, highlighting that love and family come in many forms. Her experiences of being Black and gay, navigating an interracial and bi-national marriage, and raising white children are woven into her routines, reinforcing the idea that diversity enriches the fabric of family life.

As a Black, out, gay, married celebrity, particularly in the entertainment industry, she serves as a beacon of hope and inspiration for many where there were no role models. Her platform has allowed her to amplify LGBTQ+ voices and advocate for equality. Through her work on the docuseries *Visible: Out on Television*, she traces the evolution of LGBTQ+ representation in media, revealing the progress made while recognizing the work still needed.

GEORGE AND BRAD TAKEI

To boldly love in a way few gays had done before, George and Brad intended to live life, not just exist.

George Takei, best known as Mr. Sulu from *Star Trek*, led a double life. While navigating the cosmos on screen, he concealed a profound truth from the world: his love for Brad Altman. The two met in the 1980s at a gay running club in Los Angeles, where Brad, the club's top runner, trained George for his first marathon. Their shared passion for running quickly blossomed into love, and they hid the relationship for eighteen years. At a time when being openly gay in Hollywood could be a career killer, George, an Asian American actor with limited roles, felt he had to keep their love a secret.

In 2005, everything changed. When then-California Governor Arnold Schwarzenegger vetoed a same-sex marriage bill, George's silence erupted into fury. His public coming out, an act of love and defiance, was published in *Frontiers* magazine. This moment was pivotal, not only for George but for the LGBTQ+ community. With their relationship finally public, George and Brad became vocal advocates for marriage equality.

Their joy reached new heights when the California Supreme Court overturned the state's ban on same-sex marriage in 2008. In a heartfelt moment at home, George proposed to Brad as they listened to the news. They were among the first couples to obtain a marriage license in West Hollywood, a moment they described as "beyond delighted." Their wedding on September 14, 2008, at the

Japanese American National Museum in Los Angeles, was a beautiful celebration of their love and commitment to diversity. The ceremony blended cultural elements, reflecting their belief in inclusivity, with George's *Star Trek* castmates Walter Koenig and Nichelle Nichols standing by their sides as best man and best lady.

But their fight for equality did not end with their wedding. George and Brad embarked on an "Equality Trek" across the United States, raising awareness and advocating for LGBTQ+ rights at every stop. They made history as the first openly gay couple to compete on *The Newlywed Game*, challenging societal norms and proving that their love was no different from any other.

The passage of Proposition 8, which banned same-sex marriage in California, left George and Brad devastated. Yet they remained resolute. Brad vowed never to remove his wedding ring, a powerful symbol of their enduring love and commitment. They continued to fight for marriage equality, steadfast in their belief that the issue would ultimately reach the Supreme Court. When it did, and marriage equality passed, they celebrated and continued to advocate for LGBTQ+ rights and equality for all people to live freely, live long, and prosper. Much like the voyages of the Starship Enterprise, they still work hard and hope for a future where diversity is celebrated and love knows no bounds.

Opposite: George Takei (*Star Trek*'s Sulu) and his love of twenty-one years, Brad Altman, were among the first to receive a marriage license in West Hollywood, California. They hit the media trail to defend marriage after marriage rights were taken away for a second time in the state, 2008. **Following spread**: People descend upon San Francisco City Hall chanting, "Chickens 1, Gays 0," in response to voters giving chickens in California rights while stripping away the right to marry for gay people.

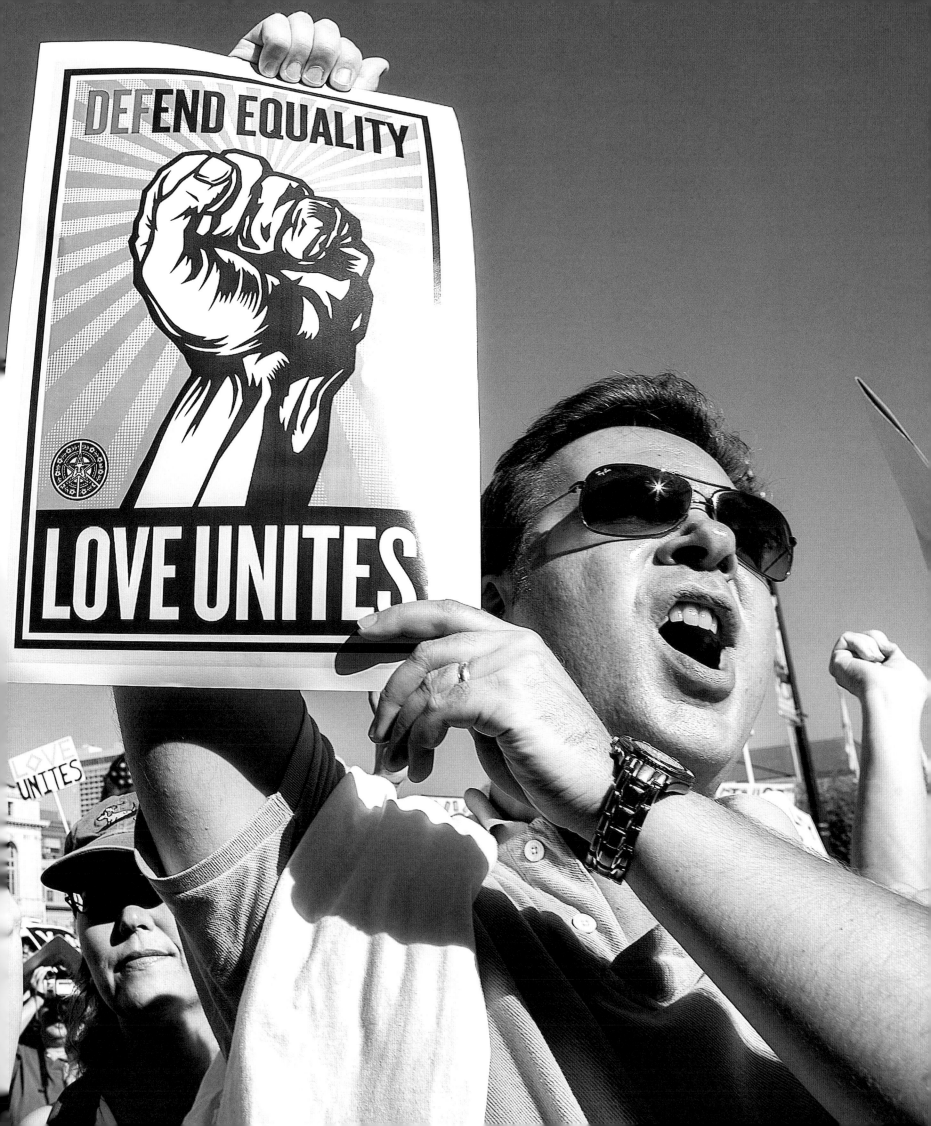

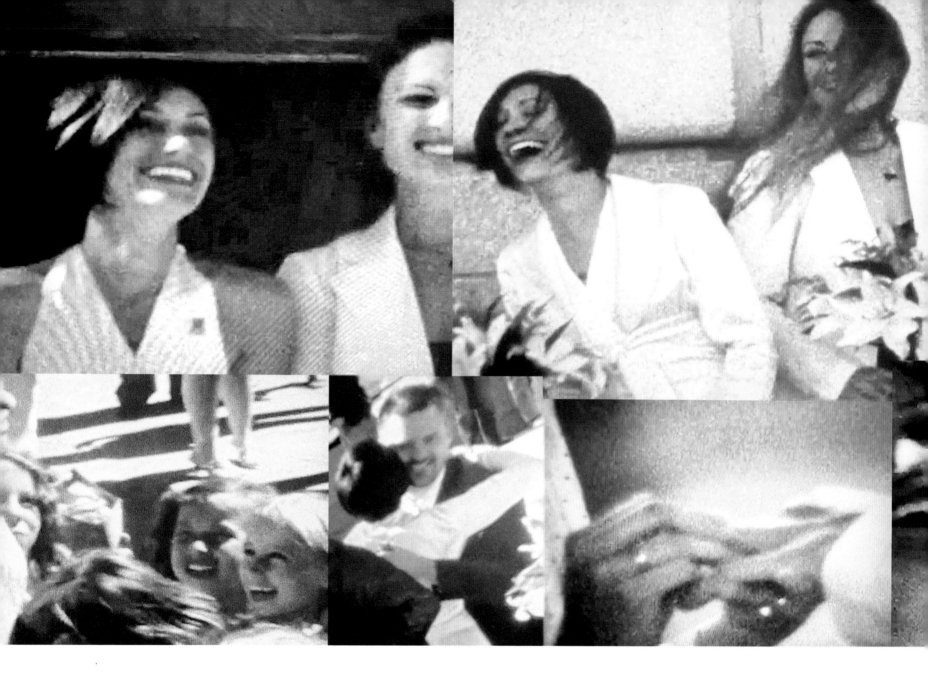

ERIN AND KERRI CARDER-MCCOY

A wedding, with gleeful children blowing bubbles and throwing rose petals, turned into an anti-equality campaign.

In the summer of 2008, with quiet pride and a profound awareness of historical significance, thousands of LGBTQ+ couples in California gleefully exchanged vows. For one couple, this magical moment took an unexpected turn as fear-mongering sentiments marred their joyous occasion.

When teacher Erin Carder met her future wife, Kerri McCoy, in 2001, like the majority of LGBTQ+ people at the time, she never dreamed they one day would have the right to legally marry. One afternoon, while they were listening to "their song," "Long Time with You," news broke that the time had indeed arrived—legal marriage was now a right in California. They giddily jumped at the

Erin and Kerri Carder-McCoy in scenes from their wedding video, San Francisco City Hall, California, 2008.

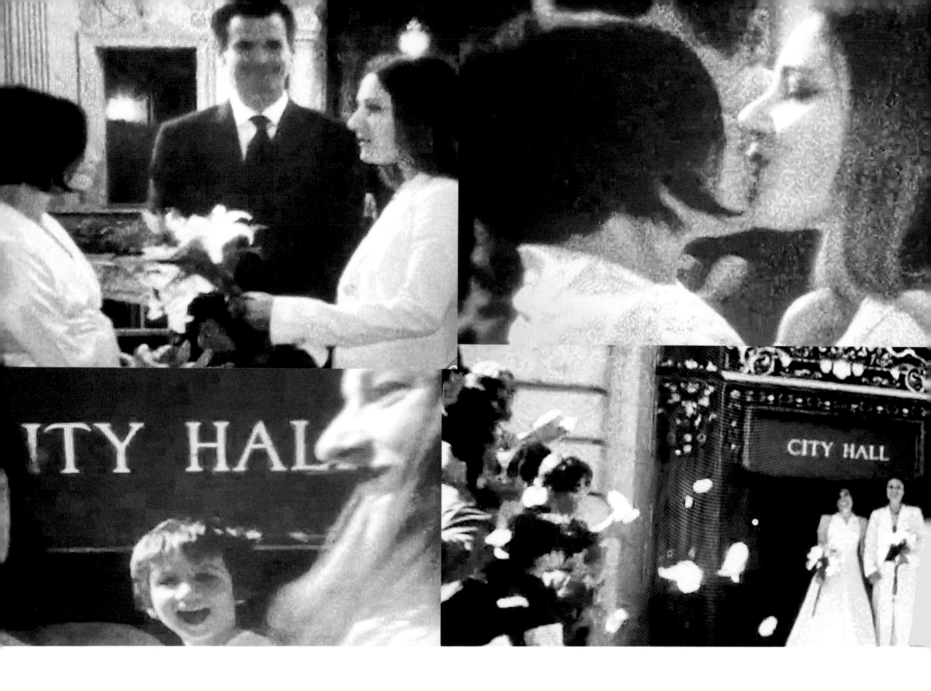

chance and set a date to wed at City Hall in San Francisco. Erin and Kerri's wedding day, August 11, 2008, was a celebration of their love and unity. Dressed in white, alongside a few witnesses, they stood hand in hand on the balcony of Mayor Gavin Newsom's office as he officiated, overlooking the majestic rotunda, and exchanged heartfelt vows.

"With this ring, I thee . . ." Erin exclaimed, her voice filled with joy and determination. She shouted the last word for emphasis, "WED!"

As they descended the steps of City Hall, they were greeted by a heartwarming surprise from eighteen of Erin's five- and six-year-old students.

The children, blissfully blowing bubbles and tossing rose petals into the air, surrounded the newlyweds, adding an extra layer of unanticipated magic to their special day.

To the organizers—a group of parents at the school—a field trip (with an opt-out in place) seemed like a straightforward educational outing. It was a chance for the headmistress, Liz Jaroslow, to impart what she deemed a "teachable moment" to her students—an opportunity to delve into the intricacies of love, marriage, and the profound historical importance of same-sex unions. However, as the day unfolded, the moment morphed into something far weightier,

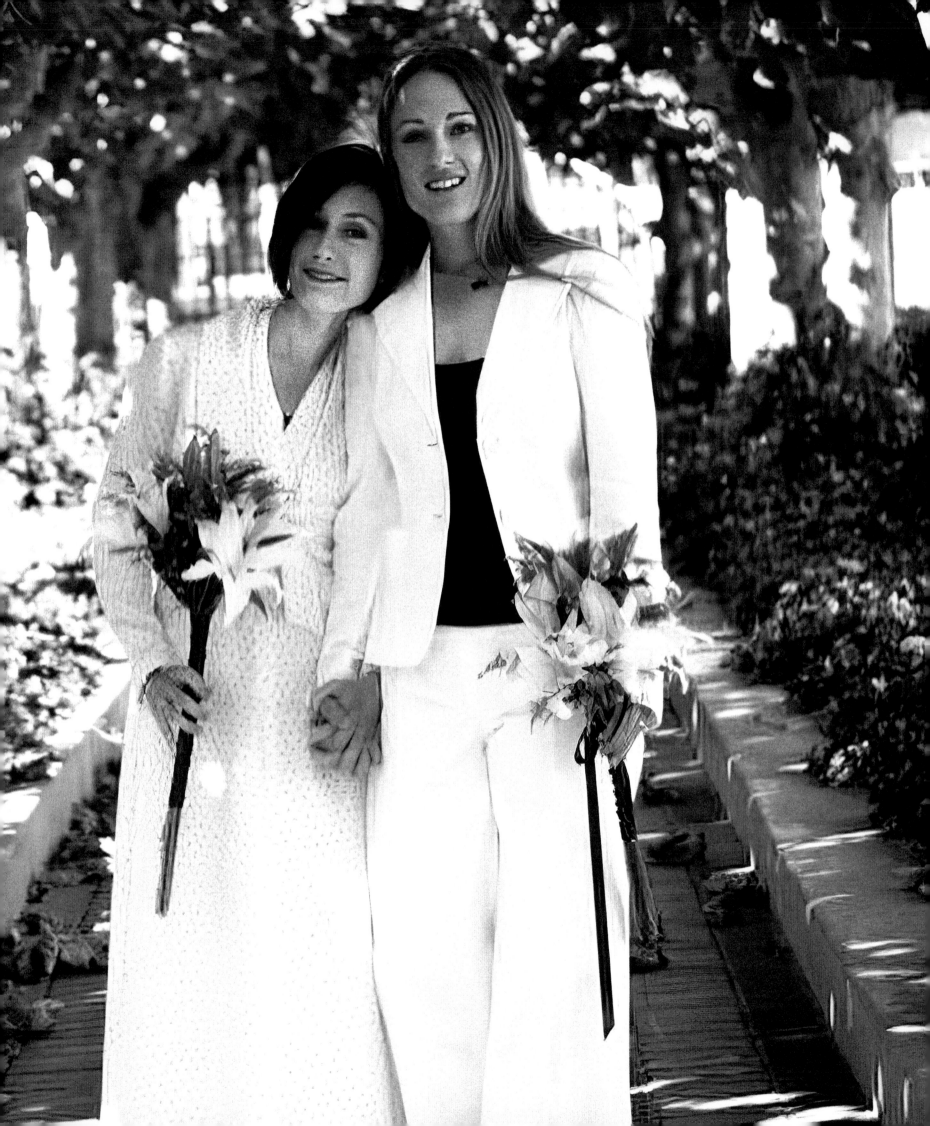

propelling the innocent excursion to the heart of a fiercely contested and rapidly escalating political showdown over the very fabric of marriage.

Earlier that year, the state's supreme court had overturned a ban on LGBTQ+ marriage, paving the way for all couples to joyfully tie the knot in June. However, anti-equality forces wasted no time and swiftly introduced a voter initiative for the November 4 ballot. Alongside choosing a president, Californians were confronted with Proposition 8, aiming to amend the state constitution. This infamous proposition sought to strip away the right for non-straight couples to marry the person they loved, marking the second attempt in just four years to enact such a restriction.

Financed mostly by right-wing Christian groups, including the wealthy Mormon and Catholic Churches, supporters of the "Yes on Prop 8" campaign made robust efforts to pass this amendment stating: "Only a marriage between a man and a woman is valid or recognized in California."

Erin and Kerri's euphoric wedding, featuring the children from the Creative Arts Charter School, was thrust into the spotlight of prime-time TV attack ads—a brazen maneuver orchestrated by the anti-equality lobby group masquerading as "Protect Marriage."

The couple's sublime day should have been followed by weeks of dreamy romance, but instead they received weeks of attacks. The newlyweds were on the news every night which left them defending their love and ceremony at

No on Prop 8 rallies. Newly launched Twitter and conservative blogs were inundated with vitriolic comments regarding Newsom's role in officiating their wedding. The ads asserted that liberals were utilizing marriage as a means to influence impressionable children within public schools. Chip White, spokesperson for the "Yes on 8" campaign, expressed his view that it was illogical for public school outings to include visits to same-sex weddings. He emphasized that this practice amounted to blatant indoctrination of children who lacked the cognitive capacity to grasp its significance. However, he failed to acknowledge that the essence of same-sex weddings was not distinct from heterosexual weddings, events that children attend regularly across the globe.

Through the storm of negativity, Erin and Kerri's love shone as a beacon of hope for equality and acceptance, and their bond has persevered. Erin and Kerri remain together, their love enduring and their spirits unbroken, serving as a testament to the resilience of love in the face of adversity. Their wedding day may have been marred by controversy, but the love and support they received from their community and students only strengthened their resolve to fight for equality.

As one of Erin's former six-year-old students at the time, Chava Novogrodsky-Godt reflected on that memorable day. She remembered "the bubbles and rose petals, symbols of innocence and hope." She also reaffirmed her commitment to ensuring that all children grow up in a world where love knows no bounds. "Erin will always be one teacher I look back on fondly. We are better for the experience. The kids are all right. Let's keep it that way."

Erin and Kerri Carder-McCoy, just married, San Francisco, California, 2008.

TYLER BARRICK AND SPENCER JONES

They escaped the silence and bigotry of the Latter-Day Saints Church and made a movie that spotlighted the acceptance of polygamy over traditional marriage.

This couple's contribution to the marriage equality movement, like several others in this book, is magnified through the stories and revelations that emerged from books or documentaries that focused on their experiences. June 17, 2008, was a landmark day for thousands of gay and lesbian couples in California. The state's supreme court had just legalized same-sex marriage, prompting hundreds of couples to rush to city hall to make their unions official. Among these couples were Tyler Barrick and Spencer Jones, two men who had grown up in Mormon families. In Reed Cowan's 2020 documentary, *8: The Mormon Proposition*, Tyler and Spencer, together for six years, recall their special day; their happiness nearly bursts off the screen. However, the documentary also reveals that forces were already conspiring to take away their newfound happiness, as efforts to pass Proposition 8, a ballot initiative to ban marriage equality, were already underway.

8: The Mormon Proposition explores the deep involvement of the Mormon Church—officially known as The Church of Jesus Christ of Latter-Day Saints—in the campaign against same-sex marriage. The documentary uncovers secret documents revealing the Mormon Church's calculated and covert efforts to pass Proposition 8. The church's strategy was to avoid presenting the initiative as solely a Mormon cause, knowing it would not be well-received. Instead, they formed coalitions to downplay the religious aspect, while funneling significant funds, including $3 million from Utah to California, into the campaign.

The documentary not only focuses on political maneuvering but also sheds light on the personal toll of these actions. Tyler Barrick's mother is featured, grappling with her Mormon beliefs while supporting her son's right to marry. The film also addresses the tragic consequences of the church's stance on LGBTQ+ issues, particularly in Utah, which has one of the highest suicide rates in the country, significantly affecting gay, lesbian, bisexual, trans, or questioning Mormon youth. By putting faces to these statistics, the film underscores the human cost of discrimination.

The narrative of *8: The Mormon Proposition* is both heartbreaking and infuriating, particularly when it reveals the extent to which church and state have become entwined. The film highlights the staggering amounts of money spent on promoting Proposition 8, suggesting how such resources could have been better used for humanitarian purposes.

The film shows how Tyler Barrick and Spencer Jones transformed from a joyful couple into dedicated activists for marriage equality. Their journey mirrors the broader movement, as many more LGBTQ+ individuals were spurred into action. The documentary also details the widespread protests that followed, including a significant demonstration in Salt Lake City, Utah, where five thousand people gathered.

The documentary serves as both a historical document and a call to action, highlighting that while progress has been made, the fight for equality and the separation of church and state continues.

224 Tyler Barrick and Spencer Jones show off their wedding certificate on the steps of San Francisco City Hall after they were married on June 17, 2008.

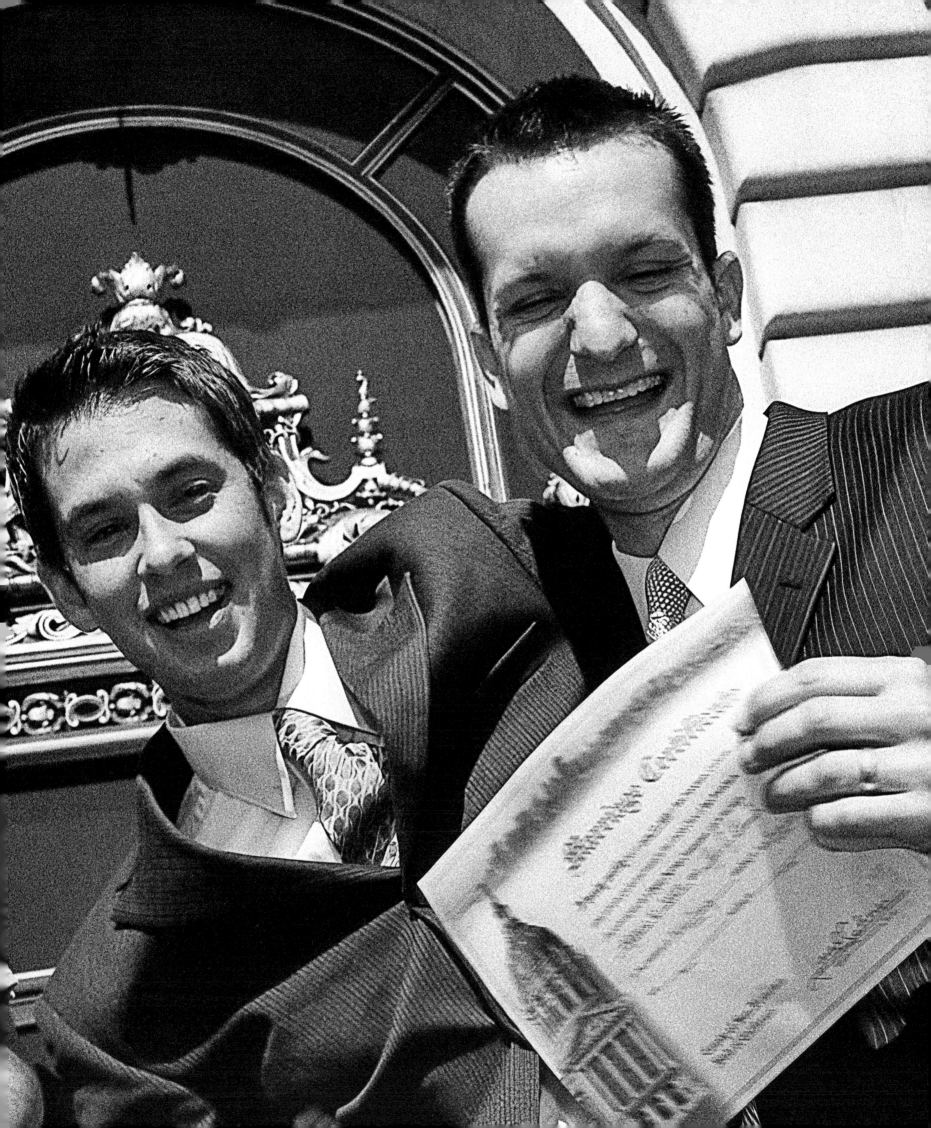

SHIRLEY TAN AND JAY MERCADO

When an asylum request was denied, this bi-national couple told their story, emboldening members of Congress to step forward and help keep the family together.

My agonizing, humiliating, and tragic
experience started when I got in their SUV.
I was taken like a criminal. It was something
I cannot imagine that will happen to my life.
I was praying so hard for me to wake up,
but it was not a dream. I was actually there.

—Shirley Tan, Senate Judiciary Testimony,
 June 2009

On January 28, 2009, at 6:00 a.m., federal
immigration authorities rang Shirley's doorbell,
placed her under arrest, and took her to jail.
Humiliated and afraid, she spent a day away from
her family, unaware of why she had been arrested.

US Immigration and Customs Enforcement officers
were carrying out an order for her deportation.
This came as a shock to Shirley and Jay Mercado,
her partner of twenty years. They were frightened,
demoralized, and felt helpless to interfere. "If only
Jay were born a man," one ICE agent affirmed, Jay
would have been allowed years before to petition
on Shirley's behalf and sponsor her for residency.
As a woman, and as Shirley's non-legal spouse, Jay
could do nothing at all.

Shirley's arrest punctuated the long-awaited
question of her application for asylum from the
Philippines. In 1989, her cousin had brutally
murdered Shirley's mother and sister, and then
shot Shirley in the head. After her cousin's release
from prison, Shirley feared for her life and fled

to the United States to be with her long-distance
love, Jay. She had met Jay a few years earlier while
on vacation in the States and the two had fallen in
love immediately. Pre-internet, their international
telephone courtship had been costly. But once
they were together, that was the way they wanted
to stay. In 1995, Shirley took all the requisite steps
to immigrate legally by applying for asylum.

From time to time, the couple checked in on
the progress of Shirley's status in the country
but went on about their daily lives, assured that
considering the brutality of her case, she would
not be turned away. They lived a peaceful life in
Pacifica, California, became Eucharistic ministers
and domestic partners, then wed in 2004. Their
marriage though, was not federally recognized,
and was a short-lived moment of joy—their
marriage was voided, along with four thousand
other couples, shortly thereafter by the California
Supreme Court. Marriage was the simplest path to
legal residency, and so Shirley and Jay continued to
keep faith, raising their two twin boys, Jashley and
Joriene, and trusting that word on Shirley's status
would soon come. Five years later, word banged on
their front door and took Shirley into custody.

After the arrest, Shirley, a devout Catholic and
church counselor, returned home wearing
an electronic ankle monitor, which she tried
desperately to hide from her sons. Her deportation
was scheduled. With no other options and with
the blessing of their children, neighbors, and their
church, Shirley and Jay appealed to the public.

Opposite and page 229: Shirley Tan and Jay Mercado over the years at their home with their sons, Jashley and Joriene, Pacifica, California.

public. Their story gained ample media attention. It garnered the cover of *People* magazine and spots on national networks like CNN, exposing the public and politicians alike to the inequitable treatment of gay and lesbian immigrant couples in the United States: if the partners were heterosexual, either would be free to marry an American citizen and remain in the States.

On April 22, 2009, the day Shirley was scheduled for deportation, House Representative Jackie Speier, along with Senators Barbara Boxer and Dianne Feinstein, were successful in getting a postponement, allowing the family to stay together for a few more weeks. Then the senators introduced a private bill allowing Shirley to remain in the country for two more years while her case was sorted out. Without this legislative effort, Shirley would be in the Philippines, where she had no friends, no family, and no life to speak of anymore. Shirley and Jay's story became another glaring reason why marriage equality was necessary.

Finally, in 2013, the US Supreme Court overturned Proposition 8, thanks to the plaintiffs in the case, couples Kris Perry and Sandy Stier and Jeff Zarrillo and Paul Katami, allowing Shirley and Jay's marriage license to stand. They married legally the following year, with Jackie Speier officiating—on

the cliffs near their home, overlooking the ocean, and surrounded by their friends, family, and most importantly, their two sons.

After several decades of trying to become a legal family, Jay could now, as Shirley's spouse, sponsor her for citizenship. It would take the requisite seven years to process her application and in 2019, Shirley's immigration court date was finally on the calendar for the spring of 2020. Then the pandemic hit, and her case was indefinitely postponed. But the couple once again went about their lives, joyously celebrating Jashley and Joriene's graduation from college and dreaming of the day they could travel abroad together. Shirley never left the United States once she arrived— not when her father in the Philippines died, and not when the twin babies went to meet Jay's mom there.

Shirley and Jay walked Joriene down the aisle in 2021 and handed him off to his future husband, with his brother as his best man. Two years later, a judge finally granted Shirley her citizenship and to celebrate, they plan to travel to Italy. As soon as Shirley has her physical green card in hand, that is. After just trying to stay together through almost forty years of immigration stress, they have the patience to wait a few more months. Shirley finally received her green card in the spring of 2024.

JENNIFER FINNEY AND DIEDRE BOYLAN

Their love transcended labels.

Author Jennifer Finney Boylan, born James Boylan in 1952, has always embraced her identity with courage and honesty. In 1988, she married her long-time partner, Deirdre, affectionately called "Deedee." The journey of their love took an unexpected turn in 2000 when Jennifer decided to begin her transition to female. Fearing that the foundation of their marriage would crumble under the weight of societal norms, she braced herself for the worst. To her amazement, Deedee stood steadfastly by her side, affirming that their bond transcended traditional definitions of love.

"Our marriage is about a lot more than what genders we are or were," Jennifer wrote, illuminating the essence of their commitment. This statement encapsulates the spirit of their relationship—one built on love, trust, and understanding rather than rigid definitions. As a couple, they have navigated the complexities of a marriage that defies conventional norms, presenting a unique narrative within the broader marriage equality movement.

For twelve years, the Boylans were legally married as a man and a woman, navigating the evolving landscape of gender identity and marriage. As their home state of Maine wavered on the issue of marriage equality, so too did the public discourse surrounding their union. Jennifer's own experience brought to light a nuanced question: When it comes to marriage, what truly defines a union?

In May 2009, as the fight for marriage rights surged, Jennifer penned an influential *New York Times* opinion piece titled "Is My Marriage Gay?" In it, she deftly highlighted the complexities of defining marriage in relation to gender identity.

She argued that many legally married same-sex couples already existed, like hers, rooted in their shared love and commitment, regardless of the gender assigned at birth.

She reflected on how Deedee's choice to remain by her side through her transition illustrated that their connection transcended gender. For them, the notion of "different" often faded into the background as they focused on their love and commitment to each other and their day-to-day lives raising their kids.

Moreover, Jennifer utilized her own experiences to challenge the rigid definitions of gender that have long dictated legal frameworks. She questioned the criteria used to determine legal gender, asking whether it should be based on chromosomes, body parts, or self-identification. Through her personal narrative, she highlighted the absurdities and inconsistencies in how the legal system categorizes transgender individuals, paving the way for a broader conversation about acceptance and understanding.

In advocating for acceptance of gender fluidity, Jennifer urged society to move away from binary definitions of "male" and "female." Instead, she championed a diverse spectrum of gender identities, emphasizing that the focus should be on love, not on categorization.

In 2012, equality marriage was legalized in Maine. By sharing her journey and the unwavering love she, Deedee, and their family embody in articles and books, Jennifer not only has contributed to the discourse on marriage equality but has also encouraged a deeper understanding of what it means to love authentically.

Jennifer Finney Boylan with her wife, Deirdre, in Greece, April 2022.

"IS MY MARRIAGE GAY?"

Amid growing momentum for marriage equality in 2009, Jennifer Finney Boylan's
New York Times **opinion piece, "Is My Marriage Gay?," explored the complexities**
of gender identity and marriage, arguing that love and commitment transcend one's gender
assigned at birth.

As many Americans know, last week Gov. John Baldacci of Maine signed a law that made this state the fifth in the nation to legalize gay marriage. It's worth pointing out, however, that there were some legal same-sex marriages in Maine already, just as there probably are in all 50 states. These are marriages in which at least one member of the couple has changed genders since the wedding.

I'm in such a marriage myself and, quite frankly, my spouse and I forget most of the time that there is anything particularly unique about our family, even if we are what is the phrase? "differently married."

Deirdre Finney and I were wed in 1988 at the National Cathedral in Washington. In 2000, I started the long and complex process of changing from male to female. Deedie stood by me, deciding that her life was better with me than without me. Maybe she was crazy for doing so; lots of people have generously offered her this unsolicited opinion over the years. But what she would tell you, were you to ask, is that the things that she loved in me have mostly remained the same, and that our marriage, in the end, is about a lot more than what genders we are, or were.

Deirdre is far from the only spouse to find herself in this situation; each week we hear from wives and husbands going through similar experiences together. Reliable statistics on transgendered people always prove elusive, but just judging from my e-mail, it seems as if there are a whole lot more transsexuals and people who love them in New England than say, Republicans. Or Yankees fans.

I've been legally female since 2002, although the definition of what makes someone "legally" male or female is part of what makes this issue so unwieldy. How do we define legal gender? By chromosomes? By genitalia? By spirit? By whether one asks directions when lost?

We accept as a basic truth the idea that everyone has the right to marry somebody. Just as fundamental is the belief that no couple should be divorced against their will.

For our part, Deirdre and I remain legally married, even though we're both legally female. If we had divorced last month, before Governor Baldacci's signature, I would have been allowed on the following day to marry a man only. There are states, however, that do not recognize sex changes. If I were to attempt to remarry in Ohio, for instance, I would be allowed to wed a woman only.

Gender involves a lot of gray area. And efforts to legislate a binary truth upon the wide spectrum of gender have proven only how elusive sexual identity can be. The case of J'noel Gardiner, in

Kansas, provides a telling example. Ms. Gardiner, a postoperative transsexual woman, married her husband, Marshall Gardiner, in 1998. When he died in 1999, she was denied her half of his $2.5 million estate by the Kansas Supreme Court on the ground that her marriage was invalid. Thus in Kansas, any transgendered person who is anatomically female is now allowed to marry only another woman.

Similar rulings have left couples in similar situations in Florida, Ohio and Texas. A 1999 ruling in San Antonio, in *Littleton v. Prange*, determined that marriage could be only between people with different chromosomes. The result, of course, was that lesbian couples in that jurisdiction were then allowed to wed as long as one member of the couple had a Y chromosome, which is the case with both transgendered male-to-females and people born with conditions like androgen insensitivity syndrome. This ruling made Texas, paradoxically, one of the first states in which gay marriage was legal.

A lawyer for the transgendered plaintiff in the Littleton case noted the absurdity of the country's gender laws as they pertain to marriage: "Taking this situation to its logical conclusion, Mrs. Littleton, while in San Antonio, Tex., is a male and has a void marriage; as she travels to Houston, Tex., and enters federal property, she is female and a widow; upon traveling to Kentucky she is female and a widow; but, upon entering Ohio, she is once again male and prohibited from marriage; entering Connecticut, she is again female and may marry; if her travel takes her north to Vermont, she is male and may marry a female; if instead she travels south to New Jersey, she may marry a male."

Legal scholars can (and have) devoted themselves to the ultimately frustrating task of defining "male" and "female" as entities fixed and unmoving. A better use of their time, however, might be to focus on accepting the elusiveness of gender and to celebrate it. Whether a marriage like mine is a same-sex marriage or some other kind is hardly the point. What matters is that my spouse and I love each other, and that our legal union has been a good thing for us, for our children and for our community.

It's my hope that people who are reluctant to embrace same-sex marriage will see that it has been with us, albeit in this one unusual circumstance, for years. Can we have a future in which we are more concerned with the love a family has than with the sometimes unanswerable questions of gender and identity? As of last week, it no longer seems so unthinkable. As we say in Maine, you can get there from here.

A LOVE THAT TRANSFORMED A MOVEMENT

Nikki Araguz Loyd's outing as transgender after her firefighter husband's death stirred their small Texas community. Their story and court battles defied bigotry in another step toward marriage rights.

When Nikki Araguz met Wharton Fire Department Captain Thomas Araguz III, it was love at first sight. The two shared a whirlwind romance, culminating in their wedding in August 2008. For Nikki, a transgender woman, and Thomas, a man of unwavering bravery and conviction, their union was a celebration of love and commitment.

But their happiness was cut tragically short. In July 2010, Thomas lost his life battling a devastating fire at an egg farm, leaving Nikki widowed and grieving. As she grappled with her loss, another battle began—a fight not just for her rights but for the dignity of her love and identity.

Thomas's family, led by his mother, Simona Longoria, and his ex-wife, Heather Delgado, challenged the validity of Nikki and Thomas's marriage. They argued that because Nikki was transgender, her marriage to Thomas was void under Texas's same-sex marriage laws. This legal challenge not only denied Nikki access to her husband's death benefits but also barred her from maintaining contact with her beloved stepchildren.

The ensuing court case, *Delgado v. Araguz*, became a watershed moment for transgender rights and marriage equality. In 2011, a state district judge ruled in favor of Thomas's family, voiding the marriage. The decision was a painful blow for Nikki, but her determination never wavered. She appealed the ruling, taking her case to the Texas Thirteenth District Court of Appeals.

In 2014, Nikki achieved a significant legal victory. The appeals court overturned the lower court's decision, affirming her marriage to Thomas and recognizing her as a woman. This ruling not only

gave Nikki hope but also dismantled a longstanding precedent that defined sex as immutable from birth. It was a step forward for the transgender community, a validation of identity that rippled far beyond Nikki's case.

The legal battle escalated to the Texas Supreme Court amid a broader shift in the national legal landscape that altered the stakes. In 2015, the US Supreme Court's decision to legalize same-sex marriage nationwide changed everything. This landmark ruling rendered the core argument against Nikki's marriage moot. Ultimately, the appeals court reaffirmed its decision, upholding Nikki's right to Thomas's estate.

Although the legal victory was monumental, the emotional toll of the years-long fight left lasting scars. Nikki often spoke about the broader significance of her battle, acknowledging that her case had implications far beyond her own life. "I'll celebrate when this fight is truly over," she said, reflecting on the resilience and strength required to see it through.

In the years that followed, Nikki found new happiness. She married William Loyd in a ceremony filled with joy and hope. Her story became more than a legal battle; it offered hope to transgender people everywhere, showing them that they, too, could marry—just like everyone else.

Through her unwavering courage, Nikki Araguz Loyd secured her rightful inheritance and set a precedent for the recognition of transgender marriage rights. Her life, marked by courage, love, loss, and triumph, continues to inspire those who seek a world where everyone's identity and relationships are honored.

Thomas and Nikki Araguz Loyd, Wharton, Texas, 2009.

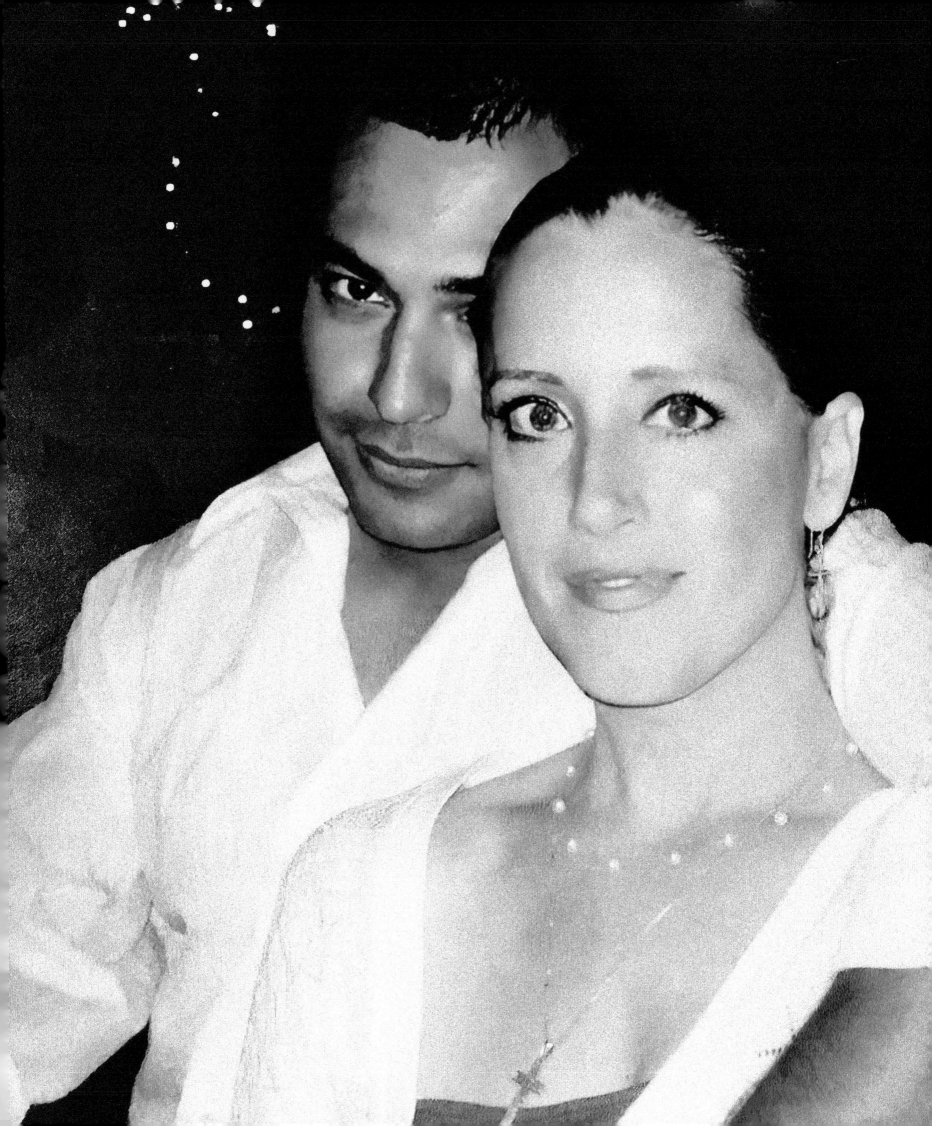

I THEE WED

2010–2013

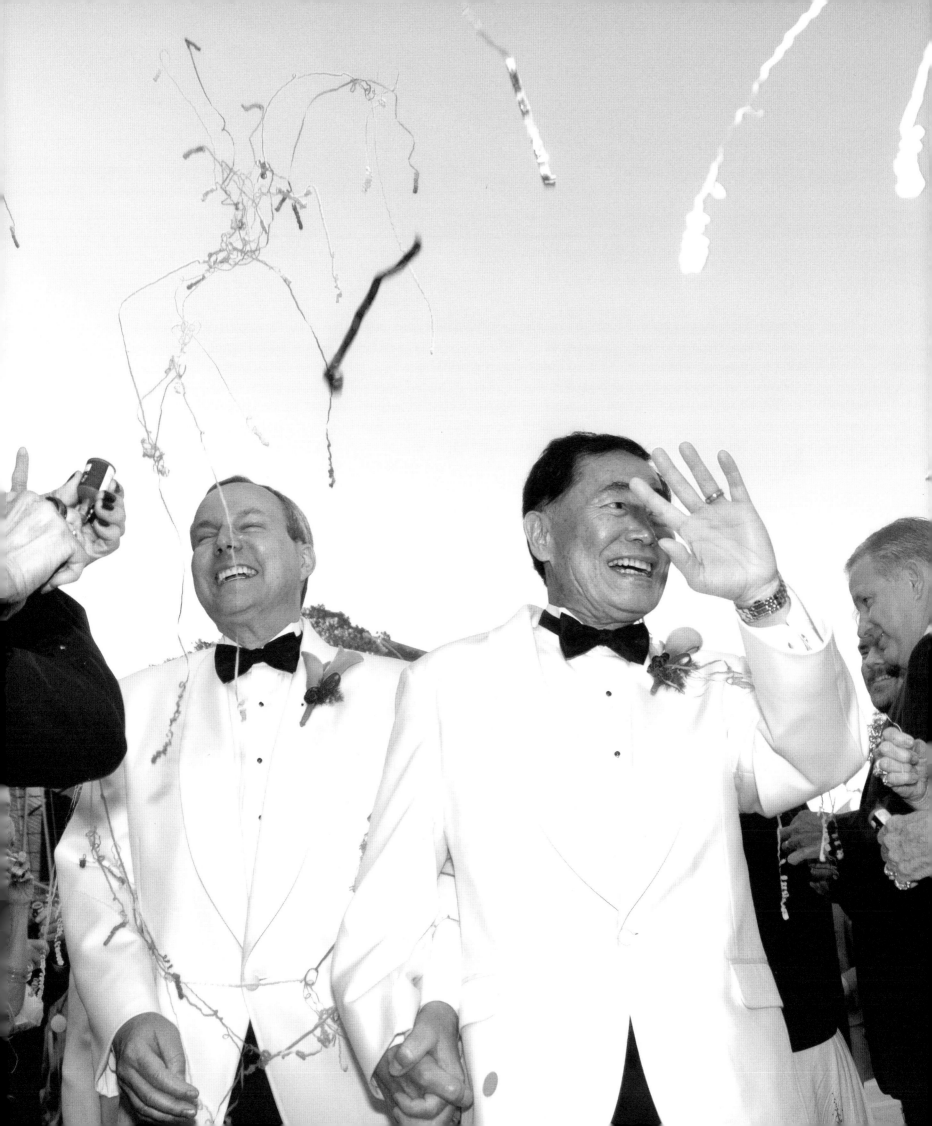

CHAPTER 7 — INTRODUCTION

Significant legal victories changed the landscape of marriage equality in the United States, which underwent a dramatic transformation from 2010 to mid-2013. This transformation altered public opinion and resulted in historic rulings that would forever impact the lives of LGBTQ+ families and reshape the fabric of American society into a more just and inclusive place for queer people.

On January 1, 2010, California made a significant step forward by extending marriage benefits to out-of-state same-sex couples, acknowledging marriages that took place before the Proposition 8 ruling on November 5, 2008. Simultaneously, New Hampshire's same-sex marriage law came into effect, highlighting the increasing acceptance of marriage equality across the country. In the early months of 2010, Maryland Attorney General Doug Gansler issued a legal opinion on February 24, allowing state agencies to recognize same-sex marriages performed in other jurisdictions under the principle of comity. March saw Washington, DC, celebrate the enforcement of its same-sex marriage law, reflecting a growing trend toward legal recognition of LGBTQ+ unions.

A crucial moment in the fight for marriage equality occurred on July 8, 2010, when US District Judge Joseph Tauro declared Section 3 of the Defense of Marriage Act (DOMA) unconstitutional, a decision championed by attorney Mary Bonauto. This landmark ruling arose from two interconnected cases—*Gill v. Office of Personnel Management* and *Massachusetts v. United States Department of Health and Human Services*—establishing a vital legal precedent that would empower future challenges to discriminatory practices faced by married same-sex couples.

The momentum continued to build in early 2011 when Illinois Governor Pat Quinn signed a civil unions bill into law, which received approval from both the state's senate and house. This law took effect on June 1. Shortly thereafter, on February 23, Governor Neil Abercrombie of Hawaii followed suit by signing a comparable civil unions bill, set to take effect on January 1, 2012. On the same day, the Obama administration made a significant announcement, stating that discrimination based on sexual orientation would be subject to heightened scrutiny, and affirming the unconstitutionality of Section 3 of DOMA. This announcement indicated that while they would enforce DOMA's provisions, they would no longer defend challenges to its constitutionality in court.

As the legal battles intensified, Bonauto continued her advocacy, successfully arguing against DOMA's constitutionality at the First US Circuit Court of Appeals in 2012. This ruling was historic; it made the First Circuit the first appellate court to strike down DOMA, further solidifying the momentum of the marriage equality movement. Simultaneously, legislative victories began to emerge across the country.

Page 237: George and Brad Takei—just married—at their Buddhist ceremony held at the Democracy Forum of the Japanese American National Museum in Los Angeles, September 14, 2008. **Opposite:** Thousands of people gather outside San Francisco City Hall to protest the passage of Proposition 8, December 2008.

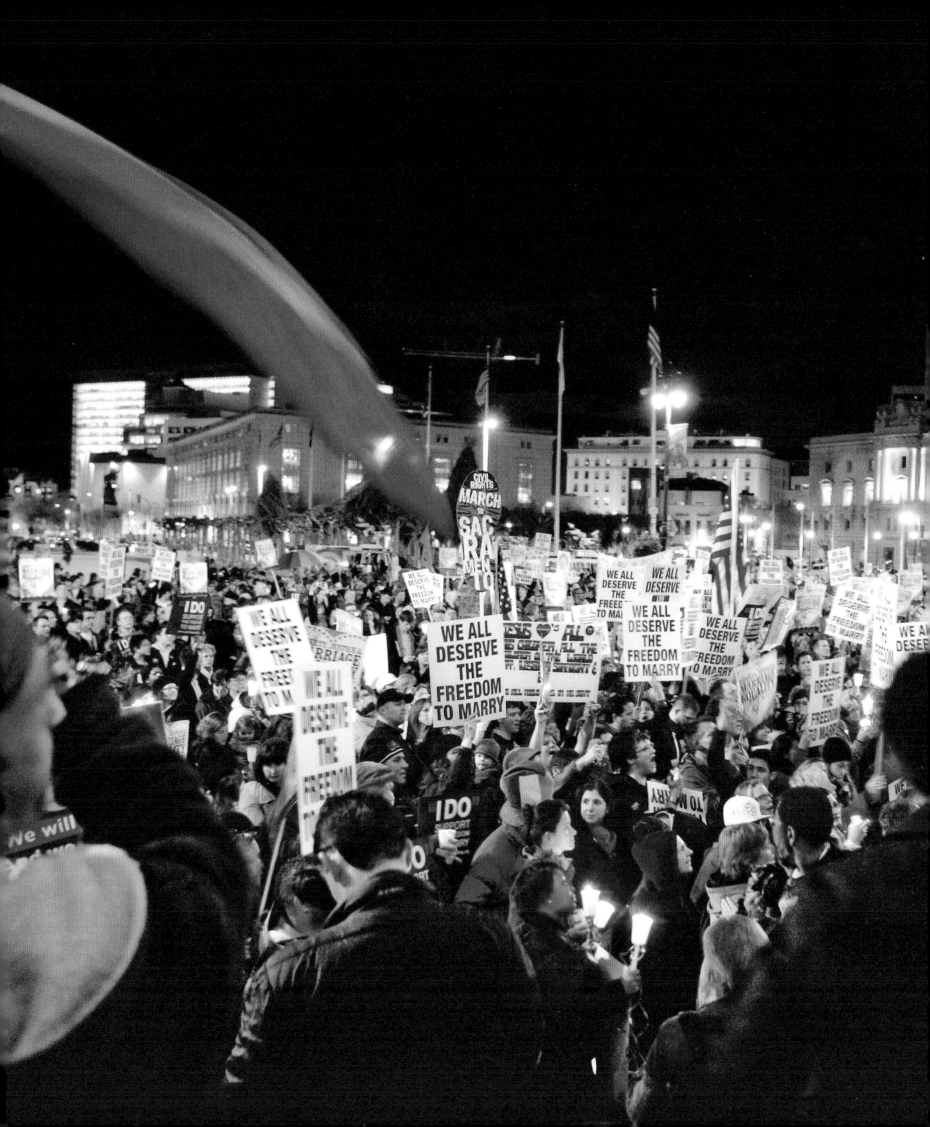

In March 2011, Speaker of the House John Boehner launched an effort to defend DOMA's constitutionality in court by convening the Bipartisan Legal Advisory Group (BLAG), tasked with initiating action by the House to defend the law.

As the legal battles continued, Maryland Governor Martin O'Malley signed a same-sex marriage bill into law on March 1, 2012. The bill had passed with a narrow margin in the state legislature, but opponents quickly organized a referendum for November. In the meantime, on February 13, Governor Christine Gregoire of Washington also signed a same-sex marriage bill into law, further demonstrating the growing acceptance of marriage equality across the nation.

In May 2012, significant events unfolded as President Obama became the first sitting US president to declare his support for legalizing same-sex marriage. During an interview with Robin Roberts of ABC's *Good Morning America*, Obama expressed his belief in the rights of same-sex couples to marry, marking a significant shift in national discourse. In contrast, voters in North Carolina approved an amendment defining marriage as the union of one man and one woman, which would be the last time a voter-approved ban on same-sex marriage would pass.

As 2012 progressed, the US Supreme Court announced it would hear a case regarding DOMA, though it would not be Bonauto's case. Instead, the Court reviewed *Windsor v. United States*, a pivotal case argued by attorney Roberta Kaplan on behalf of Edith Windsor, a widow seeking recognition of her marriage to her late partner, Thea Spyer. Despite initial disappointment at not having her case heard, Bonauto and her team supported Windsor's case by coordinating the filing of amicus briefs, highlighting the unity within the LGBTQ+ advocacy community.

As 2013 began, January 1 marked a historic moment when Maryland's statute authorizing same-sex marriages took effect. On May 2, Governor Lincoln Chafee of Rhode Island signed a same-sex marriage bill into law, which had been passed shortly before by the state legislature and took effect on August 1. The same month, Delaware Governor Jack Markell signed a similar law that would take effect on July 1.

The culmination of years of advocacy and legal battles came on June 26, 2013, when the US Supreme Court issued a monumental 5–4 decision in *United States v. Windsor*. The Court ruled that Section 3 of DOMA was unconstitutional, affirming the dignity and equality of same-sex couples. This ruling declared that the federal government could not deny benefits to legally married same-sex couples, validating the tireless work of advocates like Bonauto and her colleagues.

In a simultaneous ruling, the Supreme Court addressed *Hollingsworth v. Perry*, dismissing the appeal of a district court's decision that upheld the right of same-sex couples to marry in California. This decision effectively lifted the ban on same-sex marriage in California, allowing couples to marry once again after the tumultuous years following Proposition 8, and reassuring the 18,000 couples who had married in 2008 that their licenses and marriages were indeed legal.

The events of June 26, 2013, marked a watershed moment in the fight for marriage equality. The Supreme Court's rulings not only affirmed the legitimacy of same-sex marriages but also sparked celebrations across the country as LGBTQ+ individuals and allies rejoiced in the progress achieved.

Participants carry a giant rainbow flag during LGBTQ+ Pride celebrations on the streets of Palma de Mallorca, 2005.

On this day, the words of Justice Anthony Kennedy echoed throughout the nation, affirming that "the Constitution grants them [same-sex couples] the right to marry" and that DOMA's defense was "an unconstitutional deprivation of the equal liberty" afforded by the Fifth Amendment.

In the years that followed, the lessons learned from this period would inform strategies for advancing LGBTQ+ rights in the final fight to win national marriage rights.

The victories of 2013 served to bolster advocates and allies across the nation to push for the freedom to marry for all in every state, with thirteen states and the District of Columbia now providing full legal marriage rights for all adult couples: Massachusetts, Connecticut, Iowa, Vermont, New Hampshire, New York, Washington, Maryland, Delaware, Minnesota, Rhode Island, California, and New Jersey.

Opposite: Then-Attorney General Kamala Harris, right, officiates at the wedding of Kris Perry, from left, and Sandy Stier, in San Francisco in 2013. **Following spread**: Marriage equality rally in front of the US Supreme Court on First Street between Maryland Avenue and East Capitol Street, NE, Washington, DC, on Tuesday morning, March 26, 2013.

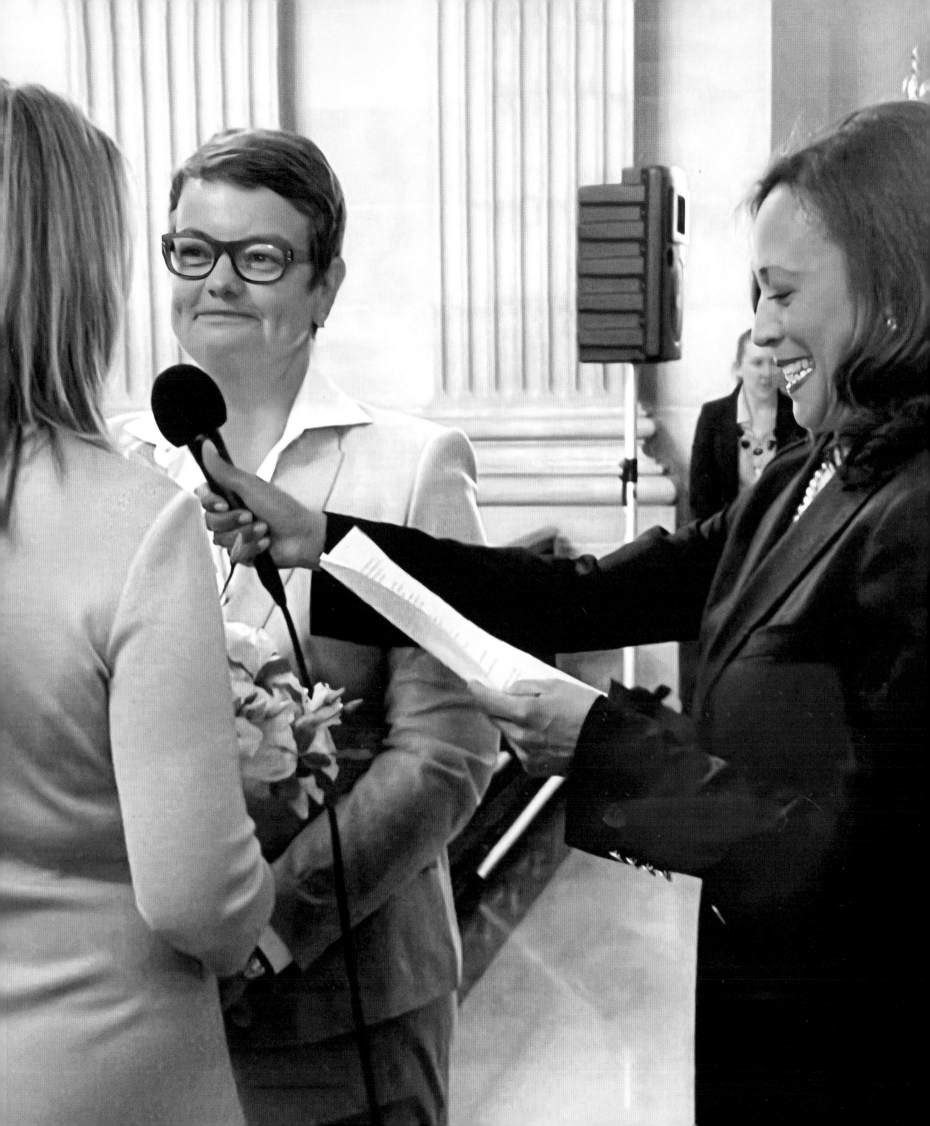

ZACH WAHLS AND HIS TWO MOMS

Zach appeared before the state senate to defend his moms' right to marry, passionately sharing his story as a sixth-generation Iowan, a college student, and most importantly, the son of two moms.

On a chilly evening in 2011, the Iowa State Senate bore witness to a stirring testimony that would resonate across the nation. Zach Wahls, a nineteen-year-old engineering student at the University of Iowa, stepped forward to speak against House Joint Resolution 6, a proposal that sought to end civil unions in Iowa. Wahls's words, heartfelt and eloquent, quickly went viral, earning millions of views and making him an overnight symbol of the fight for LGBTQ+ rights.

Zach Wahls, a sixth-generation Iowan, deeply rooted in the values and traditions of his state, was raised by his biological mother, Terry Wahls, and her partner, Jackie. Theirs may have been a family dynamic different from the traditional norm but it was also founded on love, commitment, and mutual respect. Reflecting on his childhood, Wahls shared a poignant memory of his grandparents' initial reluctance to acknowledge his mother's pregnancy via artificial insemination. "It actually wasn't until I was born, and they succumbed to my infantile cuteness that they broke down and told her that they were thrilled to have another grandson," he recounted. Despite these early challenges, Zach's family remained strong and united.

Growing up with a younger sister who shared the same anonymous donor, Zach experienced a family life that, in his words, was not so different from any other in Iowa. "When I'm home, we go to church together, we eat dinner, we go on vacations," he testified. However, like any family, they faced their share of hardships, notably his mother Terry's diagnosis of multiple sclerosis in 2000, which confined her to a wheelchair. Through these struggles, his family exemplified resilience and the quintessential Iowan spirit of self-reliance.

As a student at the University of Iowa, Zach frequently encountered debates about same-gender marriage. He often found himself at the center of these discussions, challenging misconceptions about the capabilities of his parents. "The question always comes down to, well, can gays even raise kids?" he noted. His response was both personal and powerful: "I was raised by a gay couple, and I'm doing pretty well. I scored in the 99th percentile on the ACT, I'm actually an Eagle Scout, I own and operate my own small business." He noted "If I was your son, Mr. Chairman, I believe I'd make you very proud."

Zach's testimony underscored a fundamental truth about families: their worth does not derive from legal recognition but from the love and commitment shared among its members. "Your family doesn't derive its sense of worth from being told by the state, 'You're married, congratulations.' No, the sense of family comes from the commitment we make to each other; to work through the hard times so we can enjoy the good ones. It comes from the love that binds us. That's what makes a family."

In his closing remarks, Wahls made an appeal to the lawmakers, urging them to recognize the humanity and equality of all Iowans. He argued that the vote on House Joint Resolution 6 was not just about changing the definition of family but about codifying discrimination into the state constitution. "You are telling Iowans that some among you are second-class citizens who do not have the right to marry the person you love," he stated emphatically.

"In my nineteen years, not once have I ever been confronted by an individual who realized independently that I was raised by a gay couple. And you know why? Because the sexual orientation of my parents has had zero effect on the content of my character," he declared, quoting Dr. Martin Luther King Jr. to drive home his point.

Zach Wahls's speech before the Iowa State Senate was more than just a personal narrative; it was a call to action and a plea for equality. His honesty and openness seeped into the populace of Iowa and would eventually earn Zach a seat in the Iowa State Senate in 2018 and reelection in 2022.

The cover of Zach Wahls's 2021 book, *My Two Moms: Lessons of Love, Strength, and What Makes a Family.*

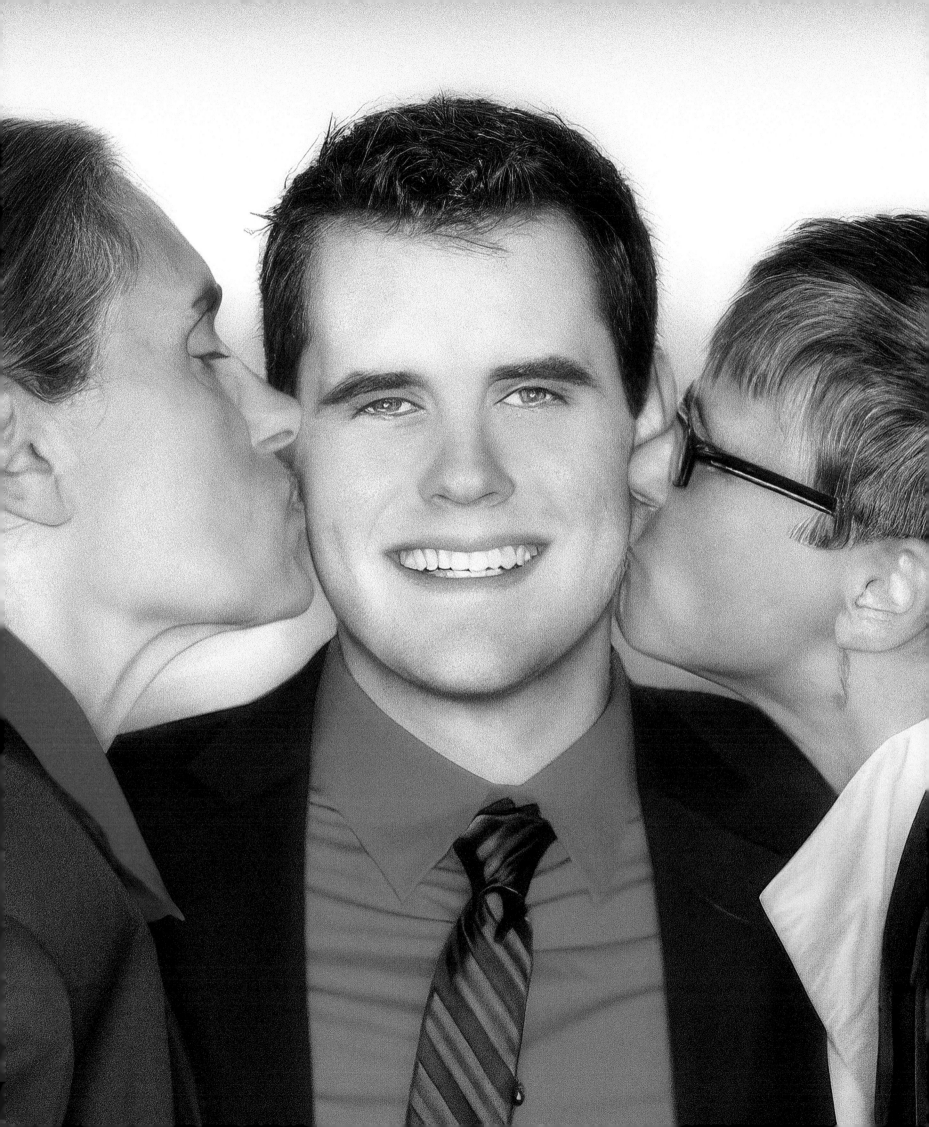

MICHAEL LOMBARDO AND SONNY WARD

Their love story touched Joe Biden's heart, inspiring him to embrace marriage equality during his time as vice president.

In the spring of 2012, the Human Rights Campaign, a prominent gay rights organization, reached out to Michael Lombardo, who was then the president of HBO, to host an event for Vice President Joe Biden. This was not a fundraiser but a meet-and-greet aimed at connecting the vice president with LGBTQ+ individuals in the entertainment industry.

The event was intended to mend fences. As former President Barack Obama and former Vice President Biden were gearing up for reelection in 2012, there was a sentiment within Hollywood's queer community that the administration had not fully met their expectations. Obama had signed a bill in 2010 to repeal the Clinton-era "Don't Ask, Don't Tell" policy and had directed the Justice Department in 2011 to stop defending the Defense of Marriage Act; however, LGBTQ+ supporters in the entertainment sector, who had backed Obama in 2008 only to witness the passing of California's discriminatory Proposition 8, demanded more substantial action from the administration.

Lombardo, along with his spouse, Sonny Ward, and their two children, welcomed Biden into their Los Angeles home. Biden's approach was remarkably personal; he spent significant time engaging with Lombardo's children and the family, showing a genuine and unguarded side that deeply moved them. Lombardo recalls that Biden was so absorbed in his interaction with the family that his aides had to prompt him to engage with other guests.

On May 6, 2012, shortly after this event, Ward received a text from his aunt in Mississippi

suggesting they watch *Meet the Press*. On the program, David Gregory asked Biden if the administration was rethinking its stance on same-sex marriage. While Biden deferred to Obama on policy, he spoke warmly about the TV show *Will & Grace* and shared his experience of meeting Lombardo and Ward's children. He summed up his view with a simple yet profound question, "Who do you love?"

Biden's spontaneous remarks positioned him ahead of Obama and much of the Democratic establishment on the issue of same-sex marriage. Just three days later, Obama followed Biden's lead and announced his support for gay marriage in an interview with ABC's Robin Roberts.

Lombardo, now the president of global television at Entertainment One, continued to support Biden, backing his 2020 presidential campaign when it had limited industry support. He even hosted another event at his home during the early primaries. Lombardo notes that despite his children being much older, Biden remained the same—authentic and deeply engaged.

Lombardo viewed Biden as a remedy for the divisiveness of the first Trump administration, emphasizing Biden's rare qualities of morality, humanity, and authenticity. After four turbulent years in Washington, Lombardo believes these attributes were precisely what the country needed. Biden was the first president elected in full support of marriage equality, marking a significant milestone in the fight for LGBTQ+ rights.

BY POSING THE QUESTION
"WHO DO YOU LOVE?,"
JOE BIDEN HIGHLIGHTED
THE UNCONDITIONAL NATURE
OF PARENTAL LOVE AND
ITS PROFOUND IMPACT ON
SHAPING OUR LIVES.

KRIS PERRY AND SANDY STIER

When Kris Perry and Sandy Stier agreed to be plaintiffs in the legal challenge to overturn California's Proposition 8, they saw themselves simply as everyday moms aiming to protect their family of six.

If someone told you a story about a lost engagement ring that turned up in a garbage bag, you would assume that they were talking about a TV sitcom episode. But for Kris and Sandy, it was a true, fraught-filled situation. It could also describe their attempt to be legally married.

"I proposed to Sandy on Christmas Eve, 2000," Kris recalled. "We'd been a couple for a while. Our new family, including our four boys, seemed happy, and I was ready to seal the deal. It was a warm, sunny day, and I suggested we walk to Indian Rock in the Berkeley Hills outside of San Francisco, which was one of our favorite spots."

With her hand in her pocket clutching a tiny velvet box, Kris asked Sandy to marry her. "I'd never proposed to anyone before, and I wasn't sure if her stunned response was normal, which was a little restrained for her," Kris reflected. Finally, Sandy said, "Yes." Then, "But how would we do that?" Kris replied, "I don't know . . . we will figure it out together."

When Sandy put the ring on, it was too big, but she refused to take it off, wearing it that night and on Christmas Day. "I wanted to look at it. And while the kids were opening their presents, I was throwing the wrapping paper away, and at one point, I looked down in horror, realizing the ring was gone," Sandy remembered.

The couple went outside and grabbed all the garbage bags and sorted through them. Kris recounted, "Just as we both lost hope, the ring appeared at the bottom of the last full bag. Before either of us said a word, I gave Sandy a look that said, 'Don't move.'" She then ran to their room, "grabbed the velvet box, and put the ring gently back inside. When I came

back into the living room, Sandy was slumped on the couch, exhausted and traumatized."

Once the ring nightmare was over, Sandy and Kris sat down together and started the process of figuring out how to get married in California, a state that banned same-sex marriage.

In early 2004, the mayor of San Francisco, Gavin Newsom, first opened the doors for LGBTQ+ couples to marry. And on a beautiful first day of August, Kris and Sandy, with their four boys in tow and surrounded by family and friends, exchanged vows. "When we got married in San Francisco, we were thrilled for the opportunity to get married," Sandy recollected. "But I think we were both a little bit tentative about it in terms of, is this going to be real?"

After their honeymoon in Italy, they returned home to find an envelope awaiting them. On August 12, the Supreme Court of California voided all recent same-sex marriages. "We had let ourselves experience this feeling of being married and happy. We told people we were married, and accepted their gifts and congratulations," Kris explained. "Then we received that cold letter, and the ensuing humiliation that comes with having to tell people that you are no longer married. It was so unfair and irrational that you had to really work hard to feel hopeful. It was very, very, very tough."

They didn't have the same legal rights and protections as married, straight couples, a fact that continued to grate on them. Equality California's leader Geoff Kors convinced the legislature twice to approve a marriage bill without a court mandate, but both times the bills were vetoed by Governor Arnold Schwarzenegger.

Kris Perry and Sandy Stier with their four boys—Tom, Spencer, Elliott, and Frank—at their first wedding in Tilden Park, Berkeley, California, 2004.

Then, a window for marriage equality opened in June of 2008, when the State of California started issuing marriage licenses to same-sex couples as a result of a ruling by the Supreme Court of California. That would last until November, when Proposition 8, which eliminated the right to same-sex marriage, was approved by the state's voters.

"In many ways, the experience we had in San Francisco dictated how we handled that summer of 2008," Sandy pointed out. "And at that point, the children were older, we were older, we had been hurt by the first process. And we said no, we will not do it this way. Which also unexpectedly led to us being able to be plaintiffs in the federal lawsuit that eventually overturned Proposition 8, because we did not marry in the window."

Before they decided to get involved in the federal case, they discussed it at length. Their kids gave them the thumbs-up. Then Kris and Sandy jumped in, joining Jeff Zarrillo and Paul Katami in suing to overturn Proposition 8.

Kris was the "Perry" in the lawsuit *Perry v. Schwarzenegger*. The case, which quickly gained national attention, argued that Proposition 8 violated the Due Process and Equal Protection Clauses of the Fourteenth Amendment. The district court trial began on January 11, 2010, presided over by Judge Vaughn Walker; he ultimately ruled, on August 4, 2010, that Proposition 8 was unconstitutional, stating that it served no purpose other than to lessen the dignity and humanity of gay and lesbian couples.

Following Judge Walker's decision, the defendants appealed; the case was heard before the Ninth Circuit Court of Appeals, which upheld the lower court's ruling on February 7, 2012. The case then advanced to the US Supreme Court.

On June 26, 2013, the Supreme Court, in a 5–4 decision, dismissed the appeal on the grounds that the proponents of Proposition 8 did not have legal standing to appeal the decision of the district court. This effectively upheld the lower court's ruling, allowing same-sex marriages to resume in California. The decision was a significant milestone in the fight for marriage equality and paved the way for the eventual nationwide legalization of same-sex marriage in 2015, with the Supreme Court's decision in *Obergefell v. Hodges*.

Finally, Kris and Sandy were ready to get married—hopefully for the final time. Their wedding included a performance by the San Francisco Gay Men's Choir, and a very special celebrant: the California attorney general at the time, Kamala Harris. "She declared us 'spouses for life,'" Kris reminisced. "And after our kiss, she embraced us warmly. From the Harvey Milk Balcony at city hall in San Francisco, we beamed at the crowd, soaking in the love and support from everyone, including Kamala."

While finally getting married was sweet and beautiful for Kris and Sandy, it was not easy getting there. That's something that gets lost in their story—the struggle to gain victory. "Looking back, there was far more pressure and stress on us as a couple, and as a family. It was a very trying time for all of us," Sandy said. "We had to withstand a fair amount of being busy, distracted, scared, and anxious."

Distracted? Scared? Anxious? Those were the same feelings Kris and Sandy had during the caper of the lost engagement ring. And while the ring was found, the legalization of their marriage is not something they will ever take for granted. "Making sure our marriage remains valid requires constant vigilance and effort," they both agreed.

As they stated in the opening of their book, *Love on Trial: Our Supreme Court Fight for the Right to Marry*, "We never expected, once we'd won, we might have to fight all over again. But that seems to be the way when it comes to human rights. When you think the war is won—think again."

252 Kris Perry and Sandy Stier relish the moment just after being pronounced "spouses for life" at San Francisco City Hall Rotunda, 2013.

PAUL KATAMI AND JEFF ZARRILLO

Paul Katami and Jeff Zarrillo joined Kris Perry and Sandy Stier in a four-and-a-half-year legal battle against California's Proposition 8, ultimately lifting the state's ban on gay marriage at the Supreme Court.

When the fight for marriage equality in California and the US is discussed, Jeff and Paul stand out for how they quietly, unassumingly stepped into history. Jeff was the manager of a multiplex cinema in Burbank, California, and Paul was a fitness instructor. Their regular lives and simple love story are integral to why queer couples can now tie the knot.

After Proposition 8 was passed in California in 2008, liberal strategists began organizing a legal challenge. They brought together an unlikely legal pairing: Ted Olson, a prolific Supreme Court practitioner, and David Boies, an attorney skilled in high-profile, strategic litigation, who had represented opposing sides in the infamous *Bush v. Gore* Supreme Court case after the 2000 election. The next step was to find ideal plaintiffs willing to put their names—and lives—on a legal document to sue the state of California and its imposing governor, Arnold Schwarzenegger.

Jeff and Paul had no reason to believe it would be them. They met online and had been a couple for twelve years, coming out to their families and moving in together, all the while growing more in love. While politically aware, they weren't activists. Jeff, who had started taking tickets at his local AMC movie theater in New Jersey as a teenager, eventually became an AMC manager in California—the only company he had ever worked for. After earning a Master of Fine Arts at UCLA, Paul dabbled in acting and eventually

became a full-time personal trainer. He developed an exercise called the Katami Bar, which he turned into an infomercial, and posted training videos online.

Paul's video expertise came into play when he was upset by an ad produced by the National Organization for Marriage titled "The Gathering Storm." The video featured doctors, ministers, and parents expressing fears about the rise of same-sex marriage. Determined to counter this narrative, he assembled a team and created a YouTube rebuttal called "Weathering the Storm." This effort caught the attention of the American Foundation for Equal Rights (AFER), recently founded by Hollywood producer and actor Rob Reiner, which was searching for plaintiffs to challenge Proposition 8.

After speaking to several couples, the Olson and Boies teams were delighted to bring on Kris Perry and Sandy Stier as plaintiffs. Kris and Sandy, two women from Oakland, California, had four boys and attempted to marry in 2004 but had their marriage licenses voided along with some four thousand other couples. Like Jeff and Paul, they did not marry during the summer of 2008 when a ruling by the California Supreme Court temporarily allowed the state to issue marriage licenses to same-sex couples. As both couples feared, the voter initiative placed on the ballot a few months later, Proposition 8, took that right away once again.

256 **Previous spread**: Attorney David Boies and members of the plaintiff's team in the *Hollingsworth v. Perry* case are photographed on the steps of the Supreme Court in Washington, DC, on June 26, 2013. From left to right: Plaintiffs Jeff Zarrillo, Chad Griffin (the president of the Human Rights Campaign at the time), Sandy Stier, and Kris Perry, celebrating the Supreme Court's decision. **Opposite**: Paul Katami and Jeff Zarrillo getting dressed to wed in Palm Springs, California, June 28, 2014.

In their brief, Jeff and Paul's attorneys acknowledged the uniqueness of marriage and their clients' simple wish to be included. They wanted to start a family, but they also wanted to marry first. It was a simple ask from a simple couple who only wanted to make their love legal. But it wasn't simple.

The case, known as *Perry v. Schwarzenegger*, quickly received significant media attention across the country. In August 2010, the judge overseeing the case, Vaughn Walker, ruled Proposition 8 unconstitutional, stating it served no purpose other than to diminish the dignity and humanity of gay and lesbian couples. The decision was appealed before the Ninth Circuit Court of Appeals, which upheld the ruling in February 2012. The case then proceeded to the US Supreme Court. On June 26, 2013, the Supreme Court dismissed the appeal in a 5–4 decision, citing that the proponents of Proposition 8 lacked legal standing to appeal the district court's decision. This effectively upheld the lower court's ruling and allowed marriage for all to resume in California. This decision was a pivotal moment in the fight for marriage equality, opening up marriages in one of the largest and most liberal states in the Union. And as more queer people were allowed to marry, polls showed the populace rapidly moving in favor of full marital rights for all.

Jeff and Paul rode the wave of fighting and frustration to eventual victory with Kris and Sandy, and David and Ted. Finally, their simple wish came true. On June 28, 2013, Paul and Jeff were married at Los Angeles City Hall by Mayor Antonio Villaraigosa. Both Boies and Olson were in attendance.

Their story helped inspire the documentary *The Case Against 8*, produced by AFER; Reiner's company, Castle Rock Entertainment; and filmmakers Ben Cotner and Ryan White, which won the Directing Award for US Documentaries at the 2014 Sundance Film Festival. It also helped inspire the play *8*, which recounts the closing arguments of the case in front of Judge Walker. The play was created by Oscar-winner Dustin Lance Black and premiered on Broadway at the Eugene O'Neill Theater in New York on September 19, 2011. At the opening, Matt Bomer portrayed Jeff, while Cheyenne Jackson played Paul. The play used actual court transcripts from the federal trial of California's Proposition 8 and firsthand interviews. *8* presented both sides of the debate, offering a moving and insightful look into the battle for marriage equality.

Opposite: Paul Katami and Jeff Zarrillo moments after saying, "I do," in Palm Springs, California, June 28, 2014.

Pages 260–61: A couple of fifty-one years holds hands during the thirty-ninth annual New York Gay Pride Parade on June 29, 2008.

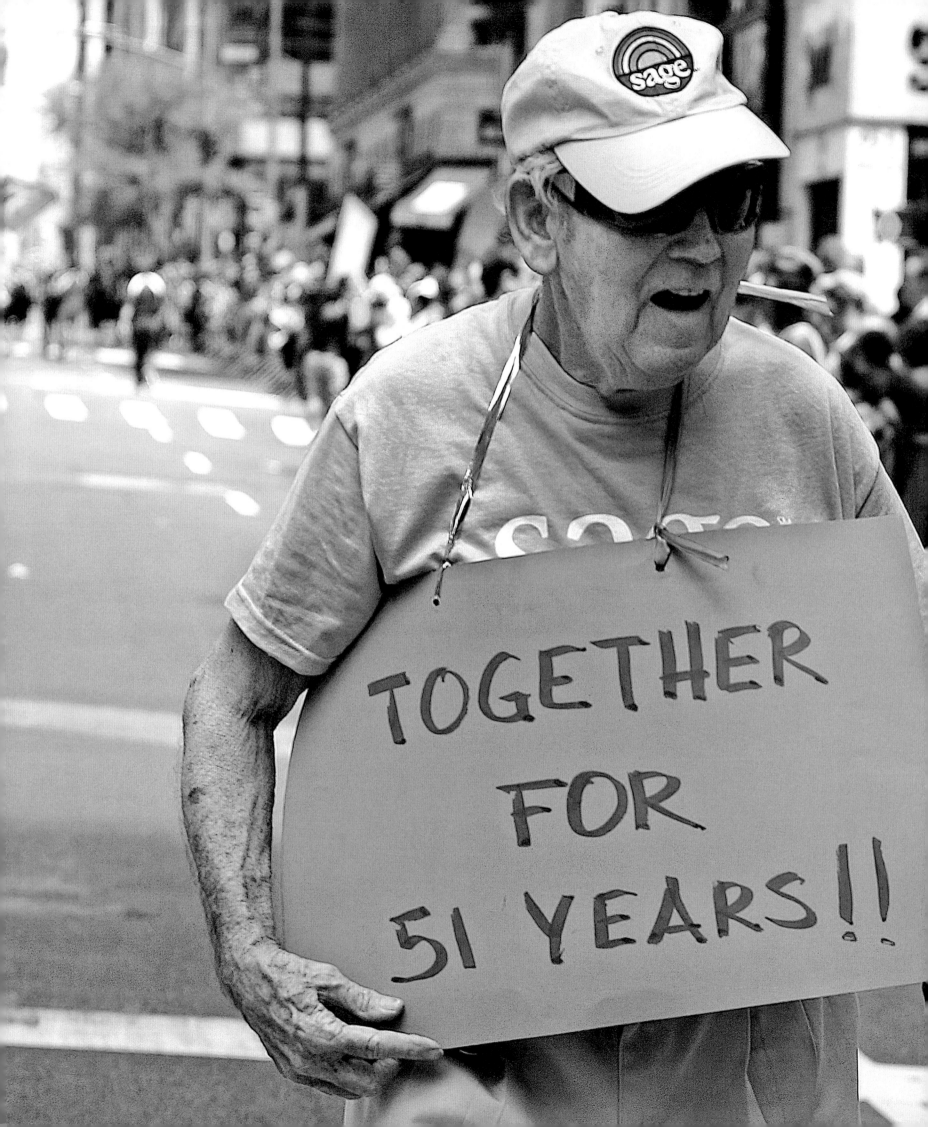

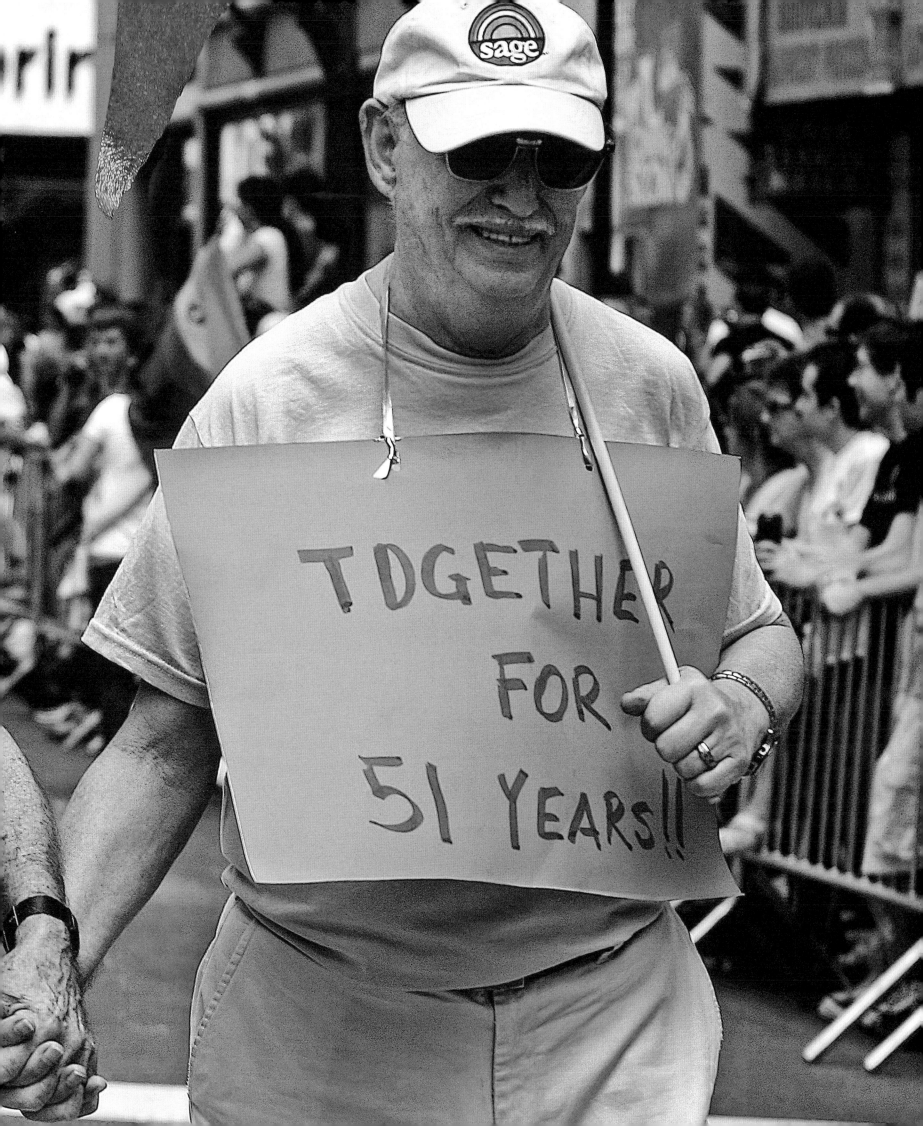

AISHA MILLS AND DANIELLE MOODIE

Their love story became the essence of bold.

Normally, when a friend asks you to help them move, your altruistic side says, "Yes!" Meanwhile, your lazy side asks, "How can I get out of this?" But when Danielle Moodie arrived to help a friend, Rashad, move from Washington, DC to New York sixteen years ago, a surprise was waiting for her. Aisha Mills, another friend of Rashad, was already in Rashad's apartment, busy being altruistic. And when Danielle and Aisha made eye contact, it became the best move they ever made.

They had their first date at a sushi restaurant soon after Rashad's apartment was emptied, and five years later, they returned to the same restaurant. This time, Danielle had a surprise: she proposed to Aisha. This was in March of 2010, when marriage became legal in the nation's capital, and they became one of the first same-sex couples to apply for a marriage license in Washington.

When they wed in August, they achieved another first. They became the first Black lesbian wedding to be featured in *Essence* magazine. This moving feature story provided much-needed visibility for LGBTQ+ people of color, challenging stereotypes and highlighting diversity within the Black community. Their wedding was not only a personal milestone but also a significant cultural moment that moved many others.

Upon their wedding, Aisha and Danielle made professional moves and became one of DC's new power couples. Both were involved in politics and advocacy, but unlike a James Carville–and–Mary Matalin marriage of rival wonks, Aisha and Danielle were both on the same side, sharing a passion for equality.

Nearly fifteen years after they wed, they not only are still in love but remain influential voices in their respective fields. Aisha is a political strategist and social impact advisor. She has worked on numerous local and national campaigns and initiatives aimed at advancing LGBTQ+ rights and racial justice. She has held leadership positions in various organizations, including serving as president and CEO of the LGBTQ+ Victory Fund, an organization that recruits and supports LGBTQ+ candidates and elected officials nationwide. Danielle remains a prominent political commentator and host of the podcast *Woke AF Daily*, which provides incisive commentary on political and cultural issues, with a focus on social justice and equity.

Together, the couple are movers and shakers, continuing their unwavering commitment to equality and justice and helping to move the needle of inspirational change for future generations—a perfect metaphor for Aisha and Danielle since their love story began with a move that shook their lives for the better.

Danielle Moodie and Aisha Mills dance the first dance at their wedding, Orchard Hill at Old Westbury Gardens, Long Island, New York, August 7, 2010.

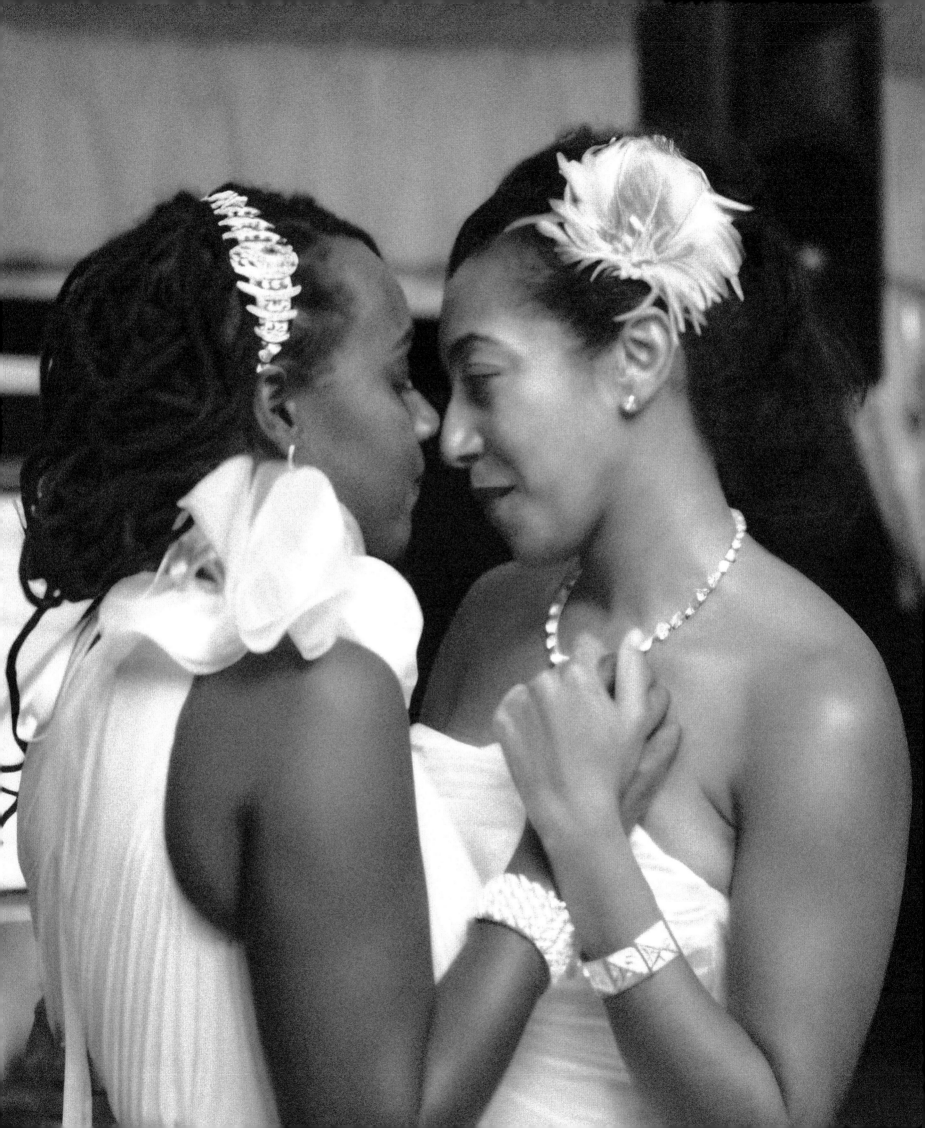

DENNIS ENGELHARD AND KELLY GLOSSIP

Missouri honored Dennis Engelhard in death but not in love. The refusal to recognize and support his family sparked statewide awareness of the importance of marriage equality.

You need not be a Christian, or even a religious person at all, to be moved by the Christmas Day tragedy of Corporal Dennis Engelhard. The officer—who usually spent Christmas morning opening presents with his fiancé—was killed while helping others on a treacherous stretch of snowbound Interstate 44 near Eureka, Missouri. An SUV skidded out of control and struck him just as he finished assisting a motorist who'd had a minor accident.

Dennis was working as a Missouri trooper, a job he had held for nearly ten years. He was the twenty-eighth member of the Missouri State Highway Patrol to die in the line of duty. The details were heart-wrenching. His devastated fiancé, Kelly Glossip, spoke to the local media about how it had been on Christmas Day—precisely twelve years before the tragedy—that the couple had exchanged rings and made a lifelong commitment to one another.

But that year, 2009, had been different because they had decided to exchange presents on Christmas Eve, rather than wait—as was their custom—for Christmas Day. It's a mystery, Kelly says, why they happened to change the routine that year at the home they owned together.

He spoke about holding Dennis's hand in the hospital, even after he had passed away, and about the devastation of losing a soul mate on such a special day. Kelly reminisced about their faith and about the support received from the church they had attended weekly together.

Dennis certainly didn't die without recognition from the state he was serving. Governor Jay Nixon ordered flags across Missouri lowered to half-mast in his honor. "Corporal Engelhard embodied the very best of the Missouri State Highway Patrol— dedicated service to the people of Missouri," said John Britt, director of the Missouri Department of Public Safety. "In addition to serving almost ten years with the patrol, Dennis worked as a paramedic and as a flight paramedic. In all, he spent a quarter of a century bravely and selflessly helping to save lives and assisting those in need." A memorial service at the couple's church, Christ Church Cathedral, drew hundreds of mourners. Dennis left behind a wonderful legacy. That, however, is hardly the end of the story. It has a footnote that would make this trooper's death very different from the twenty-seven that had preceded it.

The love of Dennis Engelhard's life, his grieving fiancé, was another man. And that man, Kelly Glossip, was not entitled to the MoDOT survivor benefits that would have gone to the corporal's spouse were he married to a woman. Kelly, struggling to make payments on the house they jointly owned, filed a lawsuit—with the help of the American Civil Liberties Union (ACLU)—claiming that he "simply seeks the same survivor benefit that the state has chosen to offer only different-sex, surviving partners of [Highway Patrol] employees."

This, of course, is where their story stops being a Christmas tearjerker. This is where it becomes just another dispatch from the escalating culture wars.

264

Many objected to the characterization of Kelly as the "fiancé" of the late paramedic. But that is how Dennis chose to describe his partner in 2000 when he named him the sole beneficiary of his deferred compensation plan at the highway patrol. Dennis designated Kelly as a fifty-percent beneficiary of a life insurance policy obtained through his state position. The two jointly owned the house, five cars, and two trucks, and shared responsibility for the loans and insurance on them.

Kelly, self-described as bisexual, had a son from a previous marriage for whom Dennis served as stepfather. They shared financially in child support. The two spent a total of fifteen years together. Whatever some might think of the morality or acceptability of their relationship, this much is

irrefutable: It wasn't casual. It wasn't some short-run episode of promiscuity, a dating relationship, or just a good friendship. There seems little doubt that theirs was a love story. It's simply one that could not be recognized in the State of Missouri during their time together.

Neighboring Iowa was one of five states that had legalized marriage equality. Kelly stated that he and Dennis had discussed getting married there but decided it would be pointless as long as it wasn't accepted in Missouri. Neighboring Illinois's legislature had passed a civil union bill that provided same-sex couples with some of the benefits that the fallen trooper would have wanted for his mate. But that law did nothing for a Missouri resident either.

Dennis Engelhard and Kelly Glossip, Missouri, 2006.

Missouri voters had been clear on the subject, overwhelmingly enacting a constitutional amendment banning marriage equality in 2004. Civil unions were also out of the question in the "Show Me State." The same state that flew its flags at half-mast for Corporal Engelhard was fully committed to denying his life partner any form of assistance. So, the story of a hero became the story of a lawsuit. And when the ACLU became involved, it lost its warmth and fuzziness in the public eye.

Legally, the ACLU and Kelly faced an uphill battle. If Corporal Engelhard had left behind a female, heterosexual fiancée with whom he had maintained a fifteen-year relationship, shared ownership in a house, and all the rest, she would not have been entitled to survivor benefits as a

spouse. It would have been wonderful if Dennis's wishes could have been honored in this case. The lawsuit did advance that Kelly and Dennis were as married as they could be in the State of Missouri. "They intertwined their lives together emotionally, spiritually, and financially, and cared for each other in sickness and in health," the lawsuit read. "The loving, committed relationship was, in all relevant aspects, the functional equivalent of a spousal relationship."

The only reason they weren't married was that they weren't allowed to marry. The story put a human face—a stereotype-smashing, heroic human face—on a subject that was too often depersonalized as a matter of agenda, lifestyle, or political philosophy. This one broke the mold.

266 **Top:** Dennis Engelhard and Kelly Glossip dressed as cowboys, Silver Dollar City, Branson, Missouri, 1995.
Opposite: Kelly, Dennis, and Zachary Glossip at a portrait studio, Missouri, 1996.

Dennis was not only a man who served the people for a decade as a state trooper but one whose life's work as a paramedic was about saving others' lives, often at great risk to himself.

Men and women like Corporal Engelhard come to the rescue of people of all walks of life, all races and religions and sexual orientations, without prejudice. Would any of those who were saved, or had a friend or loved one saved, want anything but the best in life for the hero of their story? It wasn't Dennis's heroism that should have entitled him to have his wishes respected in death. It was because he had shared his life with another person who was so special to him. They just wanted to be treated like other couples. You shouldn't have to be a hero to get that. Yet that was the grim reality for Kelly, struggling to pay bills and care for their son, Zachary.

Dennis's belongings went to his next of kin, his parents. Kelly lost complete control of the obituary and the funeral arrangements. "Anything that he had on his body at the time, whether it was mine

or not, his family got. At the funeral that they arranged for him, they skipped over fifteen years of his life. From 1995 to 2009, they just, it's like it didn't exist. They did show pictures of our dogs. They were just trying to sweep it under the carpet that their son was gay. It's like they were ashamed of him. And we never were ashamed of each other."

The other twenty-seven opposite-sex spouses who were lost in the line of duty received financial help from organizations like Masters, but Kelly was turned down. The ACLU helped him get his case in front of the Missouri supreme court, which ruled against support for Kelly and Zachary. Kelly continued to do his best to provide but suffered what friends described as several grief-related strokes. Zachary would then have to go live with his relatives. Kelly continued to go to church but grew lonelier and more depressed, missing the man who told him every morning that he was the love of his life.

He lived to see national marriage equality pass in 2015. He passed away a month later.

FROM CIVIL UNIONS TO MARRIAGE, ADVOCACY AND ALLIES FUEL A RISING TIDE OF MARRIAGE EQUALITY ACROSS THE COUNTRY.

From 2010 to 2013, the Defense of Marriage Act (DOMA) rendered marriages other than those between a man and a woman illegal across much of the United States. Despite this, love was in the air. While Edie Windsor's case was making its way through the courts, leaders like Andrew Cuomo, Christine Gregoire, Martin O'Malley, Jack Markell, and Lincoln Chafee recognized the importance of equality and used their platforms to advocate for change. Organizations such as Freedom to Marry, EqualityMaine, and Minnesotans United for All Families worked tirelessly to educate voters and legislators, ensuring that the voices of LGBTQ+ couples were heard. These victories not only transformed the lives of countless couples but also set the stage for three crucial future court cases.

All of this was bolstered by a rising public approval for marriage equality, partially fueled by high-profile couples who garnered major media attention. Elton John and David Furnish, while not US citizens, were particularly outspoken during the movement, broadening the conversation around the terminology of these rights. Despite having a civil ceremony in 2005, Elton expressed his desire to marry David and make history again, penning an article for *Vanity Fair* in which he stated, "I know a lot of people will say we should count ourselves lucky to live in a country that allows civil partnerships and call it quits there. I don't accept that. I don't accept it because there is a world of difference between calling someone your 'partner' and calling them your 'husband.' 'Partner' is a word that should be preserved for people you play tennis with or work alongside in business. It doesn't come close to describing the love that I have for David, and he for me. In contrast, 'husband' does. A 'husband' is somebody that you cherish forever, that you would give up everything for, that you love in sickness and in health. Until the law recognizes David Furnish as my husband, and not merely my partner, the law won't describe the man I know and adore. But of course, this isn't about me and David. It's about something so much greater than either of us—something that predates us by centuries and will carry on for centuries after we, and Zachary, and his children, are gone. That is the fight for equality."

In 2010, New Hampshire became one of the first states to legalize same-sex marriage through legislation. The push for equality began earlier, with the state legalizing civil unions in 2007 under Governor John Lynch, who was initially hesitant about marriage but signed the civil union bill. By 2009, Lynch had evolved on the issue, driven in part by growing public support and efforts from local advocacy groups like GLBTQ Legal Advocates & Defenders (GLAD). The bill passed narrowly in the legislature, and Governor Lynch signed it into law, making New Hampshire the fifth state to legalize same-sex marriage. He noted, "I have always believed that strong families are the foundation of our society, and we must continue to work to strengthen and support all families." His change of heart and willingness to listen to constituents and LGBTQ+ activists were pivotal in the state's victory.

Opposite: Elton John and David Furnish become legal husbands on December 21, 2014. **Following spread:** Catherine Shepherd and Brandi Carlile attend the 2024 Gershwin Prize for Popular Song award presentation to Elton John and Bernie Taupin by the Library of Congress at DAR Constitution Hall on March 20, 2024, in Washington, DC.

In Washington, Governor Christine Gregoire became a vocal advocate for marriage equality, transitioning from her initial support of civil unions to fully backing same-sex marriage. In 2012, Gregoire signed a bill legalizing same-sex marriage. However, opponents quickly organized to put the law to a public vote through Referendum 74.

Brandi Carlile married Catherine Shepard in 2012 and actively worked to end Washington State's ban on marriage equality. As Referendum 74 loomed, Carlile passionately urged her fans to support marriage equality. She expressed her desire to marry her partner, Catherine Shepard and described the barriers LGBTQ+ couples faced, from hospital visitation rights to inheritance issues. Carlile emphasized that without marriage equality, there could be no true equality, calling on her fans to vote "yes," and inspiring them through her "Music for Marriage Equality" playlist.

The campaign to uphold the law was led by Washington United for Marriage and directed by Zach Silk. The group emphasized love, family, and equality, ultimately winning the November referendum and making Washington one of the first states to legalize same-sex marriage by popular vote. Carlile and Shepard celebrated their marriage in a beautiful intimate ceremony in Wareham, Massachusetts. Surrounded by close friends, family, and loved ones, the couple exchanged vows in an outdoor setting that reflected their deep connection to nature. The ceremony was personal and heartfelt, with guests from both the music and activist communities coming together to celebrate their love and the significance of their marriage during a pivotal moment for marriage equality in Washington State. As a bi-national couple, they celebrated a second wedding ceremony in 2013 at the famous Chelsea Old Town Hall in London.

In 2011, Governor Andrew Cuomo led an aggressive charge to make New York the largest state to legalize same-sex marriage at that time. Partnering with groups like Freedom to Marry, led by Evan Wolfson and Marc Solomon, Cuomo worked tirelessly to garner bipartisan support and was clear about his national vision for marriage equality, stating, "We need marriage equality in every state in this nation; otherwise, no state really has marriage equality. And we will not rest until it is a reality." After intense lobbying, the New York Senate passed the Marriage Equality Act in June 2011 with support from several key Republicans, and Cuomo quickly signed it into law. This victory reverberated across the country, encouraging activists and politicians in other states to push for similar legislation.

Actress Cynthia Nixon and education activist Christine Marinoni have been outspoken advocates for marriage equality since their engagement in May 2009. "We have to do everything we can to open that door a little bit wider and escort same-sex marriage down the aisle," Nixon said at a 2009 rally, where she flashed her engagement ring to a crowd that included Mayor Michael Bloomberg and former New York Governor David Paterson. Ahead of her time in embracing fluidity, she responded to critics by explaining that, for her, it was a personal choice, and that others did not get to define her "gayness."

The couple lobbied politicians in Albany, New York, during the often-heated debate over marriage equality and were active in Fight Back New York, a PAC aimed at unseating politicians who did not support marriage equality. They also worked with the Empire State Pride Agenda and traveled to support efforts in New Jersey, Washington, and Maryland. Cynthia's heartfelt reasoning for marriage equality reached

Cynthia Nixon and wife Christine Marinoni celebrating New York's newfound marriage equality rights, June 2012.

millions as she spoke on platforms like the 2010 New Yorker Festival and *The Joy Behar Show*, influencing countless people across the nation. Cynthia and Christine were married in 2012 in New York City, surrounded by friends and family.

Maine soon followed, but its path to marriage equality was unique. The state had passed a same-sex marriage law in 2009, only for it to be overturned by a public referendum later that year. Undeterred, advocates, including EqualityMaine and Freedom to Marry, launched a new campaign in 2012. Matt McTighe, who managed the campaign, focused on personal conversations with voters to change hearts and minds. The 2012 campaign framed marriage as a matter of fairness and love, which resonated with Maine voters. On election day, Maine made history by becoming the first state to legalize same-sex marriage through a voter-approved initiative, with McTighe calling it "a victory of love over fear."

In Maryland, Governor Martin O'Malley was instrumental in passing same-sex marriage legislation. Initially supportive of civil unions, O'Malley became a vocal proponent of full marriage equality in 2012. Working with Marylanders for Marriage Equality, a coalition that included organizations like the NAACP and Human Rights Campaign, O'Malley framed marriage equality as a civil rights issue, saying, "The way forward is always found through greater respect for the equal rights of all." After the legislature passed the bill, opponents put it to a referendum (Question 6). In November 2012, voters approved the law, marking another crucial victory for marriage equality.

Jesse Tyler Ferguson, whose role as a gay married man on the popular TV show *Modern Family* brought gay married life into millions of homes, married Justin Mikita in 2012 and became a tireless advocate for marriage rights. The couple founded Tie The Knot, a nonprofit that works to educate the public about marriage equality and creates unique, limited-edition bow ties to raise funds for organizations advocating for marriage equality. In an interview for NBC, he told Maria Shriver, "I'm gay and I want to live in a country where I am recognized as an equal. But more importantly, I want gay kids to grow up in a world where they can dream of getting married, where it is something they can aspire to. I didn't have great role models for gay marriage growing up." He continued, "Personal stories go a long way, and a human connection and honest conversation can really create change and growth."

Opposite: Jesse Tyler Ferguson and Justin Mikita, 73rd Annual Tony Awards arrivals, Radio City Music Hall, New York, June 9, 2019. **Following spread:** Supporters of the Freedom to Marry movement gather outside the US Supreme Court as they await the ruling in *United States v. Windsor* on June 26, 2013.

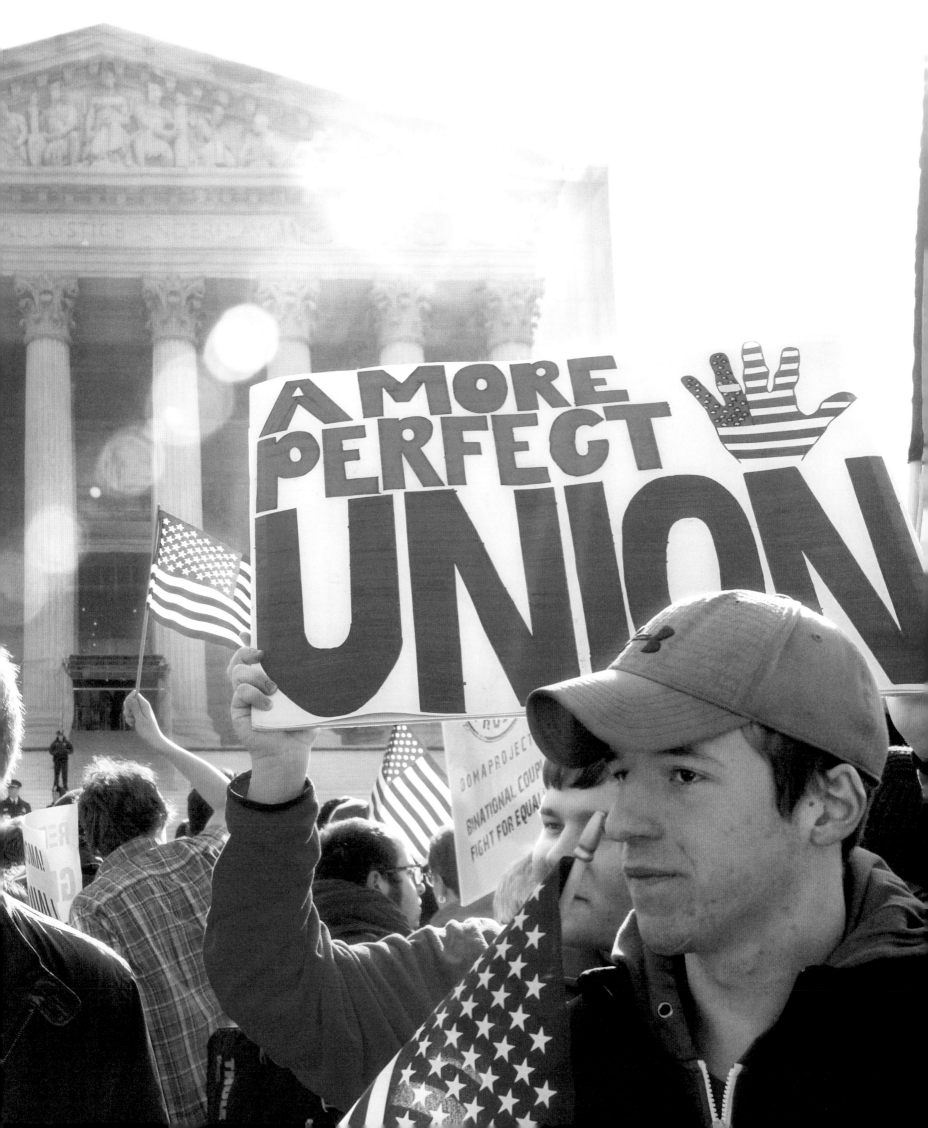

EDIE WINDSOR AND THEA SPYER

After a forty-year engagement, they finally married in Canada in May 2007. Two years later, Thea passed away, and at eighty-three, Edie challenged the system and won.

"Is your dance card full?" Edie asked the dark-haired woman whose back was to her. Hearing her voice, but without turning around, Thea answered, "Now it is." Their flirtation, and a love of dancing together, had started two years earlier, in 1963, when they met at a mutual friend's apartment. The flirtation continued that afternoon in the Hamptons, an artsy enclave outside New York City that had been attracting the LGBTQ+ community since the 1950s.

Edie Windsor was determined to see Thea that weekend, making a series of telephone calls before finally finding a spare room in the very house where Thea would be staying. Those who knew Edie would say this was no surprise, as Edie tended to get what Edie wanted.

The youngest child of a Russian Jewish immigrant family in Philadelphia, Edie had her first lesbian experience at Temple University. Under societal pressure and family expectations, Edie married Saul Wiener, convincing him to change his last name to Windsor out of concerns about antisemitism. Six months later, Edie asked for a divorce after admitting she was a lesbian. With her degree from Temple, Edie moved from Philadelphia to New York's Greenwich Village. While working a secretarial job, Edie earned a master's degree in mathematics from New York University, leading to her pioneering career in software development at IBM, in an era where the industry was almost exclusively male.

Thea Spyer, the daughter of Dutch Jews who fled the Netherlands in the 1930s, was known as a heartbreaker in the New York and Hamptons lesbian communities. A clinical psychologist and gifted violinist, Thea had switched her major at Sarah Lawrence College from music to psychology after being passed up for first violin, a sign of her headstrong ways and refusal to settle for second best. After her expulsion from Sarah Lawrence for being a lesbian, Thea continued her studies at City University of New York, earning a master's degree in clinical psychology, and eventually a PhD in clinical psychology from Adelphi University.

Despite their attraction and connection, Thea wasn't interested in a committed relationship and frequently cancelled on Edie. Edie's desire for a relationship and Thea's aversion to being tied down created complications for the couple, as Thea expressed in a letter she once left for Edie: "I wish I could really be something for you, something substantial, but I can't, not now, probably never."

Frustrated by Thea's continued inability to choose her, and her alone, Edie ended things and refused to answer Thea's calls or visits. Weeks later, during an unexpected 2:00 a.m. telephone call, Thea promised that there would be nobody else but Edie. "I love you," followed a year later, in the summer of 1966.

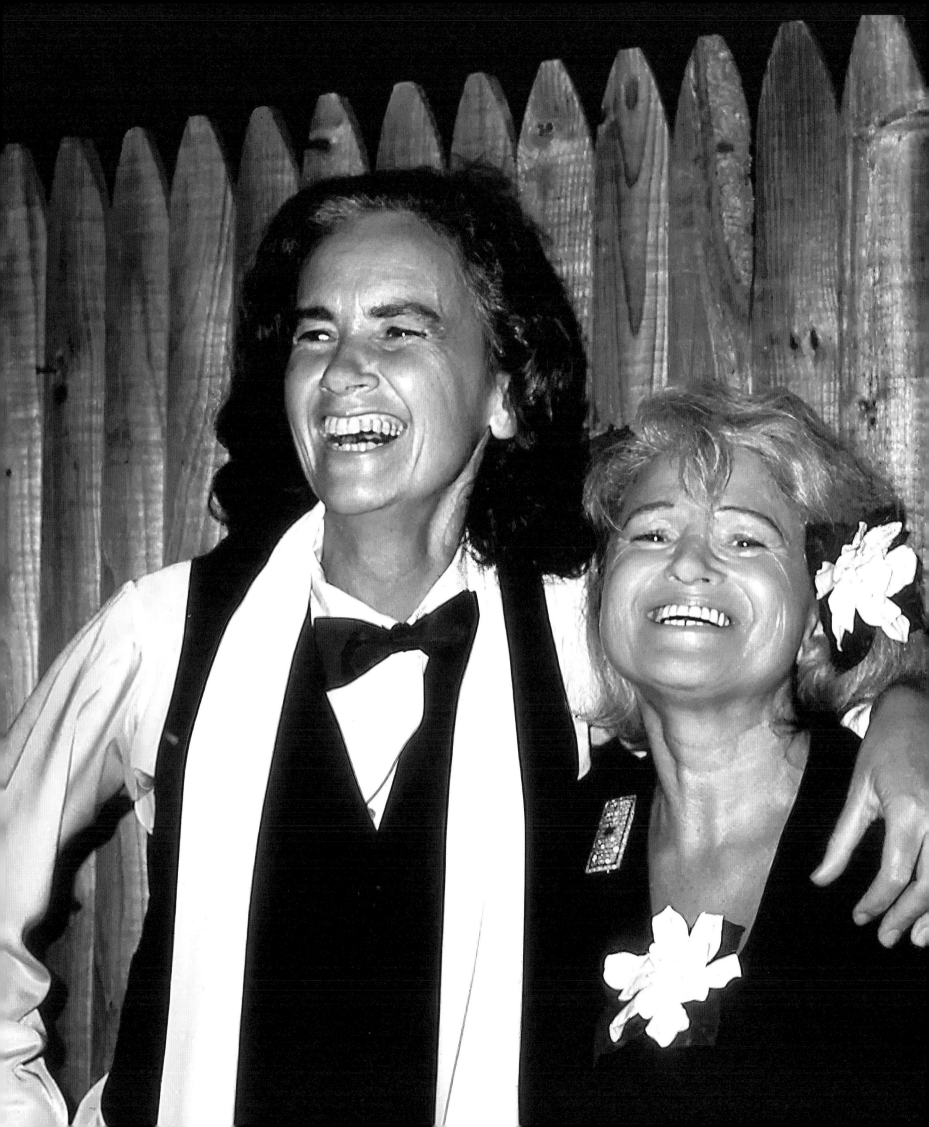

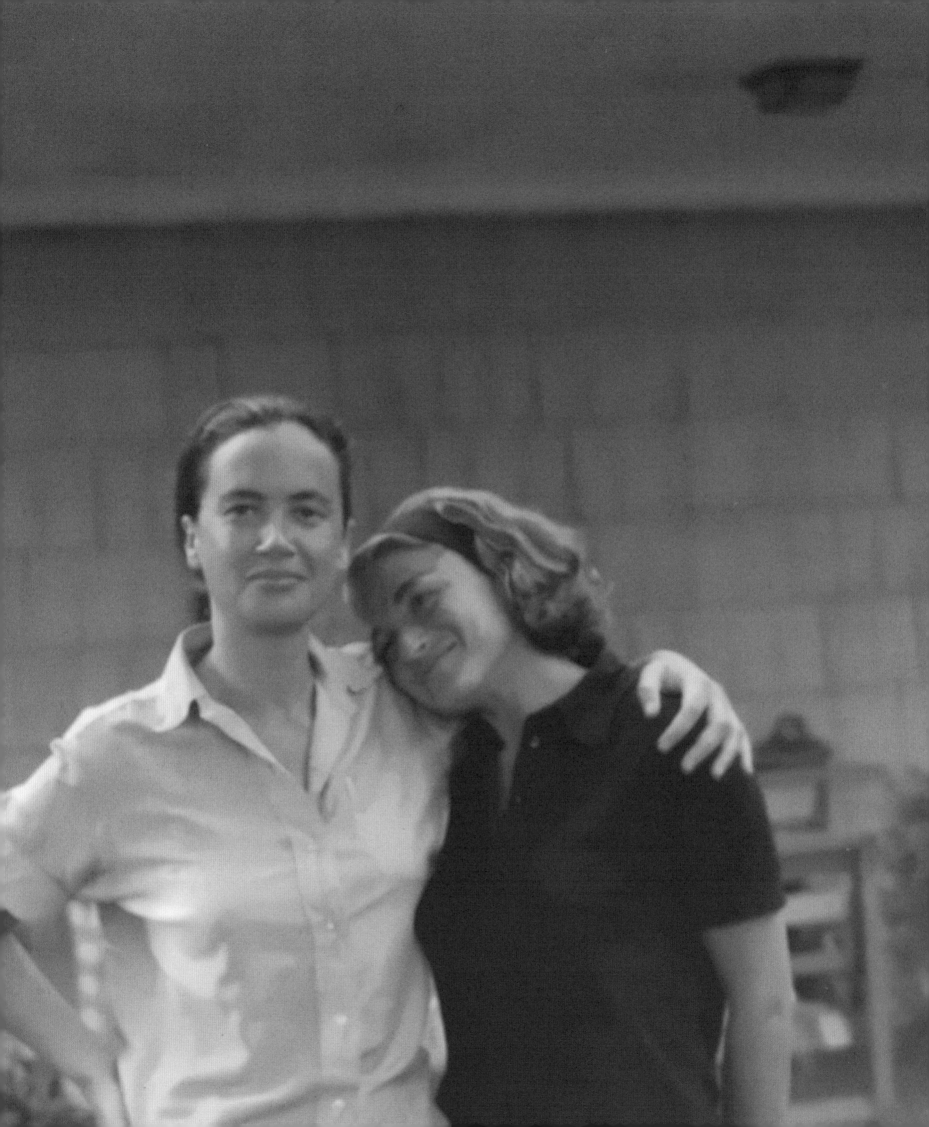

That same summer, Thea asked questions about Edie's marriage to Saul, surreptitiously probing Edie's feelings on marriage itself. When asked if she would wear a ring, Edie said she couldn't explain an engagement ring to her colleagues, but she would wear something else, perhaps a pin, something that wouldn't prompt colleagues to ask awkward questions.

When they arrived at their Hamptons rental one summer weekend, Edie jumped out of the car to go into the house, but Thea asked her to wait. Turning back, Edie found Thea kneeling with one knee on the ground and a small jewelry box in hand. As Thea proposed marriage with a pin of twenty-two diamonds placed in a circle, Edie enthusiastically responded, "Yes!" This circle of diamonds affirmed their relationship as firmly as any traditional engagement ring.

The couple filled their life with friends, travel, budding activism, and the ever-constant love of dancing together. During the summer of 1976, their dancing was occasionally interrupted when Thea's right knee would give out. In the months that followed, Thea experienced occasional falls, stiffness, numbness, and other symptoms. Thea continued to brush off Edie's suggestions to see a doctor as unnecessary.

The unusual symptoms continued to plague Thea, culminating in a diagnosis of progressive multiple sclerosis (MS) in 1979. Thea's physical abilities degenerated quickly, and she encouraged Edie to leave her to avoid being a caregiver. Edie reminded Thea that they were engaged, that they were in this together no matter what. Despite her physical decline, Thea's mind remained sharp, and she continued to see her patients while the couple adapted their two homes and routines to support her declining physical abilities. They also continued to dance, refusing to let anything—not even a wheelchair—keep them from the joy they had found together on a dance floor since their first meeting in 1963.

When New York's mayor issued an order allowing same-sex couples to register as domestic partners beginning March 1, 1993, Edie demanded that Thea cancel her therapy appointments so that they could go to city hall. As usual, what Edie wanted, Edie got, and they were the eightieth couple to register that day. Three years later, President Bill Clinton signed the federal Defense of Marriage Act (DOMA) into law, which defined marriage as between one man and one woman, which prevented the federal government from recognizing same-sex marriages in any way. Meanwhile, Edie and Thea's very long engagement continued, marked by a love and commitment that never diminished.

As Thea's MS progressed, Thea's heart became weakened to such an extent that her physician recommended heart valve replacement surgery. However, she and Edie decided against it—despite the doctor's prognosis that Thea would die within a year without the surgery—because Thea and Edie had previously agreed that there would be no hospital stays. The next morning, Thea asked Edie if she still wanted to get married. Edie said yes, and they began planning a marriage in Canada, thanks to the province of Ontario legalizing same-sex marriage in 2003. With the assistance of the Civil Marriage Trail Project, an organization that facilitated wedding travel to Toronto for same-sex couples, they made the trip to Canada with a small group of friends.

After forty-two years together, Edie and Thea exchanged vows on May 22, 2007, in a hotel conference room at Toronto Pearson International Airport. In a ceremony officiated by Justice Harvey Brownstone, the first openly gay judge in Canada, they acknowledged their decades as a couple with their vows: "With this ring, I thee wed . . . from this moment forward, as in days past." The commitment that once could not be publicly recognized with a ring finally came full circle.

Thea Spyer (left) and Edith Windsor (right) met in 1963 and became a couple in 1965.

Edie and Thea's dance continued until Thea's death on February 9, 2009. A month later, Edie suffered a heart attack and was diagnosed with stress cardiomyopathy, also known as broken heart syndrome. Heart issues took a back seat to outrage when the IRS and the State of New York billed Edie a total of $638,000 in inheritance tax on Thea's estate. Due to DOMA's restrictions, the IRS and the State of New York could disregard their lawful marriage and deny Edie the spousal estate tax exemption enjoyed by opposite-sex couples.

Refusing to accept this injustice, Edie enlisted Roberta Kaplan, an attorney who agreed to take on the case pro bono. In a strange twist of fate, Roberta had briefly been a patient of Thea's in the early 1990s. In 2010, they filed a lawsuit in US District Court to demand a refund of the taxes levied on Thea's estate. The US Justice Department decided not to defend DOMA, prompting the House of Representatives to hire an outside attorney in the Justice Department's place. In a win for Edie, the US District Court judge declared Section 3 of DOMA unconstitutional, a ruling later affirmed by the US Court of Appeals for the Second Circuit. The US Supreme Court (SCOTUS) accepted the government's appeal of Edie's win and heard arguments in the case on March 27, 2013.

As Edie explained: "In the midst of my grief at the loss of the love of my life, I had to spend countless hours defending my relationship to the federal government." Those countless hours came to an end on June 26, 2013, when SCOTUS's decision in *United States v. Windsor* struck down DOMA and ended the seventeen-year federal ban on same-sex marriage. Edie's last name became synonymous with a major advance in LGBTQ+ equality, boosting her prominence as a New York LGBTQ+ activist to the national stage.

Willing to fight for what she wanted, Edie found success in her career, and she found success in love. That love and her willingness to fight injustice brought down a discriminatory law and gave hope to millions of Americans. Touching on her love and loss during a June 26, 2013, press conference at Stonewall Inn, Edie said, "If I had to survive Thea, what a glorious way to do it."

Edie found love again and married Judith Kasen on September 26, 2016. On September 12, 2017, Edie died suddenly following a medical procedure. During the memorial service at New York's Temple Emanu-El, Hillary Clinton thanked Edie for "being a beacon of hope. For proving that love is more powerful than hate."

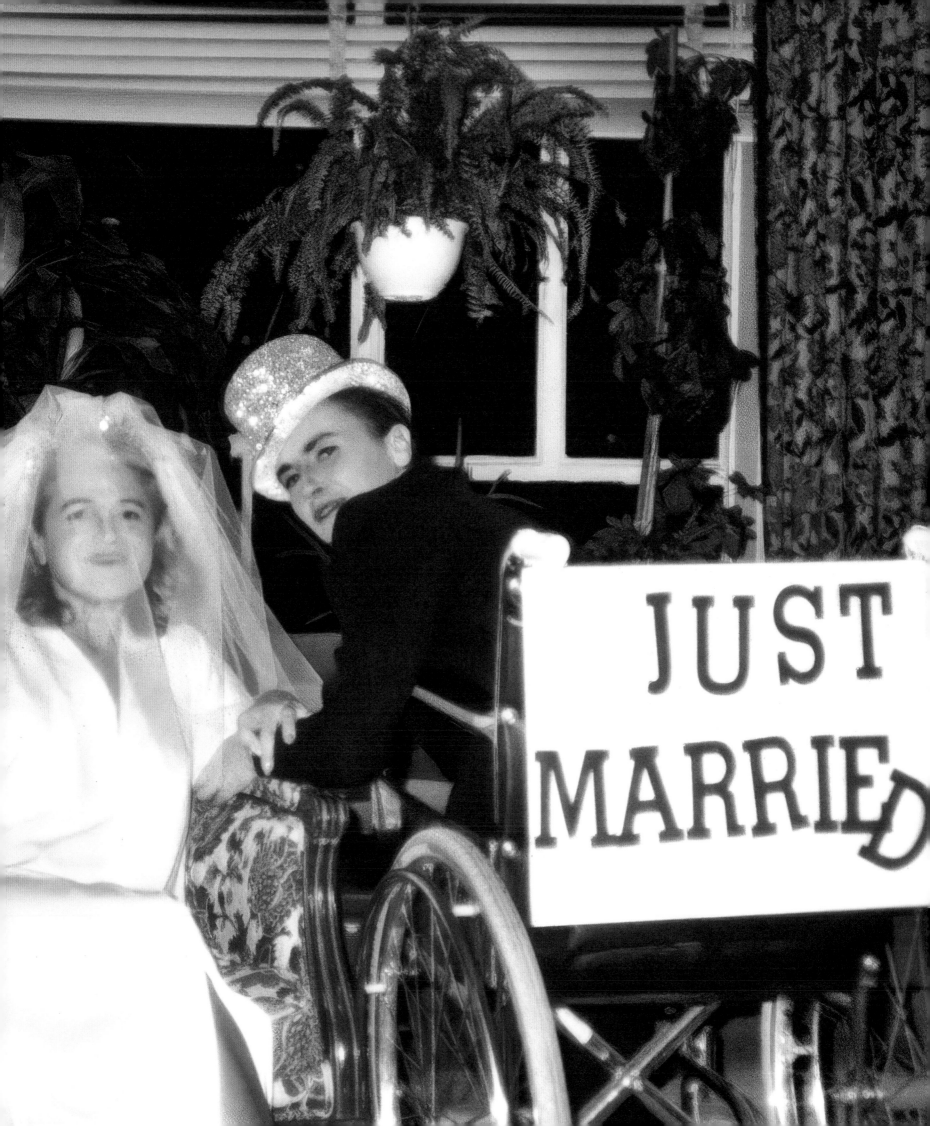

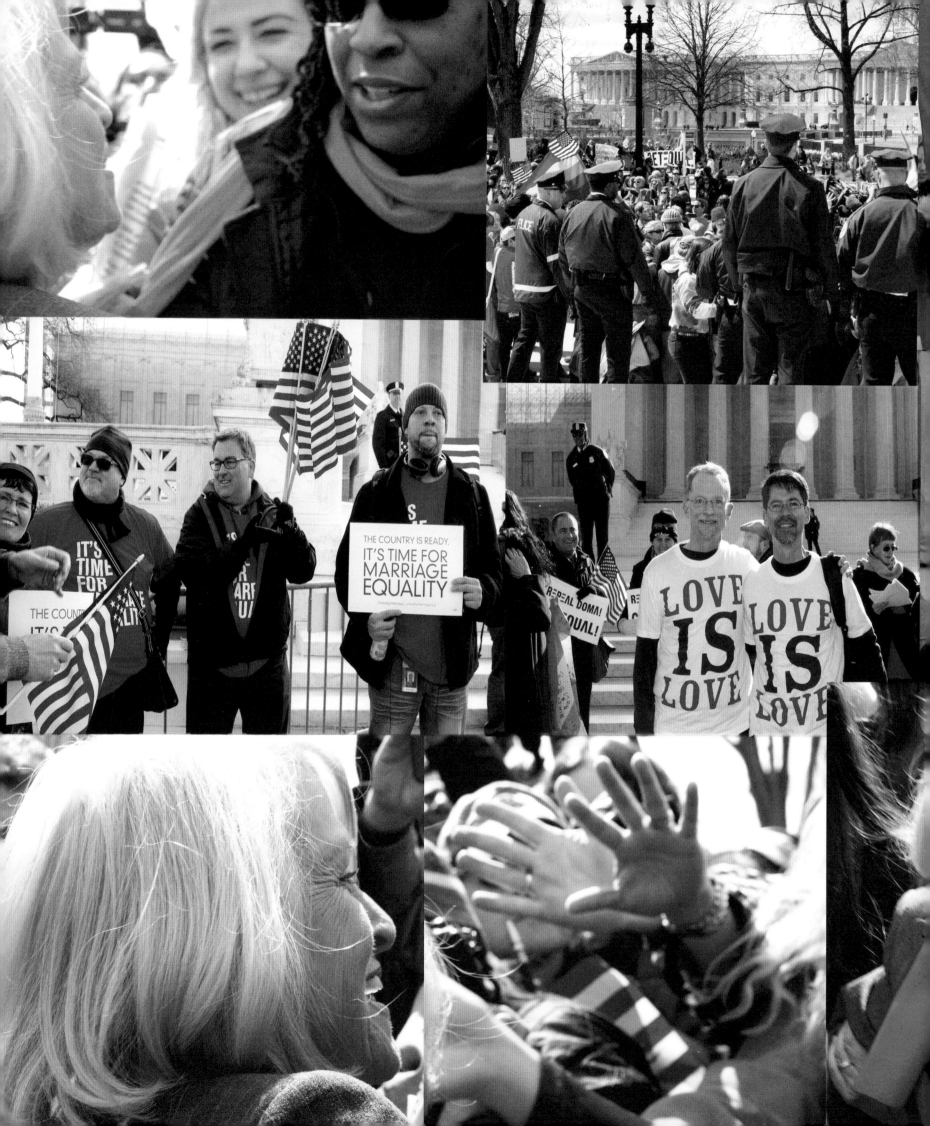

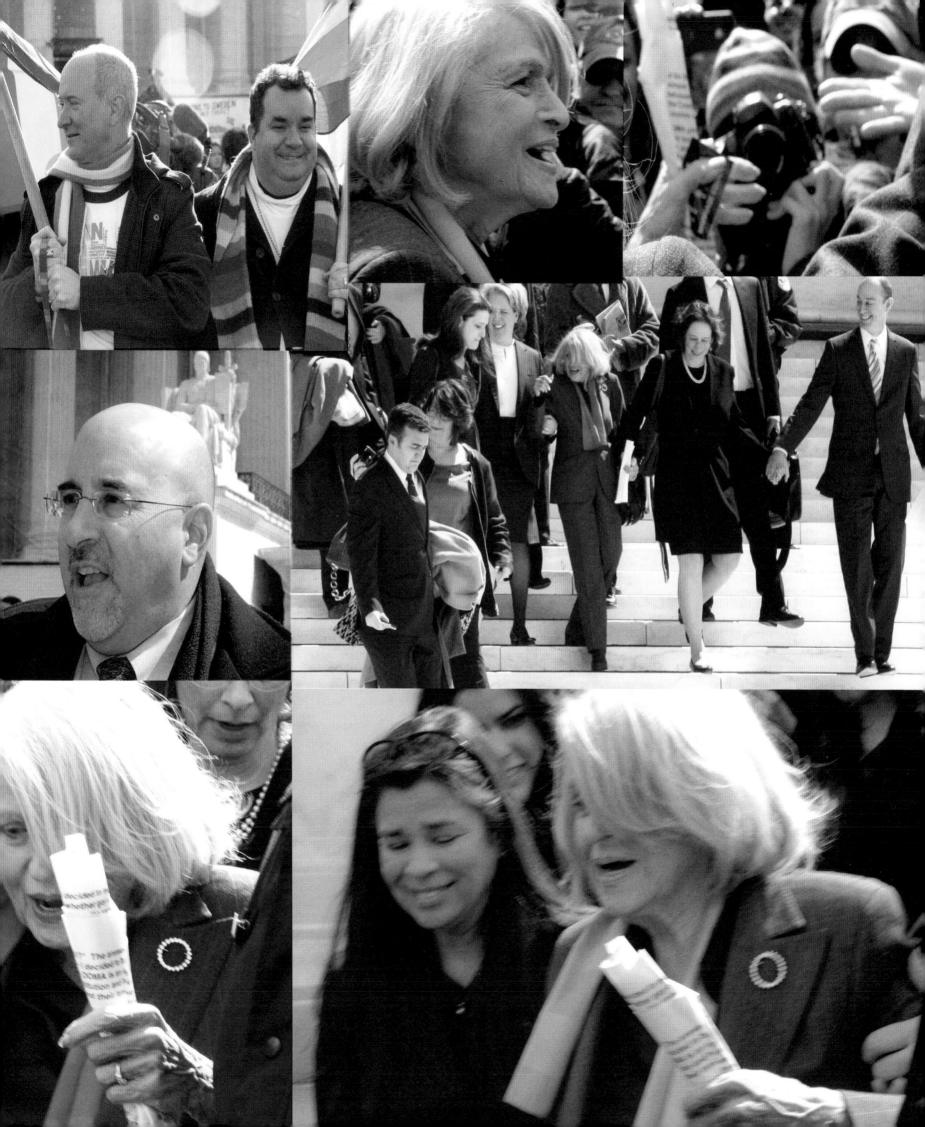

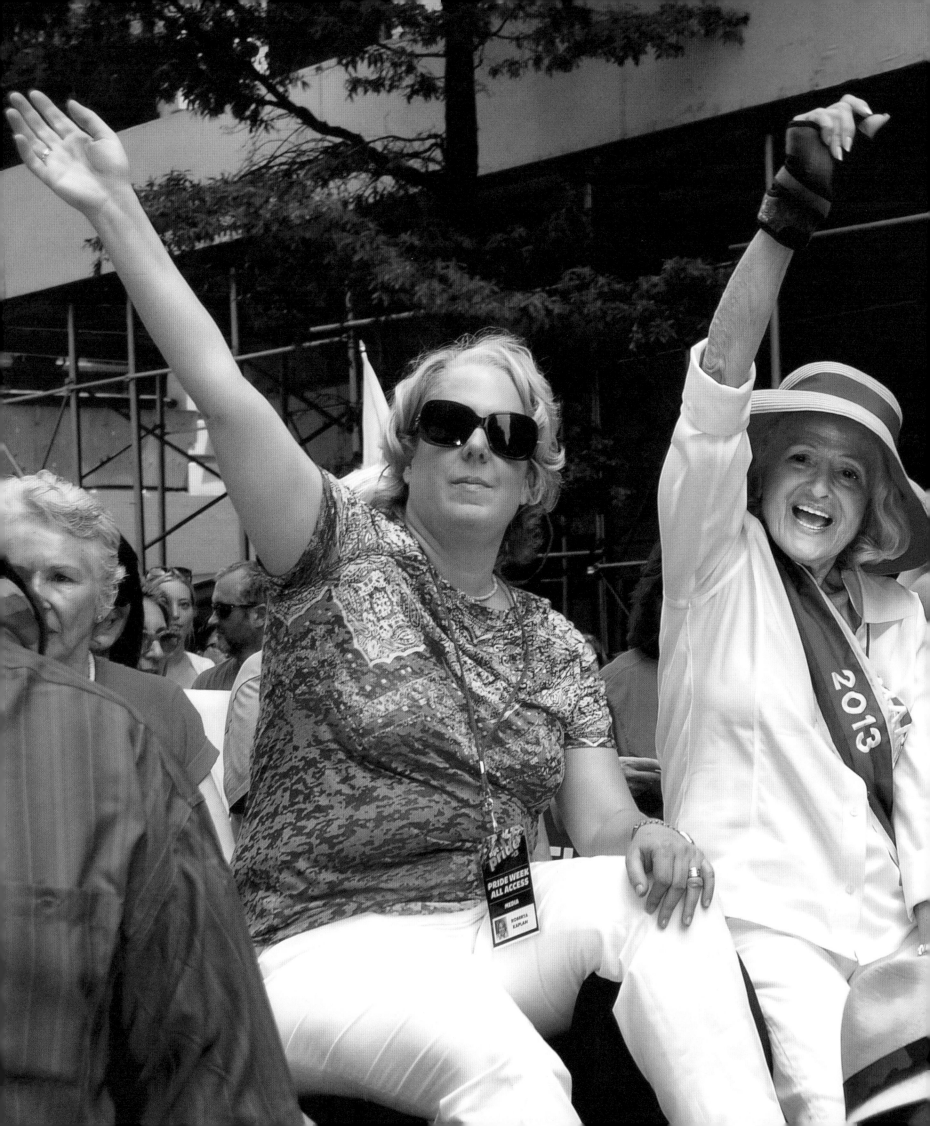

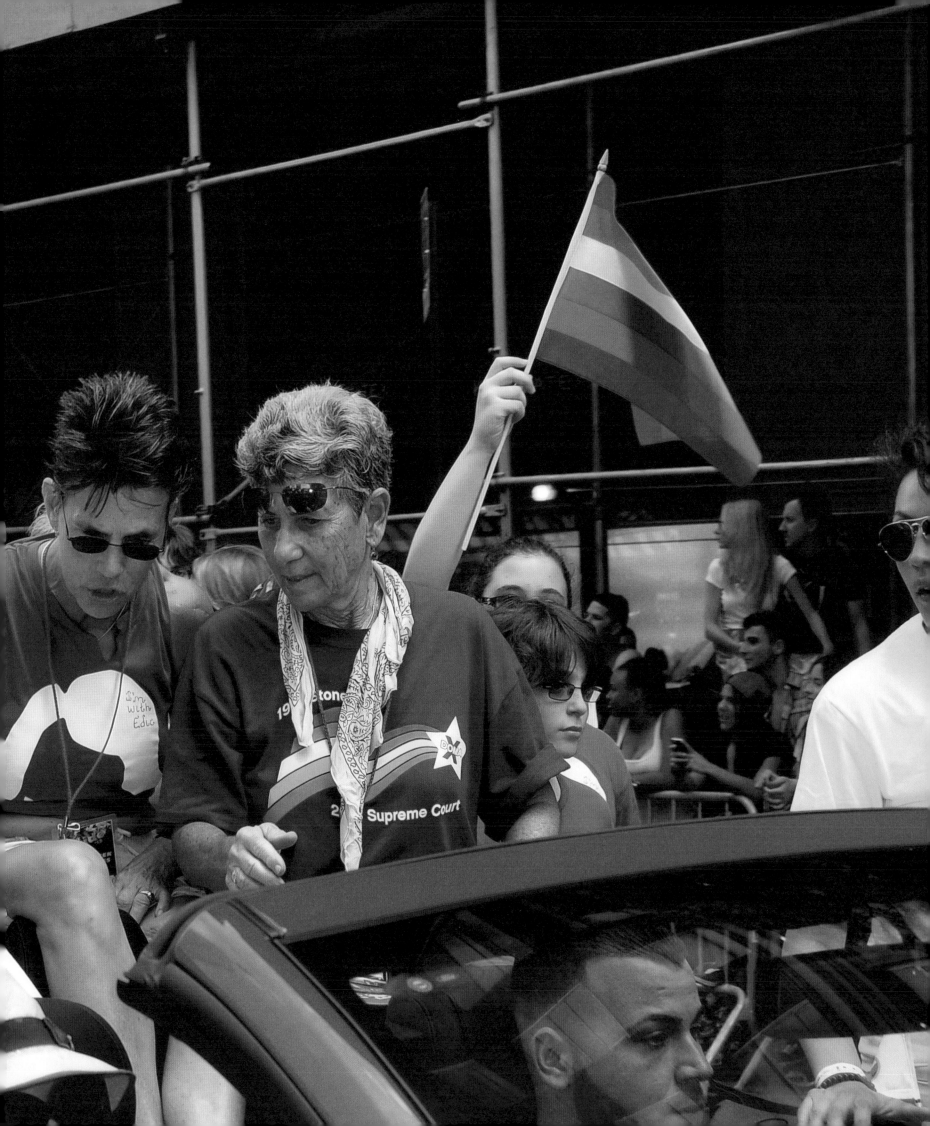

I TAKE THIS MAN

2013–2015

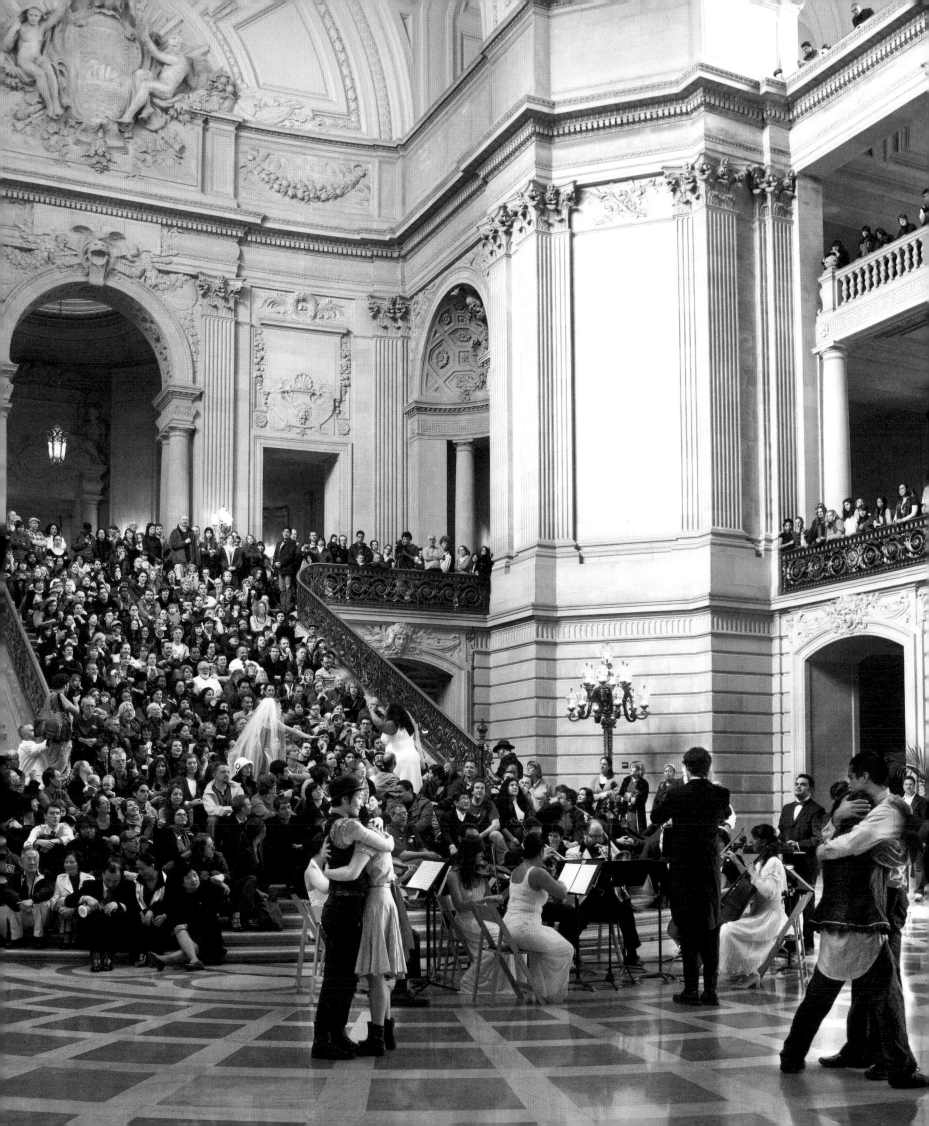

CHAPTER 8 — INTRODUCTION

On the heels of the historic wins by Kris Perry and Sandy Steir, marriage rights opening up again in California with Paul Katami and Jeff Zarrillo, and the overturning of the Defense of Marriage Act (DOMA) by Edie Windsor, the long-sought struggle for inclusion into one of society's most cherished institutions felt palpable—like heartbeats in the air.

In 2013, following the US Supreme Court's decision in *United States v. Windsor*, which struck down DOMA, the campaign to secure full marriage rights was closing in on the finish line. Throughout 2013, several states moved to authorize same-sex marriages. On July 1, Delaware's statute authorizing same-sex marriages took effect, marking a significant victory for advocates. Minnesota followed suit, recognizing the validity of all marriages from other jurisdictions, although it did not yet authorize its own LGBTQ+ marriages. Meanwhile, Montgomery County, Pennsylvania, began issuing marriage licenses to same-sex couples on July 24, despite violating state law.

The dynamic year continued. August saw Rhode Island and Minnesota enact laws authorizing marriage equality, further expanding the map. In New Mexico, several counties began issuing marriage licenses to same-sex couples. The floodgates were opening, and the push for marriage equality was gaining significant traction.

Also in August, Supreme Court Justice Ruth Bader Ginsburg—who famously differentiated "skim-milk marriages" from marriages that had full rights—made history by officiating at the marriage ceremony of a same-sex couple, showcasing the changing attitudes at the highest levels of government. This symbolic act resonated deeply within the LGBTQ+ community and beyond. As the year progressed, the New Mexico supreme court issued a unanimous decision in *Griego v. Oliver* on December 19, affirming that same-sex couples could enjoy the same marriage rights as different-sex couples. This marked a substantial legal victory in a state where marriage equality had not yet been fully realized.

The kinetic love energy continued for another year. In January 2014, US Attorney General Eric Holder announced that the federal government would recognize marriages of same-sex couples married in Utah between December 20, 2013, and January 6, 2014. In February, several significant rulings occurred: US District Court Judge John G. Heyburn ruled that Kentucky must recognize same-sex marriages from other jurisdictions. This decision set a precedent, influencing other states grappling with similar issues. Soon Virginia followed, with Judge Arenda Wright Allen ruling that the state's ban on same-sex marriage was unconstitutional.

The tide was turning. A poll released on March 5, 2014, indicated that 59 percent of Americans supported same-sex marriage, a record high. As public opinion began to favor marriage equality, more legal challenges emerged. In a move that highlighted the urgent human stories behind the legal battles, in April, US District Court Judge Richard L. Young ordered Indiana to recognize the same-sex marriage of a terminally ill woman. Meanwhile, various states, including Ohio and Arkansas, faced legal scrutiny over their bans on same-sex marriage.

Page 289: Supporters of marriage equality stage a mock wedding with hundreds of witnesses inside San Francisco City Hall to protest Proposition 8, April 2010. **Opposite:** President Barack Obama meets with Edie Windsor during a drop-by in the Oval Office, February 12, 2014.

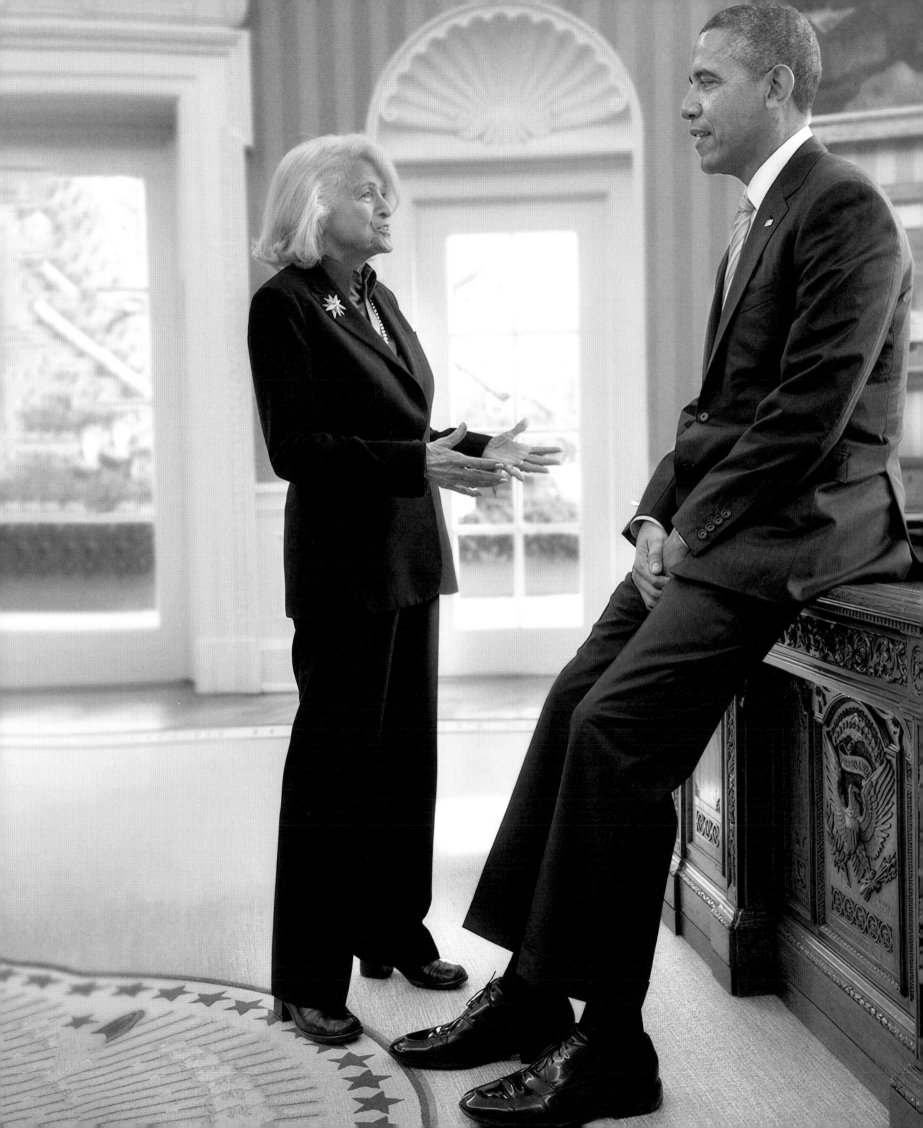

By June, the Tenth Circuit Court of Appeals ruled in *Kitchen v. Herbert*, striking down Utah's same-sex marriage ban and marking the first appellate court to find that marriage is a fundamental right for all. This decision energized activists and couples across the nation.

In October, the US Supreme Court declined to hear appeals from several states, effectively allowing lower court rulings to stand and legalizing same-sex marriage in Indiana, Oklahoma, Utah, Virginia, and Wisconsin. The impact was immediate, with couples eagerly lining up for marriage licenses across these states. As 2014 drew to a close, marriage equality advocates celebrated a string of victories. In November, a US district judge ruled that Kansas's ban on same-sex marriage was unconstitutional. The decision resonated in Missouri, where a judge ruled against the ban the next day. By the end of the year, same-sex marriage had become legal in multiple states, with the momentum continuing into 2015.

The new year brought both hope and challenge. A stay expired in Florida, making same-sex marriage legal statewide, yet some counties continued to resist granting marriage licenses. While Florida would have been big news, the focus of the movement and the media was on a court case decision coming up in June. Fourteen couples from four states had joined in the lawsuit *Obergefell v. Hodges*, which focused on the equality provisions in the Fourteenth Amendment to the US Constitution. On June 26, the US Supreme Court delivered a landmark ruling in *Obergefell*, asserting that the fundamental right to marry extended to same-sex couples. The ruling invalidated bans in multiple states and made same-sex marriage legal across the United States, a monumental victory for LGBTQ+ activists and allies alike.

There were celebratory scenes across the nation, on the front page of every local and national newspaper, and on the internet and social media. To say that a large part of the nation, both gay and straight, was overwhelmed with tears of joy might sound like an exaggeration. But for those who witnessed this unprecedented gift of human rights, the decription rings true. Couples flocked to courthouses to tie the knot. Tim Cook, CEO of Apple, celebrated the ruling on Twitter, marking the day as a victory for equality, perseverance, and love. Yet despite the victory, challenges continued. In Alabama, on January 23, US District Judge Callie V.S. Granade ruled the state's ban on same-sex marriage unconstitutional, leading to confusion as some county judges resisted issuing licenses.

Throughout this journey, public figures played crucial roles in shifting the narrative. Celebrities, politicians, and activists raised awareness, sharing personal stories and advocating for equality. As more people came out as allies and advocates, the social fabric supporting marriage equality grew stronger.

From the initial victories in states like Delaware and Minnesota, to the historic ruling in *Obergefell v. Hodges*, the movement has transformed lives and reshaped societal norms. It is essential to acknowledge the sacrifices made by countless individuals who fought for love, dignity, and equality—people who were raised to keep quiet about who they were, and who were taught they would never be able to love the way they desired and be welcomed within their communities. It is also critical to acknowledge their families and friends who, alongside them on this journey, came to understand what these brave individuals knew all along: Love equals love. It is that simple.

A three-story memorial mural of Supreme Court Justice Ruth Bader Ginsburg on East 11th Street and First Avenue, East Village, New York City, November 2020.

@ellestreetart

After the *United States v. Windsor* ruling in 2013, which struck down Section 3 of the Defense of Marriage Act (DOMA), many states began to allow same-sex marriages through either state legislation, state court rulings, or federal court rulings. The Windsor decision played a significant role in setting legal precedents that would lead to marriage equality nationwide. Below are the states that legalized same-sex marriage after the Windsor ruling and prior to the *Obergefell v. Hodges* decision in June 2015.

2013: New Jersey, New Mexico, Hawaii

2014: Illinois, Oregon, Pennsylvania, Colorado, Indiana, Oklahoma, Utah, Virginia, Wisconsin, Nevada, West Virginia, North Carolina, Alaska, Idaho, Arizona, Wyoming, Montana, South Carolina

2015: Florida

Stuart Gaffney and John Lewis celebrate Edie Windsor's overturning of the Defense of Marriage Act (DOMA), 2013.

294

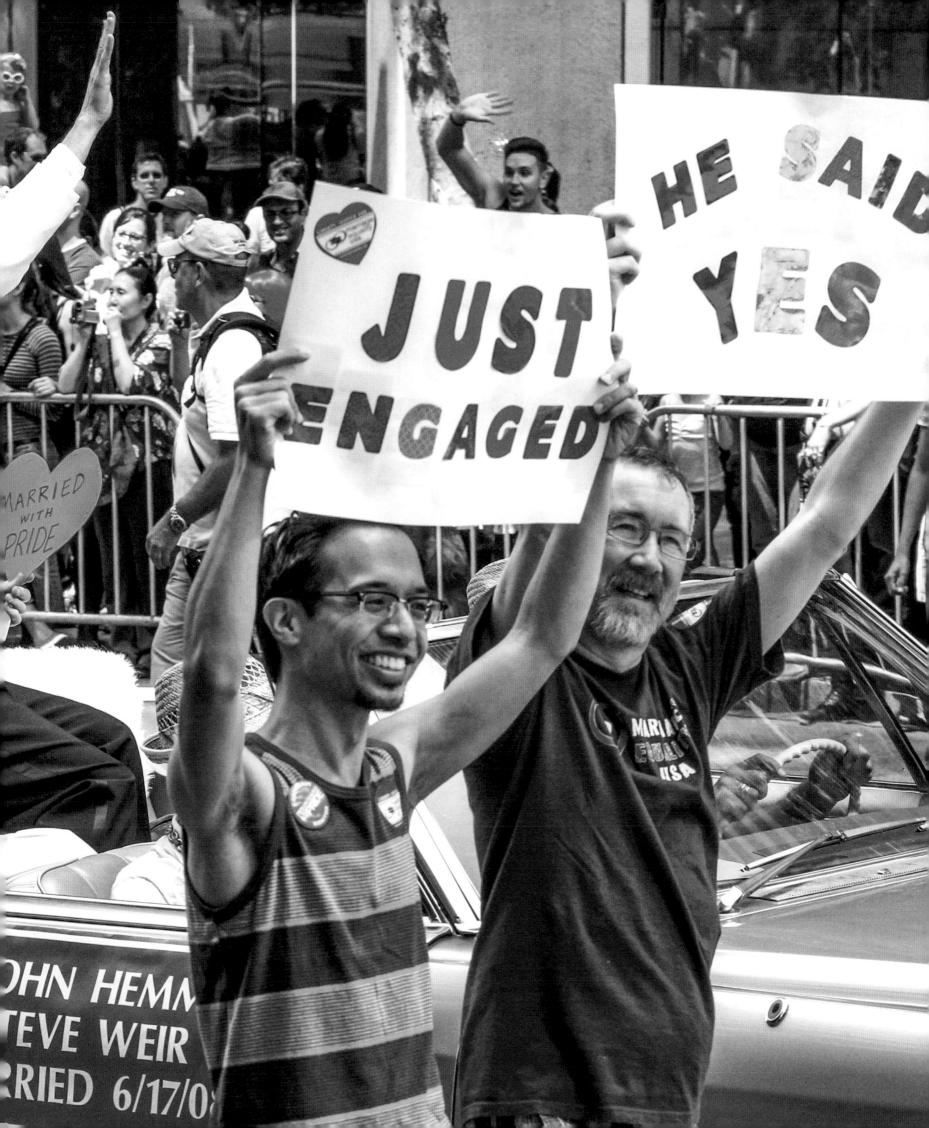

LOVE FROM COAST TO COAST

By the end of 2013, it was estimated that around 130,000 same-sex couples in the United States were legally married.

The week of October 9, 2014, marked a significant moment for marriage equality as the Supreme Court declined to hear petitions aimed at rejecting lower-court rulings on same-sex marriage bans. This decision effectively legalized same-sex marriage in thirty states, along with the District of Columbia. For marriage equality advocates, it was a triumph and one more crucial milestone on a journey that continues to bear love.

Delaware legalized marriage equality through legislation in 2013, with key leadership from Governor Jack Markell and advocates like Lisa Goodman and Mark Purpura of Equality Delaware. Markell, upon signing the bill into law, remarked, "All couples deserve the right to marry, and this law will ensure that same-sex couples are treated equally under Delaware law."

Rhode Island was the last state in New England to legalize same-sex marriage, doing so in 2013. The marriage equality bill was championed by Governor Lincoln Chafee, a longtime supporter of LGBTQ+ rights, and Ray Sullivan, campaign director of Marriage Equality Rhode Island. Governor Chafee framed the issue as one of basic fairness and human dignity, stating, "It is time to end the discrimination and ensure that all Rhode Islanders have equal access to the institution of marriage." The state legislature passed the bill with bipartisan support, and it was signed into law in May 2013.

Minnesota's journey to marriage equality began with Jack Baker and Michael McConnell in the 1970s but stalled after the US Supreme Court refused to consider their case. Five decades later, a voter referendum in 2012 sought to ban same-sex marriage through a constitutional amendment. Richard Carlbom, the campaign manager for Minnesotans United for All Families, led a well-organized grassroots effort to defeat the amendment.

On November 13, 2013, Hawaii became the fifteenth state to legalize same-sex marriage, with Governor Neil Abercrombie signing the bill into law. Advocates celebrated this victory as a significant step forward, reflecting the state's commitment to equality. Governor Abercrombie stated, "Today, we are fulfilling a promise to our children, that they will be treated equally under the law."

Illinois legalized same-sex marriage on November 20, 2013, thanks to the efforts of advocates like Equality Illinois and state leaders. The bill was signed into law by Governor Pat Quinn, who remarked, "I am proud to stand here today with all of you to sign this bill that makes history, makes progress, and makes a difference." This marked a milestone for LGBTQ+ rights in the Midwest.

Seattle's Dan Savage and Terry Miller celebrate their wedding outside Seattle City Hall on Sunday, December 9, 2012, shortly after Washington State began issuing marriage licenses.

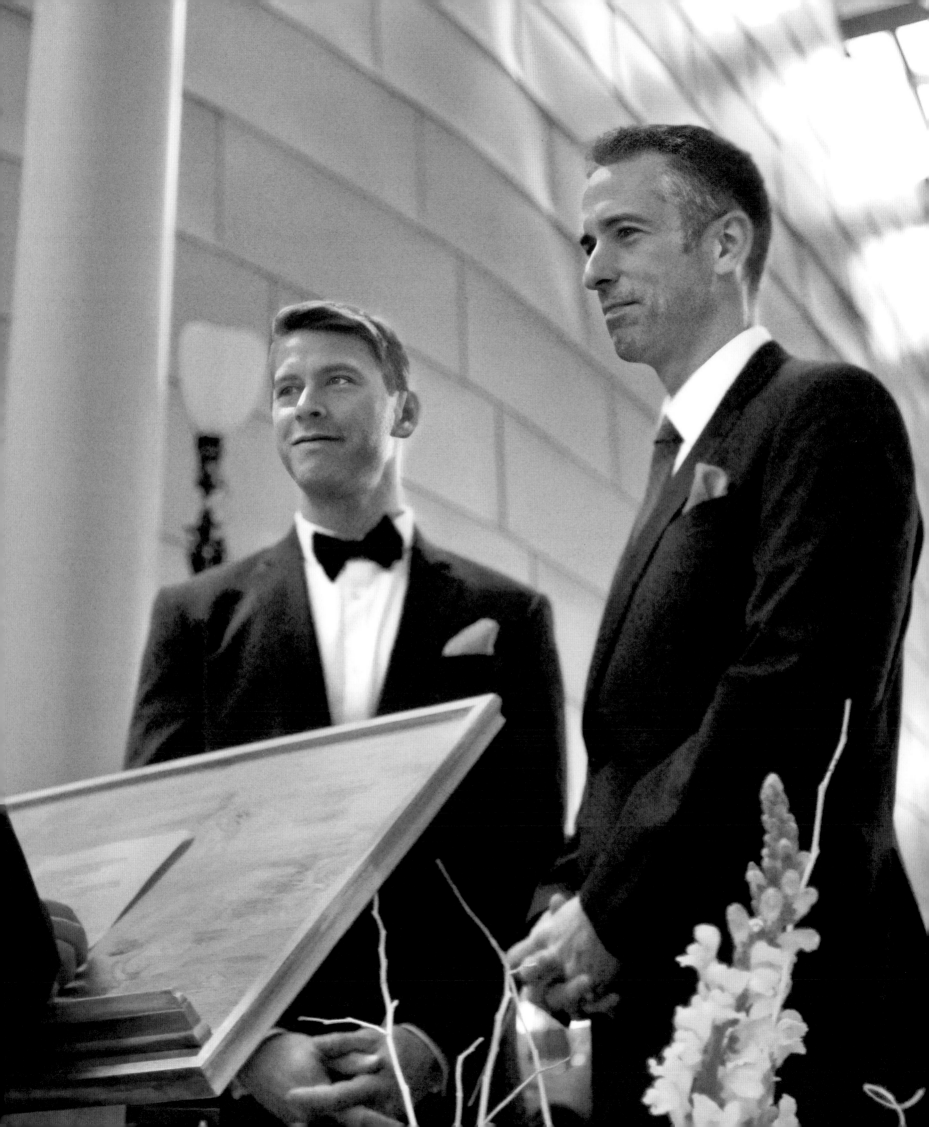

On December 19, 2013, New Mexico became the seventeenth state to legalize same-sex marriage, following a state supreme court ruling that declared bans on same-sex marriage unconstitutional. Governor Susana Martinez's administration did not appeal the ruling, allowing the celebration of love to flourish across the state.

On May 20, 2014, Pennsylvania became the nineteenth state to legalize gay marriage. The move followed a federal court ruling that deemed the state's ban on same-sex marriage unconstitutional. Advocacy groups celebrated this significant victory, marking a pivotal shift toward broader acceptance and legal recognition for LGBTQ+ couples.

On November 12, 2014, Kansas became the thirty-third state to legalize same-sex marriage. This came after the US Supreme Court declined to hear appeals from states seeking to uphold their bans on same-sex marriage, allowing lower court rulings to stand. As a result, same-sex couples in Kansas could finally celebrate their love and commitment.

Just a week later, on November 20, 2014, South Carolina became the thirty-fifth state to legalize same-sex marriage. This decision followed a federal court ruling that struck down the state's ban, signaling a major victory for LGBTQ+ advocates. Couples across South Carolina rejoiced as they were granted the same legal recognition and protections afforded opposite-sex couples.

Mark Phariss and Vic Holmes at their wedding at the Westin Stonebriar Hotel in Frisco, Texas, November 21, 2015.

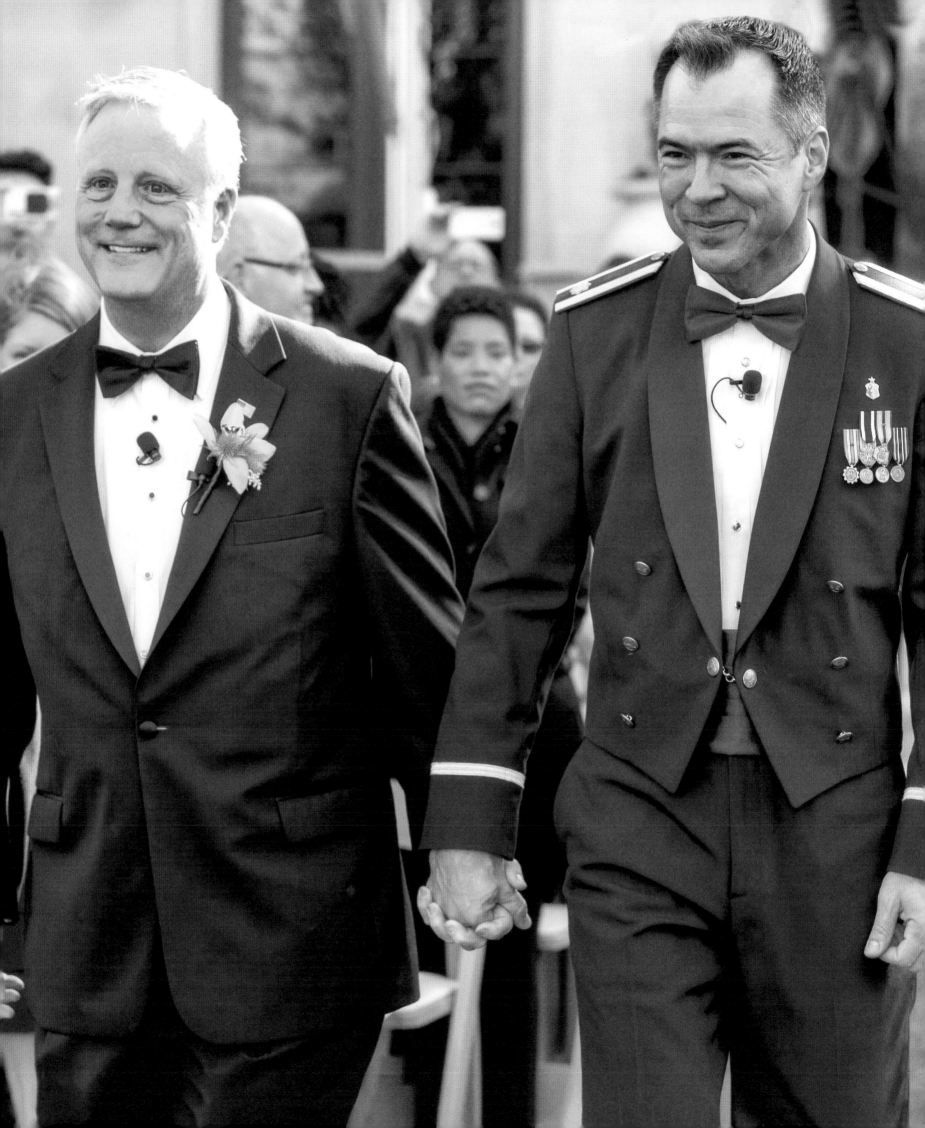

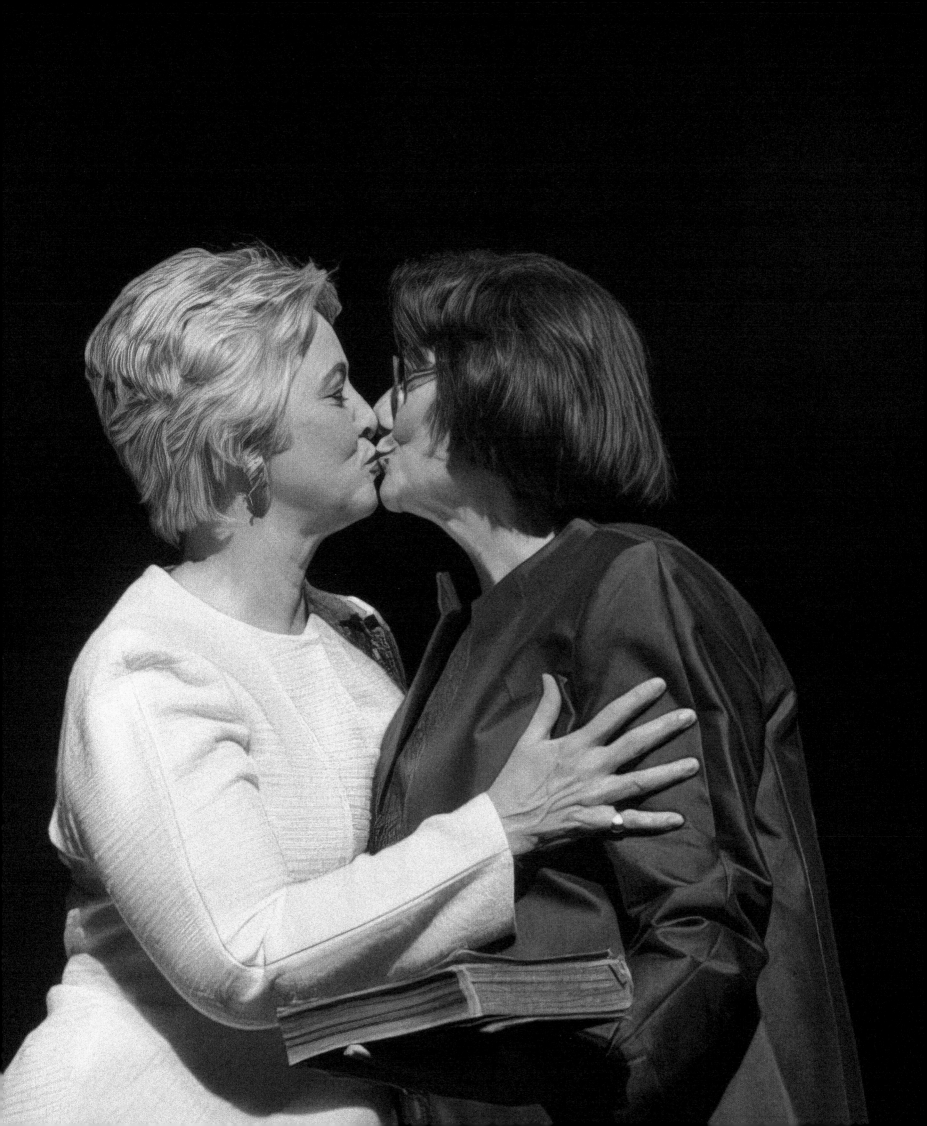

ANNISE PARKER AND KATHY HUBBARD

As the first openly gay big city mayor, Parker's same-sex marriage in conservative Texas showed the meaning of tolerance and acceptance.

Annise Parker's inauguration as the first openly gay mayor of a major US city marked a historic turning point in the fight for marriage equality. As she stood before a crowd of supporters in Houston—a city in a traditionally conservative state—her relationship with partner, Kathy Hubbard, added a powerful layer of visibility to the moment. Dressed in coordinating pantsuits, the couple held hands and shared a simple cheek kiss, an image that quickly became a symbol of progress and love.

The ceremony was infused with unexpected moments of inclusivity, highlighted by a positive prayer from Joel Osteen, a prominent evangelical leader. His presence at the inauguration prompted conversations across the nation among Christians about acceptance and tolerance, encouraging many to reconsider their views on LGBTQ+ rights. Osteen's involvement brought a sense of validation to Parker and Hubbard's relationship, reinforcing the idea that love could transcend traditional boundaries.

Adding personal significance to the occasion, Parker swore her oath of office on her grandmother's Bible. This gesture underscored her deep connection to her family and faith, reinforcing the notion that her identity as a gay woman was not in conflict with her values. It was a poignant reminder that acceptance often begins at home.

While the couple's public display of affection challenged societal norms, their visibility not only represented personal triumph but also served as a template for future LGBTQ+ politicians and activists.

Mayor Annise Parker takes the oath of office for a third and final term, with her partner, Kathy Hubbard, at her side, Houston, Texas, 2014.

JACK EVANS AND GEORGE HARRIS

From the Taboo Room to the altar: A long Southern love story.

Jack adjusted his tie and smoothed down his hair, glancing at George, who meticulously arranged a bouquet of lilies. "Nervous?" he asked, looking at his partner of over half a century.

George snorted, "After fifty-four years? Darling, I'm ready to shout it from the rooftops." He met Jack's eyes, a familiar warmth blooming in his chest. "We're finally doing this."

Their journey began in 1961 at a Dallas bar called the Taboo Room. George, a spirited young man who'd found refuge in Dallas after a tumultuous experience in the army, was instantly captivated by Jack's charm and wit. Jack, a talented antiques buyer, had faced his share of prejudice, having been fired from Neiman Marcus for being gay. Yet their shared experiences forged a bond that grew stronger with time.

They started a life together, flipping houses and eventually establishing Evans Harris Real Estate in 1978, a testament to their entrepreneurial spirit and unwavering belief in themselves despite societal norms. Their love story, however, was far from a fairy tale. The AIDS epidemic cast a long shadow over them, claiming the lives of many friends and colleagues—a heartbreaking reminder of the fragility of life and the fierce urgency of their fight for equality.

Despite the adversity they faced, their love for each other and their community remained steadfast. They became tireless advocates, their fingerprints on every major LGBTQ+ organization in Dallas. George was a board member of the Resource Center and played a key role in co-founding the Stonewall Business Association, which laid the groundwork for the North Texas LGBT Chamber of Commerce. Their dedication earned them numerous accolades, including the Black Tie Dinner's Kuchling Award and the Chamber's Lifetime Achievement Award. They even served as grand marshals of the Alan Ross Texas Freedom Parade, a fitting tribute to their unwavering support for Pride and the man who championed it.

But their greatest victory, their proudest moment, arrived on June 26, 2015. The Supreme Court's landmark decision legalizing same-sex marriage nationwide sent shockwaves across the country, and for Jack and George, it was a dream decades in the making.

The Dallas County Records Building overflowed with jubilant couples, reporters, and well-wishers. The clerk, recognizing their long wait for this moment, allowed them to skip the line. George, true to his word, was ready to shout his love for Jack from the rooftops. Judge Tonya Parker, a trailblazer who had refused to perform any marriages until she could do so for everyone who wished to marry, presided over their ceremony.

Tears, laughter, and cheers filled the air as Jack and George exchanged vows, their love story finally receiving the legal recognition it deserved. A photo of them applying for their marriage license, beaming with joy, appeared in newspapers around the world—a symbol of hope and perseverance for LGBTQ+ communities everywhere. President Barack and Michelle Obama sent a heartfelt letter congratulating them, a memento George cherished dearly.

Sadly, their first anniversary was not to be. Jack passed away three days before the date, leaving George heartbroken but forever grateful for the love they shared. "He taught me how to love," George told an interviewer for a feature on WFAA in Dallas, "and I think that that's the greatest gift you can ever give to anybody."

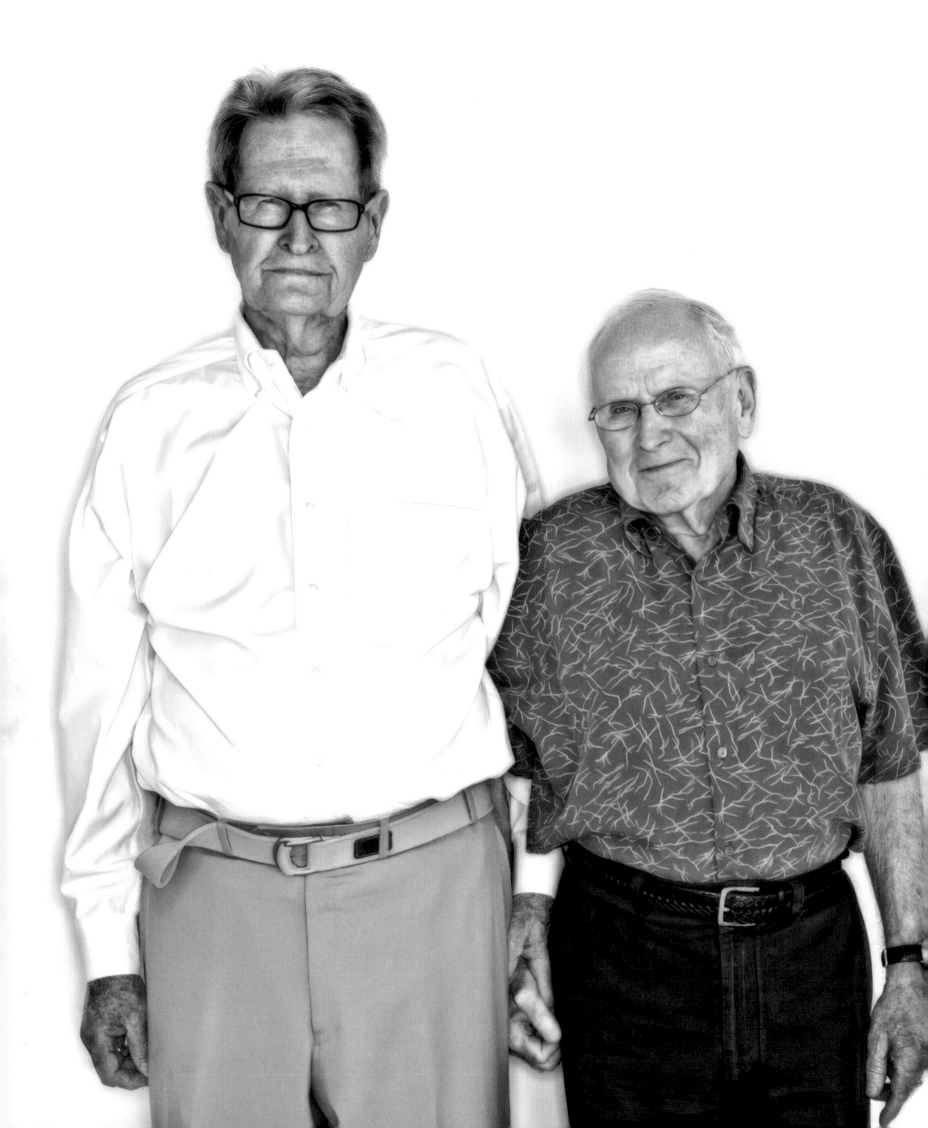

FOURTEEN SAME-SEX COUPLES FROM MICHIGAN, OHIO, KENTUCKY, AND TENNESSEE JOIN FORCES WITH ATTORNEY MARY BONAUTO, THE FREEDOM TO MARRY GROUP, AND ADVOCATES TO ACHIEVE NATIONWIDE MARRIAGE EQUALITY.

Few individuals have had as profound an impact on the human right to marry as Evan Wolfson and Mary Bonauto, who brought legal brilliance and unwavering commitment to justice. They played a crucial role in securing this vital human right across the nation in the court case *Obergefell v. Hodges*.

Born in 1961, Mary Bonauto's path to activism began early in her career. She joined GLBTQ Legal Advocates and Defenders (GLAD) in 1990 and dedicated the next three decades to dismantling the legal barriers faced by the LGBTQ+ community.

In 1993, the Hawaii Supreme Court issued a groundbreaking ruling, determining that the state must provide a compelling justification for treating same-sex couples differently from opposite-sex couples regarding marriage. This landmark decision moved Mary to redirect her work to focus on the freedom to marry and jump-started a nationwide debate on marriage equality, prompting Congress to pass the Defense of Marriage Act (DOMA) in 1996, which aimed to prevent federal recognition of same-sex marriages.

In 1997, Mary teamed up with Vermont attorneys to file a groundbreaking lawsuit aiming to secure marriage licenses for LGBTQ+ couples. This bold move was met with skepticism from many in LGBTQ+ political and legal circles, who feared it was too soon for such a significant challenge. Nevertheless, alongside her colleagues Beth Robinson and Susan Murray, she pressed on. While the Vermont Supreme Court ultimately deferred the decision to the legislature, it recognized the "common humanity" of same-sex couples, paving the way for civil unions—a critical, albeit imperfect, step toward equality.

Fueled by a commitment to securing full marriage equality, Mary took on a more ambitious project in 2001, filing *Goodridge v. Department of Public Health*, with a clear message: civil unions were not a substitute for marriage. The case reached the Massachusetts Supreme Judicial Court, where Bonauto presented a compelling argument on March 4, 2003. On November 18, 2003, the court made a historic decision, ruling that barring same-sex couples from marriage violated their rights to equal protection. On May 17, 2004, the first same-sex couples began marrying in Massachusetts. Bonauto was present, assisting her clients in obtaining their marriage licenses amid a supportive crowd of journalists and advocates. The joy in the air was palpable as couples exchanged vows, the phrase "legally married" echoing through the ceremony.

November 18, 2003: On the day the Massachusetts Supreme Judicial Court announced the release of the *Goodridge* decision, Mary Bonauto, lead attorney for the plaintiffs, stepped outside the courthouse to scan the pages and learn the outcome.

The victory in Massachusetts was monumental, and Mary turned to spearheading marriage lawsuits in Connecticut in 2004 and in Maine in 2009, advocating for LGBTQ+ individuals to share their stories and amplify their voices in the struggle for equality.

Mary's relentless pursuit of justice culminated in 2009, when GLAD filed *Gill v. Office of Personnel Management*, challenging Section 3 of DOMA, which denied federal recognition of same-sex marriages and ended with a crucial decision by Judge Joseph Tauro that declared Section 3 of DOMA unconstitutional, paving the way for subsequent legal victories against the discriminatory law. This momentum culminated in 2013 when the Supreme Court struck down Section 3 of DOMA in *United States v. Windsor*.

The pinnacle of her career arrived with the 2015 Supreme Court case *Obergefell v. Hodges*, where she represented same-sex couples from Michigan and Kentucky. On June 26, 2015, the Supreme Court ruled in favor of the fourteen same-sex couples who challenged the recognition of their marriages across state lines. The Supreme Court determined that laws prohibiting same-sex marriage infringed upon the Due Process Clause and the Equal Protection Clause of the Fourteenth Amendment. The legal strategy combined with public outreach via the couples' stories was the magic that bequeathed the win.

During *Obergefell*, Paul Campion and Randy Johnson, alongside April DeBoer and Jayne Rowse, were two of the stories in the forefront.

Paul and Randy's love story began when they met in the early 1990s and quickly fell for each other. Together, they built a loving family, adopting four children through Kentucky's foster care system. Despite the deep bond they shared and the nurturing environment they created for their children, their relationship was not recognized by Kentucky law, leaving them vulnerable to legal and social obstacles. This injustice ignited their passion for advocacy. In 2013, they joined forces with other couples to challenge the state's ban on same-sex marriage, filing the lawsuit *Bourke v. Beshear*. Their argument was straightforward: the state's refusal to recognize their marriage performed in California violated their constitutional rights.

For Paul and Randy, this legal battle was about more than just their relationship; it was about ensuring their children had the same legal protections and societal recognition as children in any other family. Motivated by the legal uncertainties surrounding their family structure, they persevered through numerous court appearances and public scrutiny, driven by their belief in equality and justice.

Similarly, April DeBoer and Jayne Rowse's journey to marriage equality began with a harrowing realization of their legal vulnerabilities. Together for over fifteen years, the couple had faced the emotional toll of infertility and unsuccessful attempts at surrogacy before turning to foster parenting. Over time, they welcomed five children into their home, including those born with severe challenges. Despite their loving commitment, Michigan's laws prevented them from jointly adopting their children, leaving them acutely aware of their fragile family status. After a near-fatal car accident underscored the risks of their situation, April and Jayne sought legal protections for their family.

With the help of Michigan attorneys Carole Stanyar and Dana Nessel, they initially filed a lawsuit for joint adoption. However, upon advice from their presiding judge, they amended their case to challenge Michigan's ban on same-sex marriage. Their case, *DeBoer v. Snyder*, became part of the broader fight for marriage equality, ultimately leading them to join the *Obergefell* case.

April DeBoer and Jayne Rowse in 2005.

A diverse group of couples from various states contributed their voices and experiences to the case. They asked: if the Fourteenth Amendment requires states to issue marriage licenses to same-sex couples, then does it require states to recognize same-sex marriages that were legally performed in other states? They thought so.

Gregory Bourke and Michael DeLeon lived in Kentucky and legally wed in Canada. They fought for their marriage to be recognized in their home state, advocating for the legal protections that come with marriage, including joint adoption rights for their children. Their resilience shined through as they navigated the complexities of the legal system, determined to create a stable home for their family.

Timothy Love and Lawrence Ysunza had spent over three decades together, longing for the legal recognition that marriage would provide. As they aimed to secure the societal recognition and legal benefits that came with marriage in Kentucky, their struggle resonated with many.

Maurice Blanchard and Dominique James faced hurdles in Kentucky when they were denied a marriage license. Undeterred, the couple sought legal recognition, advocating for the rights afforded to married couples.

From Tennessee, Valeria Tanco and Sophy Jesty faced a similar struggle after marrying in New York and relocating to Tennessee, where their marriage was not recognized. As Valeria became pregnant, their urgency to secure legal recognition intensified, as they sought to ensure both their names would appear on their child's birth certificate.

Dr. Ijpe DeKoe and Thom Kostura, also from Tennessee, encountered legal uncertainties regarding military benefits after moving to the state due to Dr. DeKoe's service. Married in New York, their experience highlighted the discrepancies in legal recognition for same-sex couples, especially concerning military families.

Randy Johnson, Tyler Johnson-Campion, Tevin Johnson-Campion, and Paul Campion.

308

Finally, from Ohio, Joseph Vitale and Rob Talmas had been together for nearly thirty years, dreaming of marrying and enjoying the same legal protections as heterosexual couples. However, when they attempted to formalize their relationship, they faced Ohio's ban on same-sex marriage. Their love endured despite these challenges, motivating them to seek legal recognition and fight for the rights of countless others in their situation.

Regina Lambert spent over a decade with her partner, who had fallen seriously ill. Regina's desire to be recognized as her partner's spouse was met with resistance due to Ohio's restrictive laws. The emotional struggles the two faced reflected the harsh realities for many same-sex couples in a state that refused to acknowledge their commitment.

David Michener experienced profound loss when his partner, William Ives, passed away unexpectedly. David's heartache deepened as he learned that Ohio would not recognize their marriage performed in Maryland, denying him the right to be listed as William's surviving spouse on the death certificate. This legal denial compounded his grief and motivated him to seek justice for their relationship.

Robert Grunn, a licensed funeral director in Cincinnati, fought for marriage rights to ensure that all couples, including same-sex couples, received equal recognition and dignity in death. Serving clients who were legally married, he feared prosecution for accurately classifying them as spouses on death certificates, as Ohio's laws did not recognize their unions. Grunn believed every couple deserved the right to be honored as spouses, regardless of sexual orientation.

Kelly Noe and Kelly McCraken faced numerous challenges when McCraken became gravely ill. The couple encountered the harsh realities of Ohio's same-sex marriage ban, as Noe was not recognized as McCraken's legal spouse, creating significant barriers regarding medical decisions and inheritance rights. Similarly, Brittani Henry and Brittni Rogers, despite being married in California, struggled to have their marriage recognized in Ohio. They sought to ensure that they could share legal protections and rights as parents of their children.

Finally, at the heart of this collective struggle, were James Obergefell and John Arthur from Ohio.

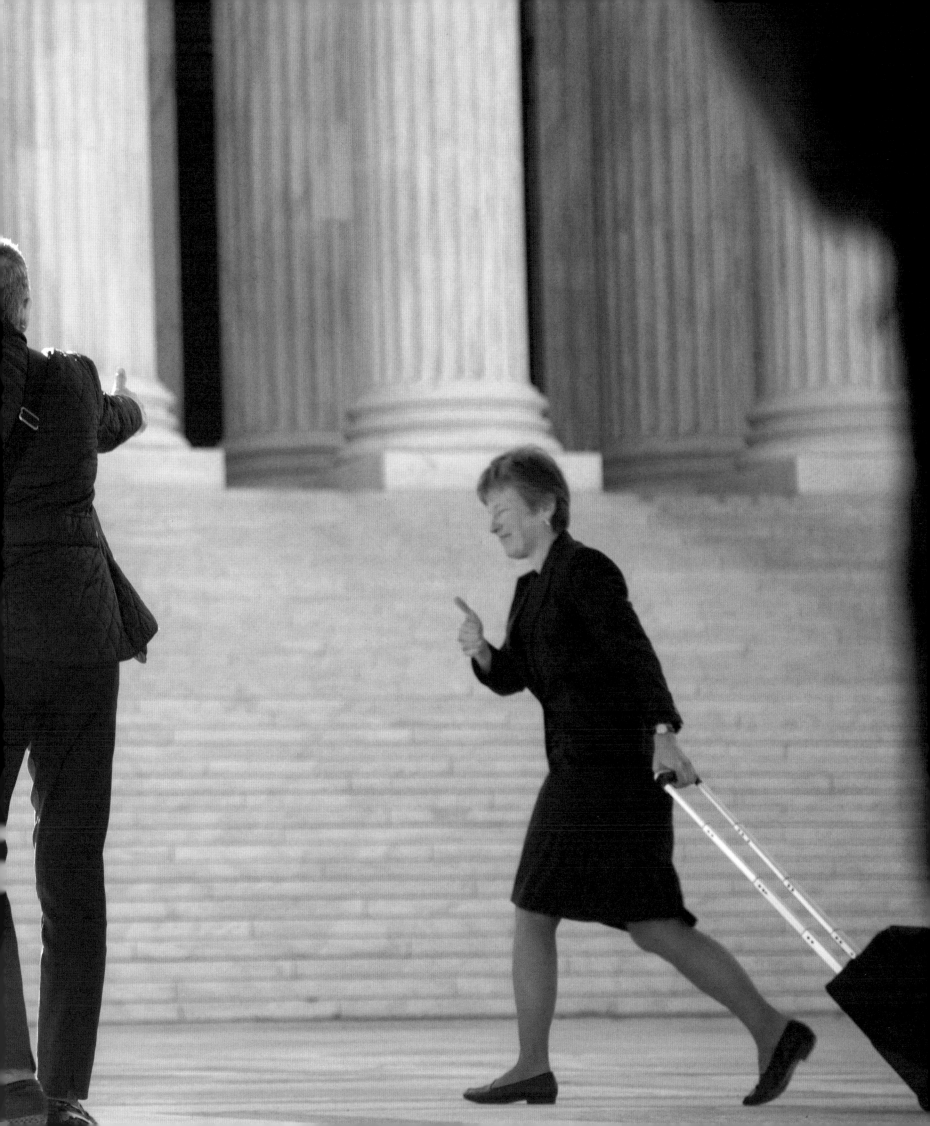

JIM OBERGEFELL AND JOHN ARTHUR

The couple of over twenty years fought so that when John died, his death certificate would not say he was single. Because he wasn't. Five sitting justices agreed that love is love.

Jim Obergefell's journey from a private citizen to a pivotal figure in the fight for marriage equality in the United States is a profound tale of love, loss, and legal triumph. His story began with a simple yet powerful desire to have his marriage to John recognized and respected. For heterosexual couples, being able to marry was simple. For others, like Jim and John, this simple act was full of complexities.

Jim and his partner of more than two decades, John, lived a simple and unassuming life, like so many of the heroes in the fight for marriage equality. They never dreamed that their story would become a singular, historic achievement that would dismantle the complex idea of queer marriage.

Tragically, Jim and John's simplicity was shattered when John became terminally ill with amyotrophic lateral sclerosis (ALS), and the couple had to face the difficult realization that their time together was short. They decided to marry before John died, and they felt somewhat confident that they could do so after the Supreme Court, in June 2013, struck down parts of the Defense of Marriage Act, making same-sex marriage legal in some states.

Since their home state of Ohio did not recognize same-sex marriages performed in other states, with the help of friends who raised funds for a medical jet, Jim and John flew to Maryland in July 2013. They were legally wed on the tarmac, as John was too ill to leave the plane. This touching moment was not just a private celebration but became a symbol of love and resilience for many, not only in Cincinnati, where they lived, but around the country.

The wedding was reported by the *Cincinnati Enquirer* and crystallized the discriminatory legal landscape faced by same-sex couples. Jim and John's story warmed hearts but also had a bitter undertone. How could the State of Ohio be thoughtless enough to deny their marriage license, given John's terminal condition and impending death?

Enter Al Gerhardstein, a civil rights attorney moved by their story. He recognized the injustice and met with Jim and John to discuss the implications. Gerhardstein brought a blank death certificate to their meeting, showing them how Ohio's refusal to acknowledge their marriage would misrepresent their relationship.

He explained that, despite their intense love and legal marriage in Maryland, the State of Ohio would not recognize Jim as John's surviving spouse. The couple, despite the heavy emotional burden of John's declining health, decided to fight. As Gerhardstein recalled, "They wanted to take these last precious days of John's life and try to achieve one more thing: correcting the official record of their love and life together." This decision marked the beginning of a legal battle that would eventually lead to a landmark Supreme Court ruling.

As their attorney, Al noted that Ohio's refusal to recognize their marriage meant that when John passed away, the death certificate would inaccurately list him as single, denying Jim the acknowledgment as John's surviving spouse. A single, simple line on a death certificate would cause immense heartache for Jim and John,

as well as for other same-sex couples in similar situations—and reverberate through the nation.

Jim and John's decision to fight for the recognition of their marriage was not taken lightly. At a time when they were dealing with the emotional and physical toll of John's illness, they also had to step into a public and legal arena that was unfamiliar and daunting, the very antithesis of the simple and private life they had led.

Jim, typically the quieter of the two, found himself in the spotlight. "They were a very engaged, but not a particularly political couple," Gerhardstein explained. "So, this was all very new to them, and very challenging."

As the case proceeded, the emotional and personal dimensions of their struggle became more apparent—and more public. Jim's statement in court during the first trial in July 2013 was a riveting account of his love for John and their life together. He spoke eloquently about the importance of having their marriage recognized, not just for legal purposes but as a true reflection of their partnership. "We've been beside each other for twenty years. We deserve to be beside each other in perpetuity," Jim said from the witness stand.

Spurred in part by Jim's words, the court initially ruled in their favor, and it was a significant victory. The court ordered the State of Ohio to recognize their marriage on John's death certificate. However, the state's decision to appeal this ruling meant the case was far from over. Sadly, John died on October 22, 2013. Jim became a widower and was left to fight the legal battle for the recognition of their marriage alone.

"The state was insisting that it would revert the death certificate to list John as single if the appeal was successful," Al pointed out. "This refusal to acknowledge their marriage, even after John's death, underscored the ongoing discrimination faced by same-sex couples."

The fight for recognition of Jim and John's marriage eventually became part of a larger legal movement. Their case was consolidated with others challenging state bans on same-sex marriage, leading to the historic Supreme Court case *Obergefell v. Hodges*. "This case did not just challenge the bans on same-sex marriage," Al noted. "It addressed the fundamental question of whether the Constitution requires states to recognize marriages between same-sex couples legally performed elsewhere."

Jim's role, in the face of tremendous loss, transformed him from a private citizen seeking justice for his husband's death to a national figure advocating for marriage equality. The emotional weight after John's death was enormous. "Jim was comfortable carrying it forward because he knew he was honoring John in the best way," Al said with admiration. "He was very brave in the face of overwhelming adversity."

Jim's resilience was rewarded when the Supreme Court handed down their decision on June 26, 2015. It was a landmark moment in American history. In a 5–4 decision, the Court ruled that same-sex marriage was a constitutional right under the Fourteenth Amendment. This ruling effectively legalized same-sex marriage across the United States, ensuring that same-sex couples could marry and have their marriages recognized in every state.

In his opinion for the majority, Justice Anthony Kennedy wrote, "The nature of marriage is that, through its enduring bond, two persons together can find other freedoms, such as expression, intimacy, and spirituality. This is true for all persons, whatever their sexual orientation. . . . There is dignity in the bond between two men or two women who seek to marry and in their autonomy to make such profound choices."

Jim Obergefell and John Arthur on a trip to Stockholm, 2007.

It was a long, hard-fought struggle for Jim. The decision was both a personal victory and a monumental step forward for our culture. The ruling acknowledged the dignity and equality of same-sex couples, recognizing their marriages as equal to those of opposite-sex couples. The decision was celebrated across the country, marking a profound shift in the legal and social recognition of gay relationships. And it made the simple and unassuming Jim a national hero and an LGBTQ+ icon.

Reflecting on the significance of this case, Al said that it was essential to consider the broader cultural and social context. At the time of the decision, public support for same-sex marriage had been growing steadily. "Something like 70 percent of the whole country supports gay marriage now," he indicated. "The Supreme Court's decision was in harmony with this growing public sentiment, highlighting a rare instance where judicial action aligned closely with public opinion."

Jim's journey did not end with the Supreme Court decision. He continues to be an advocate for LGBTQ+ rights, using his platform to speak out on issues affecting the community. His story, along with those of other plaintiffs in the case, became a symbol of the fight for equality and justice.

As for Al, it was the sweetest victory in a long career of fighting for social justice and equality. "I couldn't do anything about John's illness and death, but I certainly felt proud to be able to protect the record of their marriage and to have that stand as a beacon for others, so that queer couples across the

country would feel secure in publicly making their commitment and getting married."

But there was one moment during all the seemingly unending legal drama that Al remembers most. "It doesn't get that much attention, but when we filed the lawsuit, we had to sue both the City of Cincinnati and the State of Ohio because, under Ohio law, the city manages the Office of Vital Records, which handles death certificates, even though they follow state guidelines," Al explained. "Interestingly, during litigation, the city chose not to defend the state's position. Instead, they stood up in court and agreed with our side, effectively saying they would not oppose what we were trying to achieve. This was a rare and touching moment in legal history, where a defendant openly sided with the plaintiffs, supporting the correction of John's death certificate to reflect his marriage to Jim."

What seemed so simple to everyone else—getting married and checking a box that says "married" on legal documents—was, for queer couples, a painful reminder of exclusion. The frustration, humiliation, and devastation they faced in having their love denied legal recognition weighed heavily on them for decades. But it took the quiet strength of one unassuming couple and the unwavering dedication of a compassionate lawyer from Cincinnati to change all of that. Together, they transformed complexity into clarity, injustice into equality. Because of their courage, love now stands on equal ground, and same-sex couples across the country can share the same rights, recognition, and dignity that marriage brings.

Opposite: Jim Obergefell kisses his husband, John Arthur, who suffered from ALS, after they were married by officiant Paulette Roberts, Arthur's aunt, on a plane on the tarmac at Baltimore/Washington International Thurgood Marshall Airport on July 11, 2013. **Following spread**: James Obergefell, center, walking out of the Supreme Court on June 26, 2015, in Washington. He was the plaintiff in the Supreme Court case that legalized same-sex marriage. **Pages 322–23**: The White House lit up in rainbow colors to celebrate the Supreme Court's opinion legalizing gay marriage in all fifty states.

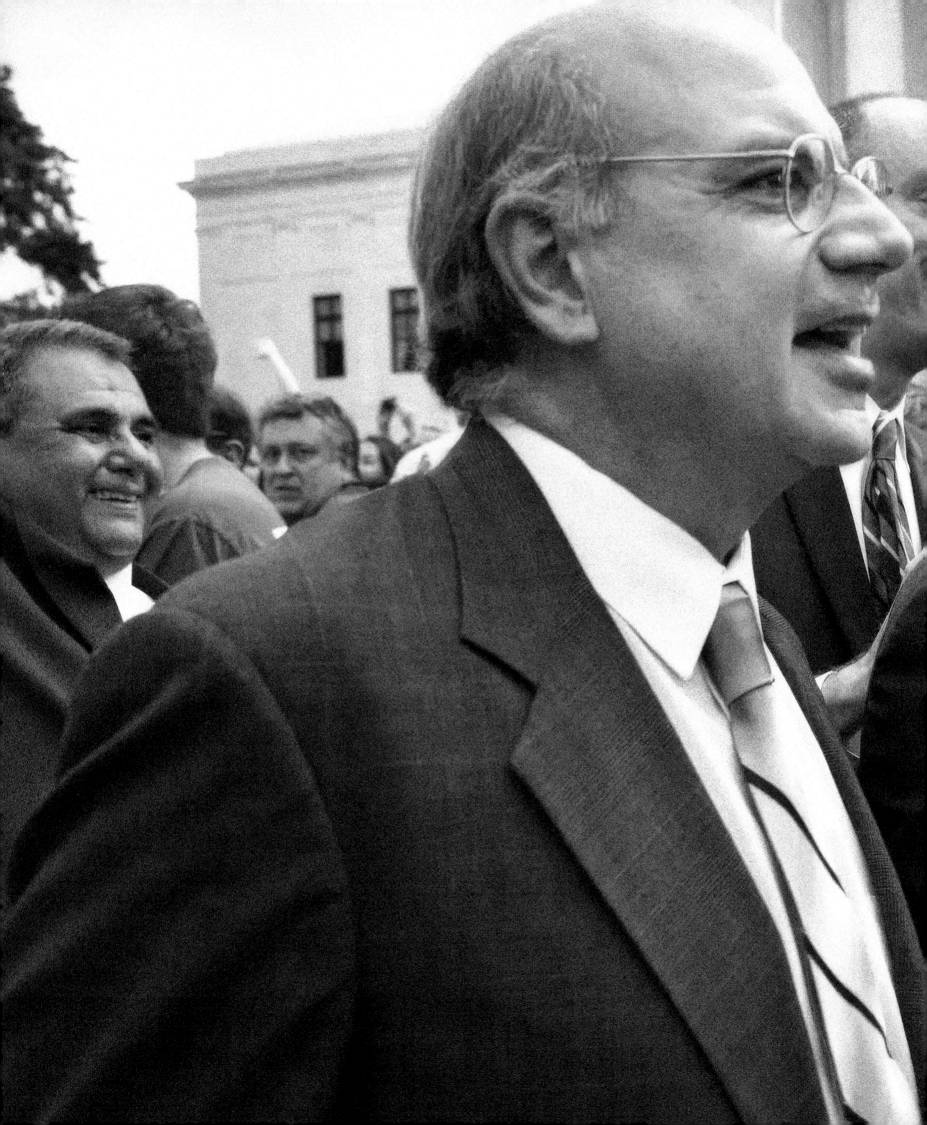

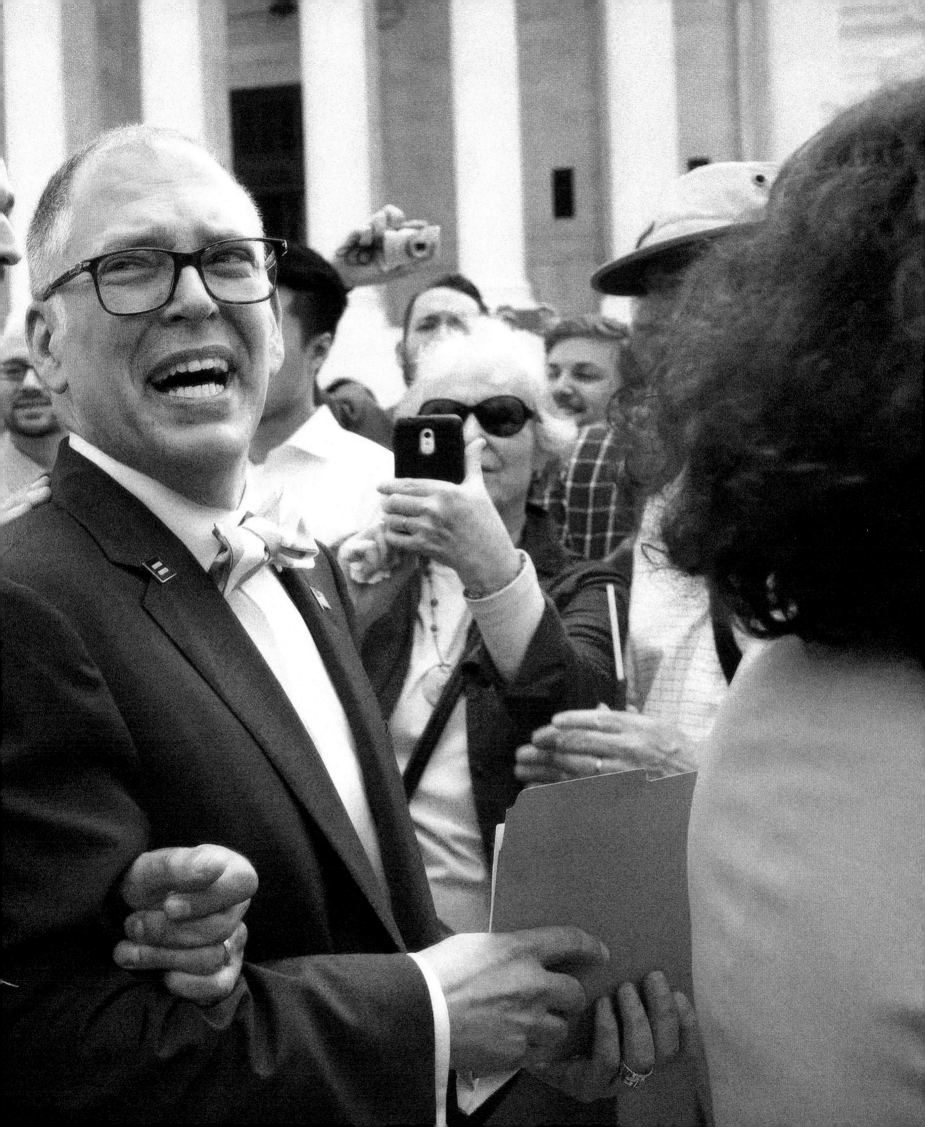

FROM THIS DAY FORWARD

POST-2015

CHAPTER 9 — INTRODUCTION

Since the momentous Supreme Court 2015 decision declaring the freedom to marry for all, *Obergefell v. Hodges*, a new era of love, hope, dignity, and equality has emerged for the LGBTQ+ community. In a society once shackled by fear, love has begun to flourish in ways previously unimaginable. New generations now dream freely of engagements and weddings celebrated among family and friends basking in a warmth that once seemed unattainable. When *Goodridge* first established the right to marry in the first State of the Union, national approval for marriage equality hovered around 40 percent. As of 2024, it has soared to over 70 percent.

In this brave new world, public figures have stepped into the limelight as married couples, embodying a shift toward acceptance. Among them is Pete Buttigieg, who made history as the first openly gay married presidential candidate. His run for the highest office in the land alongside his husband, Chasten, became a beacon of progress. The Buttigiegs have challenged stereotypes by sharing their family life through children's books and media appearances. The sight of Mayor Pete addressing massive crowds in Middle America—where his message on the campaign trail transcended his marriage—serves as a poignant reminder of how far we've come since marriage equality was legalized.

The story of Brittney Griner, the women's professional basketball star who was imprisoned in Russia, serves as a sobering reminder of the world outside the protective bubble that marriage equality has created. Yet, it is now possible for Brittney and her wife to address the media as a married couple yearning to reunite. This shift highlights the empathy and outcry surrounding her situation, reflecting Americans' broader understanding of LGBTQ+ rights as human rights—an understanding that profoundly influenced by the recognition of marriage rights. Twenty years ago, someone in Brittney's position might have referred to her partner as a "roommate" or "significant other," terms that lack the weight and significance of the word "wife," which carries thousands of years of meaning.

Gone are the days when friends and their families had to navigate the bittersweet realities of inviting gay guests to their weddings who might not be able to have their own day at the altar. In this evolving narrative, many couples have embraced love and commitment. Jessica Betts and Niecy Nash-Betts married in 2020, while Samira Wiley and Lauren Morelli exchanged vows in 2017. RuPaul's marriage to Georges LeBar in 2017 further showcased the beauty of love in all its forms. Yet, the triumph of love is accompanied by the sobering reality of systemic challenges that persist.

Page 325: Mayor Pete Buttigieg campaigns for president at a Las Vegas rally before the Nevada caucus, February 16, 2020.
Opposite: Colorado Governor Jared Polis, left, marries First Gentleman Marlon Reis, right, at a private wedding ceremony at the Mary Rippon Outdoor Theatre at the University of Colorado, September 2021.

Growing support for marriage equality has been reflected in polls and when individuals like Pope Francis advocate for civil rights. The Episcopal Church expanded marriage rites for same-sex couples, signaling a transformative moment for faith and inclusivity.

The loss of trailblazers like Edie Windsor reverberated throughout the community, igniting a wave of remembrances on social media as people shared their stories and photos with her. Edie's legacy, carried ahead by Judith Kasen Windsor, continues to inspire advocacy for equality. Her memorial service, attended by dignitaries like Hillary Clinton and Barack Obama, served as a poignant reminder of the small acts of persistence that have fueled the movement toward equality.

However, lurking behind the facade of progress is an unsettling reality: a conservative federal bench that threatens to undo the hard-won rights of LGBTQ+ individuals. Kim Davis, the former county clerk of Rowan County, Kentucky, has re-emerged in the legal spotlight, seeking to overturn the landmark marriage equality ruling, *Obergefell v. Hodges*. Following the Supreme Court's decision in 2015, Davis infamously shut down all marriage license operations at her office rather than issue licenses to same-sex couples, citing her religious objections. This defiance led to a federal lawsuit filed by David Ermold and David Moore, who were denied a license, resulting in a court order for Davis to pay $260,104 in legal fees, in addition to a previous $100,000 in damages. In a recent brief filed with the US Court of Appeals for the Sixth Circuit, Davis and her attorneys from Liberty Counsel argued that the plaintiffs lacked credible evidence for their damages and claimed that *Obergefell* was fundamentally flawed. Their argument echoes sentiments expressed by conservative justices, particularly Clarence Thomas, who have criticized substantive due process, suggesting *Obergefell* lacks a constitutional basis. With a 6–3 conservative majority in the Supreme Court, the potential exists for Davis's case or another like it to gain traction. Although the Respect for Marriage Act signed by President Biden offers some protections, it does not mandate that states issue marriage licenses to same-sex couples.

Families like Elad and Andrew Dvash-Banks grappled with the disheartening bureaucracy of a country still rife with discrimination. Their bi-national marriage faced a nightmare when the Trump State Department declared that only one of their twin sons, conceived through surrogacy with one father's sperm, would be recognized as a US citizen. Andrew Banks, who grew up in West Hollywood in the 1980s, faced severe bullying, despite living in what was believed to be a safe haven. As marriage equality became the law of the land, he thought he was escaping the shadows of his past, only to find himself entangled in a citizenship nightmare. The couple's fight for their twins became a national media blitz, shedding light on the discrimination still faced by LGBTQ+ families.

In Texas, Jason Hanna and Joe Riggs fought tirelessly to have each other's names added to their twins' birth certificates, a legal right they were entitled to but denied by a prejudiced judge. Meanwhile, Stacy Bailey, a beloved teacher in Texas, was placed on leave after a parent objected to the fact that she was sharing a life with her partner.

The atmosphere in certain states has also become increasingly hostile. In Florida, legislation prohibiting discussions about LGBTQ+ lives in classrooms—termed the "Don't Say Gay" bill—threaten to erase the existence of countless families. Book bans targeting LGBTQ+ narratives serve as a reminder of the threat of societal erasure, and a battle fought not just in the courts but also in the hearts and minds of everyday Americans.

As 2020 unfolded, history was made yet again with the election of Joe Biden and Kamala Harris—both elected as strong supporters of marriage equality, which was a first—marking a significant shift in the political landscape. Their administration represented a promise to uphold the rights of all citizens, regardless of sexual orientation.

The Dvash-Banks family eventually triumphed in securing citizenship for both their sons, thanks to the Biden-Harris administration's refusal to continue the case. Florida's "Don't Say Gay" law was deemed illegal, and the Biden-Harris administration passed the Respect for Marriage Act, protecting federal marriage rights for those already married, should the newly conservative Supreme Court overturn *Obergefell*, as they are threatening to do, and send marriage rights back to the states as they did with *Roe v. Wade*. The complexities of marriage equality in America are underscored by the ongoing battle in courts and communities. High-profile cases, like *Fulton v. City of Philadelphia*, brought the question of LGBTQ+ rights in adoption and foster care agencies to the forefront, with Amy Coney Barrett's appointment to the Supreme Court resulting in queer freedoms losing out to religious freedom.

As the chapter closes on this period, it is clear that the fight for LGBTQ+ rights continues. Love, while victorious, remains an ongoing journey, one that requires vigilance, advocacy, and unity. The stories of those who came before us guide the way, reminding us that the path to equality is paved with both triumphs and challenges.

Olivia Hamilton (right) and her wife, Molly (left), were married and officially blessed by St. James Episcopal Church in Boston on September 17, 2016.

ELAD AND ANDREW DVASH-BANKS

The Trump administration tried to deny one of this legally married couple's twins US citizenship while granting it to the other. It didn't go well for the White House.

It was a fairy-tale when Andrew Banks met Elad Dvash at a Purim party, a kind of Jewish Halloween, in February 2008 while both were attending Tel Aviv University. "I was dressed like a sexy cowboy, and Andrew was a blue fairy with wings and glitter and everything," recalls Elad. "Andrew is from Canada, and was studying abroad at the time, and I was a counselor working at the university. We met on the dance floor, and soon after Andrew was asking my colleague, 'Do you know if he's into guys and if he is, is he available?' And she responded, 'Why don't you go and ask him yourself?' So that's what he did, and the rest is history!"

However, their first date didn't go as smoothly as a Texas two-step or a gliding fairy flight. "My birthday was soon after, and Andrew texted me to wish me happy birthday, and wrote, 'Why won't we meet?'" Elad said. "We scheduled to meet for coffee, and I misplaced my phone, and forgot about it, since I didn't get the notification. He waited there all alone, and I never showed up."

Fortunately for Elad, Andrew has a forgiving heart. Over a year later, they moved in together, and in July 2010 Andrew proposed. Because Andrew was from Canada, where gay marriage is legal, they moved across the Atlantic. They married in August 2011.

"He planned the whole thing since he wasn't working," Andrew reflected. "The ceremony was at an old, English-style castle in Toronto. It was outdoors in a forest setting. All of our friends and family were there from Israel and my family in Los Angeles. Everyone who was there describes it as a fairy-tale wedding."

What made the day extra special for Andrew was that he was walked down the aisle by his father, who was a staunch Reagan Republican. "His politics definitely factored into how I was accepted at the beginning," Andrew pointed out. "But his love for me trumped his love for his party, and he became my biggest cheerleader."

Unfortunately, it was a different kind of Trump that would turn their fairy-tale marriage into a nightmare. Andrew and Elad decided to have children, which was a shared dream. They had fraternal twin boys, Aiden and Ethan, in 2016, one fathered by Andrew and the other, Elad. Soon after, the couple decided to move their family to Los Angeles to be closer to relatives. That's when their bad dream began.

Since Andrew was a dual American-Canadian citizen, Aiden was allowed to enter the United States. But then President Donald Trump's State Department prohibited Ethan from getting a US passport because he wasn't biologically related to Andrew. "The consulate wanted us to explain to them which baby belonged to Andrew, and which one was mine, and we refused to tell them," Elad relayed. "It wasn't any of their business. We're not a heterosexual couple, and so they didn't give us that same presumption of parentage." The State Department was essentially telling the husbands that their children were born "out of wedlock."

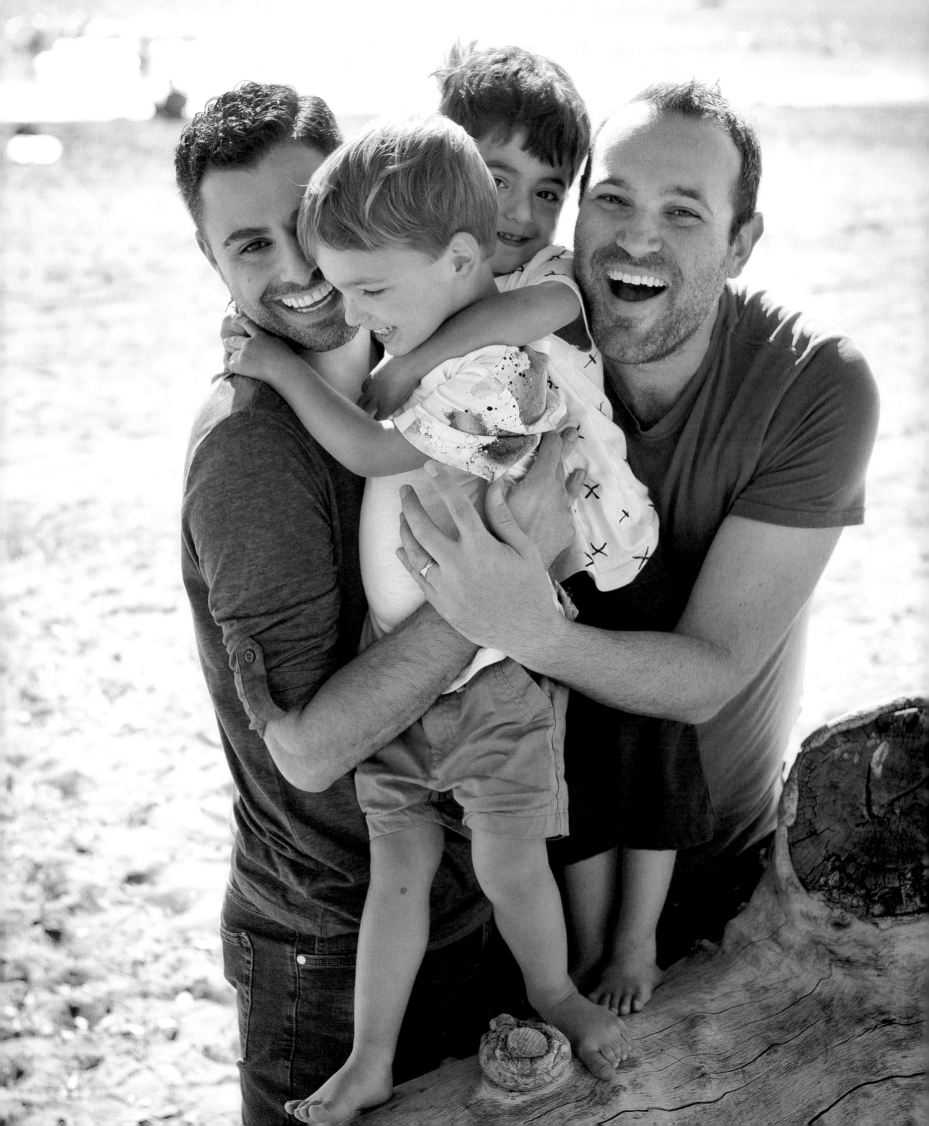

Andrew was used to dealing with bullies, having had to deal with episodes of gay bashing in high school after coming out—despite growing up in gay-friendly and very gay-populated 1980s West Hollywood, a setting one would expect to be more welcoming. Elad, who was born in Tel Aviv, Israel, had grown up understanding day-to-day how to handle conflict as well. Together they stood strong, refusing to be bulldozed by an administration that demonstrated early on its contempt for marriage equality and queer people. Immigrant rights organization Immigration Equality took on their case and filed a lawsuit against the US State Department. And that started three years of court battles and unimaginable frustration for the Dvash-Banks family, who remained separated throughout that time.

Their case gained international exposure since it highlighted a Trump administration discrimination issue not faced by heterosexual couples in similar situations. For Andrew and Elad, it was an uneasy and nerve-wracking dance—the antithesis of an easy-swaying cowboy and blue fairy.

After lots of ups and downs, in February 2020, a California judge ordered the government to issue a passport for Ethan, and the government complied, bringing relief to the Dvash-Banks family. Yet that

relief was short-lived, as the Justice Department filed an appeal of the decision in May with the Ninth Circuit Court of Appeals in San Francisco.

Finally, a year later, a California judge ruled for Andrew and Elad and the Trump administration lost on its second appeal. After the Biden-Harris administration was sworn in and quickly announced they would not continue blatant discrimination, the couple was relieved—as were many other couples in similar situations when, in 2021, Biden-Harris restored citizenship rights to children born abroad to married LGBTQ+ Americans.

After all the turmoil, Andrew and Elad prefer to remember the good times, and appreciate, daily, that the family is all together. "We have pictures around the house of our wedding day, and we show them to the kids, and we talk about that day," Andrew recounted. "We even visited Toronto in the winter of 2023, and took the kids to that estate where our wedding was."

Elan said that the kids thought it was a very scary place. "It was in the winter, and we told them how beautiful it was in the summer. We wanted to show them where their parents got married, and how it was one of the happiest days of our lives."

Twins Ethan and Aiden Dvash-Banks, born in 2016. Canadian authorities recognized both dads as legal parents, naming both of them on the twins' birth certificates.

REP. MALCOLM KENYATTA AND DR. MATTHEW KENYATTA

From love to leadership: Malcolm and Matthew Kenyatta's journey to change.

Malcolm Kenyatta's victory in the 2024 Democratic primary for Pennsylvania auditor general marked another key moment in LGBTQ+ history, not just for his political achievements but also for the visibility and importance of his out-and-proud relationship with his husband, Dr. Matthew Kenyatta. In a world where many still feel the pressure to hide their identities, Malcolm and Matthew's relationship serves as a reminder that authenticity in public life matters just as much as policy.

Their marriage is more than a personal commitment—it is a public declaration of the progress made in the fight for LGBTQ+ rights, a signal to those still struggling to be themselves that love is something to be celebrated, not hidden. As Malcolm himself has said on numerous occasions, the power of being out, visible, and true to oneself can create seismic change in the world, even more so in the political arena, where authenticity is often scarce.

From the moment Malcolm and Matthew's relationship became public, it represented a shift in the political landscape. For years, LGBTQ+ individuals, particularly those of color, were often forced to conceal parts of themselves to be accepted in public life. Malcolm's candidacy broke that mold, showing that being out and open is not a liability—it is a strength. Their love story—two Black men openly committed to each other and their shared values—is woven into the very fabric of Malcolm Kenyatta's campaign and public service.

Malcolm's victory as the first openly gay man nominated by a major party for statewide office in Pennsylvania represents the triumph of authenticity over fear, love over discrimination, and progress over the status quo. They understand that visibility—being seen, acknowledged, and accepted—is one of the most powerful tools in the fight for equality.

Malcolm Kenyatta, a third-generation North Philadelphian, shattered barriers in 2018 when he was elected to the Pennsylvania House of Representatives, becoming the first openly LGBTQ+ person of color to serve in the general assembly. In 2020, Kenyatta shared his coming-out story on the Pennsylvania House floor—a powerful moment that resonated with many in the LGBTQ+ community who had long felt invisible in the halls of power. Their wedding, while private, was a symbol of hope and progress, particularly in a state like Pennsylvania, where LGBTQ+ rights have often lagged behind.

During his 2018 campaign, homophobic posters targeting him and Matthew were distributed throughout his district, a grim reminder that prejudice against LGBTQ+ people still exists, even in progressive spaces. But rather than allowing these attacks to silence him, Malcolm used them as motivation to continue his fight for justice and equality. He remained steadfast in his belief that everyone, regardless of sexual orientation or identity, deserves to live without fear.

As Pennsylvania auditor general, Malcolm understands the importance of his position, not just for him and Matthew, but for LGBTQ+ people across the state and his role in preserving the human rights of all people. "Being out and proud means showing the world who we are, and when we do, we change everything," he believes.

Pennsylvania State Representative Malcolm Kenyatta marries Dr. Matthew Jordan-Miller at the Philadelphia Metropolitan Opera House on February 5, 2022.

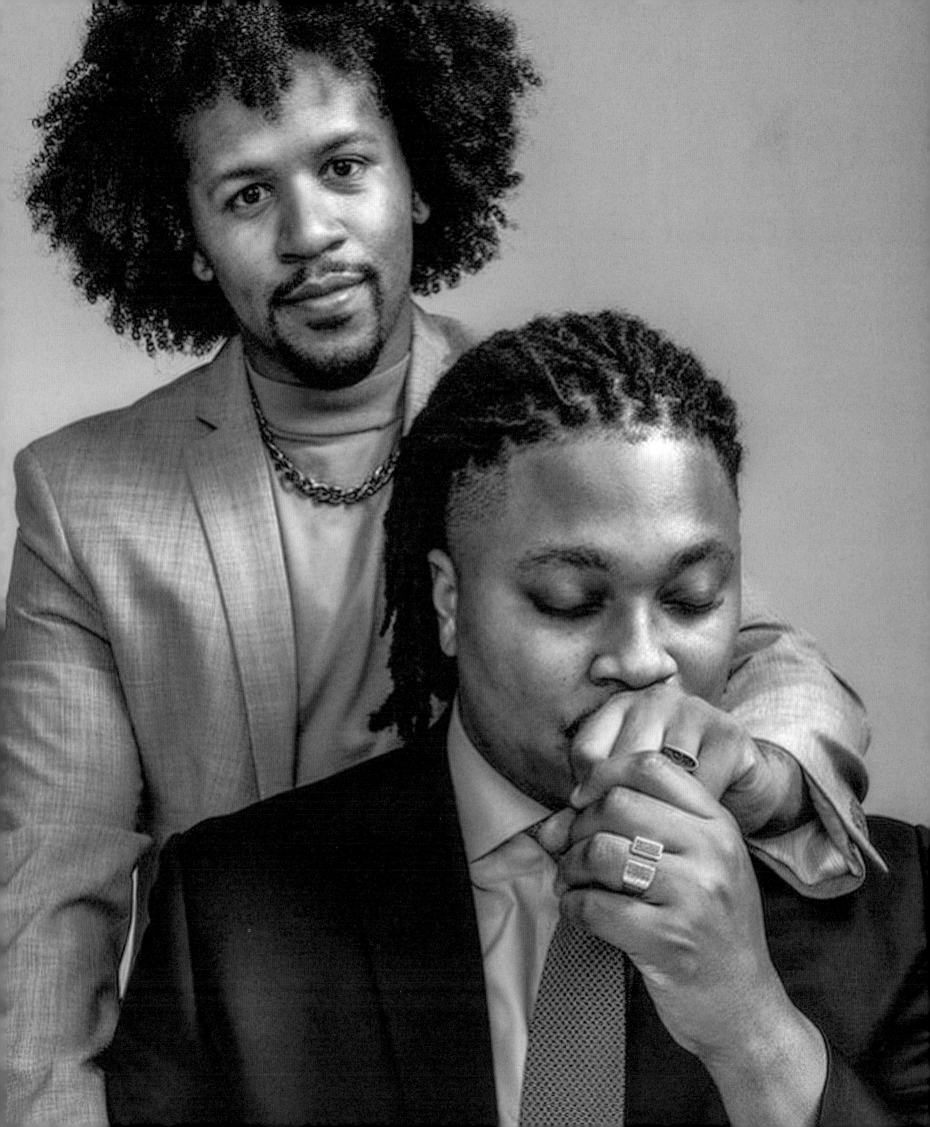

NIECY NASH AND
JESSICA BETTS

Black, queer, and unapologetically in love.

Niecy Nash and Jessica Betts's love story captivated the world when they surprised fans by announcing their marriage in 2020. As two Black women—one a beloved actress, the other a talented musician—publicly sharing their love, they brought visibility to Black and LGBTQ+ communities, especially in spaces where they are often marginalized.

Their union was not just about love but about representation. One of the beautiful results of winning the right to marry in 2015 is that more people like Niecy and Jessica can be out and love the way their hearts desire. For communities of color, particularly in cities like Nashville and in Hollywood, where being both Black and LGBTQ+ can feel isolating, their open and proud relationship sent a powerful message: It is possible to live fully and authentically, even in the face of adversity. Nash had always been open about her identity, but revealing her marriage to Betts was a moment of joy and liberation, for herself and countless others who may not see their love stories celebrated in mainstream spaces.

Their wedding, full of love and music, was a celebration that resonated with many. Niecy Nash and Jessica Betts showed the world that love, in all its forms, is beautiful. By being unapologetically themselves, they are helping to shift narratives about what it means to be Black, queer, and in love, proving to the world—and themselves—that being both married and proud is more than okay; it's something to celebrate.

Niecy Nash and Jessica Betts after their surprise wedding, Ventura, California, 2020.

PETE AND CHASTEN BUTTIGIEG

With marriage equality secured, Pete and Chasten were free to pursue the possibility of becoming the first married, gay family to move into the White House.

Pete Buttigieg, an American politician, served as the thirty-second mayor of South Bend, Indiana, and was a 2020 Democratic presidential candidate—the first openly gay person to make a serious bid for the presidency. His candidacy also marked the first time a candidate with a same-gender spouse ran for president—his spouse being Chasten Glezman, a former teacher and education advocate. Five years before that, in 2015, Pete had proposed to Chasten, and their marriage had been featured in a CNN documentary. As a presidential candidate, Pete toured the country, discussing the economy, climate crisis, and military readiness—issues he understood firsthand as an Afghanistan war veteran. He also spoke about his husband and their desire to start a family.

A devout Christian, Pete had to learn to love himself as a gay man before becoming mayor, falling in love, and legally marrying Chasten. Chasten joined Pete on the campaign trail while working on a book about his life and their shared experiences. The newlyweds consistently countered stereotypes about gay families through media interviews and books.

Mayor of South Bend, Indiana, Pete Buttigieg and Chasten Glezman-Buttigieg leaving the Cathedral of St. James in South Bend following their wedding on June 16, 2018.

However, massive crowds in middle America focused on Pete's message, not his marriage—a clear and beautiful outcome of the marriage equality victory in 2015. During Pete's presidential run and his subsequent role as secretary of transportation in the Biden administration, the couple used their platform to raise awareness about LGBTQ+ issues, including marriage equality. They have been open about their experiences as same-sex spouses.

The couple played a significant role in helping the Biden-Harris administration lobby for the Respect for Marriage Act—which promised to add protection for marriage equality into federal law, preserving it for those already married—by discussing their lives and family, which now includes twins, Penelope and Gus. Chasten wrote in a *Medium* post:

> My marriage has filled this house with so much love it makes me want to be a better husband, father, and citizen every day. It's called me to something bigger than myself while recognizing that my kids are now the most important thing in life, and I'd do anything to protect them. Our family and our union push me to make sure we leave our kids a country and a world they can thrive in so that they, too, can enjoy all of the love and light and happiness that Pete and I have known simply by falling in love with one another.

The post was published just hours before the US Senate passed the Respect for Marriage Act in 2022.

In his books, including adult and young adult versions of *I Have Something to Tell You*, Chasten aims to promote empathy, acceptance, and love for all individuals. His heartfelt autobiography recounts his journey of self-discovery as a gay man, sharing his experiences of coming out and finding love. The young adult book faced backlash and has been banned in some areas of the United States, sparking conversations about censorship and diversity in children's literature.

The formidable couple continues to face down bigotry, but the two men see times changing positively. They are steadfastly committed to speaking about their lives and helping the country understand the value of legal marriage and equality for all.

TODD AND JEFF DELMAY

They fought to win marriage rights in Florida to protect their family. And when the state said "Don't say gay," they stayed in the game to help remove the shameful law.

Perhaps best known as faces of the fight for marriage equality in Florida, Todd and Jeff Delmay were among the six same-sex couples who became plaintiffs in the *Pareto v. Ruvin* lawsuit, challenging the state's ban on same-sex marriage.

Not long after starting their business, the Delmays decided to expand their family and initially looked into surrogacy. A perfectly timed opportunity arose when a family member, who had planned to put their baby up for adoption, offered them the chance to adopt. At the time, same-sex adoption was illegal in Florida, but a family law attorney helped Todd and Jeff navigate the process. Since Jeff was the child's blood relative, he was able to adopt their son, Blake, as a single parent. Todd, however, had to remain in the background during the adoption hearing. To establish shared parental rights, the couple compiled extensive legal documentation.

Just days before Blake's birth, Todd and Jeff legally changed their last names to Delmay—a blend of their given names, Jeff Delsol and Todd May. This symbolic act affirmed their commitment to being a family, despite societal resistance. Blake was given the Delmay name on his birth certificate, solidifying their family unity.

In 2014, when the National Center for Lesbian Rights approached the Delmays to join the *Pareto v. Ruvin* case, they readily agreed, despite the sacrifice of their privacy. They deeply believed in the need for legal protections for families like theirs. Jeff, reflecting on his experiences as a Black man, saw their advocacy as a continuation of the broader civil rights movement, stating, "I have a purpose in the advocacy world." He recognized the responsibility of carrying forward the legacy of those who had bravely fought for both racial justice and LGBTQ+ equality.

On January 5, 2015, Todd and Jeff made history as one of the first same-sex couples to legally marry in Florida, with a ceremony performed by a Miami-Dade circuit judge. That evening, they celebrated quietly with their son, enjoying a family outing at the park.

Their advocacy expanded in the following years as they fought against discriminatory legislation, including Florida's "Don't Say Gay" law, which threatened LGBTQ+ youth by prohibiting the discussion of gay families in classrooms. Implemented by Governor Ron DeSantis, the law targeted queer families, even pitting the state against family-friendly corporations like Disney. Jeff, as co-chair of Equality Florida, played a crucial role in the fight against this harmful legislation. In 2024, the organization achieved a historic victory when the law was struck down.

The Delmays celebrated their twentieth anniversary as a couple in 2023, and for the past thirteen years, they have been working and parenting together, grateful to enjoy the same federal and state protections as any other family.

Jeff and Todd Delmay wed as the second same-sex couple to be legally married in Florida, 2015.

A WORLD WHERE LOVE CAN THRIVE

During the first decade of nationwide marriage equality, millions of LGBTQ+ kids grew up dreaming the same dreams as their classmates—dreams without limits or fear.

Love, once stifled and unrecognized, was now able to thrive. It could be celebrated openly by friends, family, and entire communities. LGBTQ+ couples could stand before their loved ones, declare their commitment, and have their unions recognized—not just by the government but also by faith communities. Religious organizations such as the Episcopal Church, Conservative Judaism, the Presbyterian Church in America, and the Alliance of Baptists began celebrating same-sex weddings. Even some evangelicals found a way to accept and love their transgender children.

Kids found a reason to keep living because they could finally envision a potential future for themselves, regardless of their sexual orientation, gender identity, or gender expression. The LGBTQ+ community continued to build and expand their families through adoption and alternative reproductive technologies, knowing their families would enjoy the rights and protections other families took for granted. Some who were closeted at work proudly displayed wedding and family photos. Many who once feared losing their livelihoods or reputations because of their identities began to feel more secure, as societal judgment softened and the right to marry became a reality for all.

The ripple effects of marriage equality were profound. It truly became a "brave new world"— a joyous, celebratory, and more love-filled world.

As we conclude this book, we reflect on the profound joy and dignity these civil rights victories have brought to so many lives. Our nation has witnessed incredible advancements in equality— not just marriage rights, but women's rights, civil rights, and disability rights. Yet, as history has shown us, rights gained are not always rights guaranteed.

Progress has been met with backlash and backslides, such as the loss of a woman's right to bodily autonomy, and we are reminded that as vital as it is to fight for our rights, it is equally critical to maintain them vigilantly. Over seven decades, brave individuals stood up to fight for LOVE, because many paved the way just fighting to love. For LGBTQ+ people, who once had no visible heroes on the world stage to guide them, these figures now provide vital inspiration.

Their stories—hard-fought and transformative— must be preserved. These accounts of courage and resilience are our roadmaps for the future, showing us what is possible and reminding us that progress comes from those willing to stand up and lead. If we fail to remember and honor their contributions, we risk losing not only the guidance they offer for the battles yet to come but the very advancements they helped achieve.

As we look to the future, let us hold on to the bravery and resilience of those who came before us. They are our heroes, and their stories remind us to remain steadfast in the face of adversity, ensuring that the progress we've made continues to inspire future generations to dream, thrive, and love without limits.

Opposite: Don Lemon and Tim Malone exchanged vows during a ceremony at Fifth Avenue Presbyterian Church in Midtown Manhattan in front of approximately 140 guests, 2024. **Following spread**: The ripple effects of marriage equality have created a "brave new world," bringing profound joy, dignity, and love to countless lives.

GET ENGAGED

BOOKS AND FILMS BY OR ABOUT THE PEOPLE
REPRESENTED IN *LOVE*

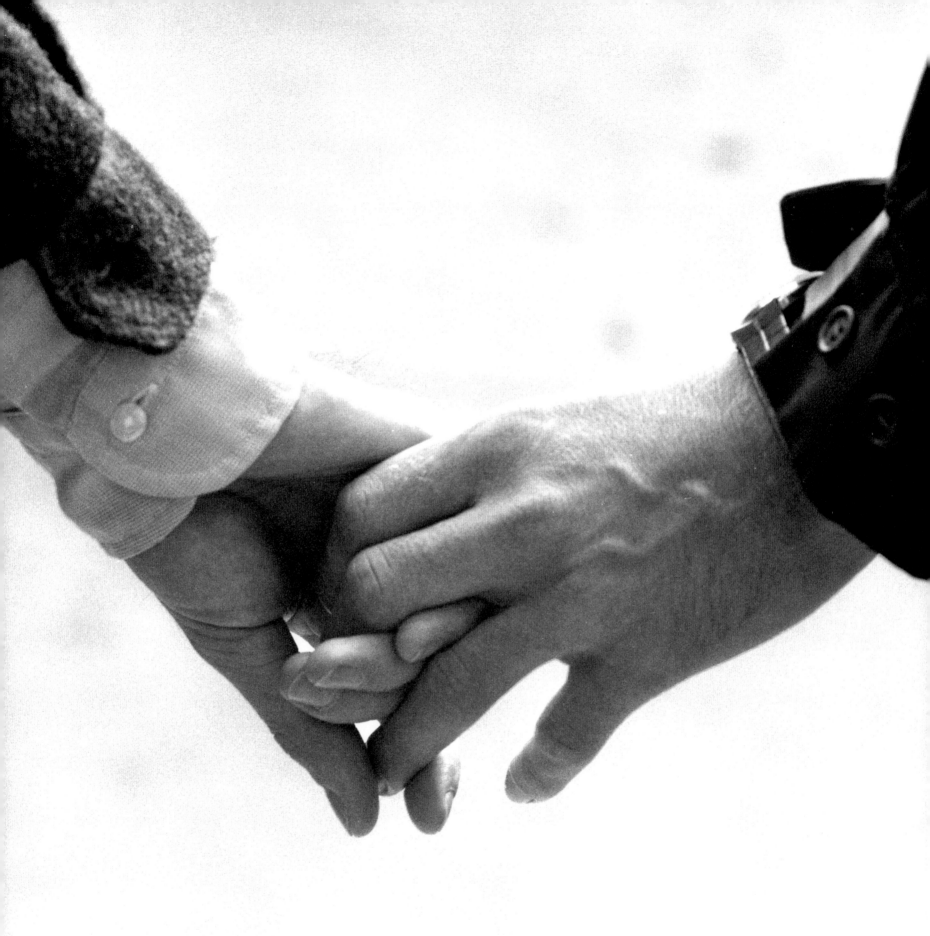

Limited Partnership, 2013
In 1975, in Boulder, Colorado, American Richard Adams and Australian Tony Sullivan's love defied borders. When Tony was denied a green card due to homophobia, they faced his deportation. Thomas G. Miller's documentary chronicles their poignant four-decade struggle for love and marriage rights, an enduring tale of resilience against formidable odds.

Edie & Thea: A Very Long Engagement, 2009
In the 1960s, a time when love was silenced, Edie Windsor and Thea Spyer found each other, kindling a clandestine romance. After forty-two years, the feisty and delightful couple finally got married. This film shows how, amid adversity and illness, they champion love's resilience, forging an epic tale of unwavering commitment.

The State of Marriage, 2016
In a gripping tale of courage and determination, the documentary *Freedom to Marry* unveils the masterminds behind the fight for marriage equality in the United States, lawyers Evan Wolfson and Mary Bonauto, as they prepare for a historic victory that changed a nation.

Waiting For the Moon, 1987
Dubbed "an imaginary biography" by the French, this film about Alice Toklas and Gertrude Stein reveals a relationship that was described only in clandestine writings. The *Los Angeles Times* calls it "the essence of their thirty-nine-year relationship, distilled with formidable insight and played with consummate artistry."

The Case Against 8, 2014
This inspirational, behind-the-scenes HBO film by Ben Cotner, Ryan White, and Rob Reiner focuses on Kris Perry, Sandy Steir, Jeff Zarrillo, and Paul Katami's fight to overturn California's Proposition 8, which banned marriage equality and left 18,000 married couples in limbo for five years.

Love Free or Die, 2012
Macky Alston's film depicts Bishop Gene Robinson reconciling his love for God with his desire to marry his partner Mark, challenging societal norms of church and marriage. As the first openly gay bishop, Gene ignites a global debate, splits the Anglican Church, and then helps Christians to see that love is truly love.

Bridegroom, 2013
After the legalization of same-sex marriage in California, Shane Bitney Crone's intention to wed Tom Bridegroom is tragically thwarted when Tom, his partner of six years, unexpectedly passes away. Compounding the irony, Tom's family denies Shane's attendance at the funeral despite his last name, "Bridegroom."

Lifetime Commitment, 1993
Kiki Feldes created a real-time documentary capturing Karen Thompson's coming out to both sets of parents, her legal battles, and her desperate efforts to bring Sharon Kowalski home.

Nuclear Family, 2021
A three-part documentary by Ry Russo-Young explores her first-generation lesbian family's journey from counterculture origins to a landmark legal battle in the 1980s. The series examines family, empathy, and the evolving perception of LGBTQ+ rights and relationships.

The Loving Story, 2011
This heart-wrenching film recounts Mildred and Richard Loving's struggle against Virginia's racist anti-miscegenation laws, leading to the 1967 Supreme Court decision that invalidated such laws nationwide. Their case set a valuable precedent for marriage equality, influencing the 2015 Supreme Court decision in *Obergefell v. Hodges.*

Silverlake Life: The View From Here, 1993
Documentarian Tom Joslin records his last months as well as his partner of twenty years, Mark Massi, both dying from AIDS at the height of the crisis. Peter Friedman finished the film after their deaths and candidly documents the love, commitment, and struggle that so many with AIDS experienced in 1993.

8: The Mormon Proposition, 2010
8 goes deeply into the Mormon Church's reprehensible influence on the 2008 California ballot initiative, Proposition 8, which outlawed gay marriage. Written and directed by Reed Cowan, it focuses on the distress of gay Mormon youths rejected by family and church leaders.

Pursuit of Equality, 2005
San Francisco Mayor Gavin Newsom's issuance of same-sex marriage licenses challenged norms and sought to reshape views on life, love, and marriage. The film highlights the human rights struggle and the emotions of couples seeking equality.

Out in the Silence, 2005
Filmmakers Joe Wilson and Dean Hamer's simple act of placing their wedding announcement in a small-town Pennsylvania newspaper led them to create an Emmy Award–winning film, sponsored by PBS and Sundance.

A Union in Wait, 2001
Director Ryan Butler chronicles Susan Parker and Wendy Scott's North Carolina same-sex union ceremony at a Baptist university that divided a community and made national headlines.

Married in Canada, 2010
This film follows seven American couples prohibited from marrying in the United States who travel north to have their love legally recognized. The newlyweds remain merely "married in Canada" as they wait for the states they reside in to make their families whole.

Freedom to Marry, 2016
Eddie Rosenstein's film follows Evan Wolfstein and Mary Bonauto in one of the greatest civil rights stories of our time and ends at the United States Supreme Court, topping an inspiring and delightful look at a decades-long battle to prove that love actually did win.

A Single Man, 2009
Tom Ford's film tells the story of a gay man grappling with the loss of his partner in the homophobic world of the 1960s. It delves into themes of love and relationships among gay individuals who are marginalized and forced to remain closeted.

Love Wins: The Lovers and Lawyers Who Fought the Landmark Case for Marriage Equality
Debbie Cenziper and Jim Obergefell. William Morrow, 2016
Love Wins is a story of law, love, and a promise made to a dying man who wanted to be remembered as a husband. Part *Erin Brockovich*, part *Milk*, this unforgettable account of the US Supreme Court case that won marriage equality nationwide will inspire readers for years.

The Wedding Heard 'Round the World: America's First Gay Marriage
Michael McConnell with Jack Baker as told to Gail Langer Karwoski. University of Minnesota Press, 2016
In 1971, Michael and Jack shared the first legal same-sex wedding in the United States. This unique account unveils their remarkable journey amid the fervor of the gay liberation movement. Their persistent fight for marriage equality stands as a model for social justice advocates and inspires those striving for acceptance.

Why Marriage Matters: America, Equality, and Gay People's Right to Marry
Evan Wolfson. Simon & Schuster, 2004
Wolfson, an influential attorney and considered the architect of marriage equality, powerfully argues for the necessity of the right to marry for all couples, highlighting its importance for equality and justice in America amid ongoing debates in effect today.

A Wild and Precious Life: A Memoir
Edie Windsor with Joshua Lyon. St. Martin's Press, 2019
A lively, intimate memoir, Edie's memoir chronicles her journey from 1950s New York City to becoming a gay rights icon, detailing her activism, landmark Supreme Court case, and personal life, including her marriages to Thea Spyer and Judith Kasen-Windsor.

Winning Marriage: The Inside Story of How Same-Sex Couples Took on the Politicians and Pundits—and Won
Marc Solomon. ForeEdge, 2014
Solomon, a key leader in the marriage equality movement, offers an insider's perspective on the strategic battles and victories while detailing the efforts against powerful opponents and the eventual triumph in securing marriage equality.

Love on Trial: Our Supreme Court Fight for the Right to Marry
Kris Perry and Sandy Stier. Roaring Forties Press, 2017
Kris Perry and Sandy Stier recount their journey from raising a family to winning their Supreme Court case that overturned California's Proposition 8, sharing their personal stories and the legal battle for marriage equality.

Why Can't Sharon Kowalski Come Home?
Karen Thompson and Julie Andrzejewski. Alyson Books, 1998
Told with candor, warmth, and with major implications for the legal rights of disabled and LGBTQ+ persons, this important book details Thompson's fight for guardianship over her partner, Sharon Kowalski, who was brain-damaged in an accident, and the struggle to bring her love back home.

God Believes in Love: Straight Talk About Gay Marriage
Bishop Gene Robinson. Knopf, 2012
This groundbreaking book lovingly and persuasively makes the case for marriage equality using a commonsense, reasoned, religious argument, made by someone who holds the religious text of the Bible to be holy and sacred.

Accidental Activists: Mark Phariss, Vic Holmes, and Their Fight for Marriage Equality in Texas
Author David Collins shares the powerful story of Mark Phariss and Vic Holmes, who overcame lifelong stigma to fight for marriage equality in Texas, ultimately triumphing in their journey to claim love in the country they cherish.

Flagrant Conduct: The Story of Lawrence v. Texas
Dale Carpenter. W. W. Norton & Company, 2012
A compelling demonstration that gay history is
an integral part of our national civil rights story,
this book examines the landmark *Lawrence v.
Texas* case, which challenged the criminalization
of homosexuality and showed how a big police lie
began to set the LGBTQ+ community free.

Marriage Equality: From Outlaws to In-Laws
**William N. Eskridge Jr. and Christopher R.
Riano. Yale University Press, 2020**
This comprehensive history of America's marriage
equality debate explores its religious, political,
administrative, and constitutional aspects while
highlighting personal stories and the significance
of the right to marry.

Higher Love: The Miraculous Story of a Family
**Paul Campion and Randy Johnson. Bristol
Publishing Enterprises, 2016**
Paul and Randy's love story encompasses their
lifelong struggle to be recognized as the parents
of four multiracial children. The two eventual
plaintiffs in the SCOTUS case that would legalize
marriage equality embrace a shared calling to
achieve a greater good for all.

*Forcing the Spring: Inside the Fight
for Marriage Equality*
Jo Becker. Penguin Press, 2014
Forcing the Spring chronicles five pivotal years
in marriage equality, focusing on California's
LGBTQ+ marriage ban. This gripping, behind-
the-scenes narrative spans the Oval Office to the
Supreme Court, showcasing top-tier political and
legal journalism.

*Courting Justice: Gay Men and Lesbians v. The
Supreme Court*
Deb Price and Joyce Murdoch. Basic Books, 2001
Groundbreaking 1980s journalist couple Price and
Murdoch explore landmark legal battles fought by
LGBTQ+ individuals, highlighting their struggles
and triumphs within the US Supreme Court, and
illustrating the evolving judicial landscape of gay
and lesbian rights.

She's Not There: A Life in Two Genders
Jennifer Finney Boylan. Broadway Books, 2003
Jennifer's love story is an insightful and beautiful
memoir of a man named James who reveals a
complex secret and becomes a woman named
Jenny—all the while married to the same woman
and parenting their two kids.

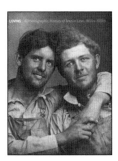

*Loving: A Photographic History of Men in Love,
1850s–1950s*
**Hugh Nini and Neal Treadwell. 5 Continents
Editions, 2020**
A collection of images taken during times when
male partnerships were illegal, this astonishing
book leans into resilience and humanity's longing
for the shared truths of love. Showcasing found
images of romantic love between men, this visual
narrative is the essence of unbridled pride.

*The Invisibles: Vintage Portraits of Love and
Pride; Gay Couples in the Early Twentieth
Century*
Sebastien Lifshitz. Rizzoli, 2014
A charming book of vintage photos from 1900 to
1960 illustrates queer couples celebrating their
relationships, often secretly. This was a time when
LGBTQ+ people were deeply closeted, yet these
proud couples camped it up for the cameras and
posed in loving portraits.

Broken Horses
Brandi Carlile. Crown, 2021
Brandi Carlile's memoir offers an intimate
glimpse into her life as a lesbian navigating faith,
love, and identity, as well as her path to marriage
equality and motherhood. Brandi recounts how
a pivotal rejection by her church propelled her
toward self-discovery and healing through the
power of music.

LESSONS IN SOCIAL CHANGE FROM *WINNING MARRIAGE*

Marc Solomon said in his book Winning Marriage *that the main reason he wrote it was to show how significant social change can happen in America. There are no shortcuts; it's hard work. It takes vision and a roadmap; it's not easy to simply assert that what you want is right. Jack Baker and Michael McConnell would have won in the 1970s. He quoted President Obama: "The marriage equality movement took countless acts of courage from millions of people across decades who stood up, who came out, talked to parents—parents who loved their children, no matter what. Folks were willing to endure bullying and stay strong, coming to believe in themselves and who they were, and slowly made an entire country realize that love is love."*

Marc created a top-ten list of lessons learned that are particularly applicable to other social movements.

CONVEY A BOLD, INSPIRATIONAL VISION

Identify what you really want to accomplish and communicate that vision early and often. The aspirational possibility of being able to marry spurred hundreds of thousands of regular people to become champions, something a watered-down goal like civil union wouldn't have accomplished. While half-measures along the way are part and parcel of our political system, accepting increments must not preclude reaching the true goal. Remind people and politicians why it matters, and don't settle in the end for anything less.

HAVE AN OVERARCHING STRATEGY

A strategy maintains focus, provides structure, and is a crucial source of support when the going gets rough. When Evan Wolfson embarked on winning marriage nationwide, he envisioned a pathway to victory that included a national ruling by the US Supreme Court. To get the court to act, however, he knew, based on the lessons of history—that we needed to rack up victories in a critical mass of states and grow public support beyond a majority. That big-picture strategy for marriage was called the "Roadmap to Victory," and it provided a simple (but not easy!) approach that served us well when the going got tough and others questioned whether we were on the right path.

FOCUS ON VALUES AND EMOTIONS

With a cause that is as fundamentally important to so many people as marriage, it is essential to tap into fundamental values when making your case. We showed straight America that same-sex couples want to marry out of profound love and commitment— which are the same reasons they want to! We thus helped them to see that supporting marriage for same-sex couples aligns with their own deep-seated values: respect for the golden rule—treating others the way you'd want to be treated, and for freedom for the right to live the way you want as long as it doesn't hurt anyone else. Tapping into those values was a powerful antidote to the fear-mongering that our opponents employed (that the freedom to marry would harm children, for instance). One mistake that some of our campaigns made along the way was in focusing on messages that polled well but didn't have emotional resonance.

MEET PEOPLE WHERE THEY ARE

To create lasting change in America, it's crucial to make the case to people who are conflicted about your cause and give them time to really think it through. On marriage, we knew that nearly everyone had grown up in a society where they were taught that marriage was between a man and a woman, and in a faith tradition where they were taught that homosexuality was wrong. Many good people were conflicted. We were asking them to take a journey that challenged some of their deepest understandings about marriage, family, and religion. That required engaging with their questions, leaving no question unanswered, and tackling their concerns head-on. To get people to yes, we had to encourage them to open their minds and hearts, to listen, question, and reconsider. That meant starting early, staying with the process, and making the case in multiple ways. A shift like that is much less likely to happen if you write someone off or call someone who isn't with you yet a bigot or bad person.

FIND THE RIGHT MESSENGERS

The person who delivers the message, and how it is delivered—matter as much as the message itself. The target audience—in this example, conflicted Americans—must identify with and trust the messenger. It was crucial that same-sex couples make their case in person to family members, neighbors, and friends. Over the airwaves, however, it was parents who were most effective. They could speak to their own struggles with accepting a child's sexuality, about their journey to overcome that struggle, and ultimately about wanting their gay kid to have all that they've had, including the right to marry. Straight people could identify and empathize

with that story. Unexpected champions, such as Republicans, first responders, service members, and clergy—also were especially effective in explaining and modeling how their own deeply held values of freedom, faith, and service to country fell squarely in line with the freedom to marry.

BUILD STATE CAMPAIGNS DESIGNED TO WIN

Winning at the state level requires an experienced manager running a professional campaign with field organizers, communications professionals, and lobbyists, along with a dedicated board helping to raise sufficient resources to carry out the plan. Each campaign must be designed to meet a specific challenge. For example, when we needed to fight against repeal of a freedom-to-marry law in New Hampshire, where the legislature was 80 percent Republican, we built a campaign heavy on GO operatives and business leaders.

INVEST HEAVILY IN LOCAL ORGANIZING

Inspiring and mobilizing supporters, then enlisting them to persuade other voters and elected officials—takes a robust organizing campaign. On challenging issues, advocates too often think they can convince a legislature simply by using top-notch lobbyists, or can win at the ballot box merely by deploying good television ads. That's simply not the case. The most effective way to persuade lawmakers and voters is to let them hear from local people—from ordinary citizens to influential leaders living in their own communities. On marriage, it was especially crucial to show that we were talking about same-sex couples and families who are active participants in their own communities, not "those people out there in the big city."

ACCEPT THIS REALITY: POLITICIANS CARE ABOUT RE-ELECTION ABOVE ALMOST EVERYTHING ELSE

The most important priority for the vast majority of elected officials is continuing to be an elected official. That means that if elected officials think they're going to lose their seats by supporting your cause, you're going to lose first. So you need to be relentless about engaging electorally. First and foremost, that means helping to ensure that those who vote with you win re-election. In the first marriage state of Massachusetts, we re-elected every incumbent who voted our way—195 out of 195 in both 2004 and 2006—in spite of concerted efforts by Governor Mitt Romney and other social conservatives to defeat some of them. And there's simply no better way to show lawmakers you're serious than by defeating at least a small number who vote against you. That means figuring out who is vulnerable, finding quality candidates to run against them, and using tried-and-true campaign techniques to defeat them. Fight Back New York, a PAC that marriage-equality advocates set up in 2010, did just that. It took out three incumbents who voted against us on marriage and completely changed the political calculus in New York State.

BE SERIOUS ABOUT REACHING ACROSS THE AISLE

In today's terribly divided political climate, it's extremely helpful, and in many cases essential, for the cause to be bipartisan. On issues that began as liberal or progressive causes, it's especially important to have Republican voices making the case. Doing so effectively means years of dedicated and serious work, demonstrating to sympathetic Republicans that you're serious about enlisting them, sensitive to their political concerns, and committed to helping them in a way that serves both your needs and theirs. When trying to shift the political center of gravity on marriage, having Rob Portman, Laura Bush, and Dick Cheney speak out was worth its weight in gold.

BUILD MOMENTUM EVERY DAY

A cause is either moving forward or backward. At the heart of my job as the national campaign director for Freedom to Marry was figuring out how to grow momentum every single day. That meant being consistently creative and nimble in identifying opportunities to move the ball forward, and in building narrative that our campaign was succeeding. So whether it's enlisting a Fortune 500 company or a new Republican member of Congress, amplifying the results of a public-opinion poll that demonstrates growth in support, focusing attention on a winning streak in court, or going on television with a new ad campaign, connecting real accomplishments to a compelling and cohesive narrative demonstrates that you're continuing to move toward your goals. An especially crucial element of building momentum is conveying optimism even in the face of defeat. You have to remind your base and opinion leaders that you can do this by highlighting the wins, large and small, that the campaign has already secured, while continuing to point toward the end result that you seek.

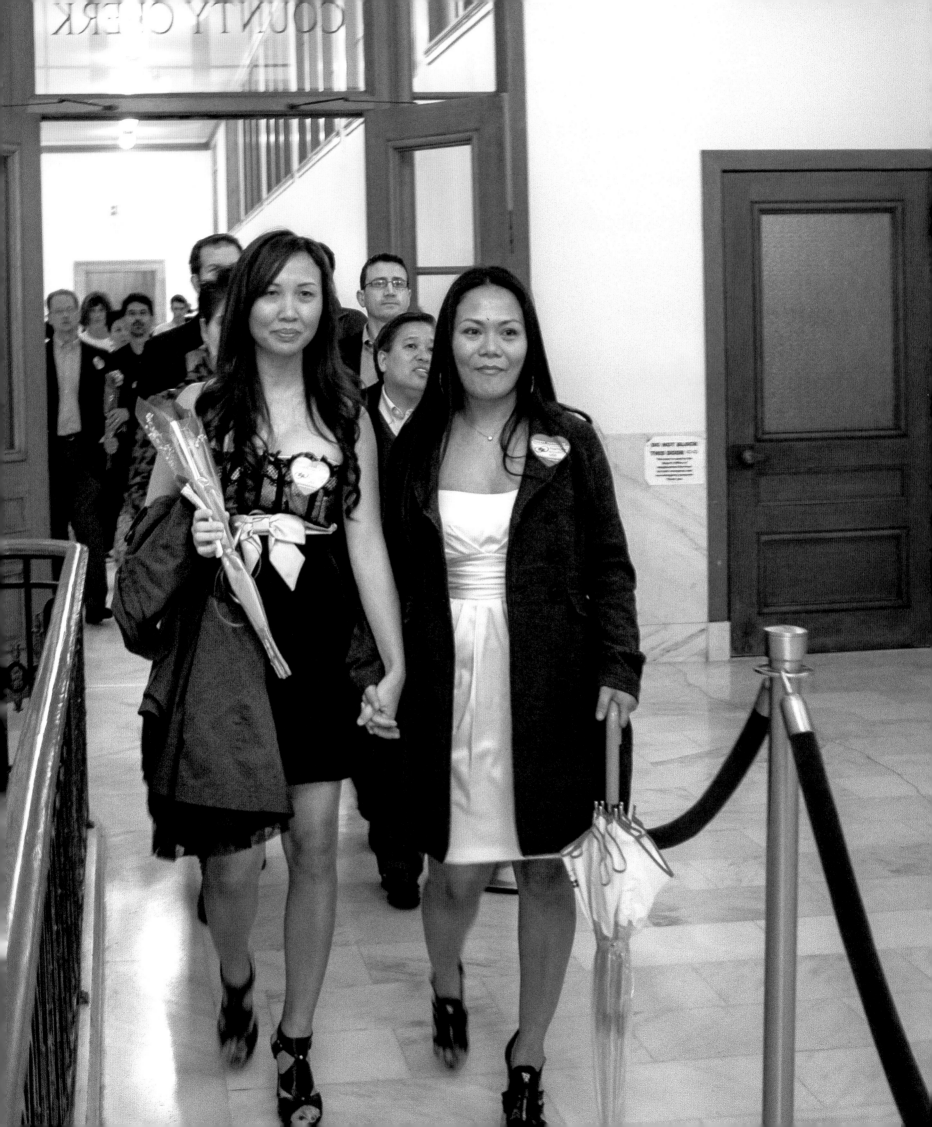

THANK YOU FOR THE LOVE

The team at the JustMarried Project extends heartfelt thanks to everyone who believed in this project, supported it from the beginning, and helped bring together these brave stories to be preserved for generations to come.

Out Leadership * Q Digital * Family Equality

Al Gerharstein
Alicia Roshong
Alison Richman and Tonya
Antoine Katabe and Milad Kohrobani
Ashli Shapiro
Barb Cook and Mike Mooney
Bill Wilson
Ci Siamo
Craig Paulson
Curtis Arthur
Debbie Rice
Desiree Asher
Edie Windsor and Thea Spyer Foundation
Elizabeth Cutter
Equality Vines
Frankeny Images
Harry Borden
Jack Baker and Michael McConnell
Jeff Frankeny and Shay Murray
Jennifer Finney Boylan
Jim Obergefell

Joann Tatum
Jocelyn Augustino
Jonathan Mintzer
Jøyus Wines
LGBTQ+ Real Estate Alliance
Luli Wines
Malin+Goetz
Mark Guisti/London
Marilyn Humphrey
Morgenthal Frederics
Protéger
Rowland Scherman
St. George Spirits
Sage Sohier
Silver Oak
Steve Smith and Ian Hartsoe
Sue-Ellen Case, PhD
Talbott & Arding
Thomas Miller
The 4 MRs—The Ramsey Family: Michael, Matthew,
 Malaki, and Makai

Stay up to date with the JustMarried Project
by visiting JustMarried.Us

ACKNOWLEDGMENTS

I'd like to thank Mindy Rabinowitz, who devoted more time to this project than anyone except me; Elizabeth Cutter, my rock throughout this journey; Bill Loccisano—your impeccable design, patience, and professionalism are unmatched; and to everyone at Rizzoli International Publications for believing in the vitality of these stories: Charles Miers, Sandy Gilbert Freidus, Elizabeth Smith, Sara Pozefsky, and Gloria Arminio—what a whirlwind, I've learned a lot, praises. To Leslie Stoker, my agent—your guidance from start to finish was invaluable; Uncle Al and Rabbit; Chris and Anne Schlatter-Gaede—you are absolute rockstars; Audrey Kuhn—your kindness, patience, and friendship mean so much to me; and to Angela Gyetvan, Jason Dorn, and Lynn Mueting—thank you for years of nurturing this project. To Bill LeBlond and Leslie Jonath— thank you for sharing your publishing insights; Sean Vahey, Kate Ellison, and Joyce Murdoch—thank you for your contributions; and to Jeff and Kelly, James and Joel—thank you for your hospitality during the madness of making this book. Jeff and Shay—I love you so much; thank you for your love and support, even though you're jerks for not telling me you have been married for five years. To Hugh Nini and Neal Treadwell, Bill Wilson, and Marilyn Humphries—thank you for access to your incredible collections of images. To John Casey, Stuart Gaffney, and John Lewis: Your kindness and willingness to jump in wherever needed was such a clutch. To Evan Wolfson: Thank you for joining this project—your brilliance made marriage equality a reality. To Karen Thompson: Your story has inspired me since I saw you speak in the 1980s and still does. To Shirley and Jay Mercado: Thank you for showing me and the world what amazing gay parents look like. To Kris Perry and Sandy Stier, Jack Baker and Michael McConnell, and all those who shared their stories: Thank you for helping to keep this history alive. To Jim Obergefell: You're courageous, funny, and smart. Your bravery in telling your story, amid grief, is extraordinary. Very few people could have shown your strength, and it's because of you that we are here today. Most importantly, to my mother—my foundation and support system, even before I came out. And finally, to every songwriter who let me know as a kid that, yes, there were people like me out there. And to every dachshund BFF I've had in my life—thank you for being there when I had no one else to come out to, to listen when I had my first crush, to console me after breakups, and to share my secrets when there was no one else to confide in. Now that is love.

CONTRIBUTORS

Jennifer Finney Boylan is a best-selling author, professor, and advocate for LGBTQ+ rights. Her acclaimed memoir, *She's Not There: A Life in Two Genders*, was one of the first best-selling works by a transgender American.

John Casey is the lead writer and senior editor at *The Advocate*. His columns feature consequential newsmakers, including Dr. Anthony Fauci, Neil Patrick Harris, Ellen DeGeneres, Jamie Lee Curtis, former House Speaker Nancy Pelosi, and all LGBTQ+ members of the US House of Representatives.

Frankie Frankeny is the creator of the JustMarried Project, which has documented the marriage equality movement since 2004. A photographer, director, producer of award-winning books, and dachshund aficionado, Frankie is also the founder of GoodDoxie Studios.

Stuart Gaffney and John Lewis are marriage equality activists and plaintiffs in *In re Marriage Cases*, the landmark California Supreme Court decision that recognized same-sex marriage in 2008.

Joyce Murdoch and Deborah Price, the first nationally syndicated LGBTQ+ columnists, co-authored *Courting Justice: Gay Men and Lesbians v. the Supreme Court* and *And Say Hi to Joyce*. Their work illuminated the legal and social struggles of the LGBTQ+ community, shaping public understanding and support for equality.

Jim Obergefell is the named plaintiff in *Obergefell v. Hodges*, the landmark Supreme Court case that legalized marriage equality in the United States in 2015. He is the author of *Love Wins: The Lovers and Lawyers Who Fought the Landmark Case for Marriage Equality*. He continues to educate through his activism and public speaking.

Marc Solomon was a key strategist in the fight for marriage equality. His book, *Winning Marriage: The Inside Story of How Same-Sex Couples Took on the Politicians and Pundits—and Won*, chronicles the historic campaign to achieve marriage equality in the United States.

Evan Wolfson, often referred to as the architect of the marriage equality movement, is an attorney and author of *Why Marriage Matters: America, Equality, and Gay People's Right to Marry*. He is also the founder of Freedom to Marry, the organization that played a pivotal role in securing marriage equality in the United States.

PHOTOGRAPHY CREDITS AND NOTES

Photography Credits

Page 5: Photograph courtesy of Judith Kasin Windsor and the Edie Windsor & Thea Spyer Foundation.

Pages 6–7: Photograph courtesy of Rick Raven.

Page 9: Jack Baker and Michael McConnell; Charlotte Brooks, photographer, LOOK Magazine Photograph Collection, Library of Congress, Prints & Photographs Division, [Reproduction number LC-DIG-ds-09727].

Page 11: Photography by Frankie Frankeny.

Page 13: Photography by Bill Wilson.

Page 15: Photography by Frankie Frankeny.

Page 16: Photograph courtesy of Evan Wolfson; *The Freedom to Marry*, documentary (2016).

Pages 19, 21, 22: Photography by Frankie Frankeny.

Page 25: Photograph from *The Invisibles: Vintage Portraits of Love and Pride: Gay Couples in the Early Twentieth Century* (2014).

Page 27: Photograph courtesy of Thomas Miller; *Limited Partnership*, PBS documentary (2014).

Page 29: Photography by Kan Sangtong.

Page 31: Photograph from *The Invisibles: Vintage Portraits of Love and Pride: Gay Couples in the Early Twentieth Century* (2014).

Page 33: Photography courtesy of George Harris.

Page 34: Photograph courtesy of Thomas Miller; *Limited Partnership*, PBS documentary (2014).

Page 37: Photography courtesy of Clela Rorex Estate via Wikimedia Commons.

Page 39: Photography by Bettmann/Getty Images.

Pages 41, 2 (row 4, image 3): Photographer unknown; photograph courtesy of Themarginalian.org.

Page 42: Photograph courtesy of Hugh Nini and Neal Treadwell, and the Nini-Treadwell Collection.

Page 44: Photography by Frankie Frankeny.

Pages 45, 46–47: Photograph courtesy of Hugh Nini and Neal Treadwell, and the Nini-Treadwell Collection.

Pages 48–49: Photographer unknown; courtesy of *Out* Magazine; archival material from the John J. Wilcox Jr. Archives, Philadelphia.

Page 51: Photography by Rowland Scherman, ca. March 1966; Rowland Scherman Collection (PH 084). Special Collections and University Archives, University of Massachusetts Amherst Libraries.

Page 53: Photography by Charlotte Brooks; LOOK Magazine Photograph Collection, Library of Congress, Prints & Photographs Division, [Reproduction number LC-DIG-ds-09636].

Pages 54–55: Photograph courtesy of the Minnesota Historical Society.

Pages 57, 2 (row 4, image 2): Photograph courtesy of Jack Baker and Michael McConnell.

Pages 59, 2 (row 2, image 4): Photograph courtesy of A.F. Archive/GLBT Historical Society.

Page 61: Photography by Liz Mangelsdorf; courtesy of *The San Francisco Chronicle*.

Pages 63 and 2 (row 2, image 3), 65, 67: Photograph courtesy of Thomas Miller; *Limited Partnership*, PBS documentary (2014).

Page 69: Photography by Sage Sohier; courtesy of Sage Sohier.

Page 70: Photography courtesy of LGSM (Lesbians and Gays Support the Miners).

Page 73: Photographer unknown; courtesy of Wikimedia Commons.

Pages 74–75: Photograph courtesy of The NAMES Project.

Page 77: Photograph courtesy of Evan Wolfson.

Page 79: Copy of thesis page courtesy of Evan Wolfson.

Pages 80–81: Photographer unknown; courtesy of *QSaltLake Magazine*.

Page 83 (all): Photographs courtesy of Karen Thompson.

Page 85: Photography by Marcy Hochberg; courtesy of Karen Thompson.

Pages 86–87: Photograph courtesy of Karen Thompson.

Pages 89, 2 (row 1, image 3): Photograph courtesy of Joyce Murdoch.

Pages 90–91: Clipping courtesy of Joyce Murdoch/*Detroit News*, May 8, 1992.

Page 92: Source: *The AIDS Quarterly*, PBS, September 27, 1989; via Rainbow History Project, YouTube.

Page 93: Photograph courtesy of Barry Warren and Tom Brougham.

Page 95: Photography by Eddie Adams. © 1970 Associated Press.

Page 97: Photograph courtesy of Genora Dancel.

Page 99: Photograph courtesy of Captains Daniel Hall and Vincent Franchino.

Page 101: Photography by Paul Smith/Featureflash.

Page 102: Photography by Gina van Hoof; courtesy of The Matthew Shepard Foundation.

Page 105: Photography by Terry Schmitt.

Page 107: Still from *Silverlake Life: The View From Here* (1993), directed by Peter Friedman and Tom Joslin; courtesy of PBS/POV.

Pages 108–109: Photography by Judy Linn; still from *Silverlake Life: The View From Here* (1993), directed by Peter Friedman and Tom Joslin; courtesy of PBS/POV.

Page 111: Photograph courtesy of Susan Parker and Wendy Scott.

Page 113: Photography by Mike Segar, REUTERS; Bridgeman Images.

Pages 114, 2 (row 4, image 1): Photograph courtesy of Genora Dancel.

Page 117: Photography by Peg Harrigan; courtesy of Peter Harrigan and Stannard Baker.

Pages 118–119: Photography by Kevin Zolkiewicz/Flickr.

Page 121: Photography by Paul Smith/Featureflash; Dreamstime.com (File ID 36047462).

Page 123: Photography by Paul Smith/Featureflash.

Page 124 (all): Photography courtesy of Transgriot.com.

Page 127: Photograph courtesy of Stuart Gaffney and John Lewis.

Page 129: Photographer unknown; public domain; source: Wikimedia Commons.

Page 131: Photography by David Shankbone.

Page 133: Photography by Bill Wilson.

Pages 134–135: Photography by Peter Dejong/AP Photo.

Page 137: Photography by Andrew Wallace/REUTERS.

Pages 138–139, 2 (row 1, image 1): Photograph courtesy *OutSmart Magazine*.

Pages 140–141: Photography by Marilyn Humphries.

Pages 143, 2 (row 3, image 2): Photography by Winslow Townson/AP Photo.

Page 145: Photography by Meredith Nierman/WGBH.

Page 147: Photography by Jim Bourg/REUTERS, via Bridgeman Images.

Pages 148–149: Photography by Marilyn Humphries.

Page 153: Photography by John Wilcox/MediaNews Group/Boston Herald, via Getty Images.

Pages 154–155: Photography by Bill Wilson.

Pages 156–157: Photography by Marcio Jose Sanchez/AP Photo.

Page 159: Photography by Stefano Rellandini/REUTERS.

Pages 162–163: Photography by BlackoutDTLA.

Page 165 (all): Photographs courtesy of Daniel Gross and Steven Goldstein.

Pages 167, 169, 171: Photography by Frankie Frankeny.

Page 173: Photography by Guillermo Fernández; source: Wikimedia Commons.

Page 175: Photography by Frankie Frankeny.

Page 176: Photograph courtesy of Stuart Gaffney and John Lewis.

Page 178: Photography by Frankie Frankeny.

Page 181: Photograph courtesy of Stuart Gaffney and John Lewis.

Page 183: Photograph courtesy of Beth Kerrigan and Jodi Mock.

Pages 184–185: Photography by Brian Snyder/REUTERS, via Bridgeman Images.

Page 187: Photography by Gillian Laub.

Page 189: Photography by Alan Light.

Page 191: Photography by Justin Hayworth. Clipping courtesy of the Des Moines Register, April 3, 2009.

Page 193: Photography by Justin Hayworth/Des Moines Register.

Pages 195, 197, 199: Photography by Frankie Frankeny.

Pages 200–201, 203, 204, 206–207: Photography by Frankie Frankeny.

Pages 208–209 (all): Photographs courtesy of Page Hodel.

Pages 210–211: Photography by Adam Bouska.

Page 213: Photography by Michael Rozman; courtesy of Warner Bros.

Pages 215, 217, 218–219: Photography by Frankie Frankeny.

Pages 220–221, 222 (all): Photography courtesy of Erin and Kerri Carder-McCoy.

Page 225: Photography courtesy of Spencer Jones.

Pages 226, 229 (all), 2 (row 5, image 1): Photography courtesy of Shirley Tan and Jay Mercado.

Pages 230, 2 (row 3, image 3): Photography courtesy of Jennifer Finney Boylan.

Page 235: Photography courtesy of Nikki Araguz Lloyd/Instagram.

Pages 237, 2 (row 1, image 2): Photography courtesy of George and Brad Takei.

Page 239: Photography by Frankie Frankeny.

Page 241: Photography by Blurf; Dreamstime.com (Image ID: 120746746).

Page 243: Photograph courtesy of Ben Cotner; The Case Against 8 (2014).

Pages 244–245: Photography by David Gallagher; courtesy of David Gallagher via Flickr.

Page 247: Photography by Adam Bouska; courtesy of Zach Wahls.

Page 251: Courtesy of Kris Perry and Sandy Stier.

Pages 253, 2 (row 2, image 4): Photography by Bill Wilson.

Pages 254–255: Photography by Diana Walker.

Page 257: Photograph courtesy of Ben Cotner. The Case Against 8 (2014).

Page 259: Photograph courtesy of Ben Cotner. The Case Against 8 (2014).

Pages 260–261: Photography by Shiningcolors; Dreamstime.com (Image ID: 5597819).

Page 263, 2 (row 5, image 3): Photography by Craig Paulson.

Pages 265, 266, 267 (all): Photograph courtesy of Kelly Glossip/Facebook.

Page 269: Photography by Harry Borden.

Pages 270–271: Photography by Shawn Miller; courtesy of the Library of Congress via Wikimedia Commons.

Page 273: Photography by Lev Radin; Pacific Press/Shutterstock.

Page 274: Photography by Laurence Agron; Dreamstime.com (File ID: 150460291).

Pages 276–277: Photography by Bill Wilson.

Pages 279, 280, 283, 2 (row 2, image 1): Photograph courtesy of Judith Kasin Windsor and the Edie Windsor & Thea Spyer Foundation.

Pages 284–285 (all): Photography by Bill Wilson.

Pages 286–287: Photography by Lei Xu; Dreamstime.com (File ID: 31945947).

Page 289: Photography by Frankie Frankeny.

Page 291: Official White House Photo by Pete Souza; source: White House Archives.

Page 293: Mural by @ellestreetart; photography by Ritu Jethani; Dreamstime.com (File ID: 223853509).

Pages 294–295: Photography by Lawrence Weslowski Jr.; Dreamstime.com (File ID: 39299184).

Page 297: Photography by Meryl Schenker; courtesy of Wikimedia Commons.

Page 299: Photograph courtesy of Mark Phariss and Vic Holmes.

Pages 300–301: Photography by Johnny Hanson; courtesy of the Houston Chronicle/AP.

Page 303: Photography by Elizabeth Lavin.

Page 305: Photography by Marilyn Humphries.

Page 307: Photograph courtesy of April DeBoer and Jayne Rowse.

Pages 308–309: Photograph courtesy of Tevin Johnson-Campion.

Page 310: Photograph courtesy of Pamela Yorksmith.

Pages 312–313: Photography by Lorie Shaull.

Pages 315, 2 (row 3, image 1), 317: Photographs courtesy of Jim Obergefell.

Page 318: Photograph courtesy of Cincinnati.com.

Pages 320–321: Photography by Doug Mills/The New York Times.

Pages 322–323: Photography by Ted Eytan; courtesy of Wikimedia Commons.

Page 325: Photography by Joe Sohm; Dreamstime.com (Image ID: 173902024).

Page 327: Photography by Jocelyn Augustino; courtesy of Gov. Jared Polis and First Gentleman Marlon Reis.

Page 329: Photography by Adam Schultz; courtesy of the White House via Wikimedia Commons.

Page 331: Photography by Stephanie Hayner; courtesy of Olivia Hamilton.

Pages 333, 335: Photography by Ashli Shapiro; courtesy of Andrew and Elad Dvash-Banks.

Page 337: Photography courtesy of Rep. Malcolm Kenyatta and Dr. Matthew Jordan-Miller.

Pages 338–339: Photography by Hutchinsphoto; Dreamstime.com (Image ID: 265906976).

Pages 340–341, 2 (row 5, image 2): Photography by Joe Sohm; Dreamstime.com (Image ID: 173902024).

Page 343 (row 2, image 1): Photography by Eli Wilson; courtesy of Dreamstime.com (ID 174254957). (All others): Photography by Chuck Kennedy; courtesy of Pete for America via Flickr.

Page 345: Photograph courtesy of Jeff and Todd Delmay.

Page 347: Photography by Tony Valadez; courtesy of Don Lemon and Tim Malone.

Pages 348–349: All images courtesy of the couples in the images. (Top row, left to right): Malaki Ramsey, Michael Ramsey, Makai Ramsey, Matthew Ramsey; John Farina, Jim Obergefell, Adam Tully; Paden Stanton, Aaron Weinerman; Bobby Tran, Steven Cayton; Kim Simes, Brennan Fox-Simes, Robin Fox, Sanibel Fox-Simes. (Middle, left to right): James DeMuth, Joel Moncada; Cedric Wilson, Tyler Walker; Matthew Harrell-Morris, Cole Harrell-Morris; Tonya Agnew, Amy Crampton; Robert Sacheli, Bruce Rosenblatt. (Bottom, left to right): Marquez Brown (top), Trent Millard; photography Sarah Werner, Jenny and Ashley Smit; Cory Claussen, Thomas Cluderay; Eric Tarring, Mohsin Ali.

Page 351: Jack Baker and Michael McConnell; Charlotte Brooks, photographer, LOOK Magazine Photograph Collection, Library of Congress, Prints & Photographs Division, [Reproduction number LC-DIG-ds-09637].

Page 358: Photography by Frankie Frankeny.

Pages 364–365: Photography by Michael Key; courtesy of the Washington Blade.

Following spread: Balloons spelling out "love" float above the Supreme Court in Washington, DC, on June 26, 2015, the day the Court declared marriage a constitutional right for same-sex couples nationwide.

Notes

Unless otherwise stated, all quotations were obtained by the writers of *Love* from interviews, correspondence, and publications, with permissions granted.

Endpapers, pages 18, 20: "No union is more profound than marriage. . . ." "It would misunderstand these men and women to say they disrespect the idea of marriage. . . ." "They ask for equal dignity in the eyes of the law. . . ." Opinion of the United States Supreme Court by Justice Anthony Kennedy, *Obergefell v. Hodges*, 576 US 644 (2015).

Page 40: "I was impressed with her presence. . . ." Gertrude Stein, *The Autobiography of Alice B. Toklas* (New York: Harcourt, Brace & Company, 1933), 5.

Pages 43–44: Hugh Nini and Neal Treadwell's story is based on interviews and their book *Loving: A Photographic History of Men in Love, 1850s–1950s* (New York: 5 Continents Editions, 2020), 7–11.

Page 50: "I am proud that Richard's and my name is on a court case that can help reinforce the love. . . ." Mildred and Richard Loving, public statement on the anniversary of *Loving v. Virginia*, 2007.

Page 58: Del Martin and Phyllis Lyon's story is based on interviews and their book *Lesbian/Woman* (San Francisco: Glide Publications, 1972) and the Daughters of Bilitis publication *The Ladder*.

Page 86: Karen Thompson and Sharon Kowalski's story is based on interviews with Karen Thompson, legal case documentation, 1983–91, and Karen Thompson and Julie Andrzejewski's book, *Why Can't Sharon Kowalski Come Home?* (San Francisco: Spinsters Ink,1988).

Page 104: "We registered as domestic partners in San Francisco. . . . We were number ten, as our license says on the back." Bill Wilson and Fernando Orlandi, domestic partnership license, California, 1985.

Page 112: Jon Holden and Michael Galluccio's story is based on their book *An American Family* (Hoboken, New Jersey: Wiley, 2002).

Page 115: Ninia Baehr and Genora Dancel's story is based on interviews and their court case documentation, 1991–96.

Page 116: "*Love is love*" Stannard Baker and Peter Harrigan's story is based on interviews. "Love is love" emerged as a prominent slogan within the marriage equality movement, gaining significant traction around 2014 and symbolizing the universality of love across all identities.

Page 125: Christie Lee and Jonathan Littleton's story is based on legal documents and case studies, 1999–2001.

Page 136: Michael Stark and Michael Leshner's story is based on interviews and archival material, 2003.

Pages 140, 142, 145: Reprint of Joe Hernandez's article, "How Making History Unmade a Family," NPR, May 16, 2019.

Page 152: "Tragically, Ron had suffered a massive heart attack and died. . . ." David Wilson and Rob Compton's story is based on interviews and statements, 2003–15.

Page 154: Essay based on the *San Francisco Chronicle*'s daily reporting by Rona Marech on same-sex marriage, February 2004.

Page 158: Page Hodel and Madalene Rodriguez's story is based on an interview with Page Hodel, and Hodel's book *Monday Hearts for Madalene* (Berkeley, CA: Ten Speed Press, 2009).

Page 161: List of rights, privileges, and protections from 2004 update to U.S. General Accounting Office, *Defense of Marriage Act*, GAO/OGC-97-16 (Washington, D.C.: January 31, 1997).

Page 210: Adam Bouska and Jeff Parshley's story is based on interviews from 2009–15.

Page 212: "She's my wife; I get to say that she's my wife, and that's just the way it is." Ellen DeGeneres and Portia de Rossi's story is based on statements and interviews, 2008–15. DeGeneres's quote is from *The Oprah Winfrey Show*, November 9, 2009, ABC.

Page 214: Wanda and Alex Sykes's story is based on a Wanda Sykes interview by Oprah Winfrey, from *The Oprah Winfrey Show*, January 2010, ABC.

Pages 232–33: Jennifer Finney Boylan's *New York Times* opinion piece, "Is My Marriage Gay?," May 11, 2009, reprinted with permission from Boylan and the *New York Times*.

Pages 278, 282–83: Edie Windsor and Thea Spyer's story is based on Edie Windsor and Joshua Lyon's book, *A Wild and Precious Life* (New York: St. Martin's Press, 2019), 121, 138, 221, 237, 260.

"LOVE IS THE MOST POWERFUL FORCE IN THE UNIVERSE—
IT CAN AND DOES TRANSFORM EVERYTHING."

—Jack Baker and Michael McConnell, the first LGBTQ+ couple
in the US to hold a legal marriage license,
recognized forty-seven years after it was issued.

First published in
the United States of America in 2025 by
Rizzoli International Publications, Inc.
49 West 27th Street
New York, NY 10001
www.rizzoliusa.com

Publisher: Charles Miers
Project Editor: Sandra Gilbert Freidus
Design: William Loccisano
Production Manager: Gloria Arminio
Managing Editor: Lynn Scrabis
Editorial Assistance: Elizabeth Smith and Sara Pozefsky

Printed in Italy

2025 2026 2027 2028 / 10 9 8 7 6 5 4 3 2 1

ISBN: 978-0-8478-4791-4
Library of Congress Control Number: 2024946658

Visit us online:
Facebook.com/RizzoliNewYork
Instagram.com/rizzolibooks

X: @ Rizzoli_Books
Youtube.com/user/RizzoliNY

Front Matter Captions:
Page 5: Edie Windsor (left) with Thea Spyer. They met in the 1960s.
Pages 6–7: The wedding of Nick and Nate Raven, Fire Island, New York, May 20, 2018.
Page 9: Jack Baker and Michael McConnell, *Look* magazine, January 26, 1971.
Pages 11 and 289: Supporters of marriage equality stage a mock wedding with hundreds of witnesses
inside San Francisco City Hall to protest Proposition 8, April 2010.

The JustMarried Project:
Executive Producers: Lynn Mueting, Jason Dorn, Jim Obergefell, and Frankie Frankeny

Be Part of the Story:
Stay up to date with the JustMarried Project by visiting JustMarried.Us

It would misunderstand these men and women to say they disrespect the idea of marriage.

Their plea is that they do respect it, respect it so deeply that they seek to find its fulfillment for themselves.